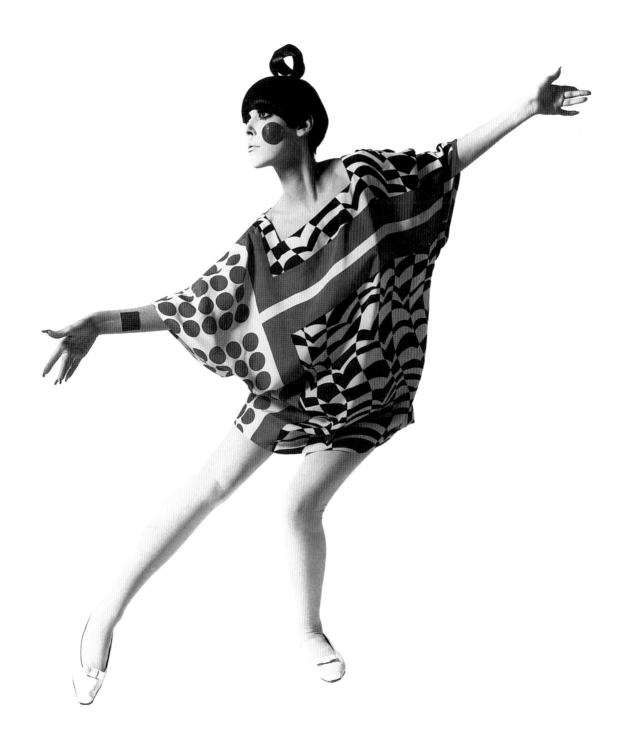

In the twentieth century there have
been a handful of geniuses whose in-
novations have changed the course
of their art for all time:

In painting it was Picasso.
In music it was Stravinsky.
In film it was Eisenstein.
In theater it was Stanislavsky.
In dance it was Balanchine.
In jazz it was Parker.
And in fashion design it was
Rudi Gernreich.

—Peggy Moffitt

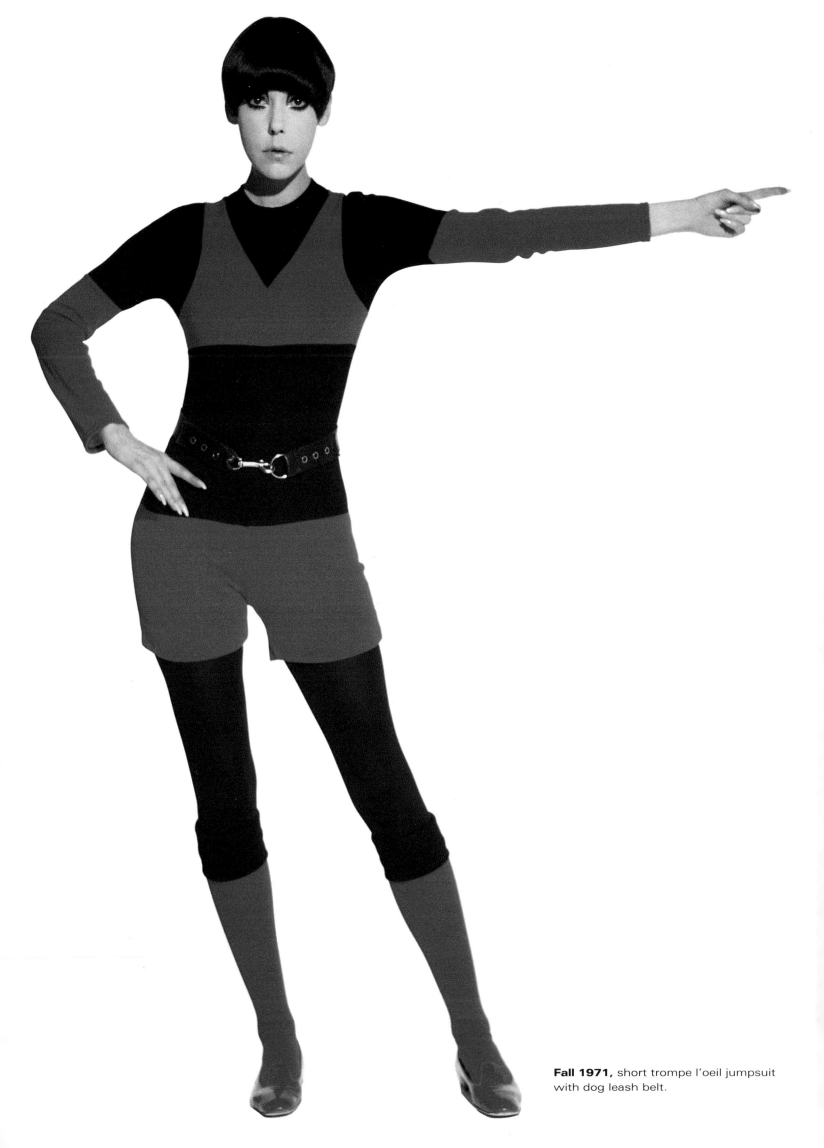

Fall 1971, short trompe l'oeil jumpsuit with dog leash belt.

THE
RUDI
GERNREICH
BOOK

Peggy Moffitt
Photography by William Claxton
Essay by Marylou Luther

TASCHEN

KÖLN LONDON MADRID NEW YORK PARIS TOKYO

Contents · Inhalt · Sommaire

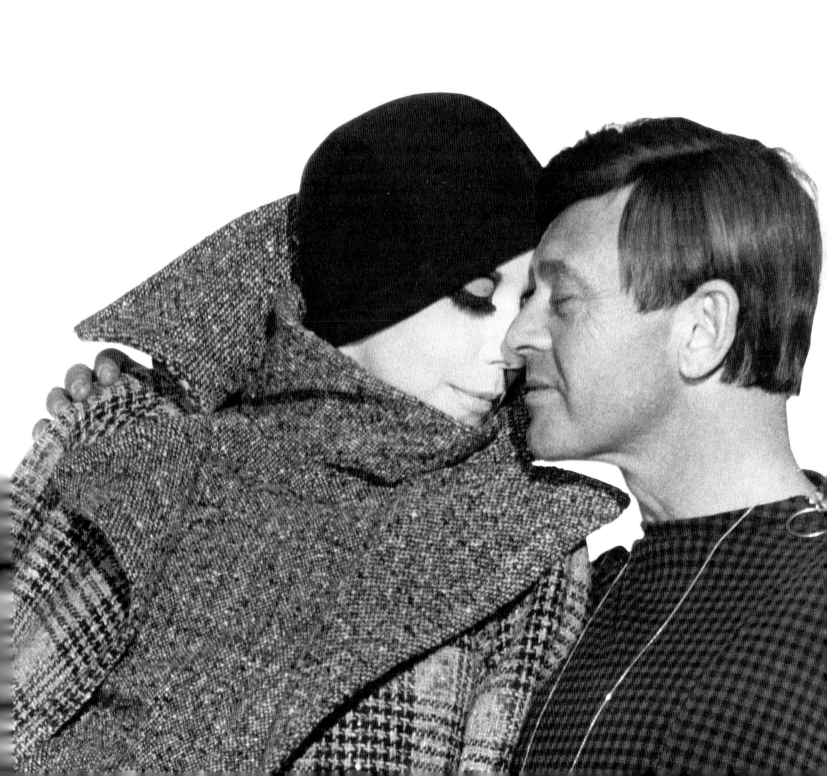

Rudi

have devoted most of my professional life to Rudi Gernreich. I believed totally in his talent and had the great privilege of knowing him as a dear friend. Through the years we developed as a team. One of the great signs of his genius was that he allowed me to express my talent fully. I never had to hold back when we worked together. I could criticize or suggest without fear that I was overstepping my position. We had indescribable fun together and shared the romance of creativity and collaboration. We always said if he had been a model, he would have been me, and if I had been a designer, I would have been him. During the great times that we worked with each other, an enormous amount of publicity and controversy was created. This, of course, was very positive and helpful at the time; but I have always felt that Rudi's great talent was overlooked because of the headlines. I have never felt this as strongly as I do now that he is gone. It is my belief that Rudi Gernreich designed almost everything that can be designed for modern people. His designs are so logical and pure that one design will work for an elderly woman and equally well for a teenage girl. I feel that most people think of his work as of the "sixties" or "trendy", when in fact his work was more universal and classical than that of Chanel.

Rudi Gernreich, **1964**.

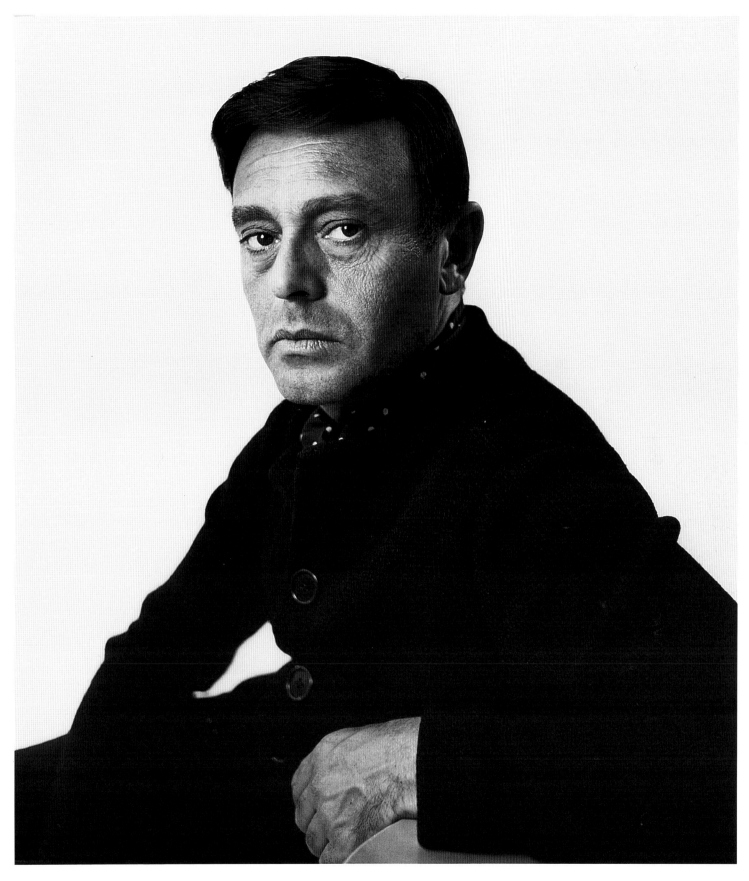

Rudi Gernreich was an avant-garde fashion designer who started in the 1940s, was acknowledged as an innovator in the fifties, and became a "household name" in the sixties.

He was best known for his design of the topless swimsuit, but the sum of his work and his design philosophy changed the course of fashion and influenced designers all over the world. His concepts have continued to feed the fashion industry, as he invented the modern way of dressing for the latter half of the twentieth century, just as Chanel had done for the earlier part of the century.

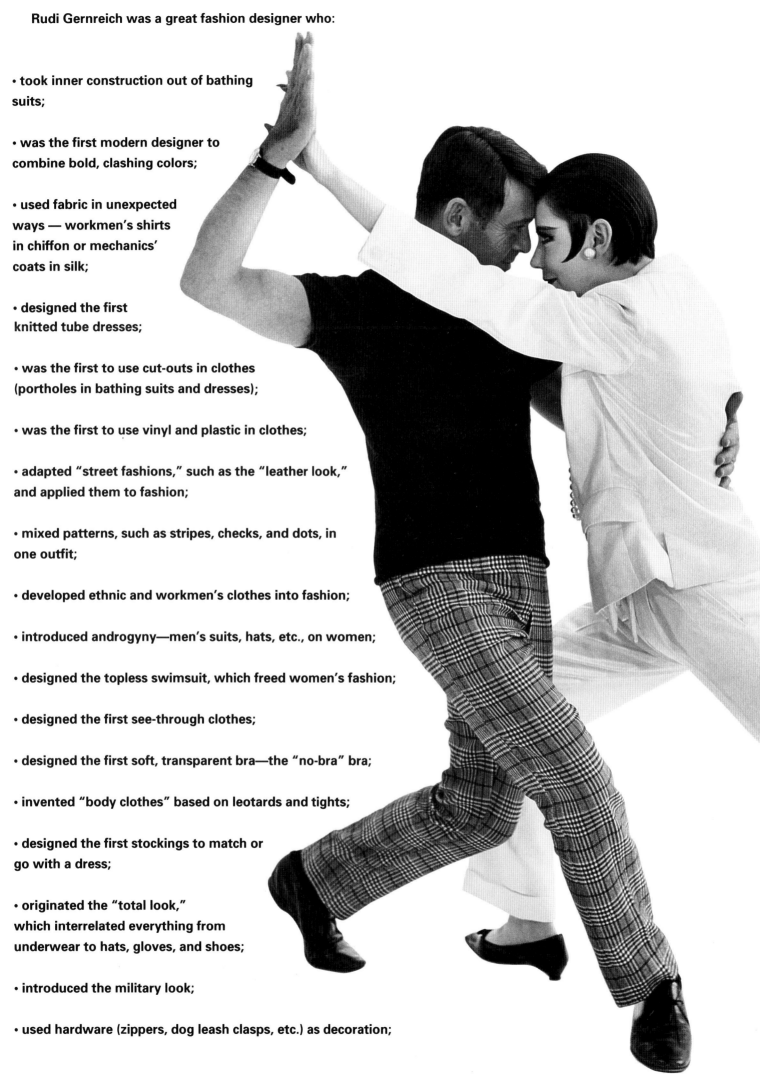

Rudi Gernreich was a great fashion designer who:

- took inner construction out of bathing suits;

- was the first modern designer to combine bold, clashing colors;

- used fabric in unexpected ways — workmen's shirts in chiffon or mechanics' coats in silk;

- designed the first knitted tube dresses;

- was the first to use cut-outs in clothes (portholes in bathing suits and dresses);

- was the first to use vinyl and plastic in clothes;

- adapted "street fashions," such as the "leather look," and applied them to fashion;

- mixed patterns, such as stripes, checks, and dots, in one outfit;

- developed ethnic and workmen's clothes into fashion;

- introduced androgyny—men's suits, hats, etc., on women;

- designed the topless swimsuit, which freed women's fashion;

- designed the first see-through clothes;

- designed the first soft, transparent bra—the "no-bra" bra;

- invented "body clothes" based on leotards and tights;

- designed the first stockings to match or go with a dress;

- originated the "total look," which interrelated everything from underwear to hats, gloves, and shoes;

- introduced the military look;

- used hardware (zippers, dog leash clasps, etc.) as decoration;

8

- did the first designer jeans;

- developed trompe l'oeil clothes (a dress that looked like three pieces but was really one, etc.);

- invented the "uni-sex" look (clothing that could be worn by both men and women—skirts for men, etc.);

- designed the "thong," the first bathing suit to be cut high on the thighs and expose the buttocks;

- was the first to design men's underwear for women;

- designed the first bathing suit to expose pubic hair, the "pubikini."

Rudi Gernreich was a proponent of reasonably priced clothes and was anti "status" fashion. He was also the first designer since Dior to become a household name throughout the world. The controversy he has caused has continued even after his death. But the fact remains, he changed the vocabulary of fashion for the twentieth century.

—Peggy Moffitt
Beverly Hills, 1991

Looking Back at a Futurist

Marylou Luther

udi Gernreich bared breasts and pubic hair, shaved heads and bodies, and passed out guns, all in the name of fashion. Clergymen denounced his fashion exploits from the pulpit. His topless bathing suit was banned by the pope, denounced by *Izvestia,* and buried in an Italian time capsule between the Bible and the birth control pill. To many in the fashion world, Gernreich was a prophet, a seer with 20/20 fashion vision. To his detractors, he was also a prophet: the oracle of ugly.

Gernreich saw himself as two designers. One was a fashion-oriented originator motivated by the need to create modern clothes for the twentieth century—and beyond. This was the Gernreich who won every major award American fashion could bestow. The other Gernreich was a social commentator who just happened to work in the medium of clothes. In Gernreich's words: "Prior to the sixties, clothes were clothes. Nothing else. Then, when they started coming from the streets, I realized you could say things with clothes. Design was not enough. Probably because of the impact of my topless bathing suit of 1964 I became much more interested in clothes as sociological statements. I feel it's important to say something that is not confined to its medium."

Rudi at work, Los Angeles, **1966.**

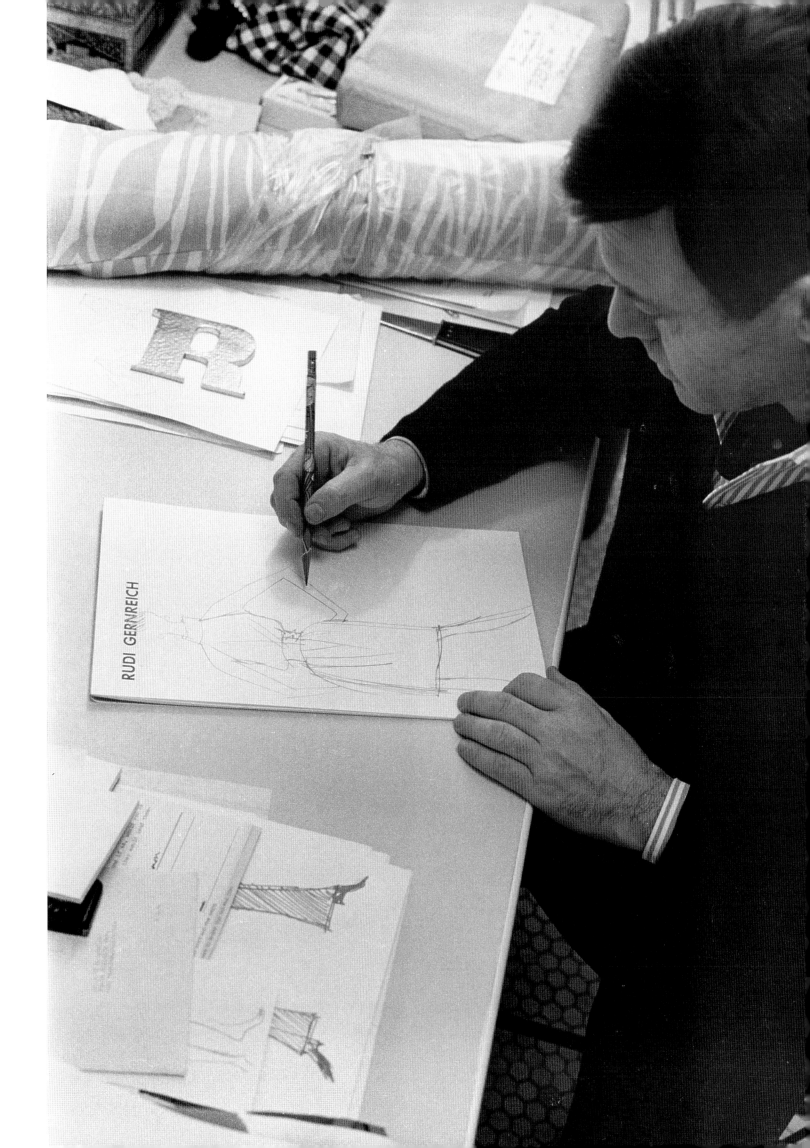

Through his designs, Gernreich said a lot of things that were not confined to fashion: that women's bodies deserve to be free of the constraints that have kept them submissive to men; that women's clothes and men's clothes could be interchangeable, thus making the two sexes truly equal; that utilitarian uniforms would take our minds off how we look so we could concentrate on how we act; that fashion isn't a tragedy—it's entertainment; that nudity is no longer equated with morality; that how we dress is inextricably linked to how we live; that wit and humor will always have the last laugh on the superserious, sometimes supercilious world of fashion.

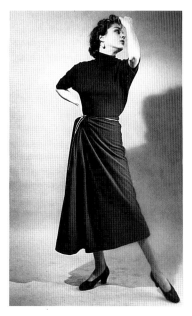

Early 1950s, wool sarong skirt. (photograph © Christa)

The man many consider the quintessential American designer was born in Vienna, Austria, on August 8, 1922. He got his first look at the world of high fashion in a dress shop run by his aunt, Hedwig Mueller. In the shop Gernreich called his "sanctuary from the rigid, militaristic atmosphere of school," he spent hours sketching designs for Viennese society and learning as much as he could about fabrics. By the time he was twelve, his fashion sketches had been seen by the Austrian designer Ladislaus Zcettel, who was leaving for London to design film costumes for Alexander Korda, and who later came to America to run Henri Bendel's couture studio in New York. Zcettel offered Gernreich an apprenticeship in London, but his mother felt he was too young to leave home. (Gernreich's father, Siegmund Gernreich, a hosiery manufacturer, committed suicide in 1930 when his son was eight.)

In 1938, just six months after the March 13 Anschluss, sixteen-year-old Gernreich and his mother joined the stream of Jewish refugees and escaped to California. His first job in the United States was working in a mortuary. Gernreich later recalled, "I grew up overnight. There I was with all those dead bodies. Eventually I got used to the corpses. But I do smile sometimes when people tell me my clothes are so body-conscious I must have studied anatomy. You bet I studied anatomy."

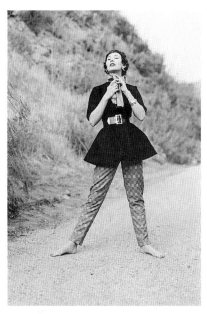

1953, black peplum and multicolored checked pants. (photograph © Christa)

As an art student at Los Angeles City College, Gernreich was close to Hollywood geographically; but though he worked in the publicity department at RKO Studios and once replace a friend who was a sketch artist for costume designer Edith Head, he did not become famous designing clothes for films. Hollywood was to become his home, but not his life.

As the direct result of watching a performance by Martha Graham's modern dance company, Gernreich abandoned art and the movie studios in favor of dance and the theater. While studying with the choreographer Lester Horton, whom he described as "a kind of West Coast Martha Graham," he became less interested in the static details of clothes and more concerned with how they looked in motion.

By the mid-forties, Gernreich was supplementing his dance career with a free-lance job designing fabrics for Hoffman California Fabrics. Realizing that he would never become another Lester Horton, he left the troupe in 1949, went to New York, and got a job with a coat and suit firm called George Carmel. Gernreich described the fashion climate of that time: "Everyone with a degree of talent—designer, retailer, editor—was motivated by a level of high taste and unquestioned loyalty to Paris. Christian Dior, Jacques Fath, Cristobal Balenciaga were gods. You could not deviate from their look. Once they'd decided on a dropped shoulder line, an American designer simply could not use a set-in sleeve. Once they'd established a hemline you couldn't depart from it by an inch. Seventh Avenue fed on their designs. I was bursting with

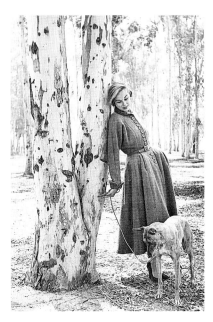

Early 1950s, wool coat. (photograph © Christa)

original ideas, but they were always rejected because they did not fit into the French idiom. After about six months, I began to vomit every time I thought about the imperiousness of it all. I produced terrible versions of Dior. I was finally let go."

In 1951, through the Academy Award-winning costume designer Jean Louis, "the only designer to help me by writing letters of introduction," Gernreich was granted an appointment with New York designer Hattie Carnegie, who told him to go back to California, make some samples, and send them to her. He did, and she responded by sending him checks—"no other communication, just checks ... Once in a while I'd recognize one of my collars or pockets in her designs."

In later 1951 Gernreich took a job with Morris Nagel Versatogs, "a schlock house with a name to match." When he took the collection to New York to show to Lord & Taylor's Marjorie Griswold, she told him the clothes were not for her. Gernreich was especially upset because this was the store that pioneered American fashion (Gernreich's idol, Claire McCardell, as well as Vera Maxwell and Clare Potter were all "discovered" by Lord & Taylor), and its president, Dorothy Shaver, was the first to shatter the unwritten law that all fashion must be French.

The bright side of that trip was Gernreich's first meeting with Diana Vreeland, who was then fashion editor of *Harper's Bazaar*. "I finally just went there with a bag of samples. I remember that I got off on the wrong floor and a charming little messenger girl brought me to the right floor and the right editor, who asked, with disdain that's peculiarly instinctive with fashion people, 'What do you want?' When I told her I was a designer from California, she said to show her what I had in my bag. I said I would need a model. She said she knew clothes and a model would definitely not be necessary. I said I wouldn't show her without one. It was a standoff but I finally opened up the garment bag and took out a couple of things. She disappeared and in what seemed to be only a second later came back with word that Mrs. Vreeland would like to see me.

"Her first words were, 'Who are you, young man? You're very gifted.' I told her about myself, briefly showed her my things, and she said if ever I needed a job in New York to call her."

When Gernreich returned to California, Morris Nagel decided the Gernreich designs were too advanced and asked him to start producing the safe and saleable clothes for which the firm had always been known. Gernreich left.

In July 1950, while watching a rehearsal at Horton's studio, Gernreich met Harry Hay, founder of the Mattachine Society, a 1950s forerunner of today's gay movement. From 1950 to 1951, Gernreich and Hay were lovers and Gernreich became one of Mattachine's seven founding members. (With typical wit, Gernreich suggested calling the Mattachine newsletter "The Gaily Homo Journal.") He and the other founders resigned from the society in 1953 after an ideological schism. In accordance with the Mattachine oath of secrecy, Hay never revealed Gernreich's membership in the society until after the design-

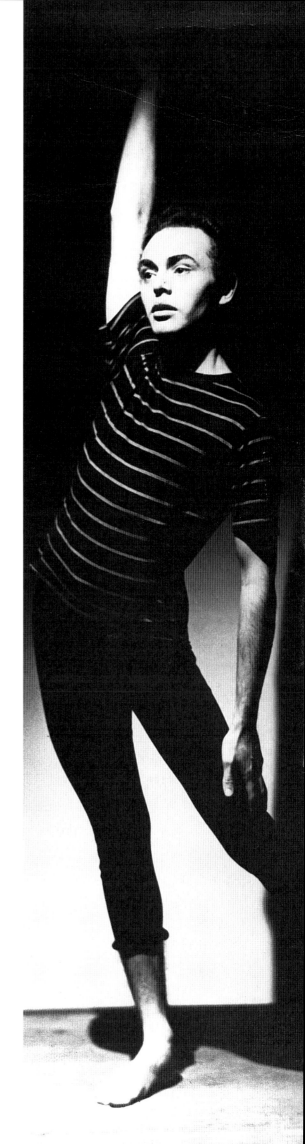

Right, Rudi as a young dancer during the early 1940s. (photograph © William Ricco, collection Lilly Fenichel)

er's death in 1985. Since that time, photos showing Gernreich with Hay and other founders have been published in Stuart Timmons's biography of Hay, *The Trouble with Harry Hay, Founder of the Modern Gay Movement.*

That the man who tore up so many closets with his revolutionary clothes never came out of the closet during his lifetime says a lot about Gernreich and his times. In those years homosexuality was illegal and Gernreich himself had been entrapped before joining the Mattachines. Oreste Pucciani, Gernreich's life partner for thirty-one years, recalls, "Rudi told me he was stunned when a guilty verdict was returned. He had insisted on pleading innocent and demanded a jury trial. He told me that he looked in the face of every jury member, and one woman, who had seemed sympathetic earlier and whose support Rudi thought he could count on, turned to the wall to avoid his eyes."

Peggy Moffitt, the designer's model/muse, says she and Gernreich "talked about sexuality a lot. His clothes were about sexuality. He told me about having belonged to the Mattachine Society, but not in a this-is-a-big-secret kind of way. He often told me that he felt a person's sexuality was understood and there was no way to hide it. I've known many gay men who seem compelled to underscore their homosexuality, as in 'I'll-order-the-roast-beef-but-of-course-I'm-gay.' Rudi was not that sort of person. I don't think it ever occurred to him to come out of the closet because he felt his sexuality was self-evident. He wouldn't have called a press conference to discuss his sexuality any more than he would have called one to discuss his brown eyes."

Pucciani explains Gernreich's reluctance to "out": "To 'out' yourself is one thing. To be dragged out is something else. Rudi never came out officially. He never felt the need. Until I retired from the University of California at Los Angeles in 1979, I lived by the principle of never make a point of it and never deny it. Intelligent people knew by the way I lived. After my retirement from UCLA I agreed to be interviewed by UCLA's gay newspaper. Rudi knew about the interview, and one morning at breakfast I asked him about it. He told me he thought it was a good interview, but 'why did you let them do it?' I told him that, after all, I was retired, so why not—what can happen? Then he asked me why I had waited, and I told him it was quite simple—no one had ever asked me. When I asked Rudi why he had never come out, he said with that lilt in his voice he always got when he was joking: 'It's very simple. It's bad for business.'

"After his death, I felt I must respect his point of view. The solution came when the American Civil Liberties Union announced that the estates of Rudi Gernreich and Oreste Pucciani had endowed a trust to provide for litigation and education in the area of lesbian and gay rights. So that was Rudi's posthumous 'outing.'"

In the early fifties Gernreich's career was not proceeding as successfully as he had hoped. After a temporary job designing for a Beverly Hills shop called Matthews, he met Walter Bass, and in 1952 began an eight-year business associa-

1956, Chinese waiter's jackets in cotton duck. (photographs © Christa, courtesy Life magazine)

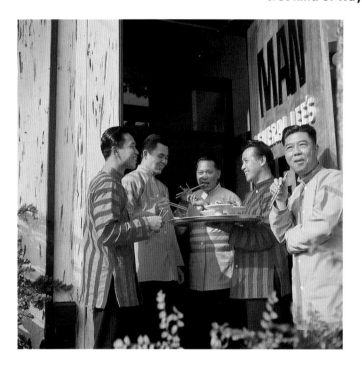

1952, first unconstructed swimsuit.
(photograph © Tommy Mitchell Estate)

tion. "There was no other chance for me at that moment," Gernreich said of this period. " I just kept running into walls. Then Walter came along and somehow, though we never got along and I knew it would be a doomed association, everything jelled."

It certainly did. Through Jimmy Mitchell, his first fitting model, Gernreich learned about Jack Hanson and his little shop called JAX. "I remember telling Jimmy I had to have a Saks or an I. Magnin to get the line off the ground, but she persisted. The three of us met, Jimmy and I showed him the line—mainly loosely cut, tightly belted dresses in ginghams and cotton tweeds—and his reaction was instantaneous. I delivered the first shipment personally and in one hour everything was gone."

Buoyed by this success, Gernreich took the line to New York. "Walter didn't want to spend the money on the trip so I said I'd pay for it myself and it worked." Sally Kirkland, then fashion editor of *Life* magazine, persuaded Gernreich to try again with Marjorie Griswold at Lord & Taylor. "This time, she raved and carried on and said she must have the clothes. At one point she asked me if we hadn't met before. I couldn't bear telling her the truth, so I said no. Years later, I told her the story of how we really met. By then we both thought it was funny."

After a year of quick and steady acceptance from stores, Bass asked Gernreich to sign a seven-year contract. "When I saw it I almost collapsed. We'd already had a history of success, but the contract didn't give an ounce in my direction. I was terribly annoyed with the way Walter's attorney treated me, and I boasted that one day I was going to be much more important than Mainbocher. I had a great deal of arrogance then and tremendous confidence, but it was shattered momentarily. 'When you're more important than Mainbocher,' Bass told me, 'we'll negotiate again.' And I signed."

In March 1952, Gernreich created the prototype for the first bra-free swimsuit—a wool jersey with tank top—and its progeny earned him his first design citation, The American Sportswear Design Award, given in 1956 by *Sports Illustrated.*

Gernreich was to spend much of the fifties freeing women of body-restraining clothes. His knitted tube dress of 1953, which won him his first magazine credit *(Glamour,* February 1953), was the forerunner of the stretch minis of the late eighties and nineties. The outfit that earned him his first *Life* magazine credit on April 27, 1953, could be considered the mother of the pop/op offsprings of the sixties. It consisted of a black felt, cinch-belted tunic over red, orange, and yellow checked pants. It was modeled by Lauren Bacall.

▲lthough he designed his first swimsuits for Bass, the ones that were to make him famous were produced for Westwood Knitting Mills, the firm he signed with in March 1955. From that date to August 1960, there were two Gernreich labels: sportswear for Bass and swimwear for Westwood.

In the fifties, a designer could literally be "magazined" into fame. The media was *Harper's Bazaar, Vogue, Mademoiselle, Glamour, Charm, Life, Look,* and *Sports Illustrated.* The message: get the editorial first and the stores and customers will follow.

Gernreich read this fashion script early and well—so well that Jack Hanson, who gave him his first big order at Jax and who later canceled all orders because of a feud over exclusivity, called Gernreich "a publicity hound."

For Westwood, Gernreich introduced wool-knit maillots elasticized to fol-

low the body instead of pushing it up and out. *Harper's Bazaar's* Diana Vreeland saw them and responded with this telegram to Gernreich: "I cannot tell you how beautifully made, how beautifully designed and how much we adore them. We hope, if we can possibly arrange it, to place them in the first suitable spot."

One of those first knitted suits, a tweed maillot with a low V neckline and five-button front was reinterpreted by Gernreich as late as 1959. Buyers knew it first as Style Number 6001, later as Style 601. In 1969 the suit was copied by a Coty Award-winning designer. Gernreich commented, "When a manufacturer does a version of something I've designed, that's very good. It's always a confirmation. When a name designer knocks off one of my best-known swimsuits, that's outrageous." As late as 1990, Style 601 was still resurfacing in other designers' lines, offering renewed confirmation of Gernreich's talent and of his designs' longevity.

Gernreich broadened his design base again in June 1955 when he designed Sarah Churchill's costumes in *No Time for Comedy*, and in June 1956 when he introduced his first designs for men. They were called Chinese waiters' coats and were originally designed for the staff of Gernreich's favorite Chinese restaurant, General Lee's Man Jen Low, in Los Angeles's Chinatown. When diners tried to wheedle them right off the waiters' backs, Gerneich decided to produce them as beach jackets, car coats, and at-home shirt-jackets. *Life* pictured them in its August 6, 1956 issue.

In 1957 Gernreich's design spectrum widened once more when he produced a shoe collection for the Ted Saval division of the General Shoe Co. *Vogue* featured his black calf T-strap with matching satin bow in its February 1, 1957 issue. Throughout 1958 and 1959, Gernreich's last two years with Bass, he became more and more involved with accessories, and he came to realize that fashion meant much more than just clothes. Here is an excerpt from a May 1958 letter inviting buyers to his fall opening:

"What is happening today is most curious—no waists, high waists, low waists, slimness, fullness, barrels, triangles—and all of it is right. It is not a silhouette but an attitude which is the important change.

There has been more radical change in the attitude of a face, a leg and foot in the last year than in the shape of the dress. The focus is on head and leg, which makes the dress an accessory. Therefore, to stimulate and strengthen the awareness of this attitude I have felt the necessity to complete my picture by adding hats to my clothes as well as shoes."

The first hats included plaid sou'westers, floppy-brimmed slouches, fedoras, and a rhinestone-studded cloche that matched a pair of little-heel pumps trimmed in the same glitter. Stockings were added in February 1959—the first in stripes and checks on sheer nylon.

Throughout this period, the only other fashion designer to take out as many superstructures, eliminate as many linings, lighten as many fabrics, and brighten as many colors was Italy's Emilio Pucci.

In 1964 Gernreich was to cite Pucci as one of the reasons behind his decision to introduce the topless bathing suit. On the eve of his fall collection in 1963, Pucci was quoted in a Eugenia Sheppard column in the *New York Herald Tribune* as saying, "In 10 years women will have shed the tops of their bathing suits completely." Gernreich, who had by then predicted a five-year wait, decided not to let Pucci beat him in the fashion breaststrokes.

16

1953, first tube dress. (photograph © Alex dePaola)

Mid 1950s, camel's hair suit. (photograph © Alex dePaola)

1954, right, white plastic dress. (photograph © Tommy Mitchell Estate)

Although Gernreich owed his fashion fame to the sixties, he said in a 1972 interview that he really couldn't talk about that decade with pride. "What appalls me is my total involvement with something to unimportant. I find it hard to believe that I once developed collections around Ophelia, George Sand, clowns, cowboys, Kabuki dancers, nuns, gangsters, Austrian cavalry officers, and Chinese operas. All these imaginary themes are unbearable to me today.

"They were in 1971, too, when I thought I was making a statement in favor of reality by accessorizing the clothes with guns and dog tags. New York publicist Eleanor Lambert set me straight. 'Aren't you playacting, too, by dressing models like soldiers?' she asked. In a way, she was right."

Moffitt sees Gernreich's latter-day recantations as totally unnecessary. "His Ophelia look was actually a pretty chiffon dress. His George Sand look was a very wearable pantsuit. All those ideas were pure design. You could still wear them without the fantasy."

Gernreich began the sixties by ending his eight-year association with both Bass and Westwood Knitting Mills. In August 1960, just two months after he was informed that he had won a special Coty Award for swimwear design, he announced that the line he formerly designed for Bass would from then on be produced in Los Angeles under his own company, G. R. Designs, Inc., and that the knitwear would be manufactured by Harmon Knitwear, Inc., of Marinette, Wisconsin, owned by Harmon Juster, formerly of Westwood.

Throughout 1960 and 1961, Gernreich was preparing the way for pop and op. While First Lady Jacqueline Kennedy was making the pillbox a national headdress and conducting White House tours in low-heeled shoes and a pared-down, two-piece dress with a high-necked overblouse and slender skirt, Gernreich was paring and baring even more. The January 1, 1961 issue of *Vogue* illustrated Gernreich's bathing suit/dress with side-cutouts, derived from a Gernreich swimsuit that was identical except for the skirt.

He was also rearranging the rainbow with shocking combinations of pink and orange, blue and green, red and purple. He was rewriting fashion graphics by positioning checks with dots, stripes with diagonals. And he was shaking up the fabric world by bringing vinyl to the beach, Spanish rugs to the coatrack.

Although Gernreich himself described the mini phenomenon as a gradual inch-up, he was baring knees as early as 1961. The June 2, 1961 issue of the *New York Times* reported, "Rudi Gernreich, California's most successful export since the orange, swings onto the flare bandwagon. Kneecaps show (on purpose), skirts swirl and ripple, clothes fall freely, touching the body only at the bosom."

In June 1962, Gernreich won another design award, this one from Woolknit Associates for "his trailblazing silhouettes and fabric manipulation in knitted dresses." The "little-boy look" was one of his major themes that year, along with reversible sheaths, drop-shoulder sweaters, long-sleeved shirt shifts, shiny cellophane cloth evening suits, and allover feathery fringe dresses.

Gernreich's role as a social commentator began to emerge as early as May 22, 1963, when he was quoted in the *New York Times*:

"There is an element of bad taste here in Southern California that is terribly strong. Slacks that are too tight. Decorated basked bags. Bejeweled eyeglasses. Cashmere cardigans with mink collars. Vinyl and gilt mules. You

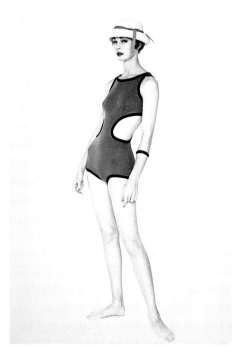

Late 1950s, left, cut-out maillot. (photograph © Tommy Mitchell Estate)

1956, center, hostess dress with trompe l'œil beach jackets. (photograph © Christa)

1957, lower left and right, swimsuits, including a ladderback version. (photographs © William Claxton)

know—the honky-tonk element. "On the positive side, people everywhere today wear a great deal more color than they used to. California and Italy are responsible. Only a few years back a woman wouldn't be seen dead in New York in an orange dress. Customers from the East and Midwest used to see my combinations of brass and shocking pink and run away. Today, they ask for them."

The year 1963 was when "kooky" entered fashion vocabularies; it was the year of pop furs, such as Gernreich's horsehide; the year of little-girl smocks, Garbo comebacks, and safari suits. It was also the year Gernreich won two more major awards—*Sports Illustrated's* Sporting Look Award in May and the Coty American Fashion Critics Award in June. The latter citation caused one of the biggest fashion ruckuses in history.

As a protest against Gernreich's win, Norman Norell returned his Coty Hall of Fame Award, telling *Women's Wear Daily* (June 17, 1963), "It no longer means a thing to me. I can't bear to look at it anymore. I saw a photograph of a suit of Rudi's and one lapel of the jacket was shawl and the other was notched—Well!" The next day he added to the explanations by telling the *New York Herald Tribune*, "Too many jury members from *Glamour* and *Seventeen* who don't get around to high fashion collections are responsible for the Gernreich vote." Bonwit Teller countered by running a half-page ad with this headline: "Rudi Gernreich, we'd give you the Coty Award all over again!"

At the Coty Award presentation, when the winning designers traditionally showed clothes from the collection that earned them the award as well as capsules from their current lines, Gernreich again caused a flap with a white lingerie satin pantsuit he called his Marlene Dietrich suit. When Moffitt wore it during dress rehearsal, members of the Coty jury told her she looked like a Lesbian and asked Gernreich not to show it. He reluctantly acceded to their demands. The next year a similar suit in white slipper satin was shown by that year's Coty Award-winning designer and no one raised an eyebrow. As Moffitt points out, "The beehive hairdo and high heels obviously made the idea acceptable one year later."

The brouhaha that literally became an international incident happened in 1964 with the topless bathing suit. On September 12, 1962, Gernreich predict-

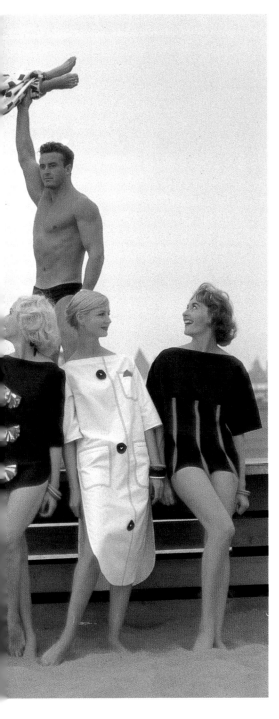

ed to *Women's Wear Daily's* Los Angeles reporter Sylvia Sheppard that "bosoms will be uncovered within five years" and later repeated the forecast in the December 24, 1962 issue of *Sports Illustrated.* Here is Gernreich's account of the events that followed: "By 1964, I'd gone so far with swimwear cutouts that I decided the body itself—including breasts—could become an integral part of a suit's design.

"At this time, breasts were growing in dimension, if not physically, cosmetically, and above all, sociologically. They had almost become jokes. Every girl I knew was offended by the dirty-little-boy attitude of the American male vs. the American bosom. To me, the really beautiful breasts belonged to the really young bodies. Baring these breasts seemed logical in a period of freer attitudes, freer minds, the emancipation of women.

"I was aware that the great masses of the world would find this shocking and immoral, but I couldn't help feel the implicit hypocrisy that made something in one culture immoral and in another perfectly acceptable. The breast had become a sex symbol not out of some preordained plan of nature, but because we'd made it a sex symbol.

"Because of the *Women's Wear Daily* statement and the *Sports Illustrated* headline, people began to ask me if I really meant what I said. The more they asked, the more I began to feel more and more right about the idea. About the end of 1963, Susanne Kirtland of *Look* magazine called to say she was going to do a trend story along futuristic lines and would like me to make the no-top suit. I said no, that the time was not right. She said, 'Oh, but you have to. I've already had clearance from the front office.'

"At first I thought if I didn't do it, she'd ask Emilio Pucci or someone else because she was so determined to get it done. I thought it would be terrible if someone else took my prediction and made it a reality. I didn't want to be scooped.

"I knew it could ruin my career, could put me right off the map, but my conviction that it was right and my fear of being preempted by someone else led me to say okay. I felt it was a little early, but it would be done in the next couple of years anyway, so I even rationalized the timing.

"The first suit I sent her was a Balinese sarong that began just under the breasts. Susanne said she didn't feel it was stark enough, that it should be bold, almost like an exclamation mark. Although I felt the suit should be just a bikini bottom, that would have been just an evolution of an idea, not a design. So I came up with the strapped suit that later made history, and the back view of it appeared in *Look* on June 2, 1964. It was photographed in the Bahamas on a prostitute.

"In order to try to avoid sensationalism, [photographer] William Claxton, model Peggy Moffitt's husband, Peggy and I decided to take our own photographs of Peggy in the suit and present them to the fashion press and the news magazines. We agreed to avoid *Playboy* and the girlie books.

"To our complete amazement, everyone in the fashion world was panicked by it. Sally Kirkland of *Life,* Nancy White of *Harper's Bazaar*—no one wanted anything to do with the suit or the pictures. Finally, Carol Bjorkman of *Women's Wear Daily* printed Bill's front-view picture of Peggy on June 3, and *Newsweek* printed a back view on June 8.

"I had no intention of producing the suit for actual consumption until I talked to Diana Vreeland of *Vogue.* She was the only editor I showed the suit to personally. Peggy was with me, and she was wearing the suit under a little

Japanese kimono she had bought somewhere on Hollywood Boulevard. I think she paid eight dollars for it. When Mrs. Vreeland asked to see the suit, Peggy came out in the robe, took it off, and proceeded to model the suit. There was dead silence. Absolutely no response. I didn't explain anything. As Peggy had her hand on the door to leave, Mrs. Vreeland boomed out in that unforgettable voice, 'Maaaaaaaaaaaahvelous kimono!' A few minutes later she asked me to tell her about the suit, asking me why I did it.

I told her I felt this was the time for freedom—in fashion as well as every other facet of life. When she asked if I were going to make it for the public I told her no, that it was just a statement.

'This is where you're making a mistake,' she told me. 'If there's a picture of it, it's an actuality. You must make it.'

"When I returned to the hotel, I already had calls from Harmon telling me buyers were demanding to buy the suit. We agreed to go ahead with it. Eventually, every major store in the country either carried it or had ordered it and couldn't sell it because of below-the-Bible-belt objections from store presidents.

"Melvin Dawley of Lord & Taylor was one of those presidents who wouldn't allow the suit to be delivered. I remember a boutique called Splendiferous immediately took over the shipment. Hess Brothers in Allentown, Pennsylvania, was picketed, and Milgrim's in Detroit had a bomb threat."

The topless became a hard-core news event unequaled in American fashion history.

New York Times, June 22, 1964: "The Soviet government newspaper *Izvestia* reported on the new bathing suit and added that American fashion was speculating on topless evening dresses. 'The American way of life is on the side of everything that gives the possibility of trampling on morals and the interests of society for the sake of ego. So the decay of the moneybag society continues.'"

Los Angeles Herald Examiner, July 14, 1964: "The suit has been legally approved to Sweden, Germany and Austria. It is banned in Holland, Denmark and Greece."

New York Times, July 2, 1964: "For a brief moment, the mayors of the Riviera had a chance to stand up and be counted as men who would fight to preserve a decent and normal way of life. Women were warned that even if they dropped the tops of their bikinis—all 3 inches—there would be legal repercussions. It was the Mayor of Saint-Tropez who endeared himself to the most indignant. He was reported to have said that if there were signs of trouble he would use helicopters to patrol the beaches and spot offenders."

Saturday Evening Post, October 31, 1964: "Such natural enemies at *Izvestia*, *L'Osservatore Romano* and the Carroll Avenue Baptist Mission of Dallas, invoking Scripture and Karl Marx, agreed that it was immoral and antisocial."

New York Herald Tribune, November 16, 1964: "Italy didn't react after the suit was banned by the Pope."

Of the three thousand women who bought the suits, at least two wore them in the public. Carol Doda, a San Francisco entertainer of 39–26–36 proportions, wore hers while entertaining at the Condor Club. *Playboy* magazine chronicled her appearance in its April 1965 issue. Toni Lee Shelley, nineteen, was taken into custody by a Chicago policeman for wearing the topless

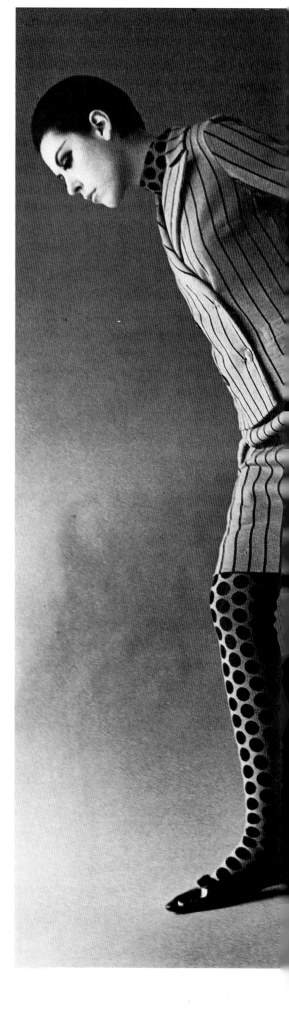

1964, brown and black wool-knit suit and stockings. (author's collection)

bathing suit at the beach. She was booked on a charge of suspicion of improper attire for bathing. At her arraignment she asked for an all-male jury.

Moffitt describes the sensation caused by her posing in the topless bathing suit: "When Rudi told me he had agreed to create the suit for *Look*, I asked who he would get to model it. He said, 'You.' I said, 'ho, ho, ho.' Later, because I understood the point of overstating the case for unrestricted expression of freedom, I agreed to pose for the pictures my husband took, but I told Rudi there would be a few rules. Bill, Rudi, and I agreed that I would never wear the suit in public—that this in itself would sentionalize the whole affair. I also refused to pose for another photographer.

Bill first took the photos of me to *Life*. They told him they couldn't print them because 'this is a family magazine, and naked breasts are allowed only if the woman is an aborigine.' Because they'd goofed the story as a news event—and by that time it was really an event—they asked Rudi, Bill, and me if we'd help them present the story as an historical evolution of the breast in fashion history. So we reshot the photo especially for *Life*, and I covered my breasts with my arms at their insistence.

The photograph of me in that issue—hiding my breasts with my arms—is dirty. If you are wearing a fashion that does not have a top as part of its design and hold your arms over your bosom, you're going along with the whole prudish, teasey thing like a Playboy bunny.

The *Women's Wear Daily* picture, which I think is beautiful, really shook up Madison Avenue. If the breast stops being a sex symbol—and it does the moment you uncover it—how could they tease any more in ads? How were they going to sell toothpaste?"

Claxton later took his photos of the topless to *Paris Match*. He recounts, "They said virtually the same thing as *Life*—that *Paris Match* was a family magazine and could not show bare breasts on the cover. I always found it strange that that week's cover photo of the magazine showed a family totally mutilated in a car accident."

The topless controversy still raged as late as 1985, after Gernreich's death, when the Los Angeles Fashion Group staged its Gernreich retrospective, "Looking Back at a Futurist." Moffitt said she would resign as the show's creative director if the topless was modeled on stage at the Wiltern Theatre. She told the *Los Angeles Times* (August 2, 1985), "Rudi did the suit as a social statement. It was an exaggeration that had to do with setting women free. It had nothing to do with display, and the minute someone wears it to show off her body, you've negated the entire principle of the thing. I modeled it for a photograph, which was eventually published around the world, because I believed in the social statement. Also, because the three of us—Rudi, Bill, and I—felt that the photograph presented the statement accurately. I was offered $17,000 in 1964 to let *Playboy* publish that photograph of me in the suit. I turned it down as unthinkable. And I don't want to exploit women any more now than I did in 1964. The statement hasn't changed. The suit still is about freedom and not display."

Sara Worman, then vice president of Robinson's and regional director of The Fashion Group, told the *Los Angeles Times*, "I can't believe this: it's 1964 all over again. I agree the suit was a social statement—the most prophetic ever made by any designer in the world. It was his most brilliant concept, and from it grew all sorts of things we now take for granted. Why take the single

most important idea he ever had—the one that changed the way women dressed all over the Western world—and refuse to show it on a model, when we are showing everything else he ever did on live models?"

Moffitt won. The suit was not modeled. Only photos of it were shown.

The topless also occasioned another Gernreich first: the no-bra bra. It probably did more to change the way clothes fit than any other single item of apparel—intimate or not. Compared with the twin torpedo brassieres of those days (Gernreich compared them to "something you put on your head on New Year's Eve"), the no-bra bra that was made for Exquisite Form was indeed revolutionary, allowing breasts to look natural, freeing women of the padding, boning, and topstitching that characterized bras of that era. It consisted of two cups of soft, transparent nylon attached to shoulder straps, with a narrow band of stretch fabric encircling the rib cage.

By the spring of 1965, the no-bra bra had proved itself a retail success and was quickly followed by the no-sides bra (cut low to accommodate dresses with deep armholes), the no-front bra (cut low to go with slit-to-the-waist necklines) and the no-back bra (anchored around the waist instead of the rib cage).

The no-bra bra was also to be the catalyst that brought Moffitt to New York, where, at Richard Avedon's studio, she met another modernist of the era, London hair designer Vidal Sassoon. Months later, when he came to Los Angeles, she introduced him to Gernreich. The two became instant friends and collaborators in creating graphic new cuts in hair and clothes.

As the Mods and Rockers fought it out for fashion supremacy in London and the Beatles kicked off the Hair Happening, Gernreich saluted Ringo Starr by naming his vested, pin-striped flannel pantsuit fall 1965 the Ringo look. England returned the compliment when the *London Sunday Times* gave Gernreich its international fashion award for his part in "establishing the current world fashion for the unconstructed look of clothes and influencing American women's fashion through his sportswear and lingerie." Moffitt and Claxton accompanied Gernreich to England to receive the award. Moffitt remembers, "After the show, Rudi, Bill, and I went to Paris. I met Dorian Leigh and she encouraged me to stay there for modeling jobs with her agency. Rudi, too, encouraged me to stay in Europe—he said that it would be good for my career. And so I did, working for almost a year in both Paris and London. Years later, Rudi told me that even though he knew it would be best for me to stay in Europe he was afraid he could not design without me. That was one of the most touching things he ever said to me."

In August 1965, what was to become a long-standing feud with *Women's Wear Daily* surfaced in publisher John Fairchild's book *The Fashionable Savages.* In her review of that book, *New York Herald Tribune's* Eugenia Sheppard wrote, "I think he [Fairchild] underrates Rudi Gernreich, one of the real creators. His objection that Gernreich's clothes are badly constructed is just the point—a rebellion against couture-type fashion that John Fairchild won't accept."

The high price of high fashion was troubling the designer even more than Sheppard suspected. On January 3, 1966, Gernreich broke American fashion's unwritten rule that name designers don't sell to chain stores by signing with Montgomery Ward to create a special group of exclusive designs. The agreement lasted several seasons, proving to both Gernreich and Montgomery

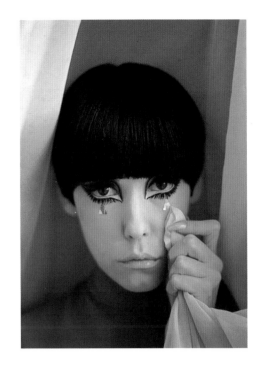

1965, above, geometric tears (photograph © William Claxton)

1966, above right, vinyl designs for Montgomery Ward. (author's collection)

1966, below right, vinyl decals and bikini. (photographer unknown)

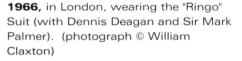

1966, in London, wearing the "Ringo" Suit (with Dennis Deagan and Sir Mark Palmer). (photograph © William Claxton)

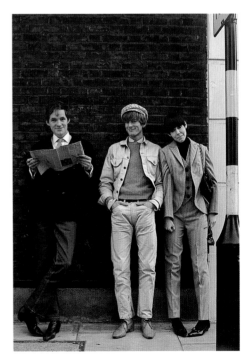

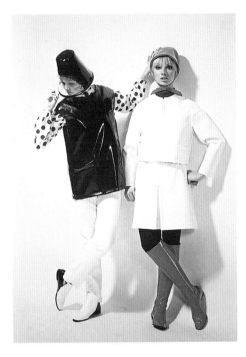

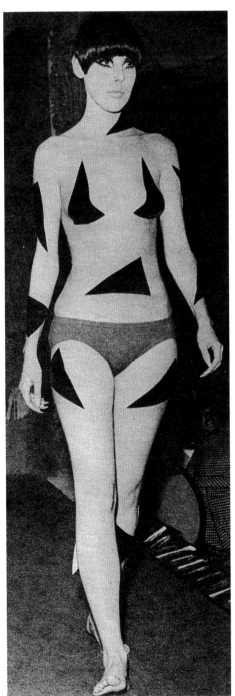

Ward that original design can be popular at popular prices.

During this time, Montgomery Ward asked Gernreich to make a personal appearance at one of their Chicago stores. It was to be a lesson in humility. "It was a completely conventional appearance of a designer in a store, arranged so people could come up and ask questions—you know, harmless. They put a little poster in one of the pillars on the floor, with a picture of me in the background. They had wads of photographs for me to autograph. And they had the area cordoned off with velvet ropes. It was announced that I'd be there between lunch and 2 P.M. At noon, there were droves of people coming up the elevator. I thought I was about to be mobbed. Well, no one came up to me. Not one single person came to see me. And I'm standing there, and finally a couple of ladies came up, and I thought, well, it's going to start now. And they said, 'Where's the ladies' room?' That was all."

In his own collections of that period, Gernreich introduced knitted swimsuits with vinyl-appliquéd elastic stockings held by vinyl garters. He designed the first chiffon T-shirt dress. He created helmets that extended over the face, coats with nose-level necklines, swimsuits that looked like turtleneck ski sweaters. And he feather-printed matte jersey in shifts with matching stockings and feather headdresses. He was rewarded with a second Coty Award in 1966.

By September 1966, Gernreich was bringing his strong sense of graphics directly to the body, effecting the first modern tattoos by pasting triangles, squares, circles, and rectangles all over the arms, legs, and torsos of his bikini-clad models. The adhesive ornaments were packaged in plastic bags and accompanied his swimsuits for Harmon Knitwear. Moffitt recalls the evolution of those first body graphics: "When we were doing the Indian collection of 1965, I wanted to wear a caste mark, but I couldn't put lipstick on my forehead because I'd be wearing modern, non-Indian, swimwear one change later, so I cut a circle out of a fuchsia-colored matchbook and put it on with eyelash glue. The decals that were to appear later came from that matchbook idea. The next collection I made little geometric tears out of aluminum foil. Later, when I came back from Europe, Rudi had taken that idea to its ultimate limit by giving me a red bikini bottom to wear and pasting black vinyl triangles over the rest of my body."

later in 1966, Gernreich's clothes were featured in what has come to be known as the first fashion videotape, *Basic Black*. Claxton tells the story: "After Peggy and I came back from Europe, I was approached by a producer of television commercials who wanted a film so he could show examples of my work—a sample reel, so to speak. I decided to combine the things I knew best—Rudi's clothes and my photography. Peggy and I wrote a shooting outline for what we considered an abstract fashion film. The next weekend, we rented a studio in New York, and with Peggy, Léon Bing, and Ellen Harth, completed the project in two days. Rudi often showed the film as part of the shows he took to South America and the Orient, and Vidal Sassoon is still using it. I consider it the first film where clothes spoke for themselves, without commentary."

Gernreich's once-grudging recognition by his peers on Seventh Avenue had become by this time so cemented that even Norman Norell admitted he was wrong. "He [Gernreich] has grown in talent," Norell told a *Washington Star* reporter (September 30, 1966). "Today, I would go along with their giving

1966, left, children's wear in purple wool knit with yellow vinyl dots.

1965, right, beige and black wool "Ringo" suit.

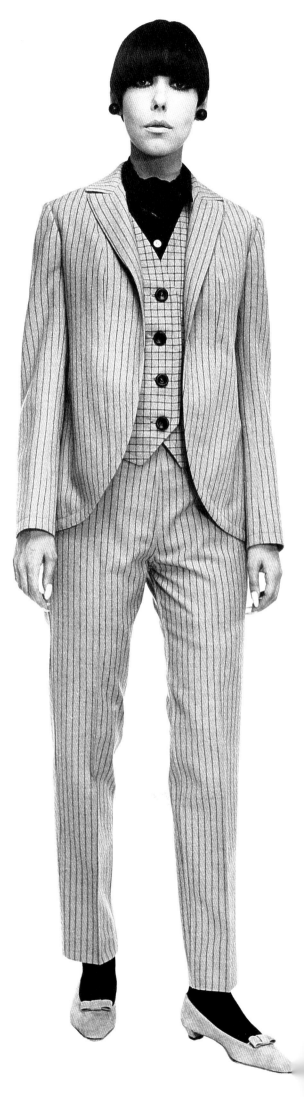

him the top [Coty] award." Gernreich, the showman, surprised the audience at his October collection by showing a model wearing a belted shirtwaist dress that covered her knees. As if that weren't shock enough, she wore a padded bra, nylon stockings, and spike-heeled pumps with bag and gloves to match. Just as bewildered reporters and buyers started to gasp in amazement, out came Moffitt in a thigh-high mini of the same print as the shirtwaist dress and little-heeled shoes. The point, said Gernreich, was that there were no rights or wrongs in fashion—that the spirit of that moment was in how clothes were put together.

To make sure no one misunderstood his fashion message of 1967, Gernreich opened his resort-spring collection with this statement: "For the first time in the history of the world—at least since the Children's Crusade—the young are leading us. There is now a Power Elite of the young. They are discovering their fashion power just as they are discovering their social and political power.

They are bringing about a natural fusion of person and dress. And what is amusing is that the older people are beginning to revolt. That in itself might have interesting fashion consequences in a few years as the young get older. For more than three hundred years the French woman has dictated fashion. Now at last, the American woman is coming into fashion maturity, fashion freedom.

And nothing, of course, is more limited than freedom. It's the razor's edge, a hairline, the skin of a tooth. It's beauty, but beauty is always ugly at first. It's sex appeal, but sex appeal is always austere. It's art, but minor, not major."

On June 30, 1967, Gernreich's fashion art became major in the sense that he was elevated to the Fashion Hall of Fame by the Coty American Fashion Critics—the highest award of that time—and received his honor later that year at the Metropolitan Museum of Art.

He also received this kudo from the *New York Times*: "Virtually everything starting in American fashion appears to have been done first by the 44-year-old, Vienna-born and California-based designer. Best known for the only fad that didn't sell—his topless bathing suit—Mr. Gernreich has always had a way

Resort 1967, Mrs. Square and Miss Hip.

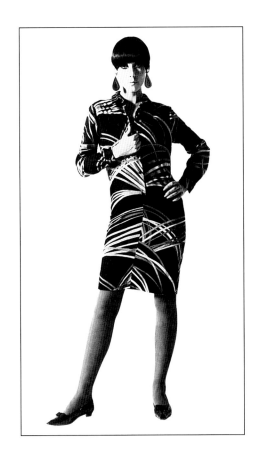

of anticipating trends. He is famous for taking things off—or out—of clothes, beginning with an unlined knitted swimsuit 15 years ago and continuing through transparent or cutout dresses in recent seasons."

Gernreich's body-works of 1967 featured tunics and dresses with necklines that plunged to new lows—four inches below a wide leather belt. He called the collection "Beyond the Navel." By October, the hemline was resting at twelve inches above the knees, and Pierrot, Edith Sitwell, and Dighilev had become Rudi-mentary elements of style.

Bloomers were also a big part of that collection, as were bubble skirts. One of Gernreich's white chiffon dresses with bubble skirt and matching tights went to the White House wedding of Lynda Bird Johnson to Captain Charles S. Robb. Its owner, Carol Channing, became the center of controversy over fashion versus propriety. She told *Newsweek* (December 25, 1967), "I thought it was what you wear to a wedding in the year 1967."

Gernreich's biggest journalistic tribute came on December 1, 1967, when he, with models Peggy Moffitt and Léon Bing, made the cover of *Time*, where he was described as "the most way-out, far-ahead designer in the U.S."

Although he continued to expand his design sphere in 1968—first to stockings for McCallum Boutique, later to signature scarfs for Glentex and patterns for *McCall's*—Gernreich was becoming more and more desenchanted with the direction of fashion. In January 1968, he told fashion editors attending his show that "the fashion impact of Bonnie and Clyde is just plain sick. The movie is great—a beautiful, tragic film—but it has nothing to do with fashion as such. Previous historical periods always recur in fashion. However, they must always be reinterpreted. Otherwise there is a flight from reality into costume nostalgia and escapism. History must be used, not just restored."

Gernreich's fashion ideas of that year included Siamese harem dresses that folded diaper-fashion between the legs, clear vinyl bands on knitted dresses and swimsuits, cossack clothes, boots with white feathers, and pantyhose and scarfs printed not with Gernreich's name (so-called signature scarfs printed with designer's names were at the height of their popularity) but an alphabet of scrambled letters that said nothing. As Gernreich put it, "the unsignature scarf."

He proved his seeing powers again in May with a statement that other designers were later to second. "The era of fashion dictatorship is gone," he announced in a news release for those attending his fall collection, "and with it the authoritarian approach to clothes. There is worldwide confusion about everything and this includes fashion. Everywhere structures are breaking down. The confusion can be felt everywhere and the designer must work with it and against it. It's interesting, but it's an awful mess. We have discovered that nakedness isn't necessarily immoral, that it can have a logical and decent meaning. The body is a legitimate dimension of human reality and can be used for a lot of things besides sex. Slowly, the liberation of the body will cure our society of its sex hangup. Today our notions of masculine and feminine are being challenged as never before. The basic masculine-feminine appeal is in people, not in clothes. When a garment becomes sufficiently basic, it can be worn unisexually."

He ended his statement by declaring the skirt was finished, that pants and tunics with tights had replaced it. *Women's Wear Daily* disagreed. Gernreich, not the skirt, was the endangered fashion species, according to a story that

ran June 12, 1968. "Rudi Gernreich has boxed himself right into a corner. For years, he's been America's most avant-garde designer and has been praised for it. But this season, Rudi misses with his gimmicks and costumes and jokes of past seasons. His mini tunics over laced-up leg coverings, his layered look which adds pounds and his inflated bloomers don't look today or tomorrow. Rudi says we need fun and games during these times, but his collection looks more like a comedy of errors."

The fun and games stopped on October 16, 1968, when Gernreich announced he was taking a year's sabbatical. In a brief statement to the press, he said, "It's not a big deal. I just think it's time to take off for a while. I just want to rest."

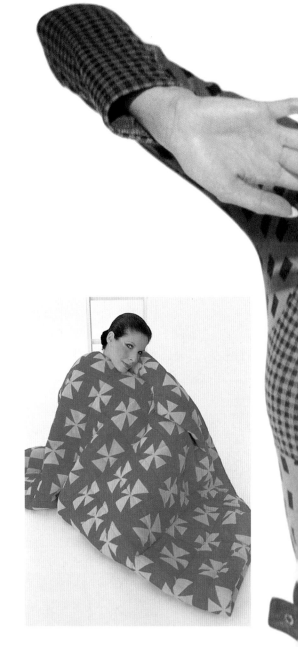

The story behind the decision was more complex: "I had felt for several years that couture was over, that expensive clothes didn't make sense. My own Rudi Gernreich designs were becoming outrageously high. By the time an outfit was complete with matching stockings, shoes, and headgear it was not only expensive, it was difficult to handle in a merchandising sense. Stores weren't geared to sell stockings and underwear in the same department with a dress or skirt, so the total look I believed in was never really totalized.

"I knew I either had to expand in order to bring down prices or stay small and suffer increased prices. The idea of expanding to a much larger business scared me. I didn't want to be a big manufacturer with all the attendant business problems. This was not my calling, not my interest. I felt I had to be experimental at any cost, and that meant always being on the verge of a success or flop.

"At the same time, I had staff problems, difficulties which meant a major change would have to be made. I was at the point of nervous collapse—overworked, overpressured, fed up. My last collection had been terribly extreme, an absurd kind of statement. Everyone criticized it. And I had become so involved with the business end I couldn't find enough time to design.

"The knits for Harmon were everything I believed in—utilitarian, wearable, priced right—but I wanted out of that arrangement, too. Even though with Harmon, unlike any other manufacturer I've ever worked with, there never had been a problem.

"When I told Harmon of my decision, he was marvelous—very, very understanding. He told me to take three months off and we'd talk again, and assured me that we'd do the Harmon Knitwear line the easiest possible way. He said I'd be foolish to give up our association, and since I already had a collection for him in the works I finished it before I left for Morocco. It was one of the most profitable collections I ever did for him.

"Once I made the decision, there was no more trace of the nervous breakdown. I felt free, relieved. And I rented a dream place, a castle in Tangiers owned by Yves Vidal, president of Knoll International. I traveled through Morocco, also in Europe and was away almost a year. I did the Harmon thing easily, happily, and I never missed a knit collection.

"When I returned, a whole new professional life opened up for me."

It was the fall of 1969, soon after he returned from his sabbatical intent on uncomplicating his design life. It was the year his European counterparts were conjuring up midis to welcome the new decade. The year of moon walks and moratoriums, Right On and Up the Establishment.

To Gernreich, it was also the year fashion died. Almost symbolically, *Life*

1971, quilt made for Knoll International.

1971, right, trompe l'oeil wool-knit minidress.

magazine asked him to take it into the future. Editor Helen Blagden asked Gernreich to project what men and women would be wearing in 1980.

Again, as in the case of *Look* magazine and the topless bathing suit, Gernreich said no, that it was impossible to predict a visual reality without creating a Buck Rogers caricature. Swayed by the fact that *Life's* special year-end double issue, "Into the Seventies," was also to include speculations on the consequences of moon flight by Norman Mailer and a Louis Harris poll on the social coalitions that would shape the future, Gernreich agreed to do what he considered a somewhat realistic projection of clothes for tomorrow.

"If you go too far away from something plausible you lose just that—the plausibility of it. I really believe you can only see things in your own moment, that you're bound by your time. My ideas for *Life* were bound by the time, but I tried to take the limit off the time they were meant for by extending it to the year 2000."

Those ideas—shaved bodies and everyone stripped down to their barest essentials—were synopsized by *Life* (January 1, 1970, special double issue): "According to him [Gernreich], the nostalgic and 'circusy' look of today's clothes is a sinister sign that we are not facing up to the problems of contemporary life. The clothes of the future will have to be functional. Gernreich foresees a time just ahead when 'people will stop bothering about romance in their clothes.' Tomorrow's woman will divest herself of her jewelry and cosmetics and dress exactly like tomorrow's man. Fashion will go out of fashion. The 'utility principle' will allow us, says Gernreich, to take our minds off how we look and concentrate on really important matters. Clothing will not be identified as either male or female. So women will wear pants and men will wear skirts interchangeably. And since there won't be any squeamishness about nudity, see-through clothes will only be see-through for reasons of comfort. Weather permitting, both sexes will go about bare-chested, though women will wear simple protective pasties. The aesthetics of fashion are going to involve the body itself. We will train the body to grow beautifully rather than cover it to produce beauty."

For the elderly, Gernreich predicted caftan-like coverups. "The present cult of eternal youth is not honest and certainly not attractive. In an era when the body will become the convention of fashion, the old will adopt a uniform of their own. If a body can no longer be accentuated, it should be abstracted. The young won't wear prints but the elderly will because bold prints detract. The elderly will have a cult of their own and the embarrassment of old age will fade away."

When the article appeared with sketches, Eugenia Butler, an art dealer acquainted with Gernreich, arranged a meeting with Maurice Tuchman, senior curator of modern art at the Los Angeles County Museum of Art and head of the American art and technology section scheduled for Expo 70, a world's fair that took place in Osaka, Japan, in 1970. Tuchman asked Gernreich to create a special event for Expo—an art-in-fashion statement for artists and

art press who would be attending the Japan exhibition. In explaining his decision to bring the drawings in *Life* to life, Gernreich recounted, "I was terribly upset with what was going on. I wanted people to be disturbed. I felt a strong anti-statement was in order and that a drawing was vague and unreal. I believed that if I translated that drawing into clothes it would be real. It would have an impact. Most people saw the *Life* article as a violent antisex statement. A few thought it was lyrical, that the unisex statement represented a peaceful getting together. I was curious to see how they would react to the real thing."

He first asked Moffitt to be his model. She refused. "To me, it was perfectly legitimate to project a future thirty to fifty years hence, but then to actually present the nudes seemed questionable. If you're predicting the future and next week show it, it's no longer futuristic. I tried to tell him he would be attacked personally for showing people without hair while he was covering his baldness with a toupee, but I couldn't say it. He justified going ahead with the idea of bringing his sketches to life, but I could not be a part of it."

After Léon Bing also begged off, Gernreich started his search for a young man and woman who would agree to shave their bodies and heads and accompany him to Expo 70. The woman was Renee Holt a twenty-two-year-old model, and the man was thirty-year-old Tom Broome, manager of a Los Angeles boutique called Chequer West.

Time magazine chronicled the shaving event in its January 26, 1970 issue: "The first order of business was to shave the heads and bodies of his two models. 'Hair hides a lot,' explained Gernreich, 'and body hair is too sexual. I don't want to confuse the idea of freedom with sexual nakedness. Openness and honesty call for no covering of any kind.'

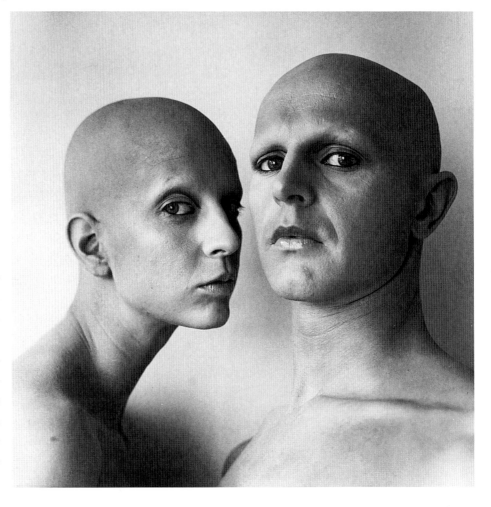

1970, unisex. (photographs © Patricia Faure)

For Thomas Broome, Rudi's male model, the prospect of allover alopecia held no horror: 'I've wanted to shed my hair for a long time. I have this theory that when I do, I will shed other things, too—maybe my inhibitions.' But Holt approached her barber's appointment with anxiety. Fondly caressing her long golden tresses, she said bravely, 'In a way, long hair is a crutch for a woman. Once the hair is short, one may develop other things like the intellect. But I have been thinking what my father will say.'

An hour later, Tom and Renee emerged from under their barber's aprons and entered separate bathrooms to shave off every vestige of body hair. 'You look great, just great,' gushed Rudi when they returned. A cosmetician applied a thin coat of flesh-colored makeup to their naked bodies, and it was time to get into their costumes, such as they were. Both models dressed identically in black-and-white monokinis, covered

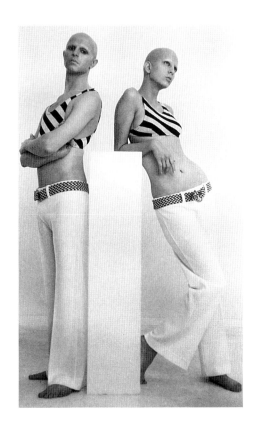

with white knit bell-bottom trousers and rib-length black-and-white tank tops. Then, while photographers snapped pictures and Gernreich gave cues and directions, the models rehearsed their act for the January 20 showings at both Eugenia Butler's Hancock Park home and, later, at her gallery. Off came the tank tops, Down dropped the trousers. The monokinis slid slowly to the floor. After stepping to one side, Tom and Renee stood silently like statues—or inmates of a concentration camp."

Gernreich's curiosity over how people would react to Tom and Renee turned into shock at the Butler event. While he was leading the models through the crowd-turned-circus, a man suddenly appeared, exposing his genitalia and carrying a mock version in the form of a yellow stuffed pillow. When Gernreich learned that the flasher was Paul Cotton, one of Mrs. Butler's artists, and that she had staged the entire spectacle, he asked her if it were true and she denied it. Later, when she was arrested along with an exposed Cotton while standing in line at the American Pavilion in Japan, Gernreich realized he'd been duped. And when Cotton repeated his performance by appearing totally nude, except for a body coating of silver paint, at the presentation at Tuchman's home near Kyoto, Gernreich realized that he'd been set up again.

Although Gernreich's clothes statements of the sixties drew press response the world over, his anti-statement of 1970 triggered fewer headlines. *Women's Wear Daily* covered the show in its Arts & Pleasures section. Much of the press was more interested in the failing hemlines of that time than fallen hair.

Los Angeles Times, January 22, 1970: "Rudi Gernreich's Projection 1970 is more philosophy than adamant statement on the future of fashion. It is, in fact, anti-fashion. Behind the shockery of completely hairless bodies and nudity, Gernreich's projection is a sincere probing of what he believes the future may be and how it will affect our appearance."

Los Angeles Herald Examiner, January 21, 1970: "The proceedings were inexplicably joyless. When he was through, much more than clothes and body hair were missing. Gone also were imagination, so-called 'modesty' hangups, traditional male-female attitudes, not to mention the future profits of the world's fashion, fabric and dry-cleaning professions."

Fashion Week, January 26, 1970: "Is 2001 any the less beautiful and awesome because Kubrick is not there? No. We are involved in the future. And it may be our salvation that somebody is serious about it."

Women's Wear Daily, January 22, 1970: "Designer Gernreich has been on a sabbatical for some months now, recharging his creative batteries. It's a shame he went back to the drawing board too soon."

Gernreich summed up the reviews by saying people had become less easy to shock. "They're used to unusual statements. There are some who are easily rattled, but not as many. I did get some hate letters, but the silent majority was more silent than it used to be."

Of all those speaking out against Gernreich's bald statement, only one, the Ponce College of Beauty in Pao Alto, California, took any action. The beauty college ran a half-page ad in the *Palo Alto Times* headlined "Help Stamp Out Rudi Gernreich." The trip to Japan, while not a part of the official Expo program, was financed by Max Factor. Because of the sponsorship, Gernreich expanded his original *Life* magazine projection to include makeup in a new

1973, overleaf, plastic armor designed for a Max Factor promotion.

role as a kind of body protector to shield man from the sun's rays and from the cold. The unisex clothes that were part of the presentation—pants, skirts, bikinis, jumpsuits—were all clothes from previous Gernreich collections. The boots had been made for him by Capezio in 1965. If the clothes looked new and bizarre, Gernreich said it was only because they were worn by two bald people. "This is true of all clothes—who puts them on makes them what they are."

When Gernreich put the clothes for his spring 1971 collection on models carrying guns and wearing dog tags and combat boots, he fired another shot heard round the fashion world. The clothes themselves—previewed in October 1970, shortly after the student killings at Kent State—were basic, wearable knitted separates, but the rifles that the models carried took dead aim at the fashion industry itself.

"Women are on the warpath," Gernreich told press and buyers attending the opening. "They're tired of being sex objects." Then, in a swipe at designers showing the clothes of Russian peasants and other heroines from history books, Gernreich went on, "You simply can't design clothes for Chekhov heroines in 1970! Fashion has got to be relevant to women today. There are no 'escape clothes' in this collection because there is no escape. To desire the past is to negate the present and the future as well."

In keeping with the realism theme of the collection, all the clothes were priced under ninety dollars. And at a time when most major designers were showing the midi, Gernreich kept his hemlines well above the knees.

By fall 1971 Gernreich extended his attack on what he called "the nostalgia cult." "I see the conditions today like this: anonymity, universality, unisex, nudity as fact and not as kick, and above all reality. By reality, I mean the use of real things: blue jeans, polo shirts, T-shirts, overalls. Status fashion is gone. What remains? Something I am obliged to call authenticity. Comfort is the rationale. Good looks deriving more from the person than from the clothes. The clothes are merely an instrument for the individual's own body-message. Prices must be kept down. No more conspicuous consumption. Today, 'expensive' is what 'cheap' used to be: the hallmark of an inveterate vulgarity. And there is at last an awareness of age, true age, that is the sign of a real enlightenment. At last a woman over twenty-five no longer feels a moral obligation to look like a teenager. A division line between the ages is beginning to appear. This in itself opens countless opportunities."

Perhaps the biggest shock Gernreich delivered in the seventies was that he had nothing more to say about the future. Fashion's leading futurist became the champion of "right now." Amazingly, he was as alone in the present of the early 1970s as he used to be when he was predicting the future in the 1960s.

While yesterday-fever gripped most of the fashion world, Gernreich immunized himself and his followers with massive doses of what he liked to call uniforms—simple, functional knitted tops and bottoms that took on the personality of the men and women who wore them. "Do you see any Gernreich signature in these clothes?" he would ask buyers. If they said yes, his face fell. More than anything, he wanted his clothes of that time to be anonymous.

Moffitt recalls a revealing incident of the era: "It was 1972, Bill and I had just moved back to Los Angeles. I was depressed with the fashion scene in New York and wanted to work more with Rudi. He and I were having lunch across the street from the Los Angeles County Museum of Art and were talk-

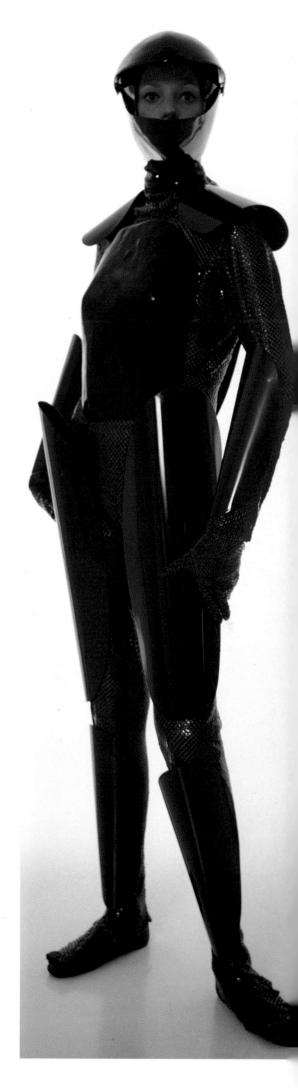

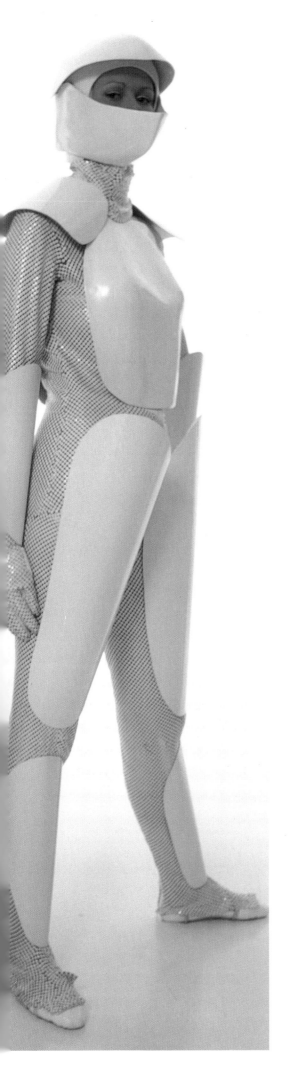

ing about how silly it was that *Women's Wear Daily* was raving so about Halston showing cardigan sweaters knotted around the shoulders. I said, 'If they think that's so great, why not just build a sweater right into the dress!' Rudi looked absolutely dumbfounded and said, 'How did you know? That's exactly what I'm doing.' He then turned very serious and said,' I don't want to work with you now. You inspire me, and I don't want to be inspired.' Crestfallen, I went home and decided to start a family. Two months later, an effervescent Rudi bounded into my living room and asked me to model futuristic armor that he was going to do for a Max Factor promotion in July. When I reminded him that I would be eight months pregnant by then, he still thought that I could model. That was Rudi. Everything had changed, and now it was okay to be inspired. And while I did not model on that occasion, I continued to work with him after my son, Christopher, was born right up to his final collection in 1981."

Convinced that "the creative part of fashion is gone," Gernreich believed that the next breakthrough in clothes would be technological. "Once the sewing machine has been replaced or sophisticated, once a designer can spray-on clothes or transmigrate fabrics to the body, new things will happen," he said in 1971.

"The designer will become less artist, more technician. He'll be like an architect or engineer, with a sound background in chemistry. There won't be a need for sewing machine operators or cutters. Other machines will do this work. So a knowledge of machinery such as computers will therefore be essential.

"When our technology made it possible to put men on the moon everything developed so quickly that people just couldn't face it. They took refuge in the past. The past became the security blanket of the present. Today, no one talks about the present. It's gone to most people. Instead, they're trying to adjust for the future. We used to think only in terms of the present. But today's present is the past and the future is just a fleeting moment in time."

In Gernreich's view, the futuristic, lunar look of the sixties stopped short in the seventies and designers started reverting to the past because the moon was still a remote idea at the beginning of the sixties and it made sense to abstract it as a design theme.

"Once it became a reality, once we saw the possibility of relating to it directly, it became frightening. To most of us, the moon still seems remote and unconnected with our daily problems. In a way, many are bored with the emptiness of the moon. Some—like me—are even turned off by it. Getting a man to the moon was a phenomenal feat. I don't deny that. But the monies spent in accomplishing that feat might well have been spent solving earthly problems. I still feel that the legitimate thing is for right now—not the future, not the past. Maybe when the first space station is an actual fact, there will be a stronger sense of reality about the moon and it will become a realistic influence. Right now, there's no room to playact with the moon."

What there was room to do in the seventies was to continue to produce clothes for the seventies while extending the boundaries of fashion design into other design fields. In the fall of 1971, Gernreich introduced a furniture collection for Fortress—a combination of glass, leather, polished aluminum, including such items as a coffee table simulating a door that was complete with doorknob, end tables that looked like orange crates, and tables that re-

sembled stretchers. In 1971 he created quilts for Knoll International that incorporated all the knitwear graphics he had used in his clothes. They were displayed at the Louvre in Paris. In 1974, the tenth anniversary of the topless swimsuit, he introduced a Rudi Gernreich fragrance packaged in a chemist's beaker and produced under the auspices of American Essence. After a brief success buoyed by his personal appearances, the company failed and Gernreich's perfume, along with the Anne Klein fragrance introduced at approximately the same time, disappeared from the market.

ater in 1974, Gernreich created yet another less-is-moreism called the thong. A thin strip of fabric, the thong separated otherwise bare buttocks. There were both male and female versions. Gernreich said he created the thong to provide "the undeniable comfort and pleasure human beings take in nakedness." He considered the thong a compromise between liberty and legality because it offered the freedom of nudism without breaking the law on public shores. Little did Gernreich dream that sixteen years after his creation first hit the beach it would be considered indecent and illegal. In June 1990, the seven-member Florida cabinet in Tallahassee passed a restriction that banned thong swimsuits—those with only a string between the buttocks—on state-owned beaches. The ruling went into effect June 22 and set off a national controversy on what the Florida legislators called the case of the anal cleft. Even Phil Donahue got into the act when he interviewed two young thong-wearers who had been arrested in Sarasota for violating the law. They modeled their suits on national television.

Also in 1974, Gernreich once more costarred with Bella Lewitzky, with whom he had danced in *Salome* almost thirty years before, when both were members of Lester Horton's troupe. His remarkable costumes for the Lewitzky presentation of *Inscape* were often part of the set and part of the plot. For instance, his "Siamese" wrestlers were joined at the skull in stretchable hoods that kept the dancers connected both literally and figuratively. Gernreich continued to collaborate with Lewitzky, designing sets and costumes for *Pas de Bach* in 1977, Rituals in 1979, *Changes and Choices* in 1981, and *Confines* in 1982.

Gernreich's idea of connecting the costumes for *Inscape* became a fashion pursuit as well: in 1975 Gernreich created black nylon-jersey tube dresses fastened to sculptured aluminum jewelry by Christopher Den Blaker. Free-form necklaces, for example, held halter gowns in place and wide bracelets formed cuffs. That same year, Gernreich designed the first Jockey-like briefs and boxer shorts for women for Lily of France, predating Calvin Klein's 1983 renditions by seven years. Rudi Gernreich cosmetics for Redken Laboratories appeared in 1976, Rudi Gernreich leotards for Ballet Makers, Inc., in 1977, Rudi Gernreich kitchen accessories, towels, and placemats for Barth & Dreyfuss in 1977, Rudi Gernreich rugs for Regal Rugs in 1978, and Rudi Gernreich ceramic bathroom appointments for Wicker Wear, Inc., also in 1978.

he last Rudi Gernreich knitwear collection appeared in 1981. His last venture outside the world of fashion, gourmet soups, started in 1982 and lasted until shortly before his death. His final design statement was the pubikini, "totally freeing the human body." Eyewitness photographer Helmut Newton reconstructs the proceedings: "Rudi told me about the project and asked if I would take a photo. There was no mention of a final look or anything like that.

1974, above, with perfume made for American Essence.

1983, right, Rudi as guest chef at the Cadillac Café, Los Angeles.

I said of course. He said to come to his house and he would have a model ready. It was an early afternoon in March."

The model, Sue Jackson, had been prepared in advance, her pubic hair shaped, shaved, and dyed poison green by Los Angeles hairdresser Rodney Washington, who followed the line Gernreich drew on Jackson's body with a grease pencil. Makeup artist Angelika Schubert created a body makeup and gave the model bright red lips and nails. Jackson, whose hair also had a streak of bright green, wore a tiny strip of fabric that extended in a wide-open V from hips to crotch, exposing the triangle of green-dyed pubes.

"I posed her on the couch and Rudi sat next to her. I remember Rudi putting some green paint or dye on her, and I remember how very excited he was about the design. Since then, I've always thought how that pubikini with the green on the pubic hair was so much newer an expression of nudity than just letting a boob hang out the way Yves Saint Laurent's models did in 1989. It struck me as touching and wonderful that he was so excited at this point in his life."

Gernreich died one month later, April 21, 1985, of lung cancer.

Epilogue

I met Rudi Gernreich in 1957 when I was in Los Angeles covering a story for the *Chicago Tribune*. From then until I moved to Los Angeles in 1969, I called him Mr. GERN-rike. He never once corrected my mispronunciation. I finally caught on after several calls to his Santa Monica Boulevard headquarters when I heard Fumi, his secretary, answer, "Rudi GERN-rick."

I always felt that anyone kind enough not to have corrected me all those years was someone very special. And Rudi certainly was very special. He wasn't the only designer in the world with vision. But he was the first designer to look beyond the salons into the streets, beyond the beautiful people and the lunch bunch, as they were called in his heyday, to the hard-hatters and the tuna-sandwich crowd.

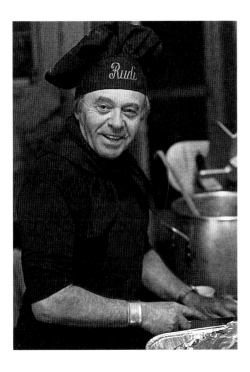

He was artist, sociologist, economist, humorist, psychic, Leo, and probably the only two-car revolutionary to wear Gucci loafers. Even at the height of his antistatus statements, he drove to work in a big, white '64 Bentley and had a love-hate relationship with his always-ailing '53 Nash Healy.

Christian Dior said he got his greatest fashion inspiration while in his bath or bed, and he compared what he called his incubation period—the two weeks he spent in the country before beginning each collection—to the migration of the eels to the Sargasso Sea.

Gernreich's fashion incubator was his mind. He was as cerebral as he was visual, as smart as he was heart. So were his clothes. They talked, tantalized, teased, tormented, and tickled the imagination. Sometimes they even scared people.

Gernreich was a great wit and punster. He loved playing jokes. In 1972, for example, I remember snickering, then laughing out loud at his spoof of Halston's twin sweater sets—the then-fashionable affectation of wearing on sweater tied around the shoulders over its twin. Gernreich's takeoffs had four

sleeves—two for the arms and two to tie around the shoulders.

Rudi had a presence, a kind of center-stage persona that belied his five-foot six-inch frame. If he was the center of attention, he purred. If he was not, he either became the center of attention— usually with an amusing story—or he left. And although his body was strong and compact, he moved with a dancer's grace, even as he became more barrel-chested with age. Gernreich the brilliant colorist always wore black so he could "hear himself think."

He spoke with a stage/American accent, and he expressed himself with ease, eloquence, and often a self-deprecating wit. He loved telling stories. One of my favorites concerned the maid at the Algonquin Hotel, where Gernreich stayed for years. "Poor Mr. Gernreich," he overheard her telling one of the buyers she'd seen many times during his presentations of samples in the suite. "He comes here at least four times a year. He works so hard trying to sell his clothes, showing them over and over, and yet no one ever buys a thing. He always has to pack them up and take them all back to California with him."

The Gernreich headquarters at 8460 Santa Monica Boulevard was a square stucco saltbox painted khaki—a modern, almost mysterious building. I was always struck by what I saw as the symbolism of that building standing alone on a highly trafficked street just as Rudi stood alone in the world of fashion.

The building's only decoration was the twelve-foot-high carved panel doors on which the designer's name was spelled out in chrome letters—all in sans serif uppercase. Inside, the setting was part Bauhaus, part 2001, part pre-ecology (there was a zebra-skin rug on the floor), part post-status (a single T-shirt with the designer's picture on it was tacked on the wall that was once covered with Gernreich on the cover of *Time*).

Everything in the showroom was either white (three walls and the floor made of hexagonal bathroom tiles), black (the leather on the chrome-framed Marcel Breuer chairs and sofa), or khaki (one burlap wall). The only color was the green floor-to-ceiling jungle of Schefflera and palm, and the red and green in the lithographs by Carmi.

There were no family photographs, no scrapbooks, no tourist's treasures, no hidden bar timed to open at the stroke of 5:30, not even a gold reproduction of his one millionth no-bra bra.

Gernreich's private office was a world of browns—personal, warm browns that contrasted with the more public schematics of the black-and-white showroom. A Charles Eames chair, leather pig, tortoise-shell telephone, mushroom lamp—all these sepia tones made the room feel like an old Sunday rotogravure section redesigned with modern graphics. The room's only concession to the past was a Mexican chest inlaid with bone. It was brown too, and inside, behind its closed doors, were Gernreich's many awards.

Behind the Moroccan wall that surrounded the home he shared with Oreste Pucciani in Hollywood's Laurel Canyon, Rudi was both open and closed about his relationship with his lover: he readily invited straight guests to dinner parties cohosted by Oreste but was reluctant to discuss his sexuality—at least with me. I "knew" he was gay, and I think he knew I knew, but neither of us ever brought up the subject.

Rudi started each new season by taking the thumbnail sketches he'd been preparing whenever and wherever the idea struck and worked them into detailed drawings, complete with fabric samples and color swatches. Those

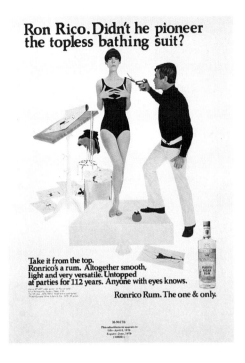

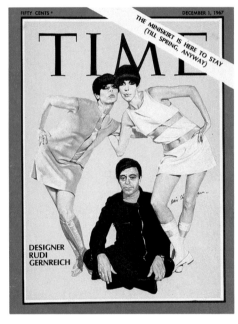

FIFTY CENTS DECEMBER 1, 1967

TIME

THE MINISKIRT IS HERE TO STAY (TILL SPRING, ANYWAY)

DESIGNER RUDI GERNREICH

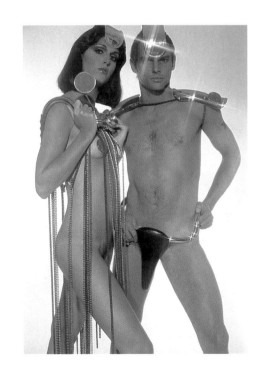

34

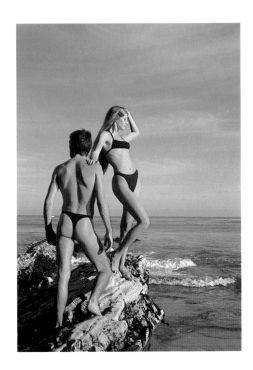

1974, above, the thong. (photograph © William Claxton)

quick, crude sketches might have been generated by an actual incident witnessed by Gernreich, as was the case in his 1970 swim clothes that came about as a direct result of "watching kids jump into a swimming pool with their clothes on and emerge in a dripping wet cling of sex appeal that made bikinis look almost boring."

Rudi said ideas often came to him in those moments just before waking or just before falling asleep. He called the experience a bit mystic, an almost trancelike state that he always entered before a collection deadline.

Rudi's most immediate critics were his three fitting models, Jimmy Mitchell, Peggy Moffitt, and Léon Bing. "I care very much what the model thinks," Rudi told me during an interview about their effect on his work. "I work only with models I like and respect, and their reactions are extremely important to me. I'm excited by an honest and instantaneous reaction. If the model is cool, if she says something doesn't feel right, or if it's just okay, I feel I'm not really on the ball. I'm not too concerned if she doesn't like a specific design, but I'm very concerned if she doesn't feel comfortable in it."

So how will Rudi Gernreich go down in history? Is he better than Chanel? Dior? Balenciaga? Givenchy? Pucci? Cardin? Courrèges? Saint Laurent? Because he never had Paris for a stage, with all its attendant publicity and fashion power, it's difficult to rank him internationally. But his continuing influence on international fashion was evident as late as 1991, when Gernrichian graphics came back into style along with Gernrichian colors, tattoos, shapes, and attitudes. The space-age clothes he first sent up and later shot down were once more rocketing around fashion runways from Milan to New York. All the Gernreich bywords of the sixties— skinny, mini, neo, geo, pop, op—returned to the language of international fashion. The simple, spare shapes that were considered futuristic in 1961 were suddenly "modern" thirty years later. The wit Gernreich brought to fashion was fashionable again. Unisex was in everyday usage. And those historical costumes that looked so dated to Rudi in the seventies were finally beginning to look out of sync to a lot of people twenty years later.

My favorite appraisal of his talent comes from *New York Times* fashion reporter Bernadine Morris: "Gernreich's big contribution wasn't the cut of a sleeve or a particular color or any of those dressmaking details so dear to the hearts of fashion people who love to return to the good old days which they understood so well. It was a brave new sweeping concept—that clothes should be comfortable. And just the tiniest bit fun to wear."

As for me, Rudi was my first fashion hero. I think he was a genius.

Upper left, spoofing the topless in a 1970 advertisement. (Courtesy J. Walter Thompson Advertising Agency)

Center, TIME magazine cover, December 1, 1967. (Copyright © 1967 Time Warner Inc. Reprinted by permission)

1976, lower left, Rizzoli asked a group of prominent designers to create fantasy clothes for an exhibition. Rudi dressed a couple in bicycle parts. (photograph © William Claxton)

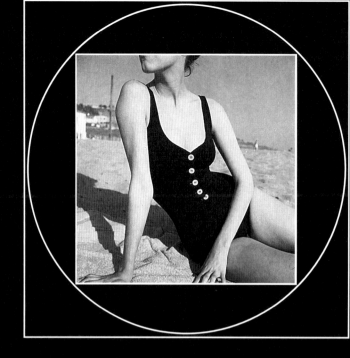

The Circle in the Square

Once in Vienna, a little boy went to kindergarten where his teacher told the class to take a sheet of paper and draw a square and inside the square to draw a circle. The boy took his pencil and drew an enormous circle that just touched the edge of the paper all the way around. When he was finished, he proudly ran to the teacher. She looked at his work and said, "But Rudi, you have failed. You didn't follow my directions." And he replied, "Yes, but isn't it beautiful?"

Years later and on the other side of the world, a little black-haired four-year-old girl put on her older sister's too-big shoes, a long pink dress, and a dark blue cape. She then went clomping through the neighborhood shouting to anyone who would listen, "I'm Snow White!"

Most of this book is a fond pictorial memory of what happened when those two people met.

1955, above, the five-button swimsuit, style 6001, probably the most copied swimsuit in history. (Photograph © William Claxton); right, the five-button swimsuit worn by model Jimmy Mitchell. (photograph © Tommy Mitchell Estate)

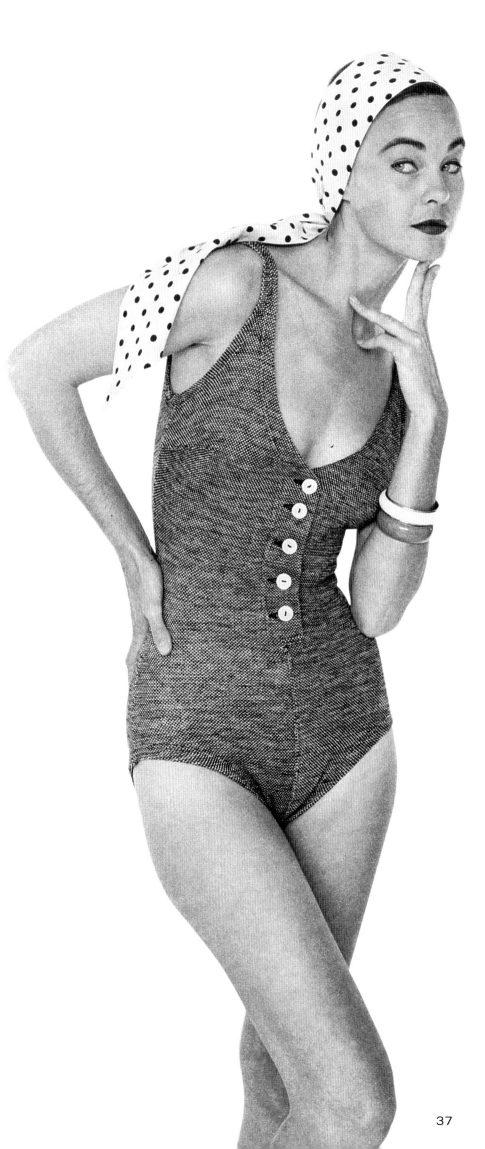

Jimmy

My first glimpse of Jimmy Mitchell occurred when I was a teenager working after school at JAX in Beverly Hills. One Saturday the most extraordinary couple walked into the store. He looked like a small, handsome version of Peter Lorre, and she looked like a cheetah in human form. It was Rudi and Jimmy Mitchell. Jimmy helped him start his career and remained his friend until his death. She still looks like a cheetah.

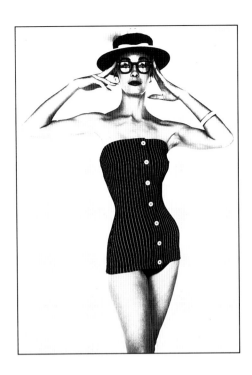

mid 1950s, unconstructed swimsuits based on menswear. (Photograph © Tommy Mitchell Estate)

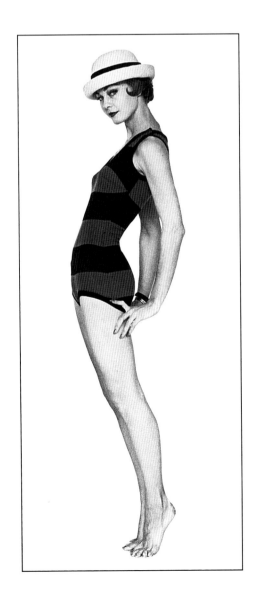

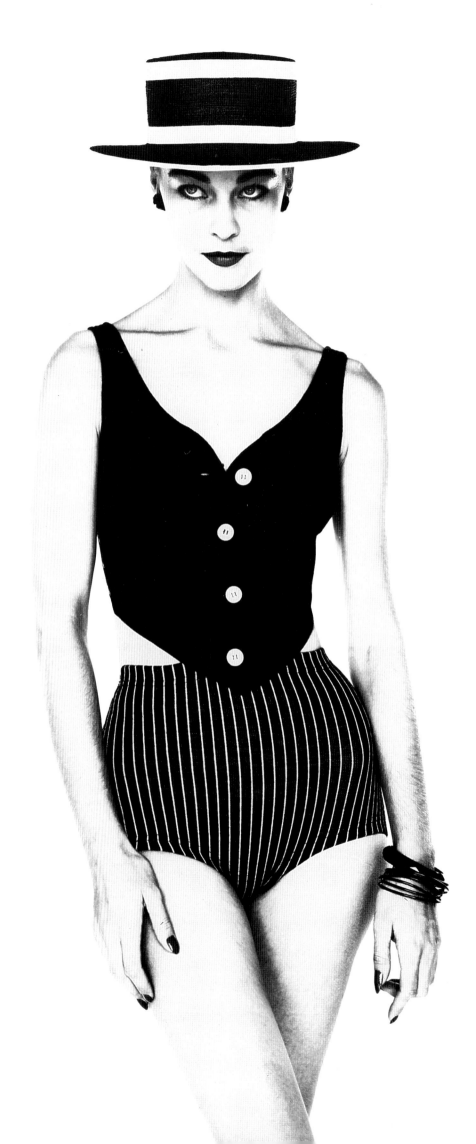

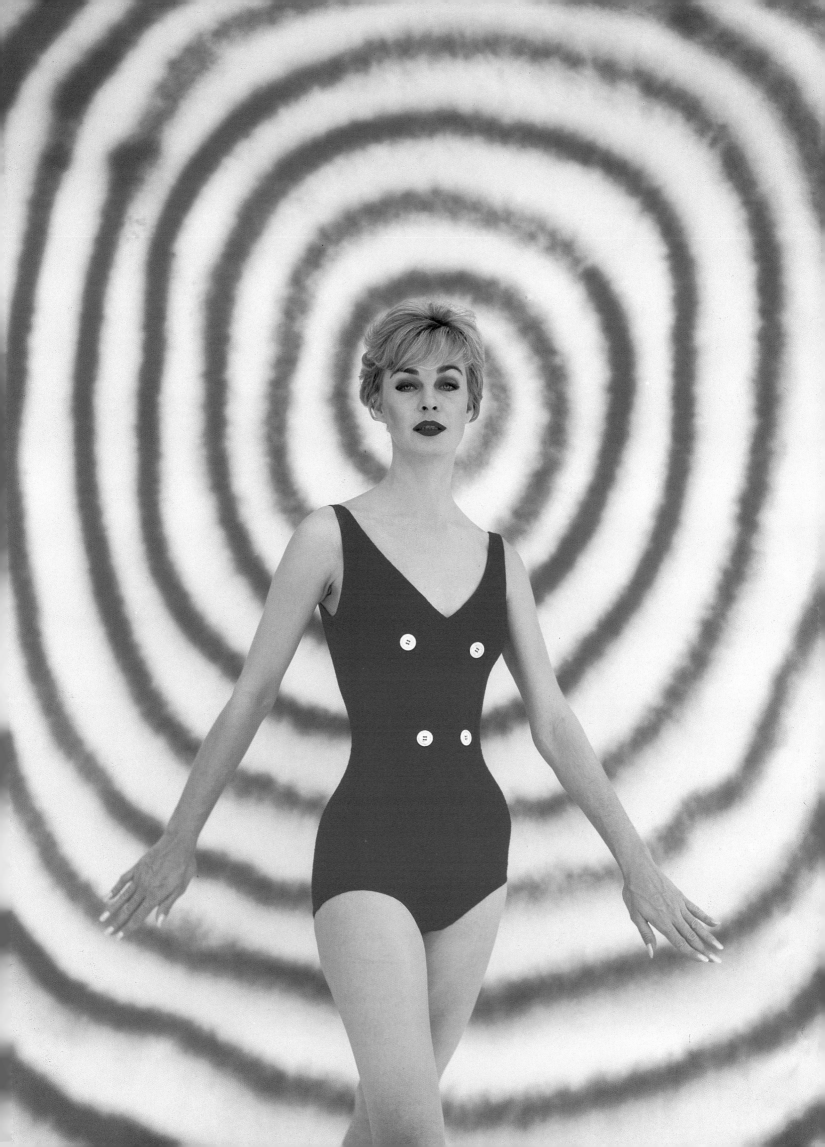

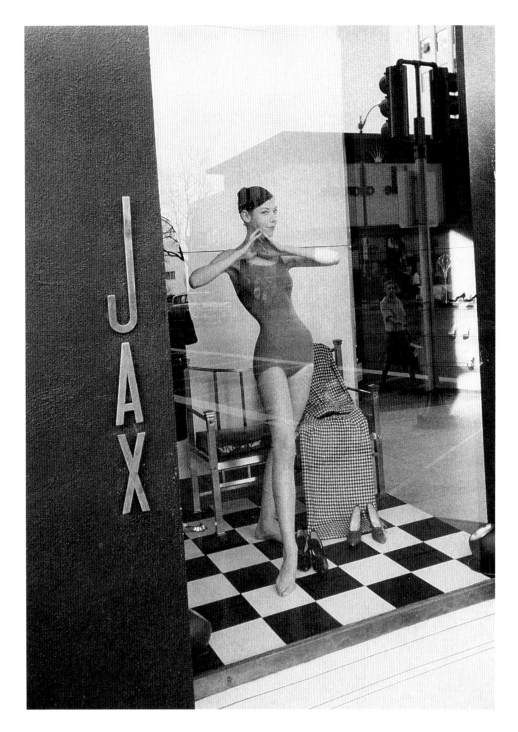

JAX

When I was a teenager, I discovered a terrific shop in Beverly Hills called JAX. I glanced at a dress in the window and the heavens parted—a giant thunderbolt riveted me to the spot. My life changed forever.

What I saw was a dress that would now be called a caftan. It was short black crepe and had two stripes running from the left shoulder to the hem. One stripe was ochre, and the other was orange. The dress had no bust darts, no waistband. It was as flat as a kimono and was hung on a wire hanger. All I could see was the body that wasn't in the dress. What that dress could do for a body—moving, changing, enveloping, revealing a body. This was designed by someone who loved bodies. This person had to be a dancer. And what a shock it was next to the other clothes of the day. Everything from haute couture to the Sears catalogue was based on Dior's "New Look." Every woman's garment in the world had a million darts, seams, wasp waists, petticoats, shelves to put bosoms in, and cupolas for hips. Even anorexics wore "Merry Widow" corsets to give themselves hourglass figures. And here was this supremely elegant, simple, sexy rebuttal to all of that— this perfect dress, this completely logical, alluring way to be a woman. This dress on this hanger was all about arms and legs and feet and necks and movement, and yet it was hanging—static—waiting for a body it could enhance rather than dominate and contort.

Looking at that dress, I thought, "I don't know who designed that, but someday I'm going to marry him or work with him or something."

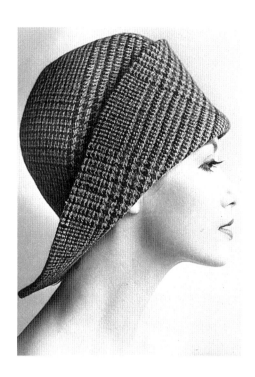

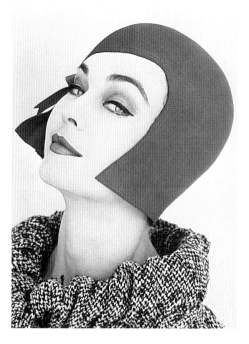

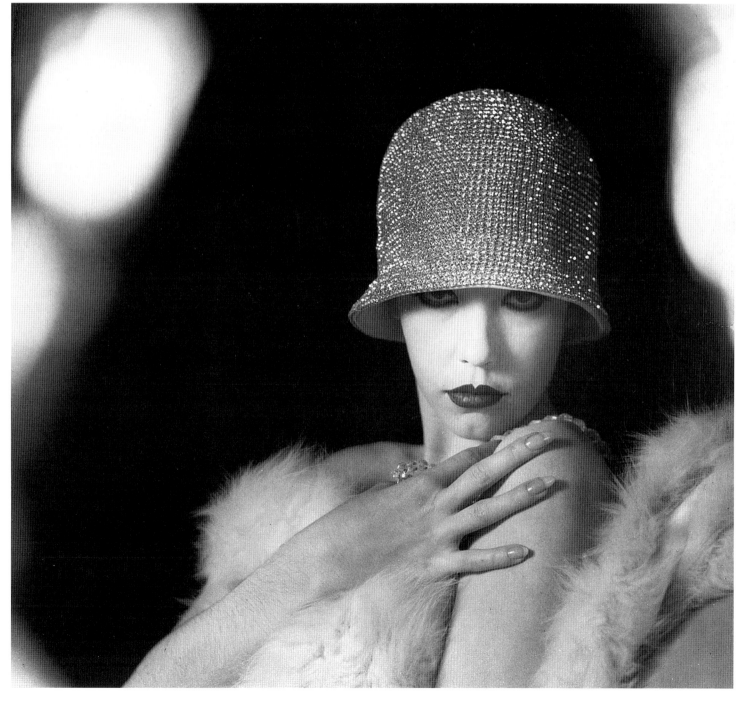

1963, upper left, men's patchwork sweater in wool knit; upper right, wool-knit checked pants and sweater.

1962, below, swimsuits in characteristic Rudi colors in a promotional shot for the Ferus Gallery, Los Angeles, with art dealer Irving Blum; right, playing by a friend's pool wearing one of Rudi's wool-knit tank suits designed for men.

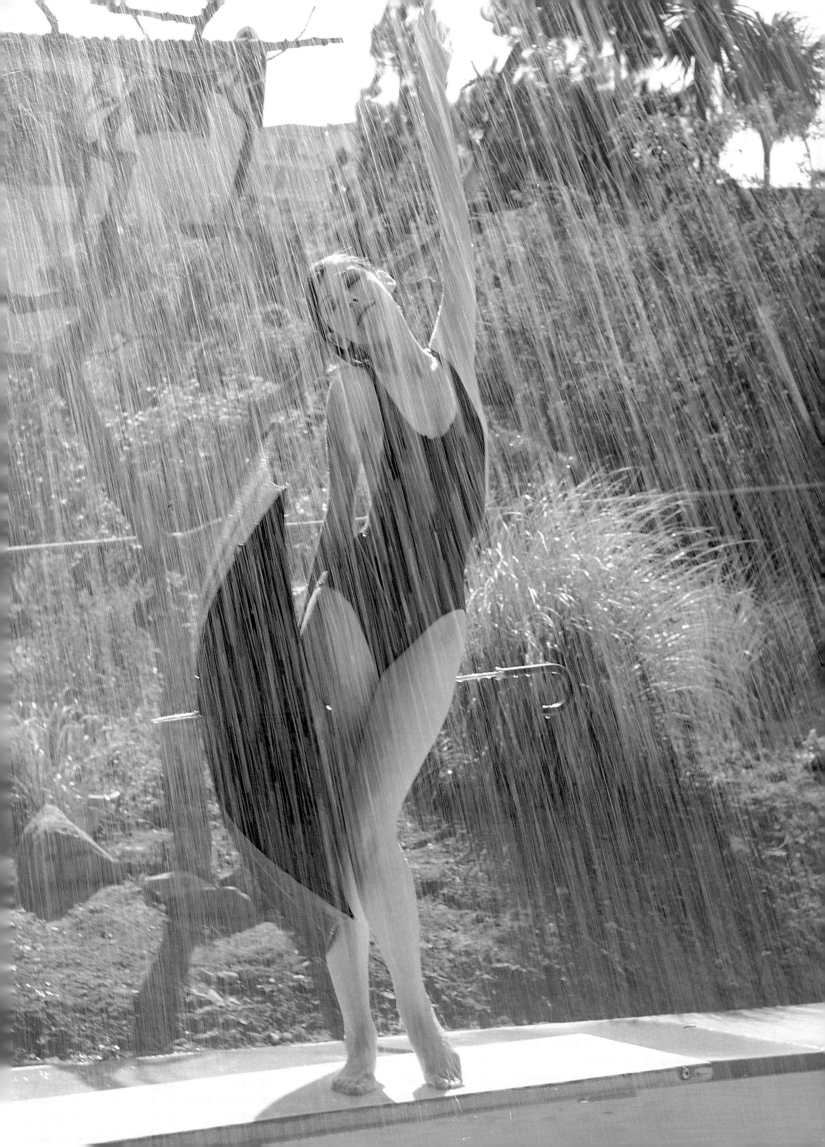

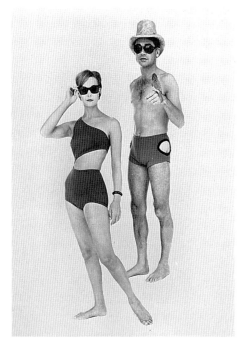

Resort 1962, upper left, wool-knit cut-out and porthole swimsuits; upper right, barrel-coat Irish linen suits; center left, single-sleeve gray flannel and silk dress; center right, black-and-white op art silk dress; lower left, wool-knit "skindiver" swimsuits; lower right, blue-and-white tablecloth damask suit with gingham blouse. (Photographs © Tommy Mitchell Estate)

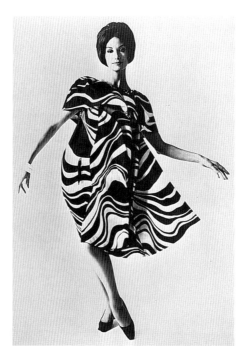
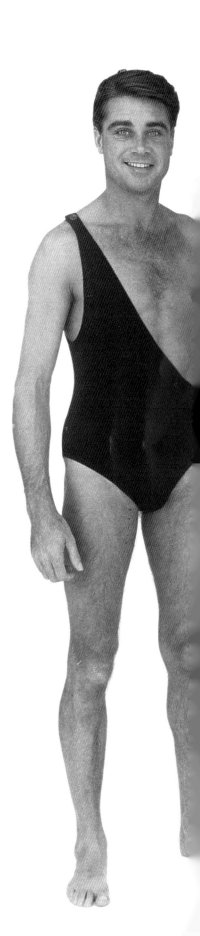
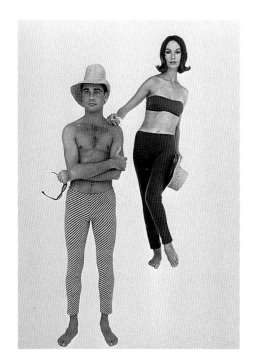
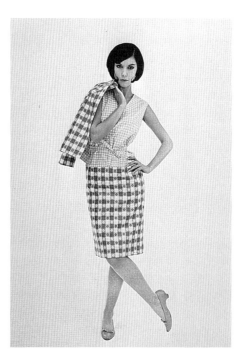

44

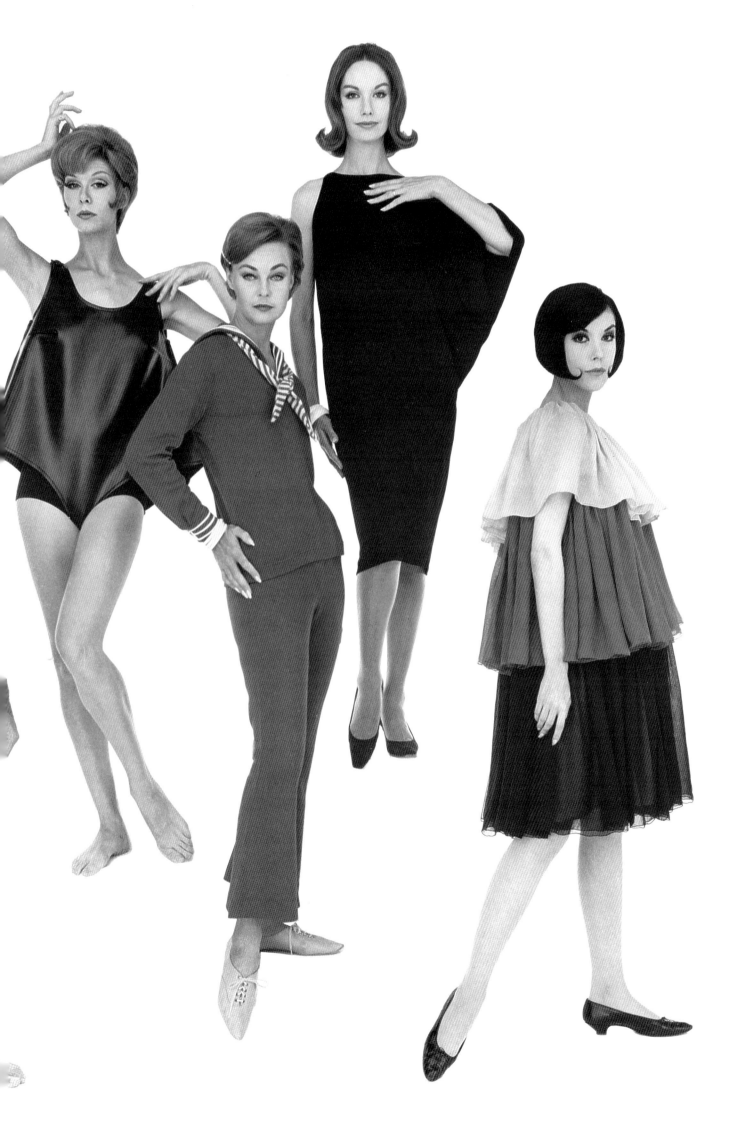

The Little Black Dress

In 1963 Rudi and I were showing his line at his suite in the Gotham Hotel in New York. One day a buyer came in and said as I was modeling the line, "I've looked all over the market, and I can't find a good black cocktail dress anywhere." We had one black silk matelassé dress that tied with a self sash at the waist. I put it on and showed it to him. He said, "That's nice." When I returned to change, I had an idea. As Rudi was saying, "Come on, come on, Peggy," I took the sash and tied it over my bodice, obi fashion and went out and showed it to the man as though it were a totally new outfit. Rudi was concealing his laughter as we returned to the changing room. Then I put the same dress on backward, unzipped the zipper all the way down, cinched the sash tightly around my waist, and proceeded to show it for the third time. By this time the buyer was overwhelmed and said, "To think I've been looking all over town for the perfect little black dress and you show me three! I don't know which one to buy!"

Rudi and I exploded with laughter and told the buyer that they were all the same dress. He was the only designer I know whose clothes could be worn upside down and backward and still look wonderful.

1963, We become friends. I'm wearing one of the patchwork dresses.

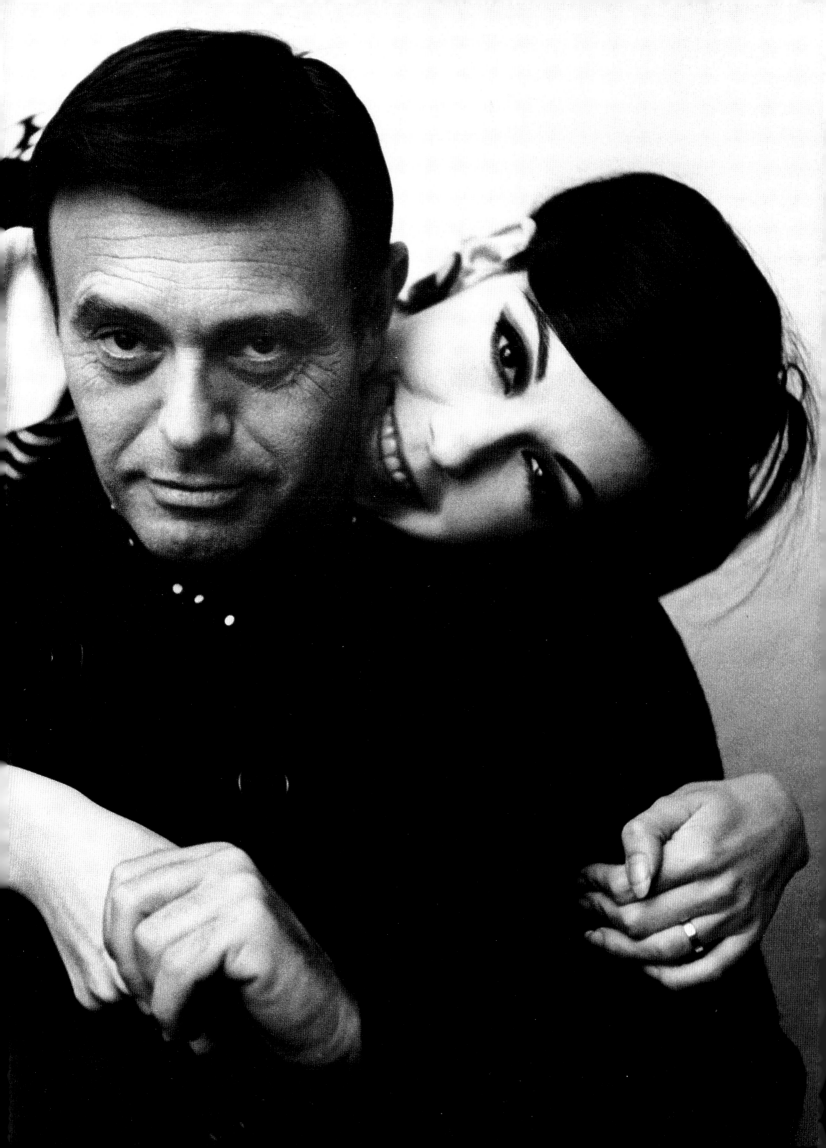

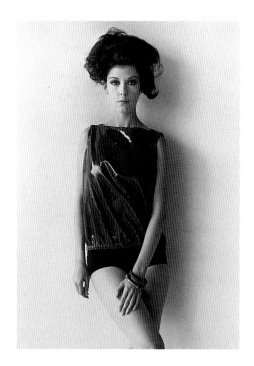

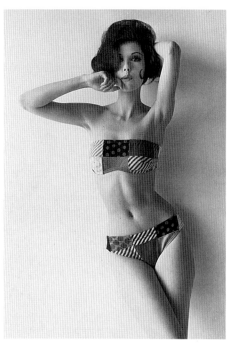

1963, upper left, brown vinyl-topped swimsuit with black wool-knit trunks; center, wool-knit patchwork bikini; lower left, yellow and orange wool-knit swimsuit with vinyl belt; lower right, black and red one-piece suspender swimsuit; right, yellow vinyl swimsuit.

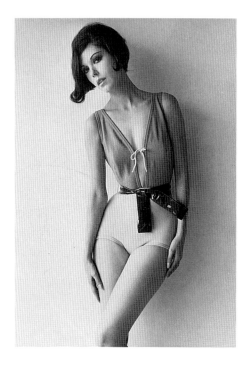

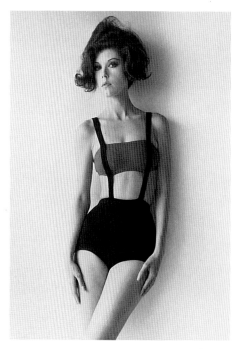

1963, overleaf, black vinyl swimsuits.

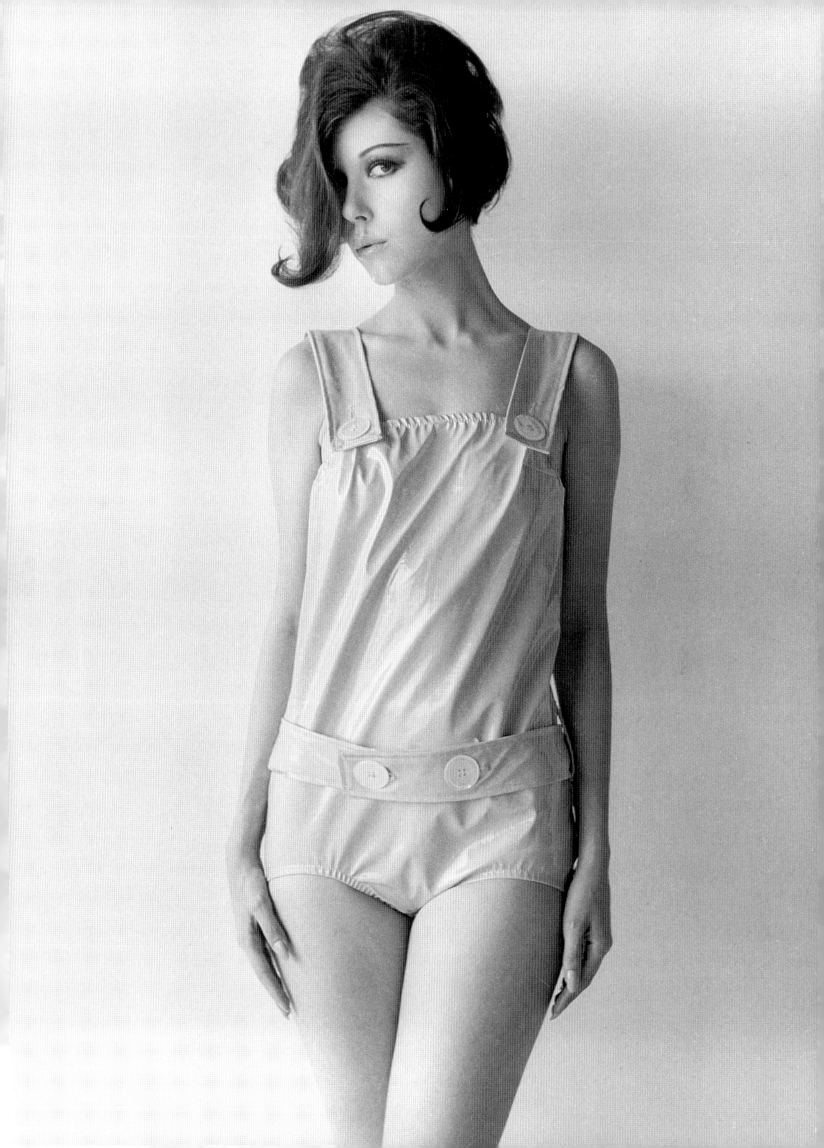

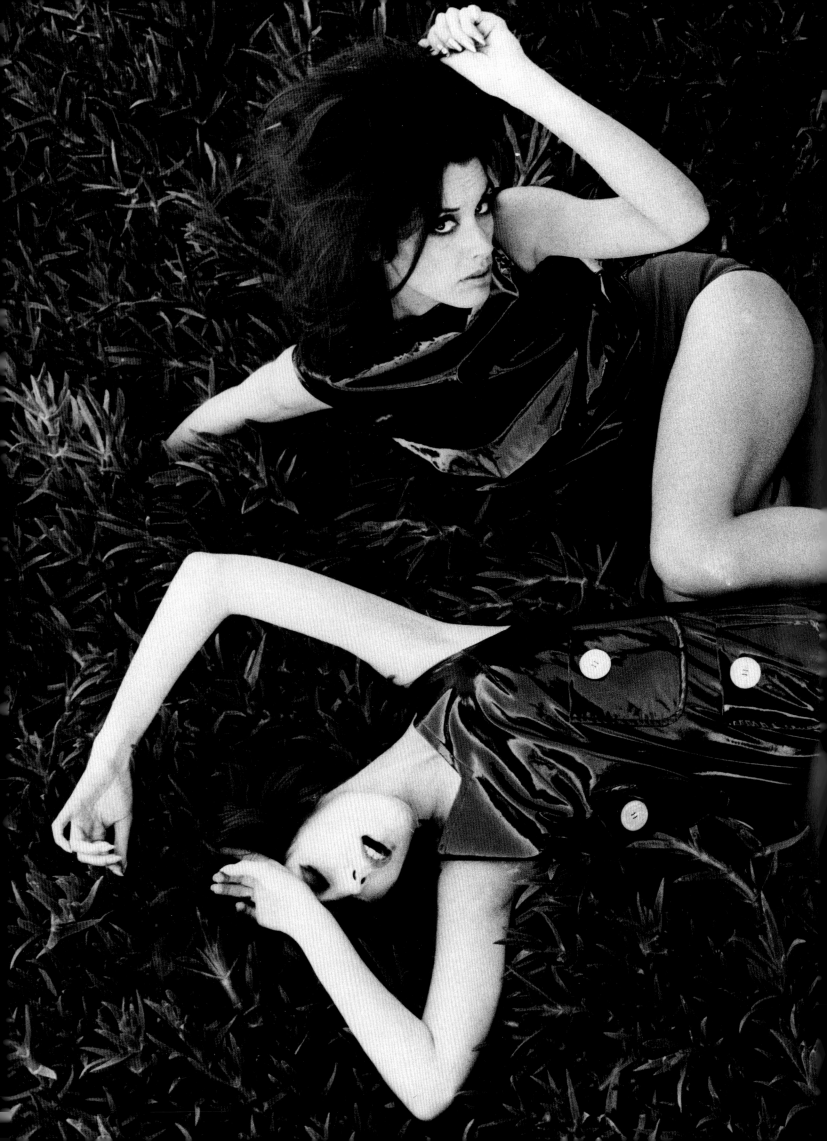

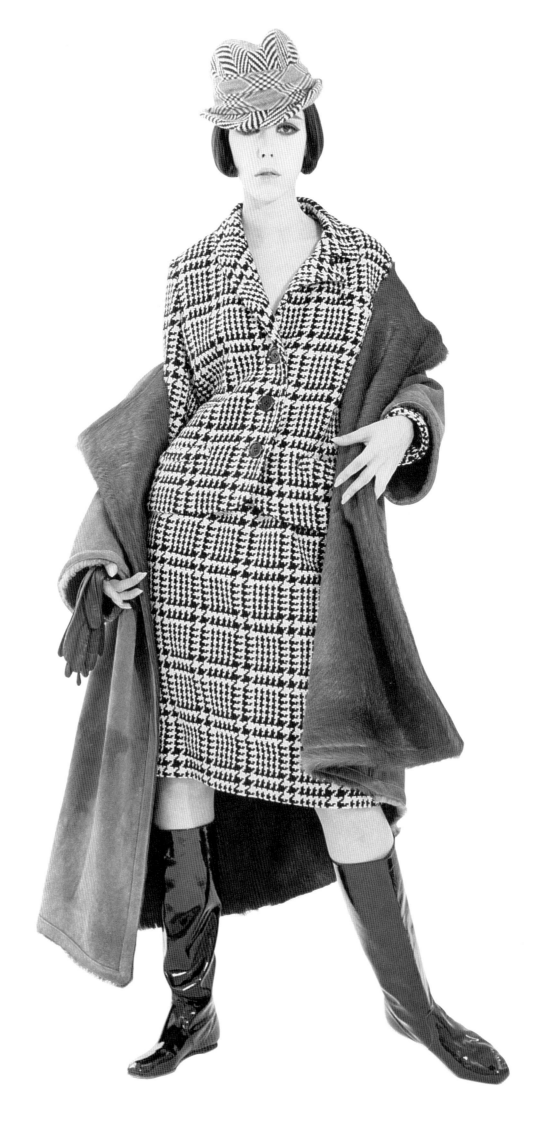

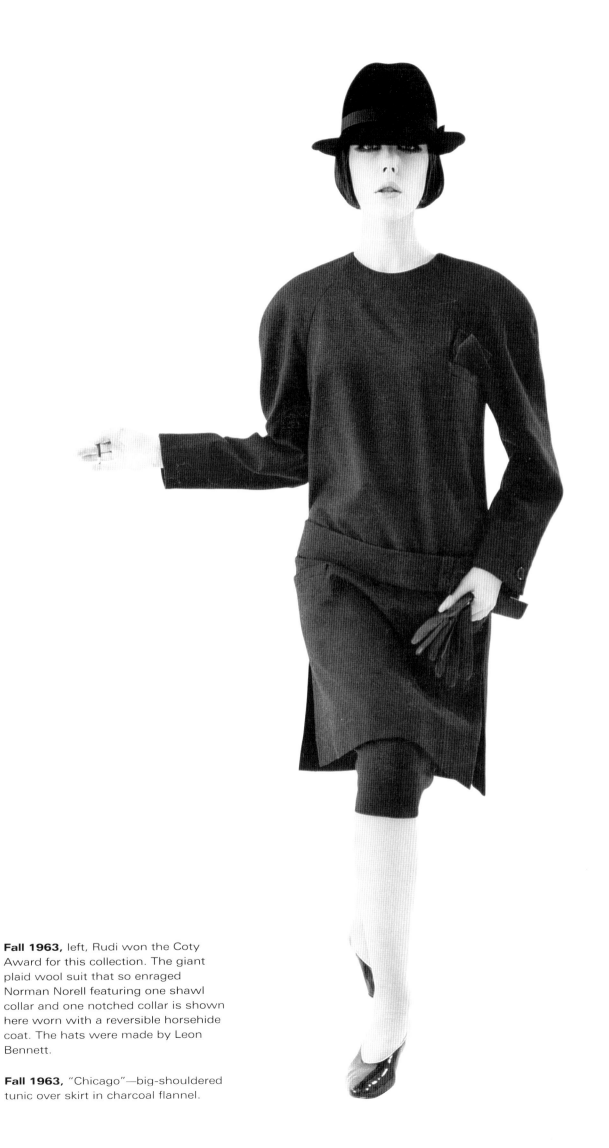

Fall 1963, left, Rudi won the Coty Award for this collection. The giant plaid wool suit that so enraged Norman Norell featuring one shawl collar and one notched collar is shown here worn with a reversible horsehide coat. The hats were made by Leon Bennett.

Fall 1963, "Chicago"—big-shouldered tunic over skirt in charcoal flannel.

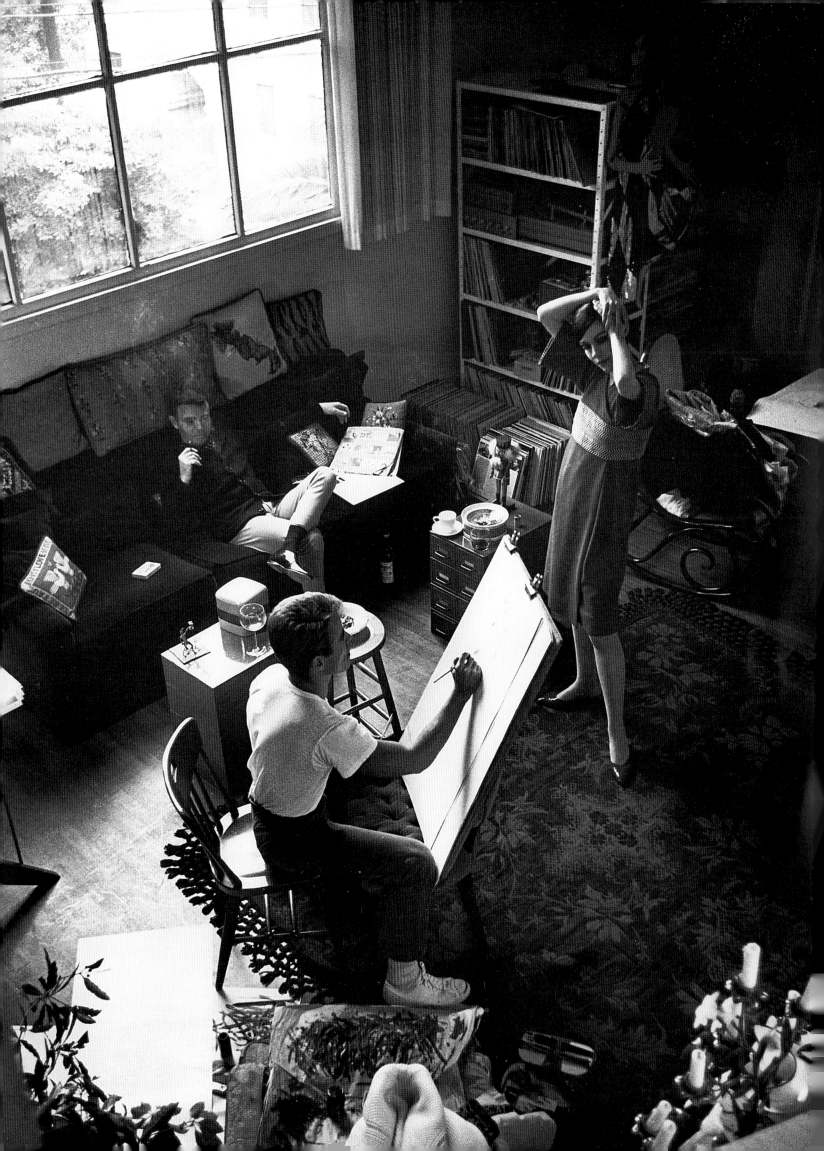

Fall 1963, wool-knit "Kabuki" dresses (upper left and right, photographs © William Claxton; below, photograph © Peter James Samerjan)

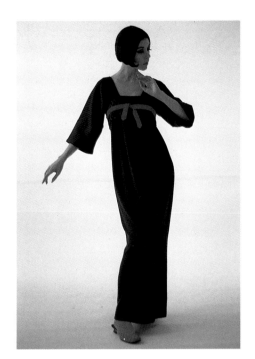 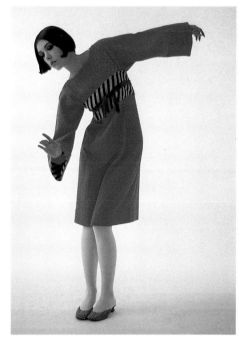

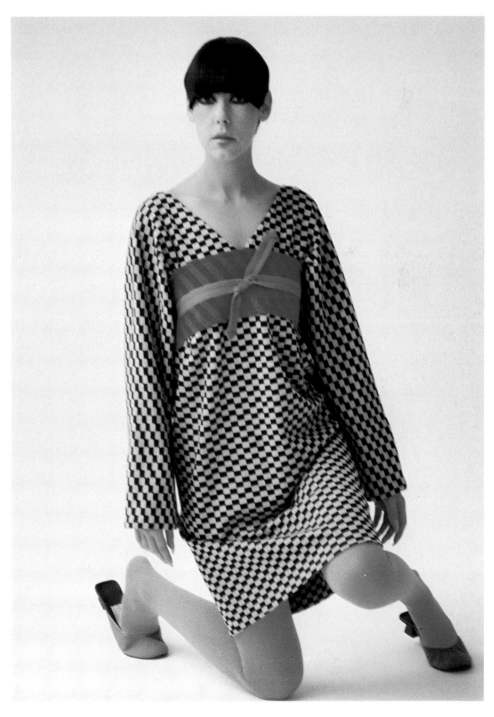

Fall 1963, left, Don Bachardy drawing one of the "Kabuki" dresses in our studio apartment in Hollywood.

Fall 1963, right, "Actors Studio"—big-shouldered pantsuit in tobacco vicuna.

Fall 1963, below left, black-and-brown wool-knit dress with jockey cap; below right, "High Noon" in gray flannel. The fun of this was that the vest was worn over the jacket so that when the jacket was seemingly taken off, one was still left wearing a jacket. The shirt and linings were made of "barber's cape" striped cotton.

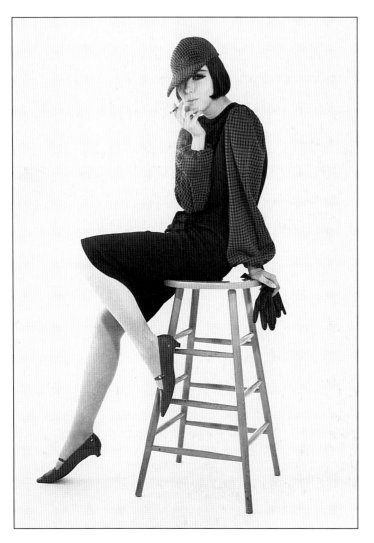

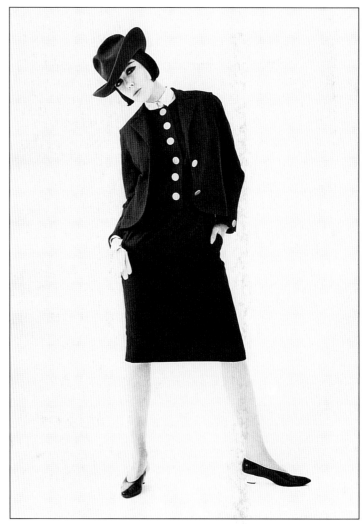

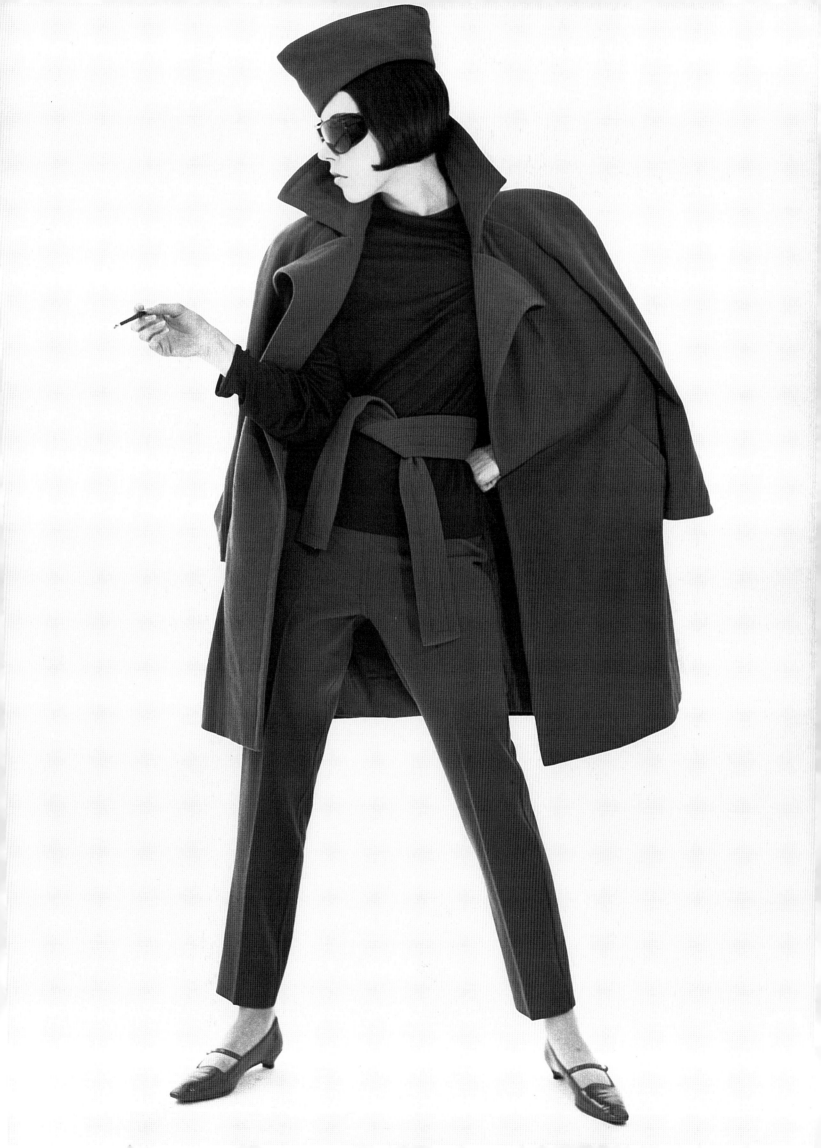

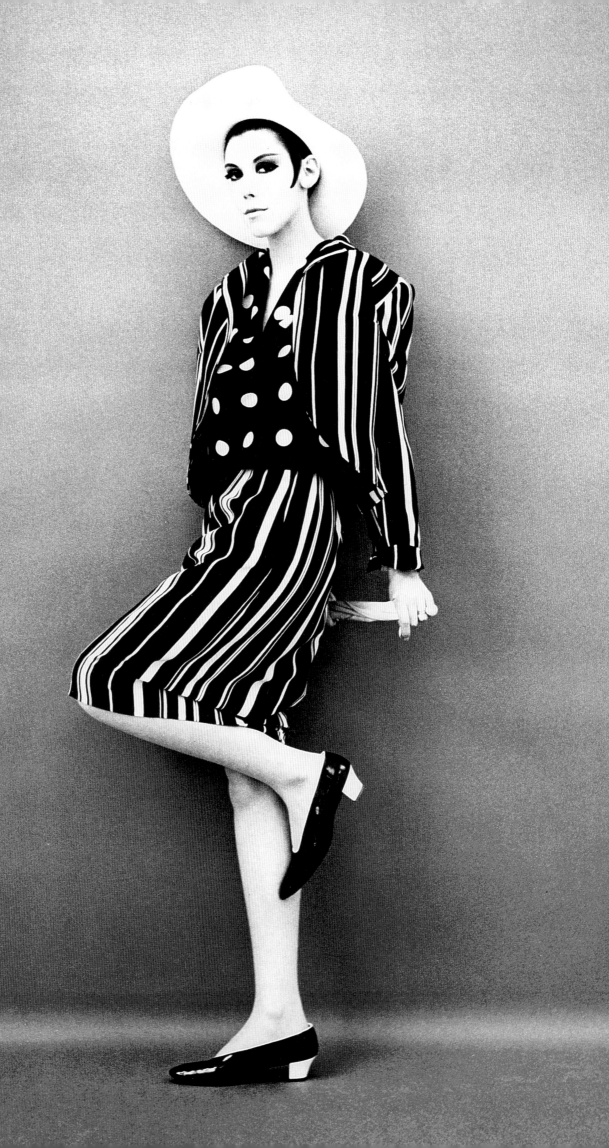

Resort 1963, black-and-white mixed prints in silk crepe.

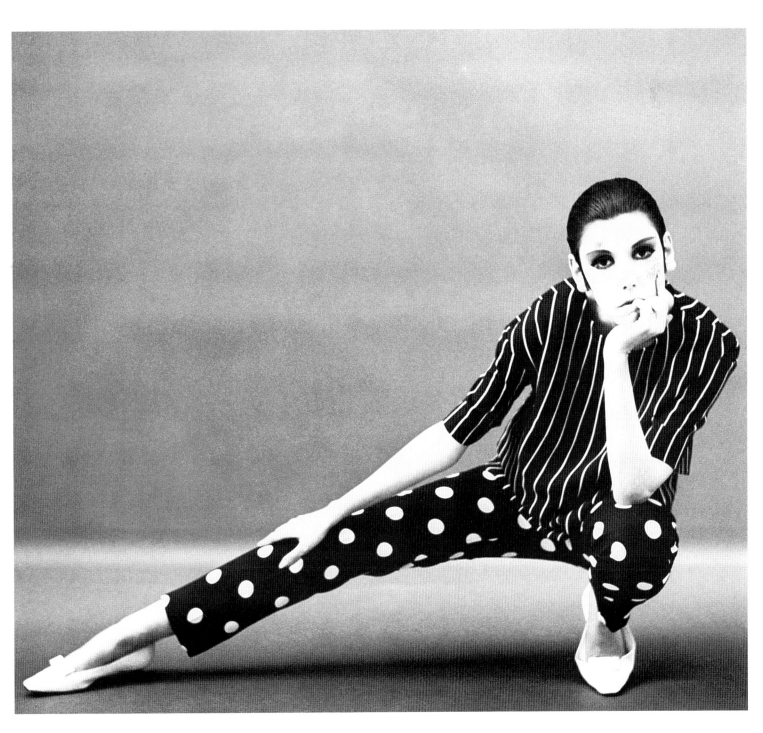

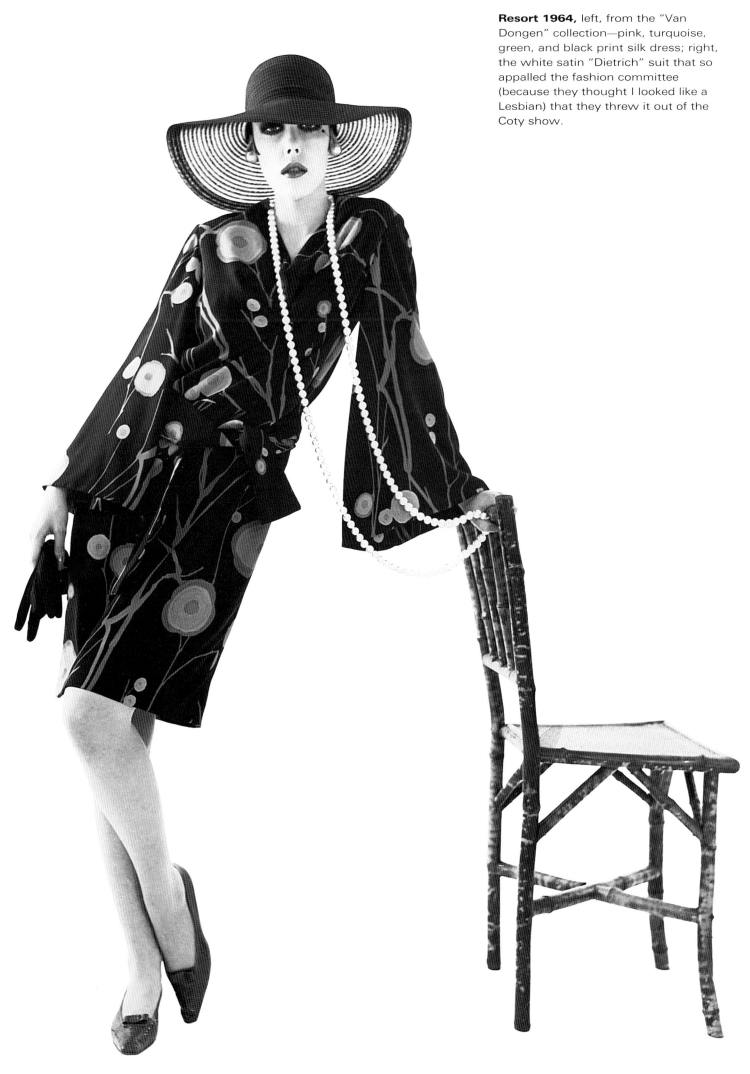

Resort 1964, left, from the "Van Dongen" collection—pink, turquoise, green, and black print silk dress; right, the white satin "Dietrich" suit that so appalled the fashion committee (because they thought I looked like a Lesbian) that they threw it out of the Coty show.

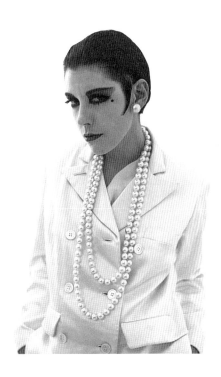

My Day

When I started working with Rudi in 1962, I was living in Los Angeles. I was both his fitting model and his show model. This involved going to New York several times a year and staying at the Gotham Hotel where Rudi would take a suite to show his line.

My day consisted of getting up around 6:00 in the morning, bathing, washing my hair, having coffee while I put on an elaborate makeup, getting dressed, and going up two flights to Rudi's suite. I would sit and chat with Rudi while he had his coffee and a soft-boiled egg. Our appointments would start around 8:30 or 9:00 and go straight through the day. We would show to buyers and editors, often one at a time, and I was usually the only model. This meant that I had to follow myself. Three things prevented me from going completely crazy from this tiring and boring routine: Rudi was fascinating to be with as a friend and a creator; the clothes were so brilliant that they were always a pleasure to wear; and I entertained myself and the audience by regarding the collection as a play, with each outfit a new act or a new character. This meant that the collec-

tion had an emotional beginning, middle, and end, with drama, jokes, tension, and slapstick. In fact, I really didn't model the clothes so much as perform them.

At the end of the work day we would go out together. Often we would socialize with people in the fashion business. Once we went to the Russian Circus. We sometimes went to the movies or plays, but usually we would just go out to dinner. Occasionally we went to great restaurants like Lutèce, but more often, we chose quiet, unpretentious places. One of our favorites was a Greek restaurant near 42nd Street called the Pantheon. After dinner, we would walk home through the whores and pimps, and we would sing songs together. Rudi's favorite was *Falling in Love Again*. And he always sang it at least once on the way home.

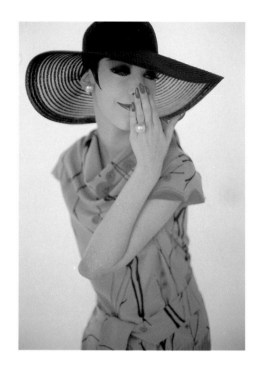
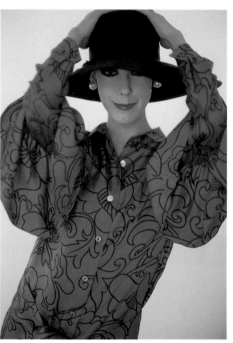
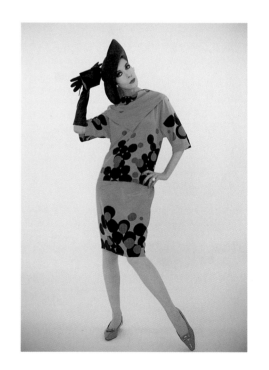

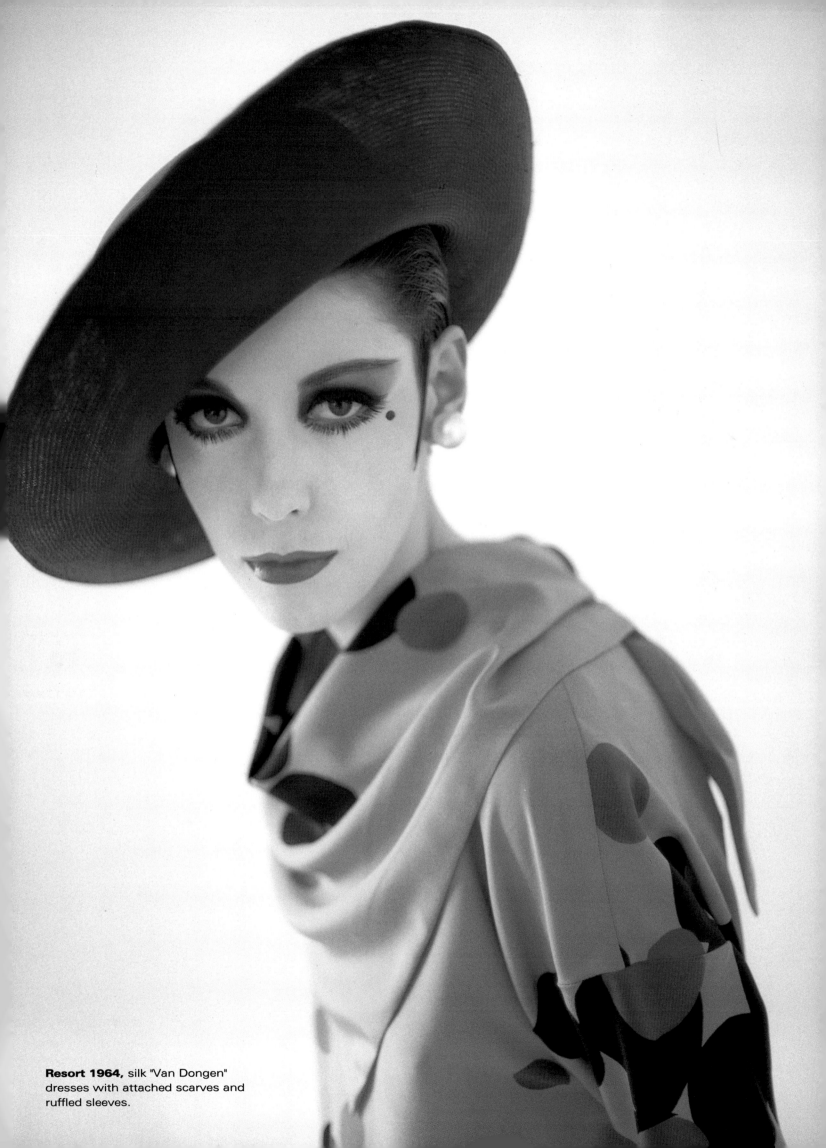

Resort 1964, silk "Van Dongen" dresses with attached scarves and ruffled sleeves.

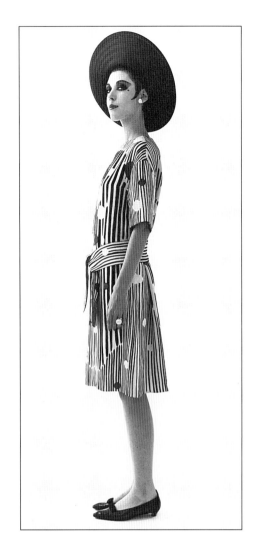

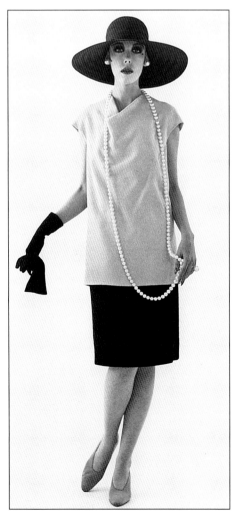

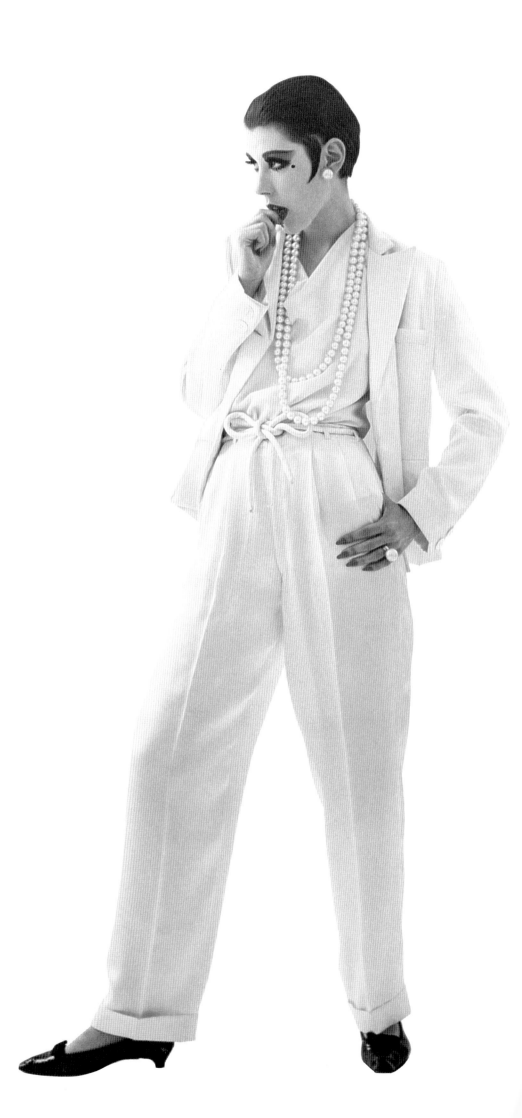

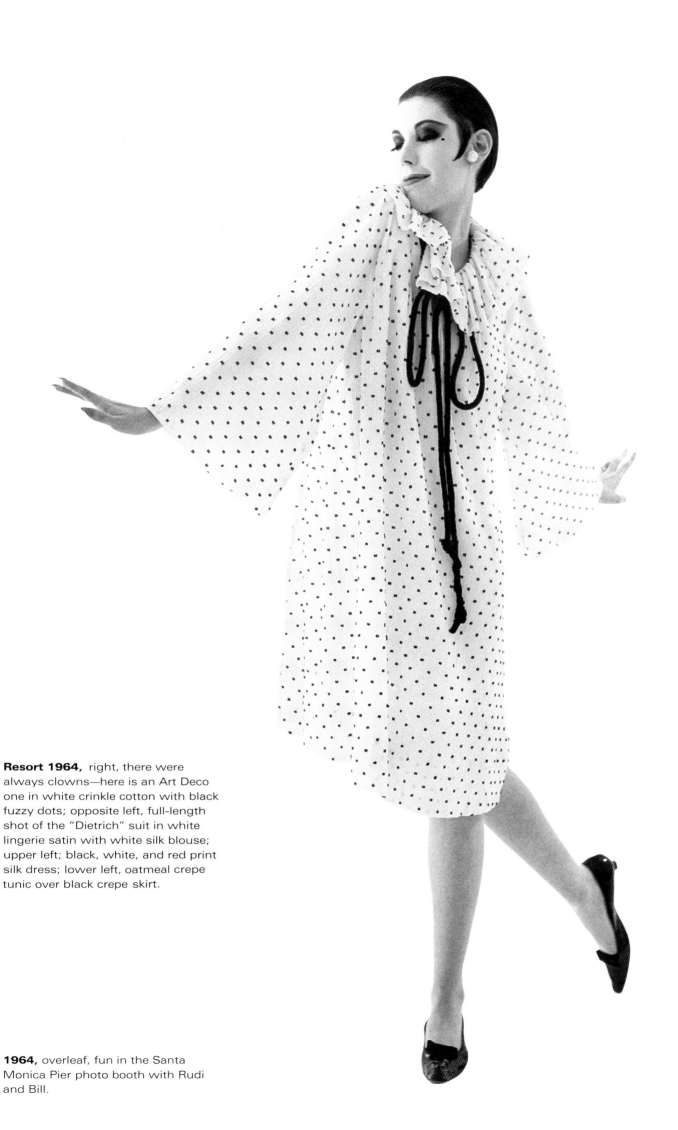

Resort 1964, right, there were always clowns—here is an Art Deco one in white crinkle cotton with black fuzzy dots; opposite left, full-length shot of the "Dietrich" suit in white lingerie satin with white silk blouse; upper left; black, white, and red print silk dress; lower left, oatmeal crepe tunic over black crepe skirt.

1964, overleaf, fun in the Santa Monica Pier photo booth with Rudi and Bill.

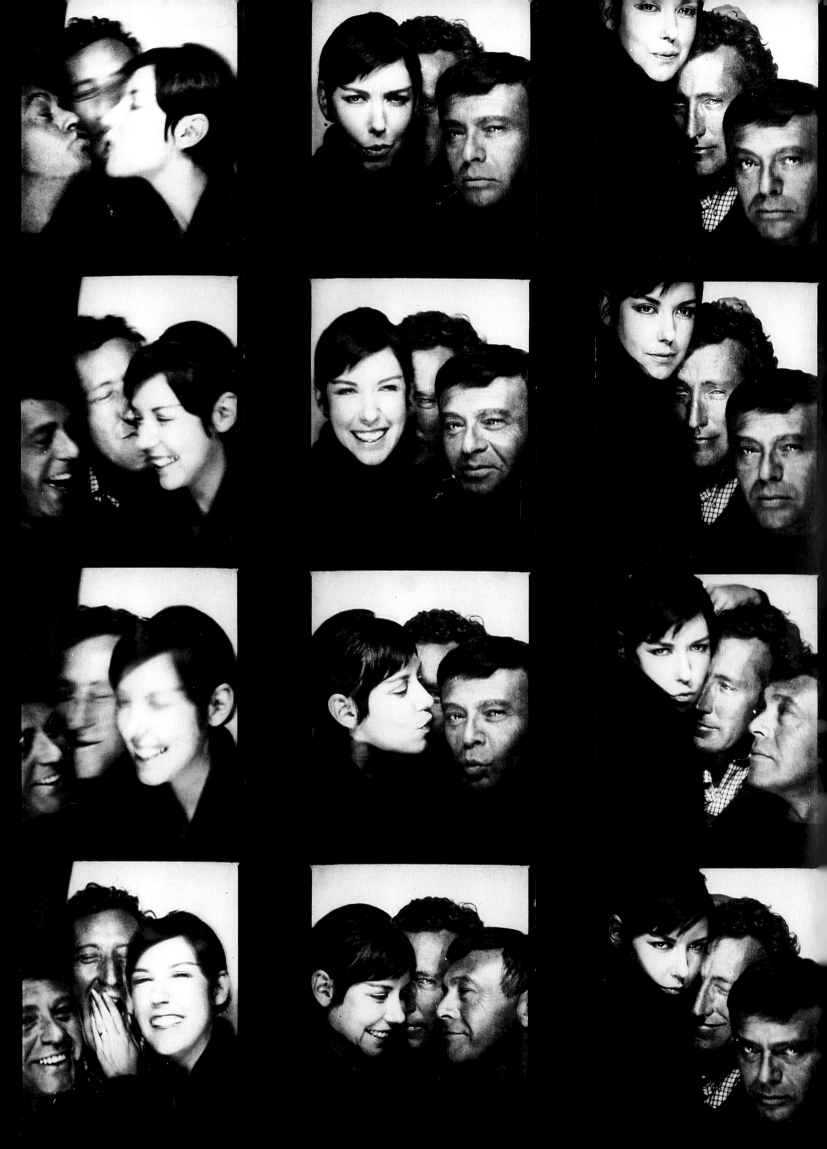

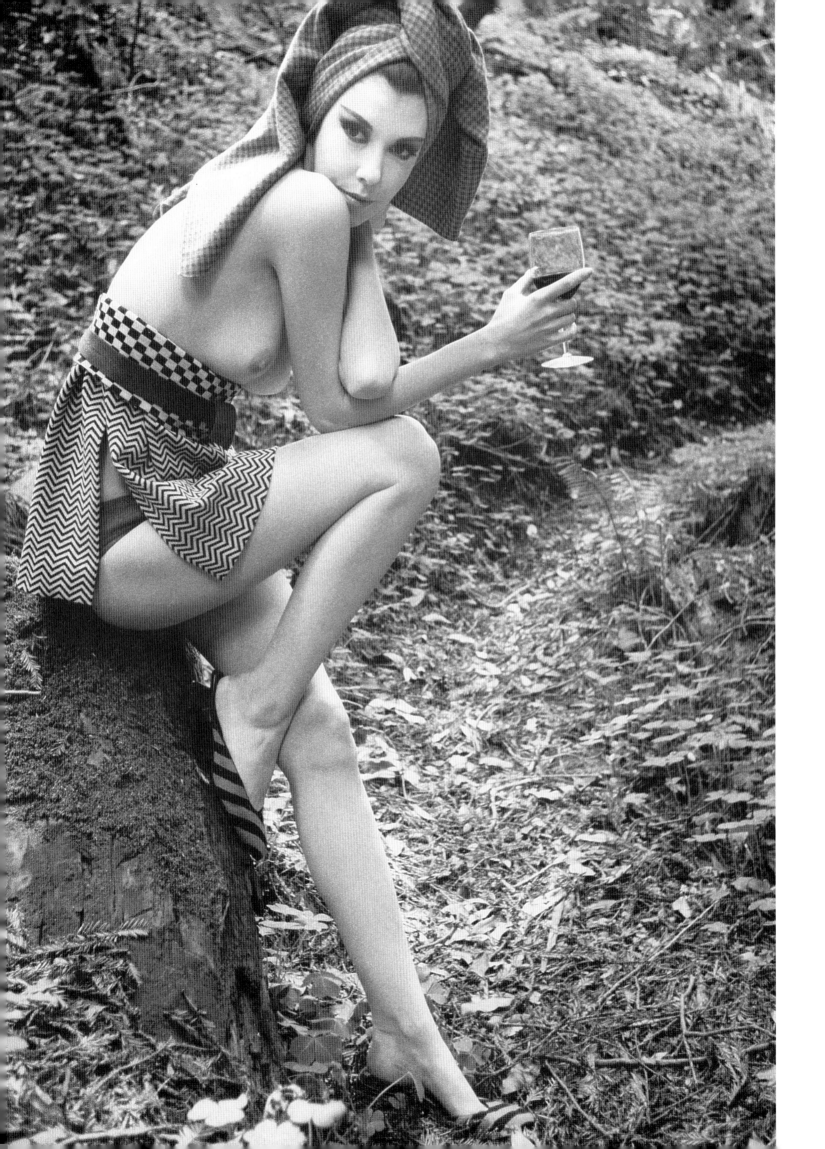

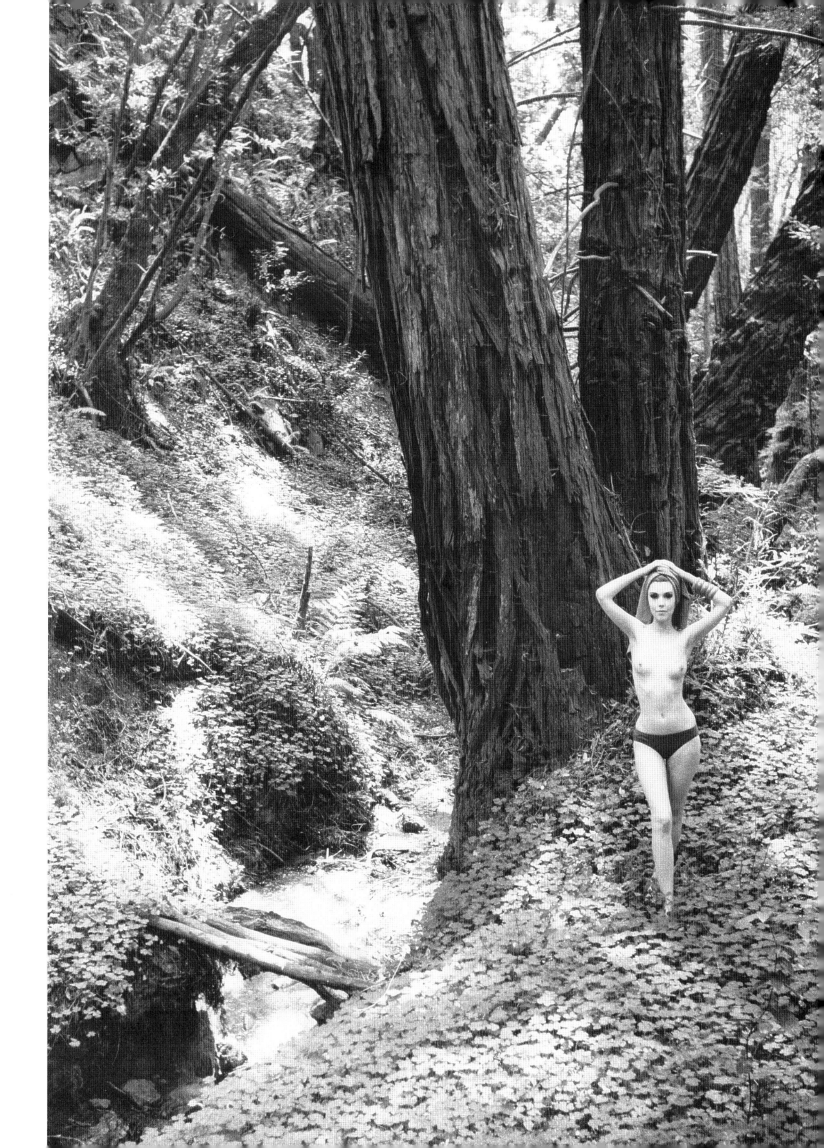

1964, above, the first topless swimsuit design; right, the second topless swimsuit design—which became famous.

The Shot Seen 'Round the World

Think of something in your life that took one-sixtieth of a second to do. Now imagine having to spend the rest of your life talking about it. Here is the topless swimsuit—probably the most famous fashion picture of all time and my bête noir.

I still think it's a beautiful photograph. But, oh, am I tired of talking about it.

Fall 1964, I had seen the first show of Jacques Henri Lartigue's rediscovered photographs at The Museum of Modern Art and was so excited about it that I went back with Rudi. Rudi was very impressed and said, upon leaving, "I was going to do an Indian collection, but I can't now, even though I've got the fabrics ordered." The result was this collection—Rudi's favorite. The Lartigue photographs are a child's brilliant reportage of La Belle Epoque. In them one can see how Rudi took turn-of-the-century clothes and turned them into exciting modern fashions. Rudi always regretted that the hoop-la caused by the topless overshadowed this collection, which he felt had more innovative ideas than any other.

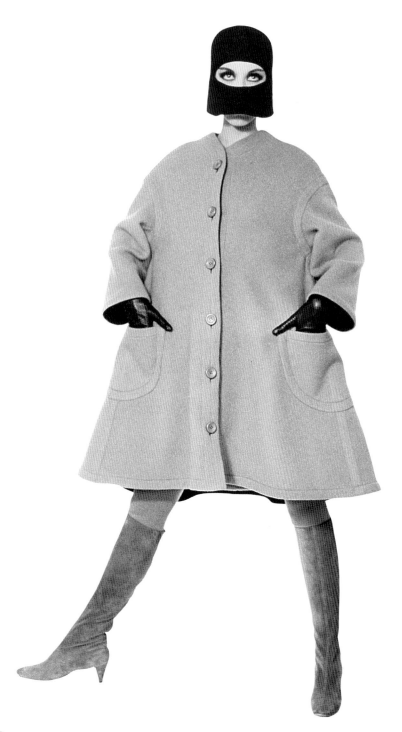

Fall 1964, left, camel's hair coat that reverses to black, with black felt "Yashmak" hat. All of the hats in this collection were made by Leon Bennett; right, the camel's hair dress worn under the coat at left, which also reverses completely to black.

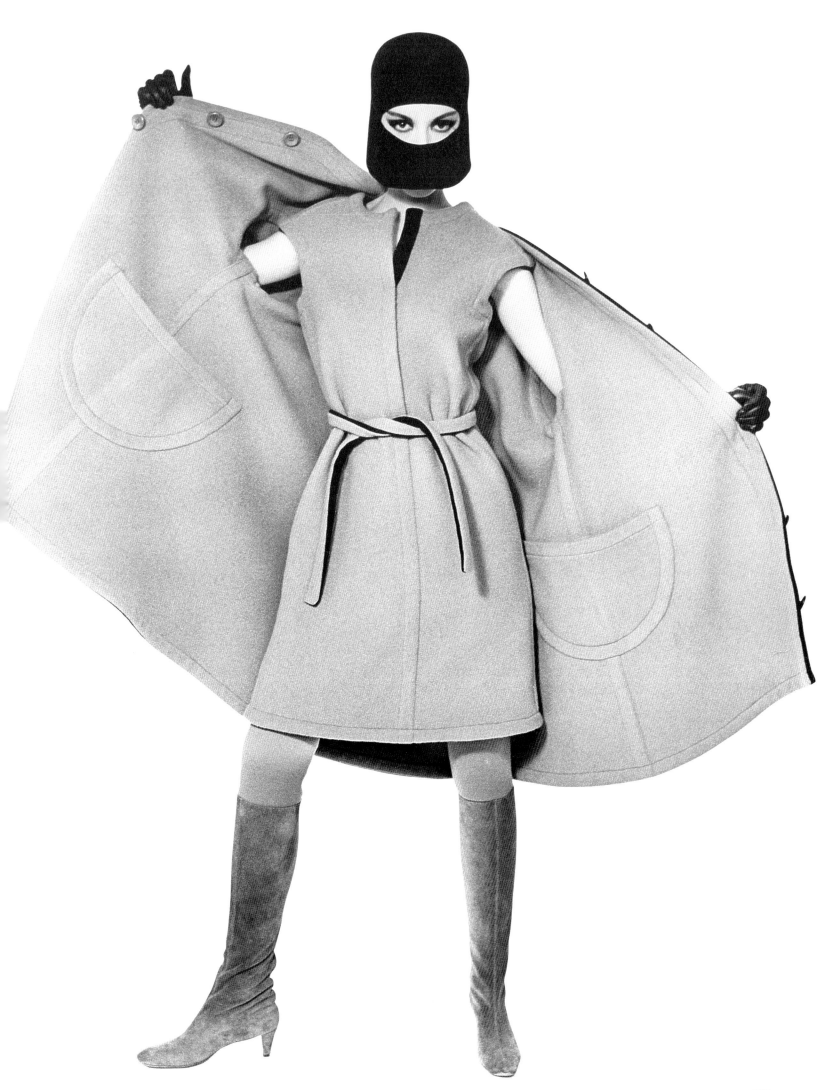

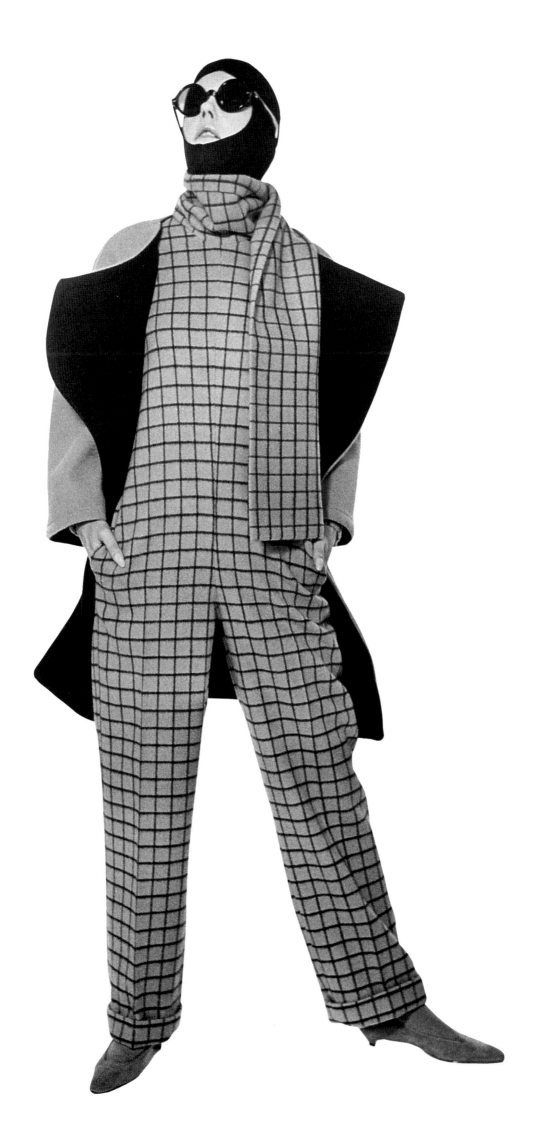

74

Out of the Closet

When I first started showing Rudi's clothes in New York, Rudi and a dresser would help me change, and I always wore a bra for modesty's sake. (I never wore a bra privately when I was wearing his clothes.) After working a few seasons, I said to him, "I'm doing your clothes a disservice by wearing a bra. They look so much better without one. From now on I'll change in the closet, and you can zip me up when I come out." I then spent hours everyday going in and out of the closet and generally wearing myself out as the clothes got more and more complicated to put on. Finally, at the time when the photograph of the topless first appeared, the collection we were showing was absolutely impossible to put on quickly by oneself. Each change involved tights, leggings, zippered boots, tunics, dresses, hats that covered the face, coats that reversed. . . you name it. So I made a formal announcement to Rudi and the dresser that from now on I was going to change in front of them because I had to have their help and modesty be damned. All the other models who helped show on the opening day came to the fitting and, having seen the photograph of the topless, instantly stripped down to their underpants without question. There were bras all over the place. They were hanging from the chandelier. Rudi loved it. And that's how *I* came out of the closet.

Fall 1964, left, camel's hair aviator jumpsuit with reversible camel's hair coat; right, first wool-knit outfit with matching stockings in navy and oyster worn with poison green shoes.

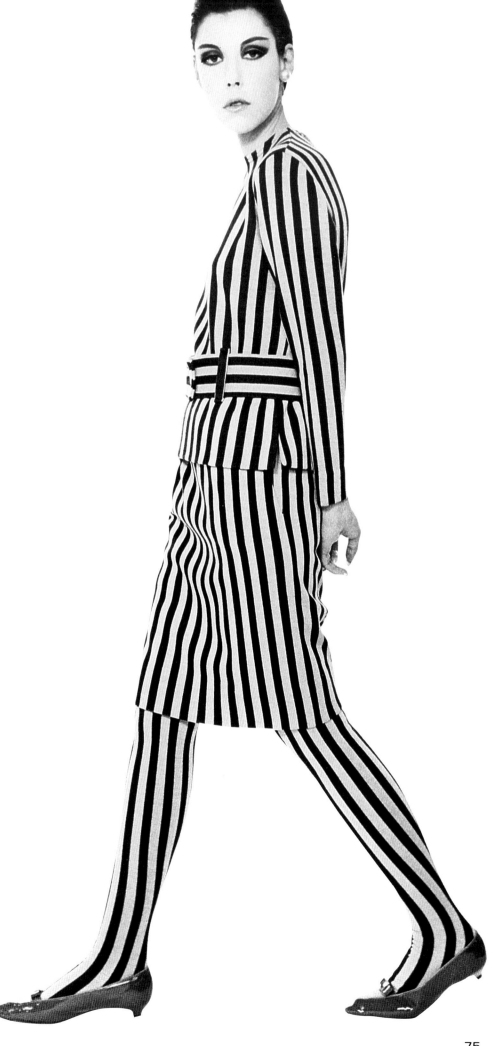

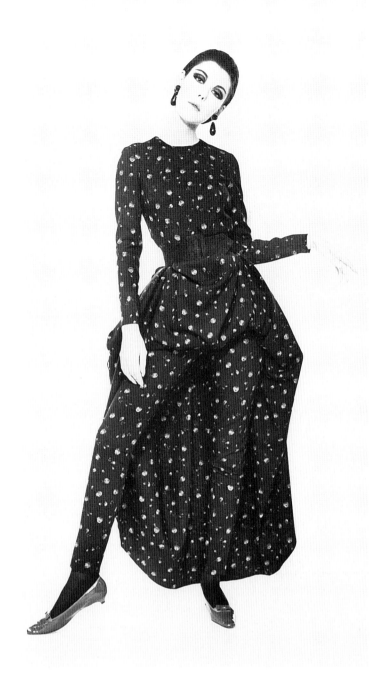
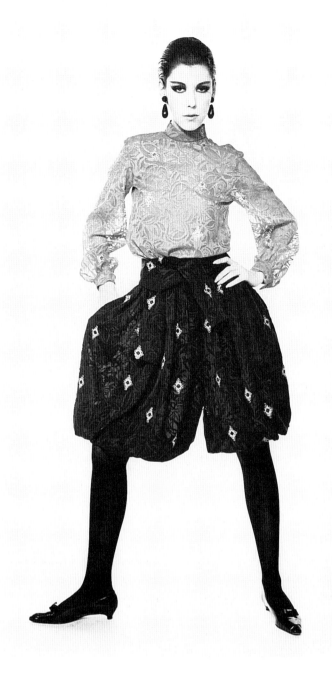

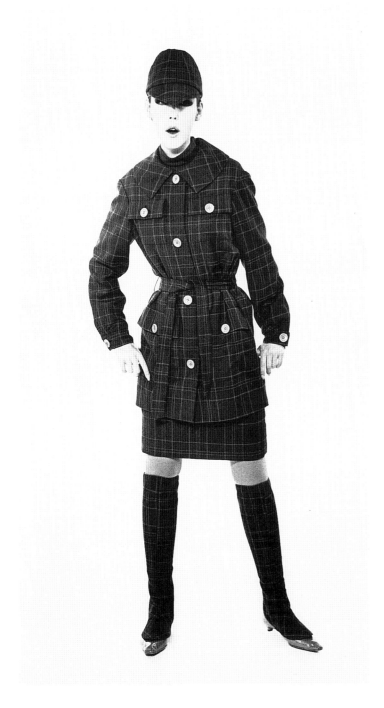
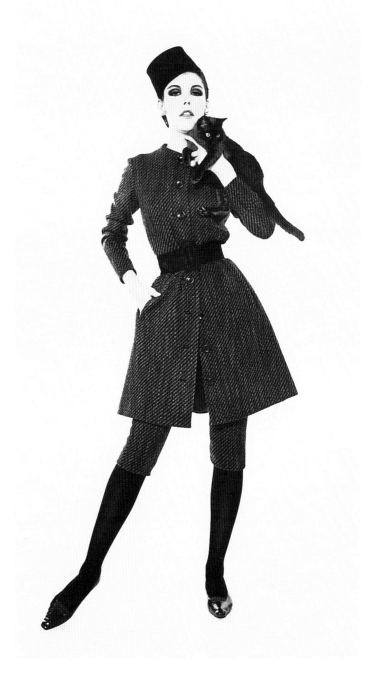

Fall 1964, far left, a modern "Marie Antoinette"—long black challis dress with pink rosebuds (the skirt is tucked into the belt to reveal matching skin-tight pants); near left, gold-embroidered red chiffon blouse with gold-embroidered black chiffon bloomers; near right, a "Japanese soldier" in gray and lavender plaid wool with matching spats; far right, brown, beige, and black tweed "Mozart" pants and tunic.

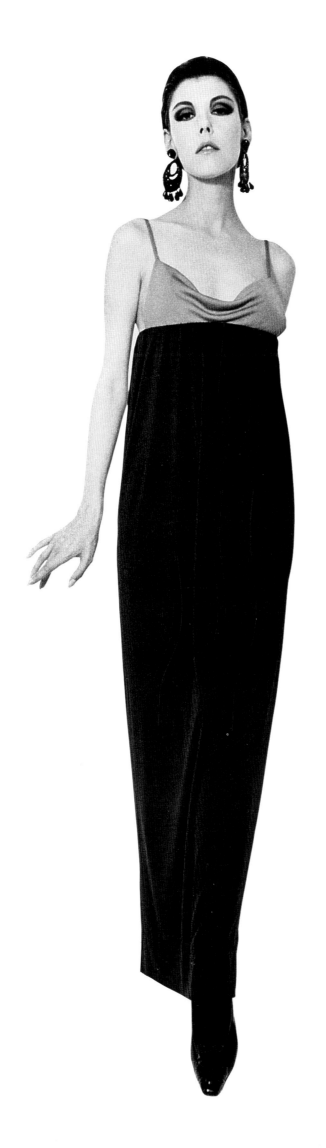

Fall 1964, left, poison green and
chocolate matte jersey evening dress;
right, black ciré pantsuit with black
lacquered chiffon "see-through" shirt.

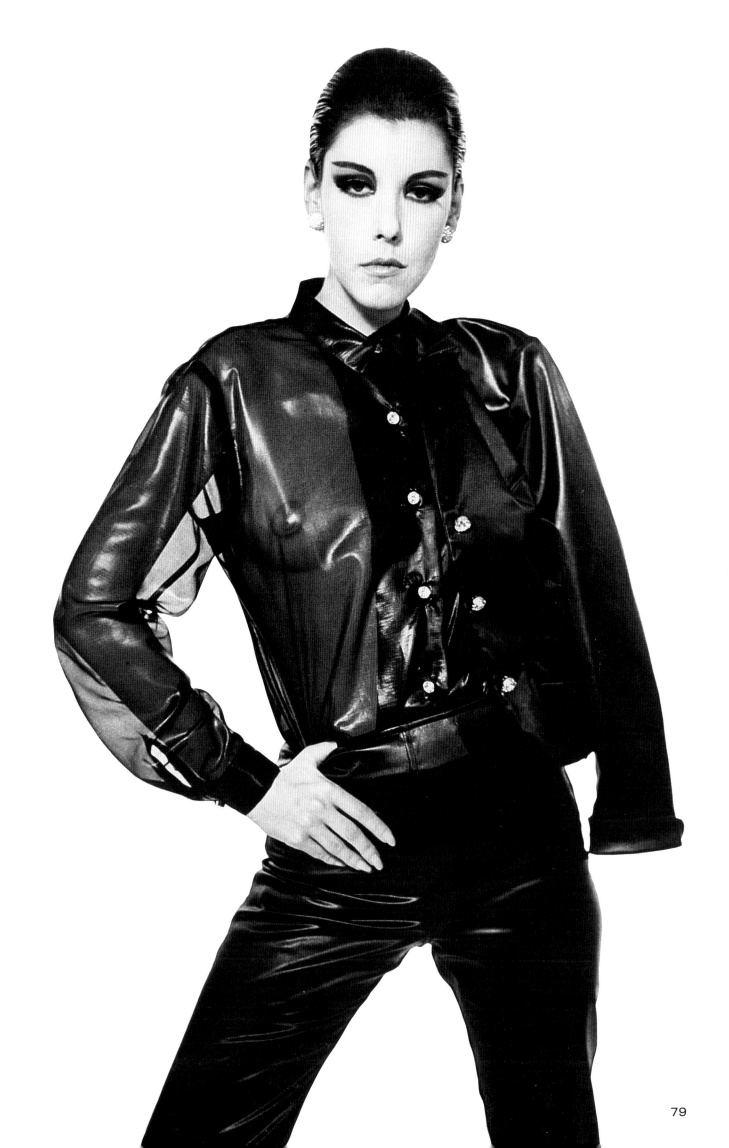

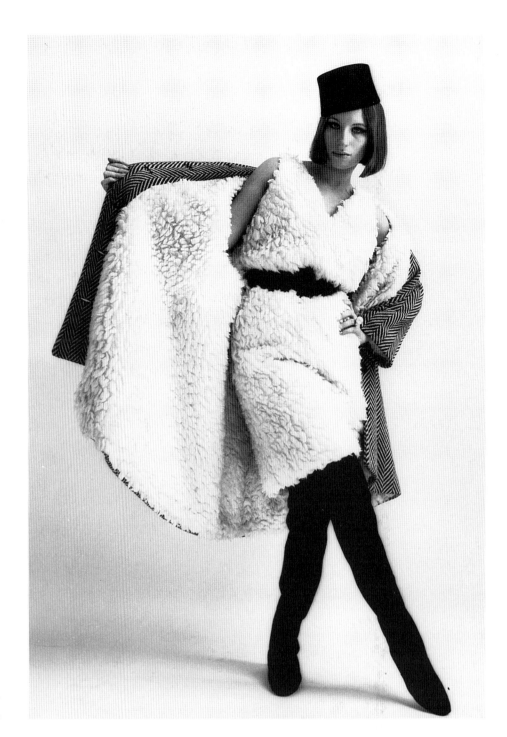

Fall 1964, from Barbra Streisand's
first fashion shooting, which appeared
as a cover story in SHOW magazine;
above, black-and-white herringbone
tweed coat, lined in imitation lamb's
fleece with fleece dress; below, Rudi
with Barbra in a reversible camel's hair
outfit; right, with black coq feather hat.

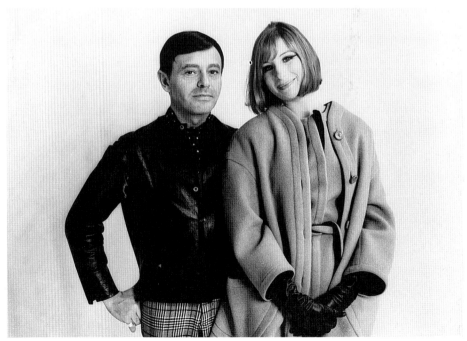

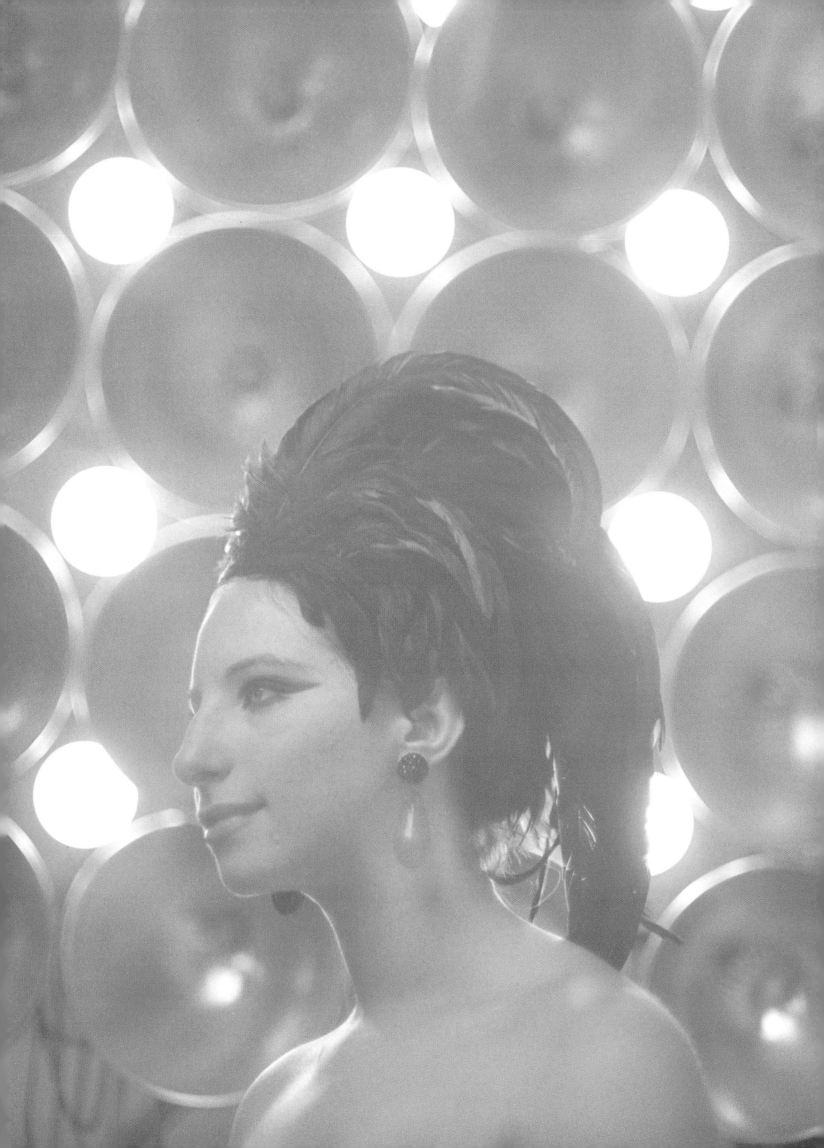

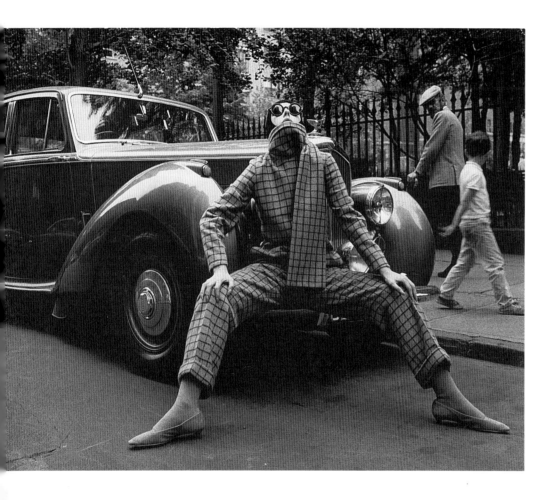

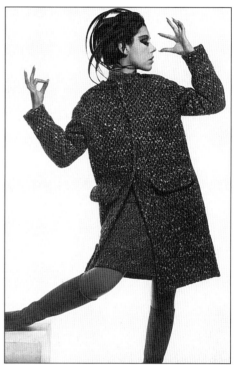

Fall 1964, above, giant tweed coat with smaller tweed dress and feathered hat (photograph © David Bailey, author's collection); in the manner of a Lartigue photograph, left, camel's hair aviator jumpsuit and, right, black print chiffon cocktail shift and matching veil. (photographs © Jerry Schatzberg, author's collection)

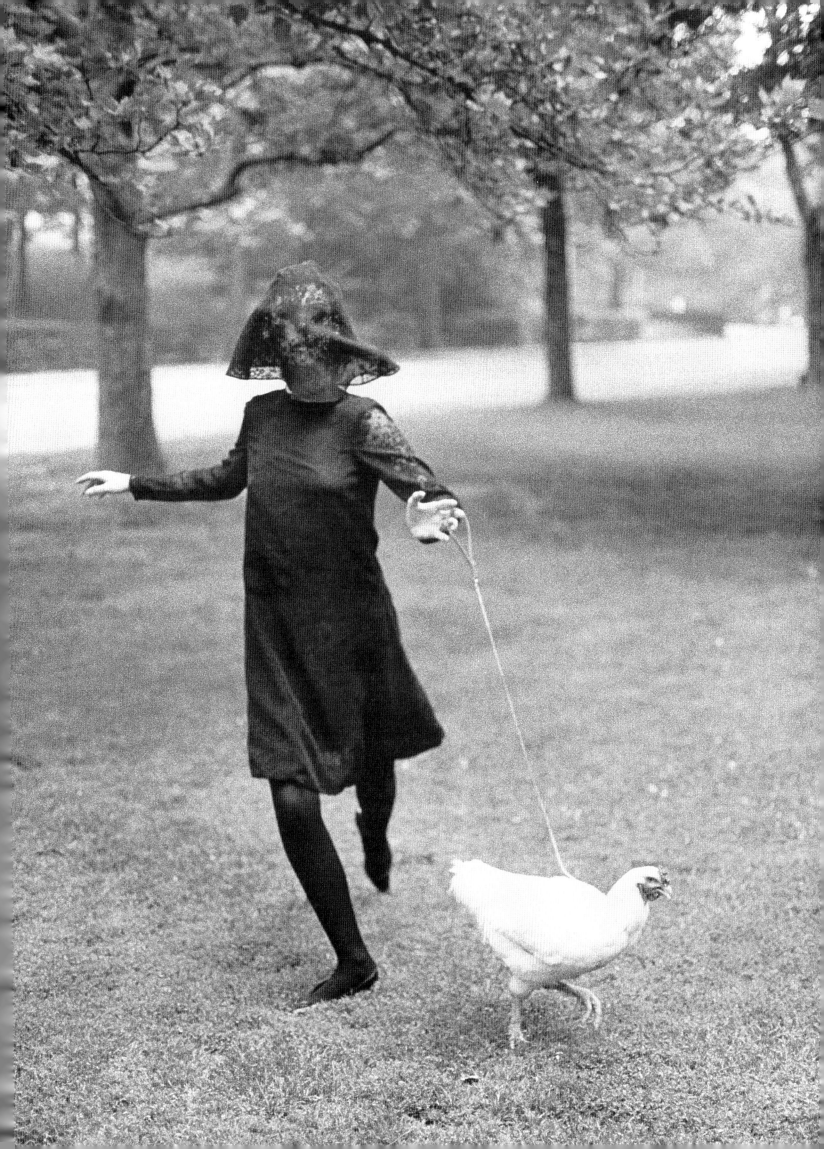

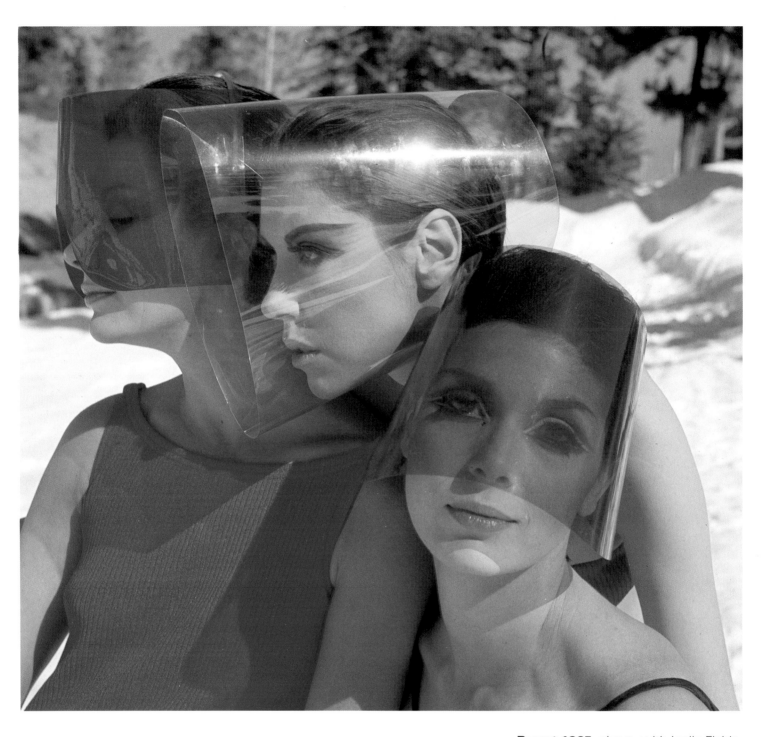

Resort 1965, above, with Lydia Fields and Léon Bing wearing sun visors made by Layne Nielson; right, wool-knit tank swimsuit with vinyl hip boots and sun visor. Boots are by Capezio, as were all the boots and shoes used with Rudi's designs.

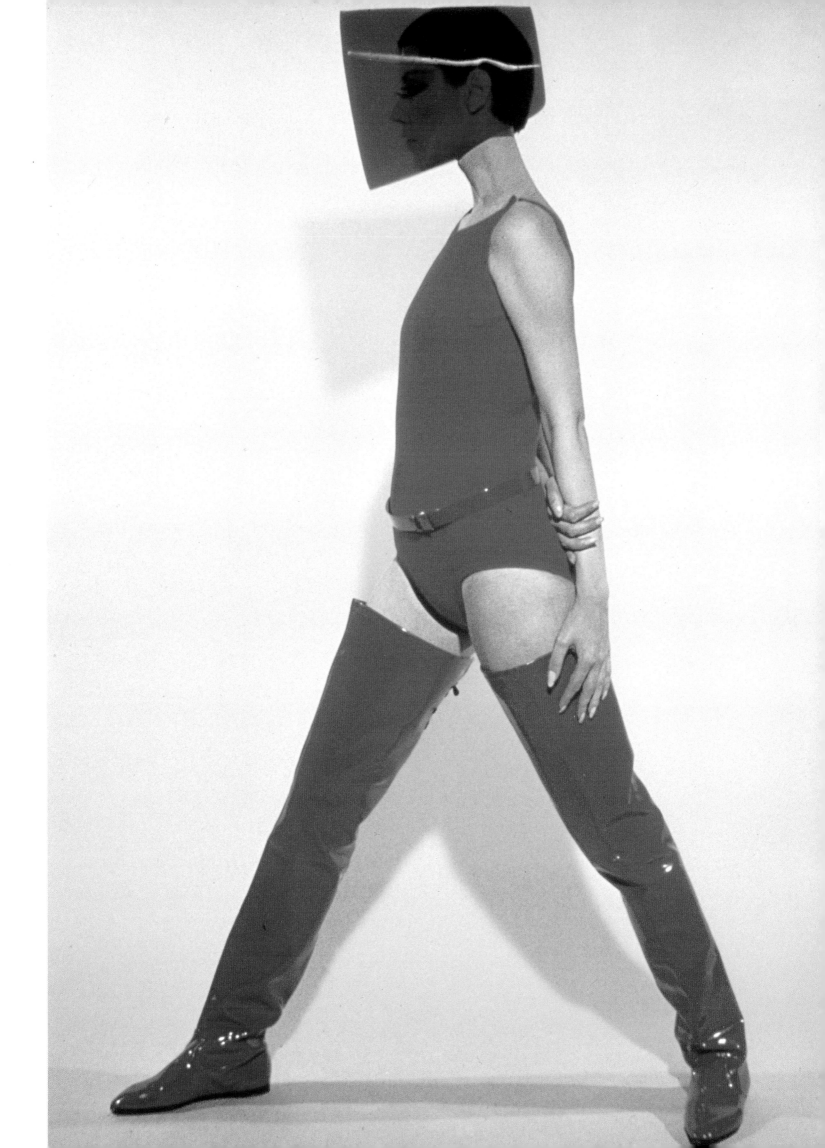

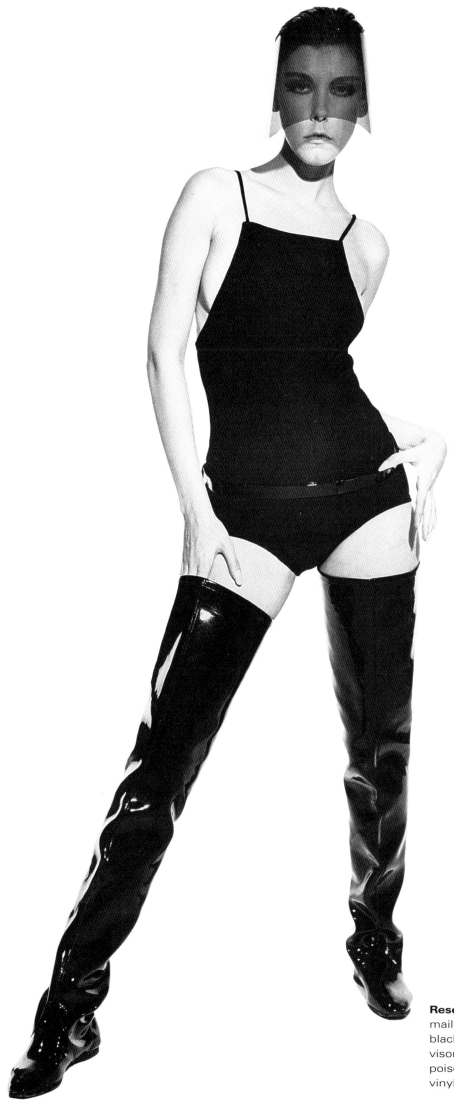

Resort 1965, left, black wool-knit maillot with black patent leather belt, black vinyl hip boots, and purple sun visor; right, ochre wool-knit bikini with poison green vinyl hip boots, orange vinyl belt, and yellow sun visor.

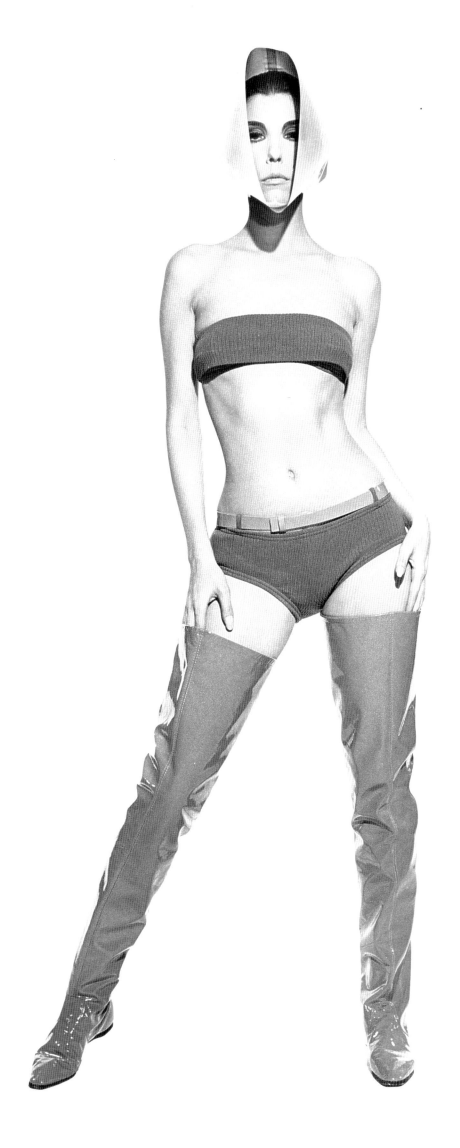

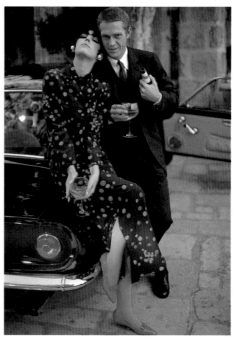

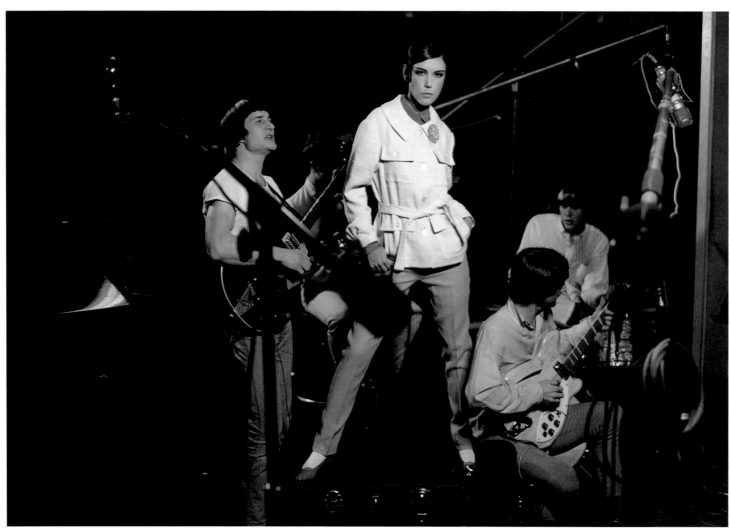

Resort 1965, above left, chiffon "Klimt" cocktail dresses photographed at Brooke Hayward and Dennis Hopper's home, with television producer Bert Berman, art dealer Irving Blum, and painter Billy Al Bengston. On the floor are Brooke's son and Dennis Hopper; above right, silk "little boy" suit photographed with Steve McQueen; center, linen safari jacket and pants and silk shirt photographed with the Byrds; right, silk "Kandinsky" prints photographed at La Scala restaurant in Los Angeles with owner Jean Leon.

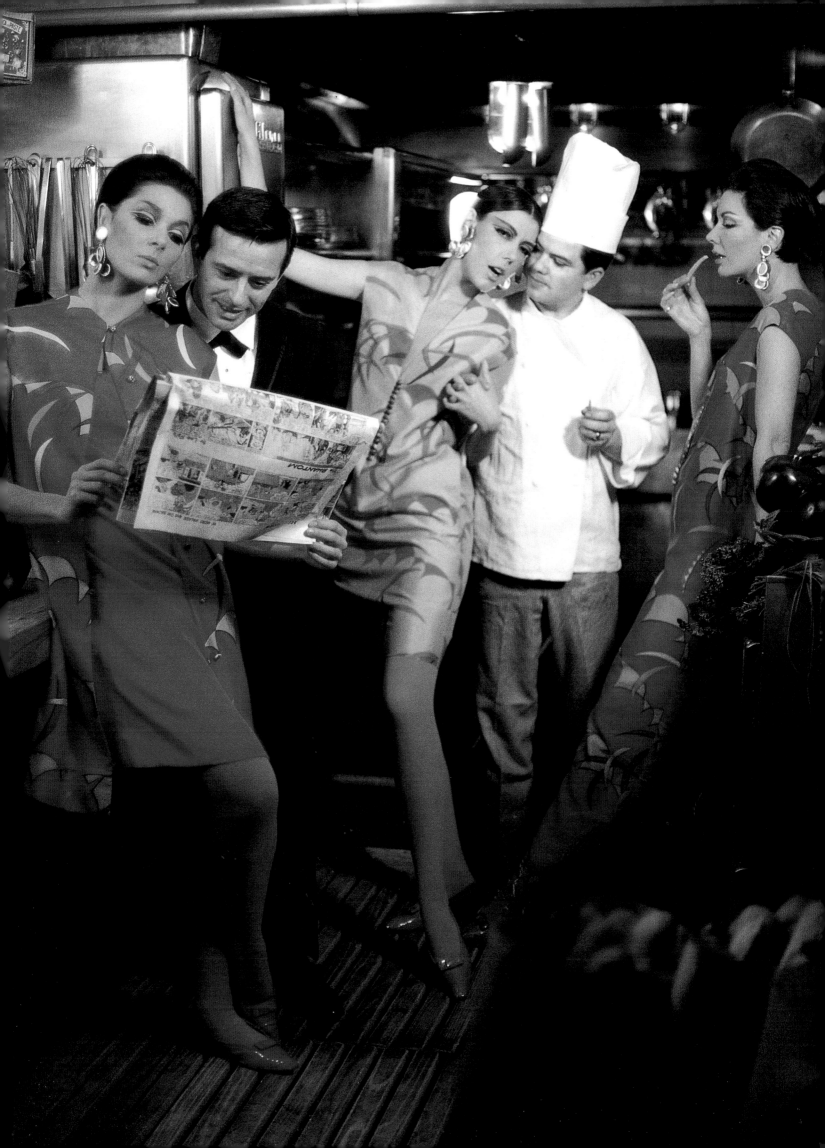

The Total Look

In the early 1960s, I kept meeting Rudi at parties and events. I admired him immensely and one night told him so. But I did have one reservation—I thought his clothes, which to me were so witty and amusing—were presented without much humor. There was at the time an image of the "Ideal American Woman" that was all about money, country clubs, and Wonder Bread. I saw European tongue-in-cheek and Oriental purity of design in Rudi's work.

One day Rudi called me, saying he was going to do a junior line and wanted me to fit for him. (He had thought I was too young for his regular line.) I started fitting for him, and since the junior clothes looked the same as his regular line, we started working together on everything.

We clicked instantly. We thought alike and tossed ideas back and forth. What bothered me the most about what he was doing at the start of our working together was a certain "artsy-craftsiness" about his presentation. He really didn't care if a beautiful, innovative tweed suit was shown barefoot, or if a perfect silk dress had an uneven hemline. I did, and I told him that a pair of shoes (maybe even one that fit) would make all the difference. Rudi took that comment to heart and soon the "Total Look" was invented, which matched the dress to the underpants to the stockings to the hat. Anyone else would have just given me a pair of shoes that fit.

Resort 1965, lime, turquoise, aqua, pink, yellow, and apricot chiffon "Gauguin" top and pants. The pants were cut like blue jeans.

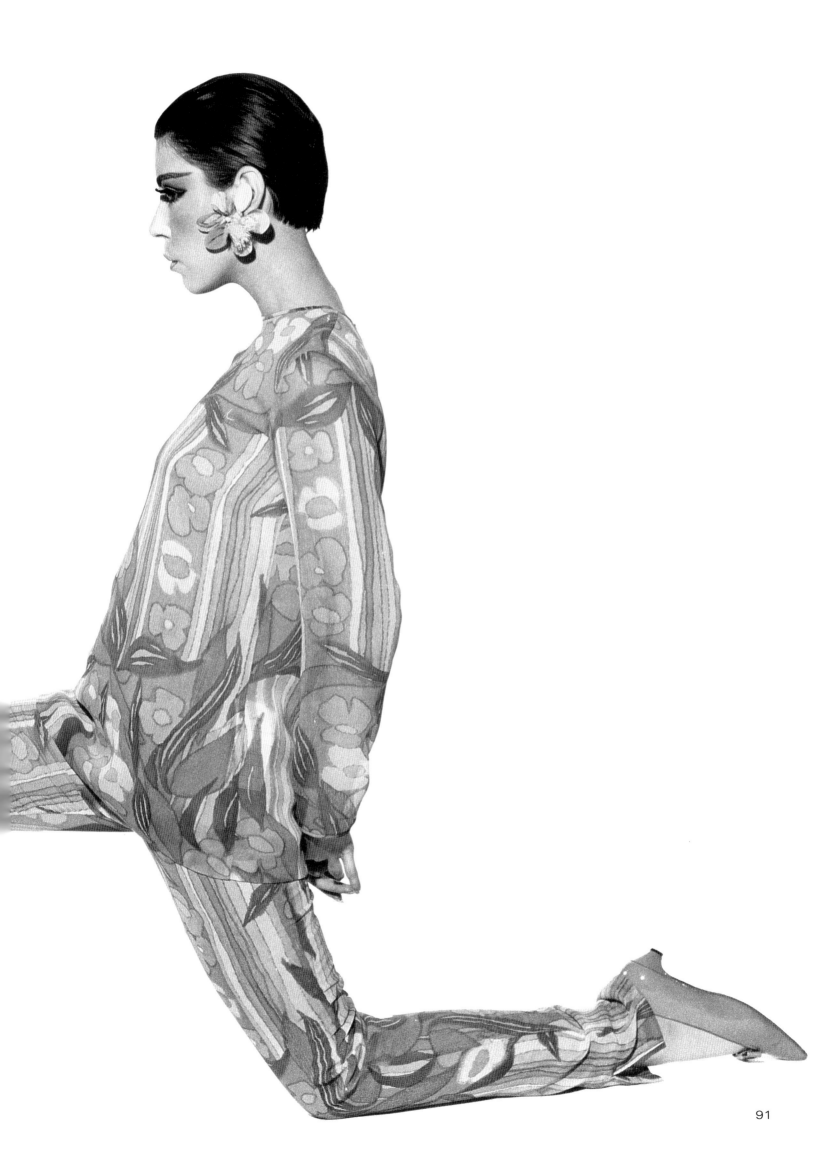

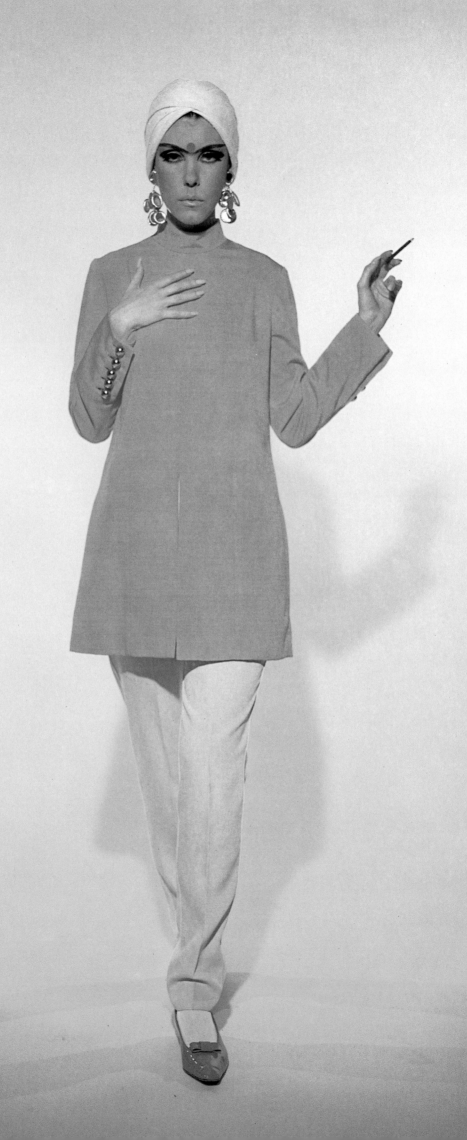

Resort 1965, Rudi finally got to do his Indians; left, orange linen tunic with pink linen pants (photograph © William Claxton); right, saffron silk Nehru jacket; above, mirrored earrings by Layne Nielson. (photographs © Peter James Samerjan)

Summer 1965, unitards with extra-long sleeves and legs made in brightly colored matte jersey. Insets show black-and-white crepe tops lined in color worn over unitards.

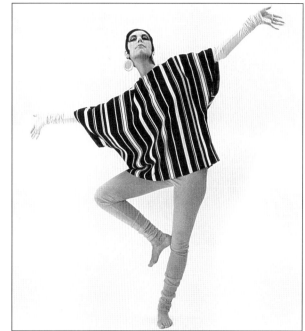

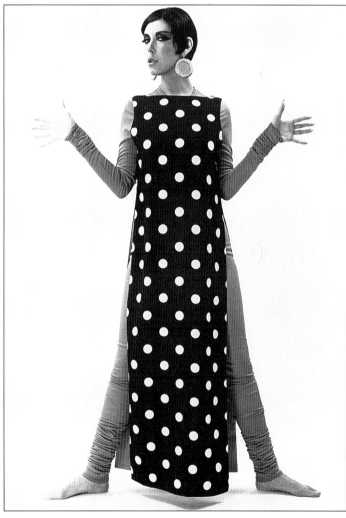

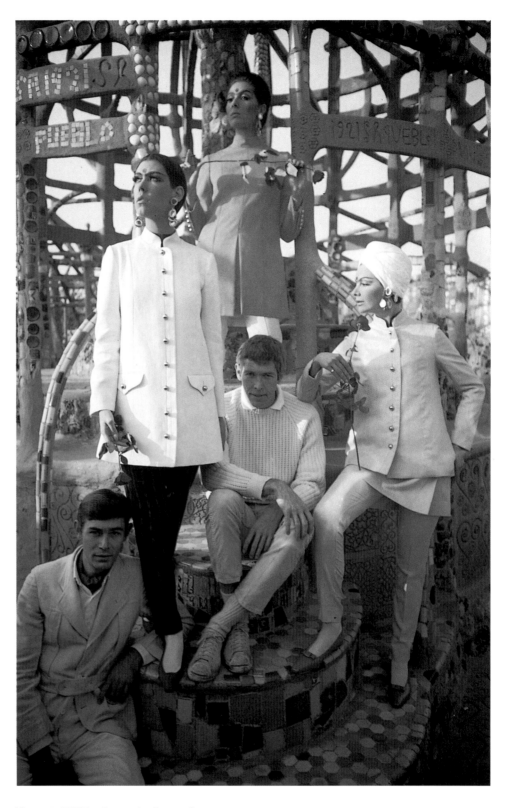

Resort 1965, above, Indian suits photographed at Watts Towers in Los Angeles. The pink suit had a skirt worn over pants. Actor James Coburn is in the center and Layne Nielson is at the lower left (Layne executed all of Rudi's accessories for many years beginning in 1965); right, with Lydia Fields and Léon Bing wearing the caste marks I made out of matchbooks that became the inspiration for the decals Rudi made later on.

1965, overleaf, the "No Bra" bra advertisement. (Photographs © Richard Avedon, courtesy Exquisite Form)

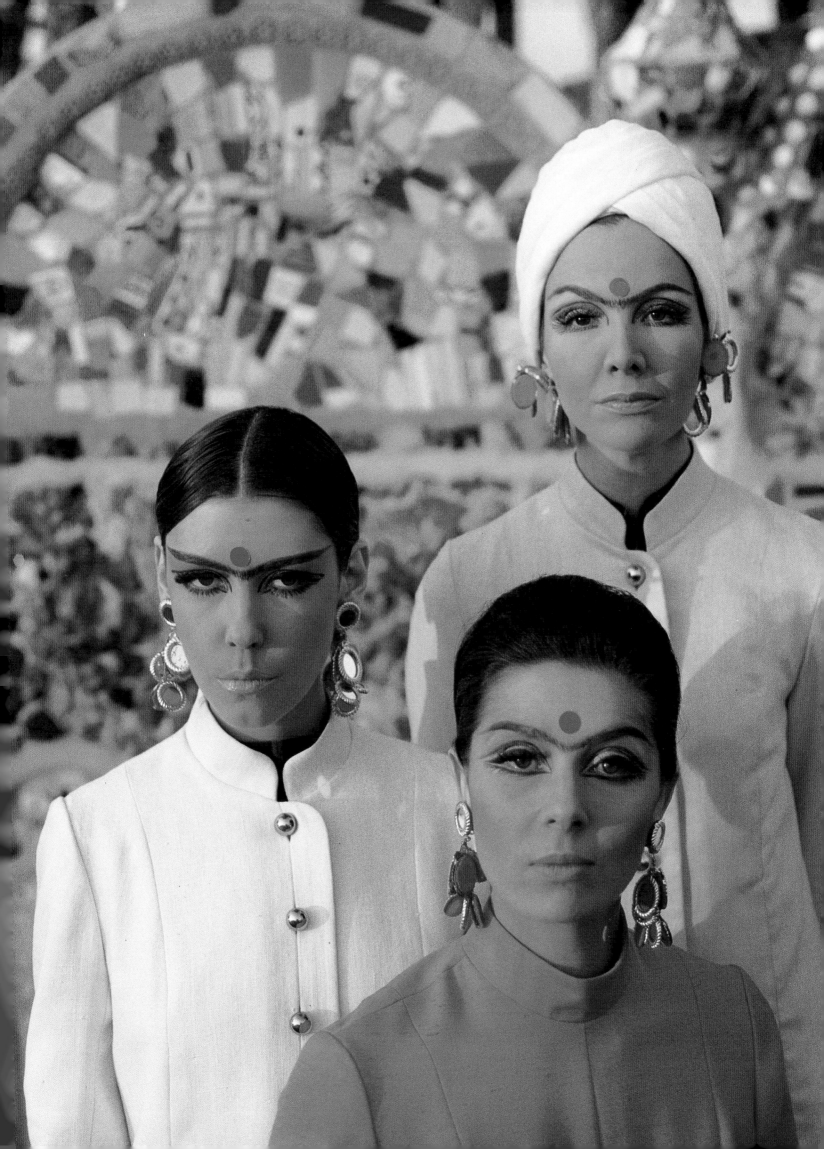

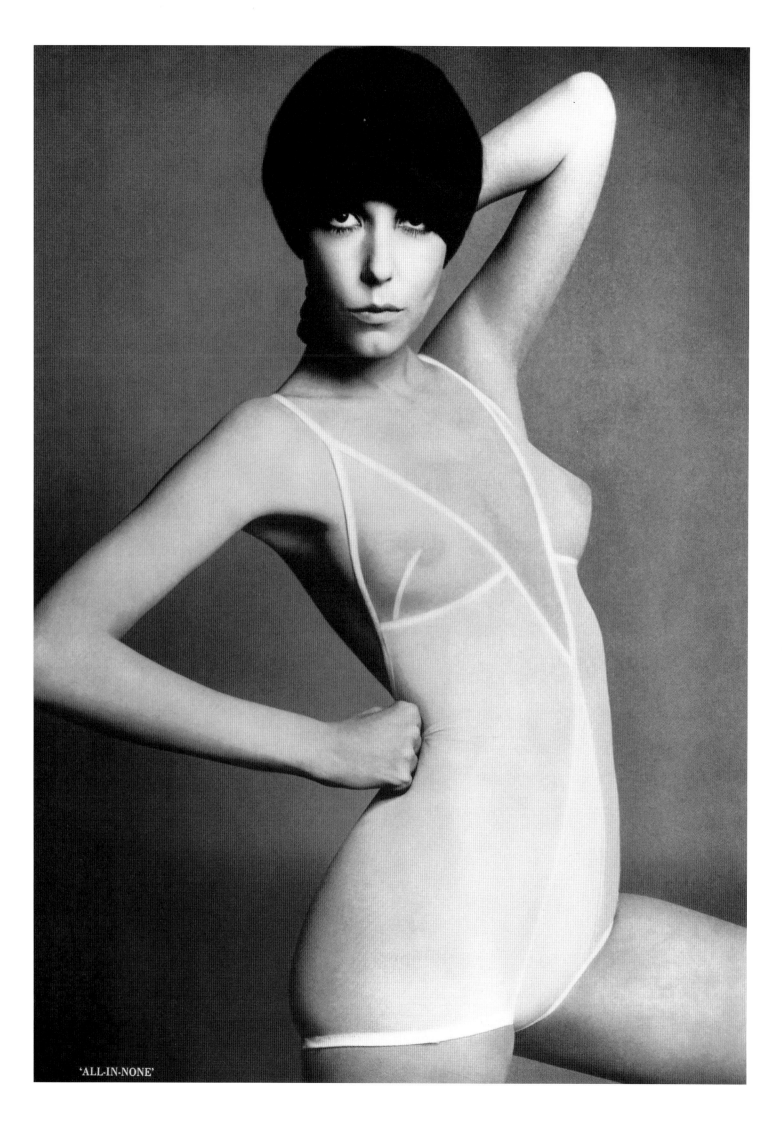

'ALL·IN·NONE'

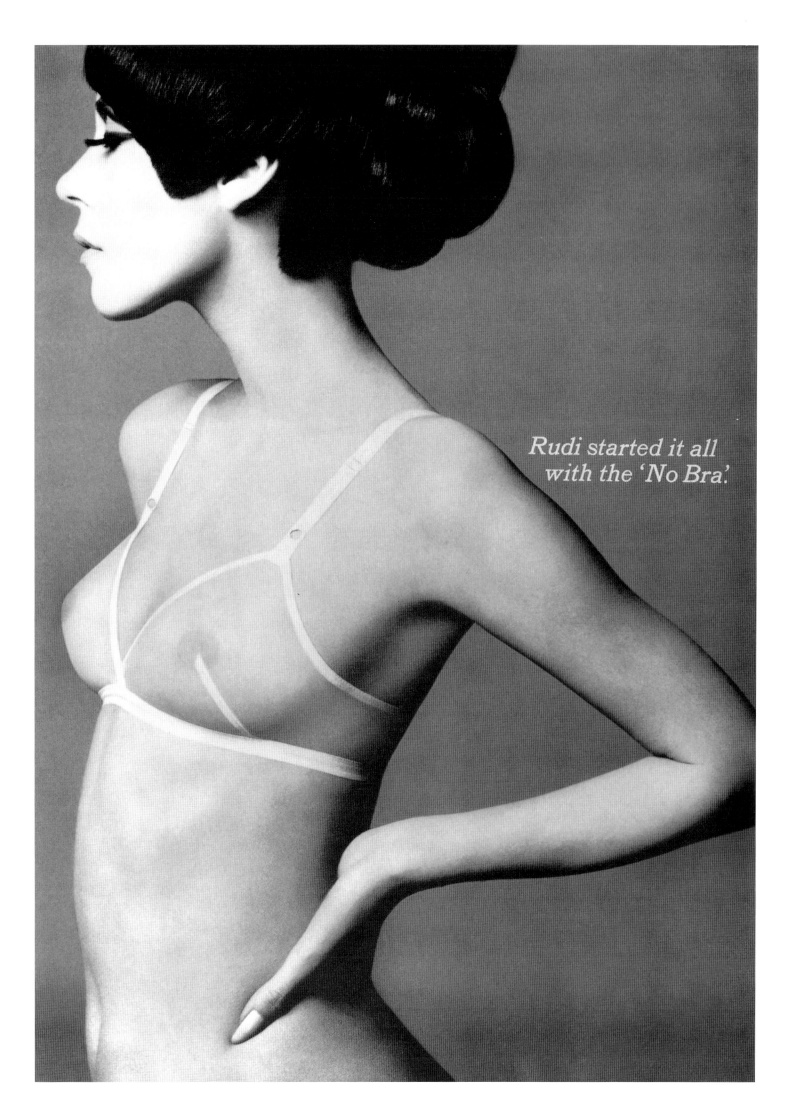

Rudi started it all with the 'No Bra'.

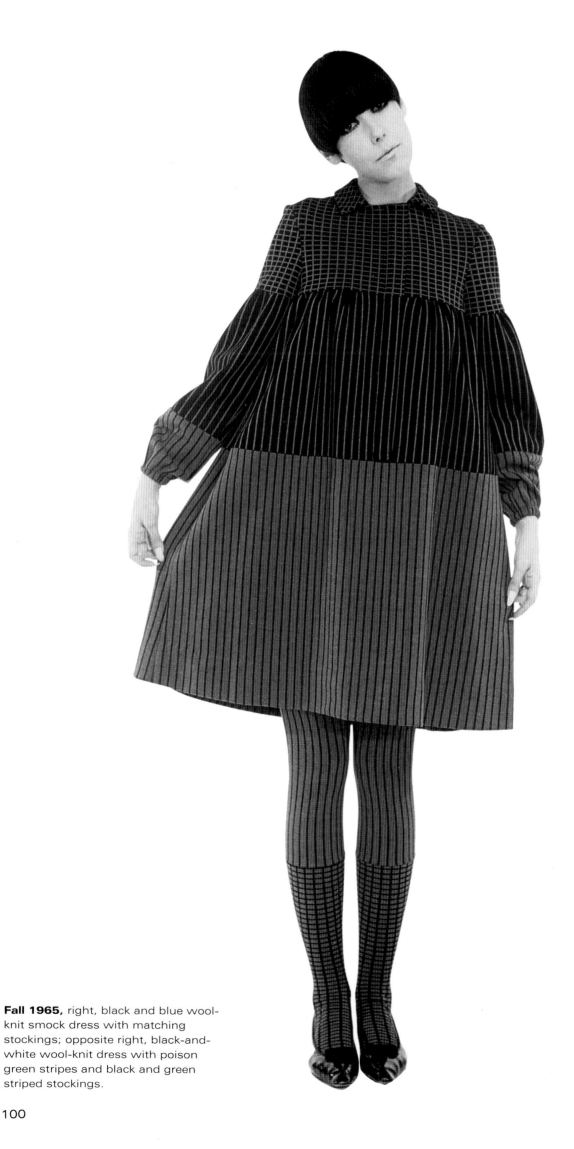

Fall 1965, right, black and blue wool-knit smock dress with matching stockings; opposite right, black-and-white wool-knit dress with poison green stripes and black and green striped stockings.

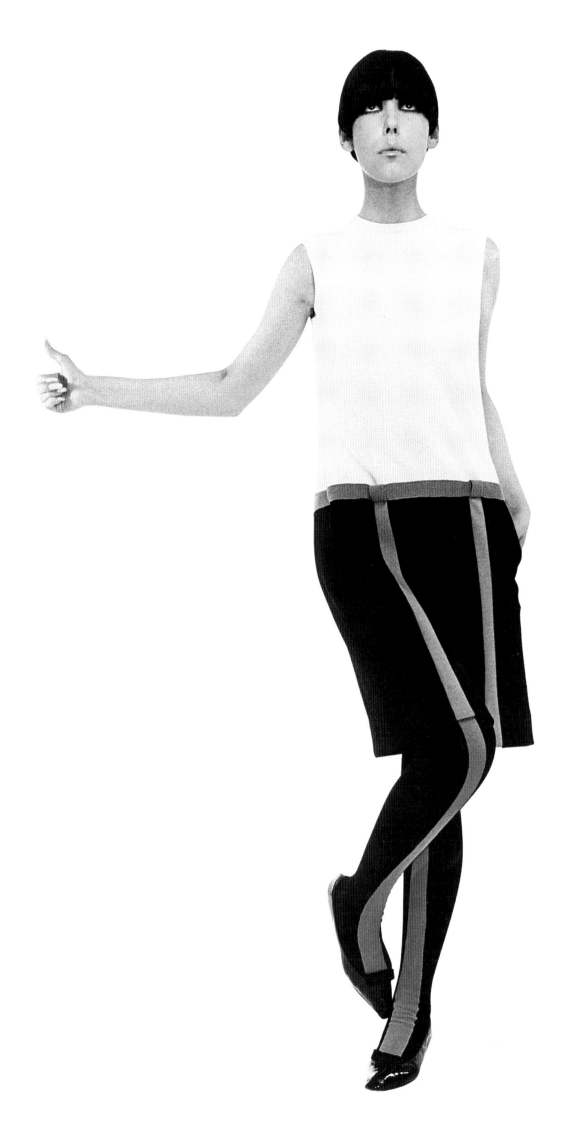

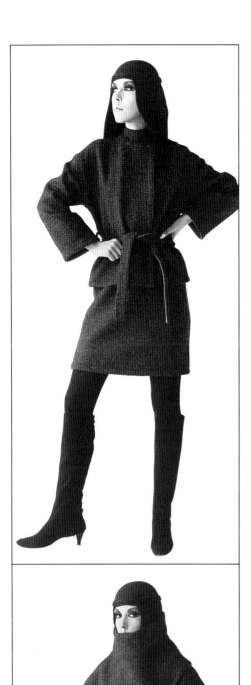

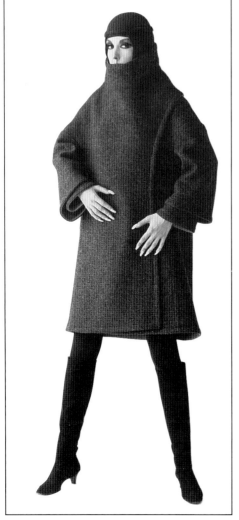

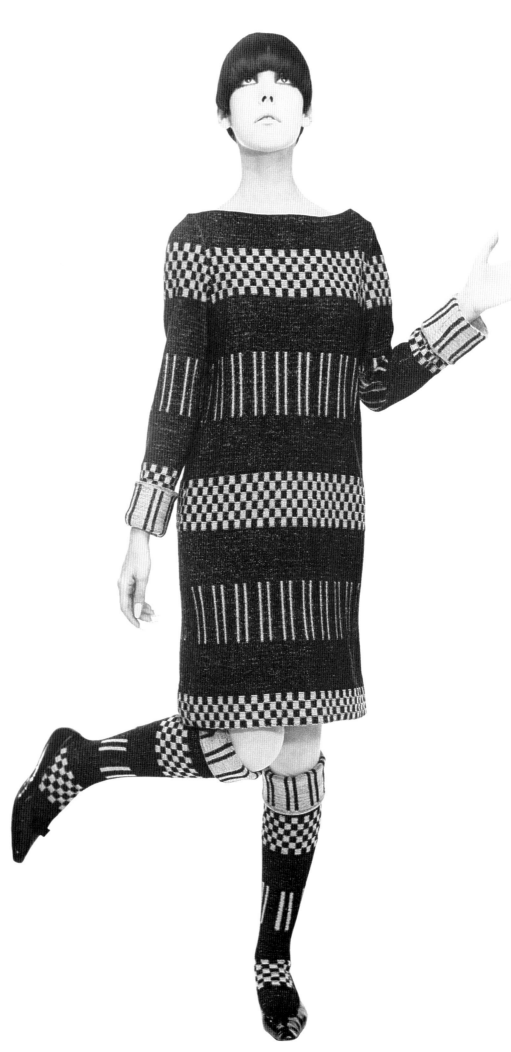

102

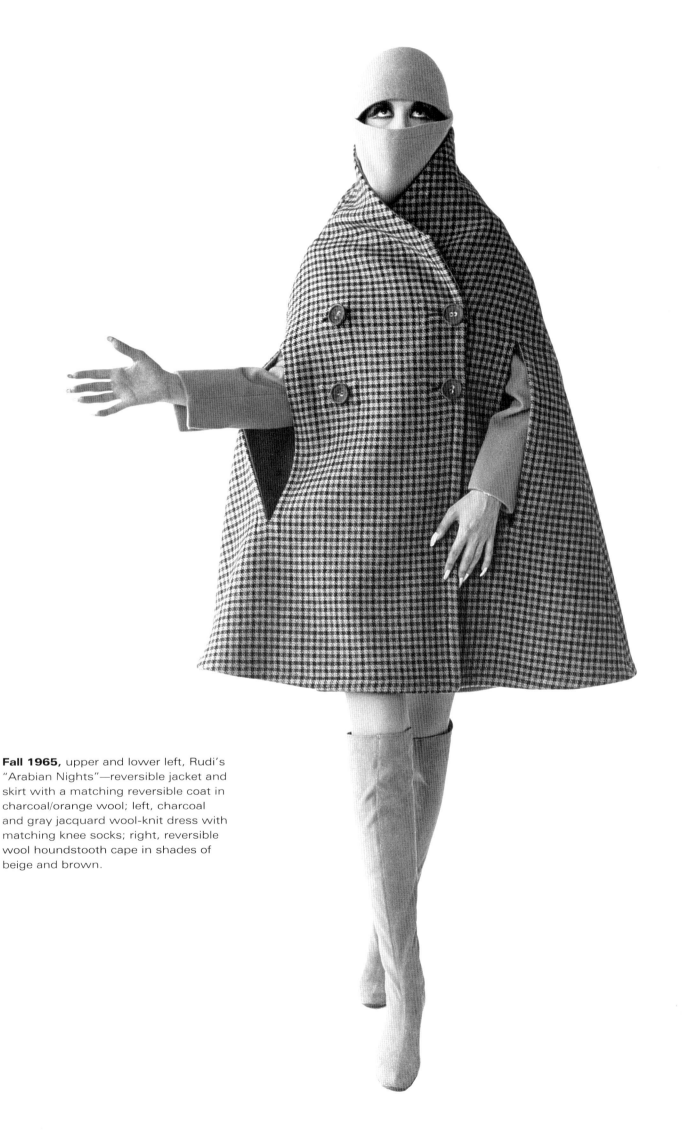

Fall 1965, upper and lower left, Rudi's "Arabian Nights"—reversible jacket and skirt with a matching reversible coat in charcoal/orange wool; left, charcoal and gray jacquard wool-knit dress with matching knee socks; right, reversible wool houndstooth cape in shades of beige and brown.

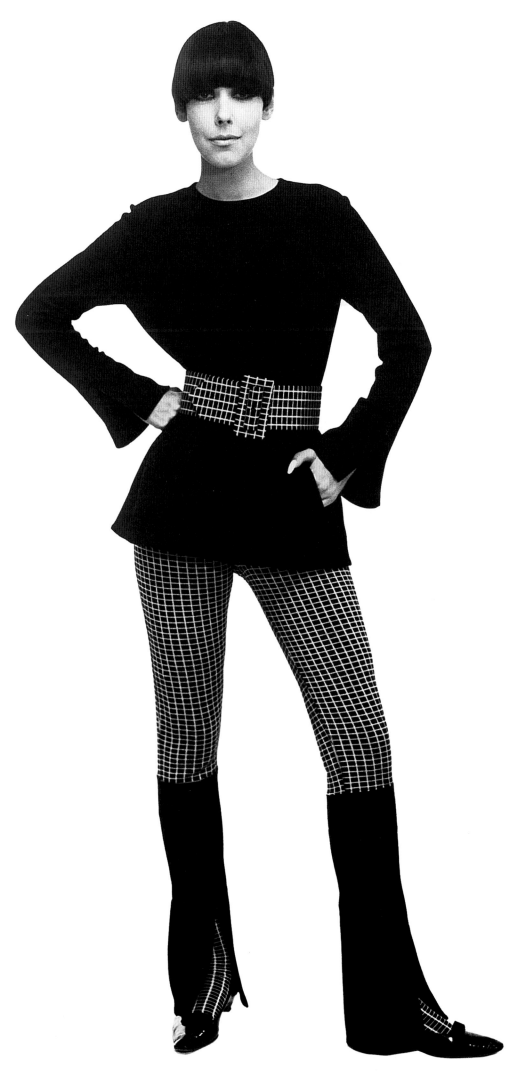

Buttons and Bows

Most fashion designers are really what I call dressmakers. The good ones can make beautiful and intricate dresses that have a little curve here, a big swag there, a silk camellia at the neck, and it's quite a lot like making expensive lampshades. The dresses they make are exact and specific to the time, fabric, age, and wealth of the woman and materials at hand. These dressmakers produce what is called fashion. What they manufacture cannot be translated into other fabrics and retain its integrity without sacrificing the intrinsic quality of the garment. Think of a beautiful taffeta ballgown printed with cabbage roses. Now imagine it in Harris tweed. It just doesn't work.

Design, however, is a different matter. If the design is valid, pure, and functional, it can be interpreted in different materials and be used again and again. Fashion becomes dated, good design does not. Fashion creates problems, design solves them.

The three-tiered dress at right is the same design as the one on page 45. There it is shown in beige, brown, and black chiffon. It was like wearing a cloud. Here it is in multipatterned wool knit. It looked and felt completely different. It had the eccentric look and the swing of the sixties (the era it reflected). Because it is pure design, it could be made in dozens of different fabrics and lengths and always look right and contemporary. This was the most important element of Rudi's talent. His designs could be reinterpreted endlessly.

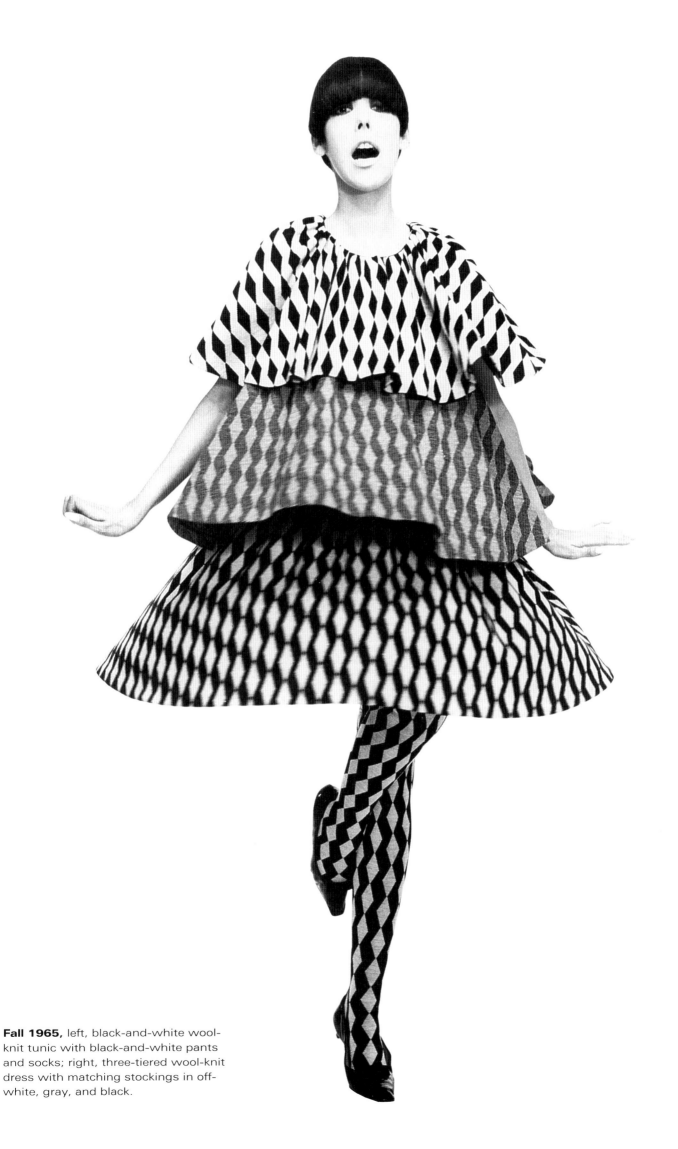

Fall 1965, left, black-and-white wool-knit tunic with black-and-white pants and socks; right, three-tiered wool-knit dress with matching stockings in off-white, gray, and black.

105

1965, above, aboard the QUEEN ELIZABETH, two sailors and a "baby" dress.

1965, right, swimsuit, lavender wool-knit top with red vinyl dots, and lavender bikini with detachable red vinyl garters and off-white fishnet stockings.

1965, London, pages 107–110, the swimsuits shown at the LONDON SUNDAY TIMES Awards fashion show. (Rudi made me carry them in my luggage because he was afraid if he carried them he would be stopped by customs and thrown in jail.)

"Babies"

It seems to me that all the truly great, classic shapes in women's fashion originated in men's clothes. From togas, sarongs, kilts, and monk's robes to shirtdresses and trench coats, everything started with men except the Empire dress, which is beautiful and completely feminine. Rudi made hundreds of these, and we called them "baby" dresses.

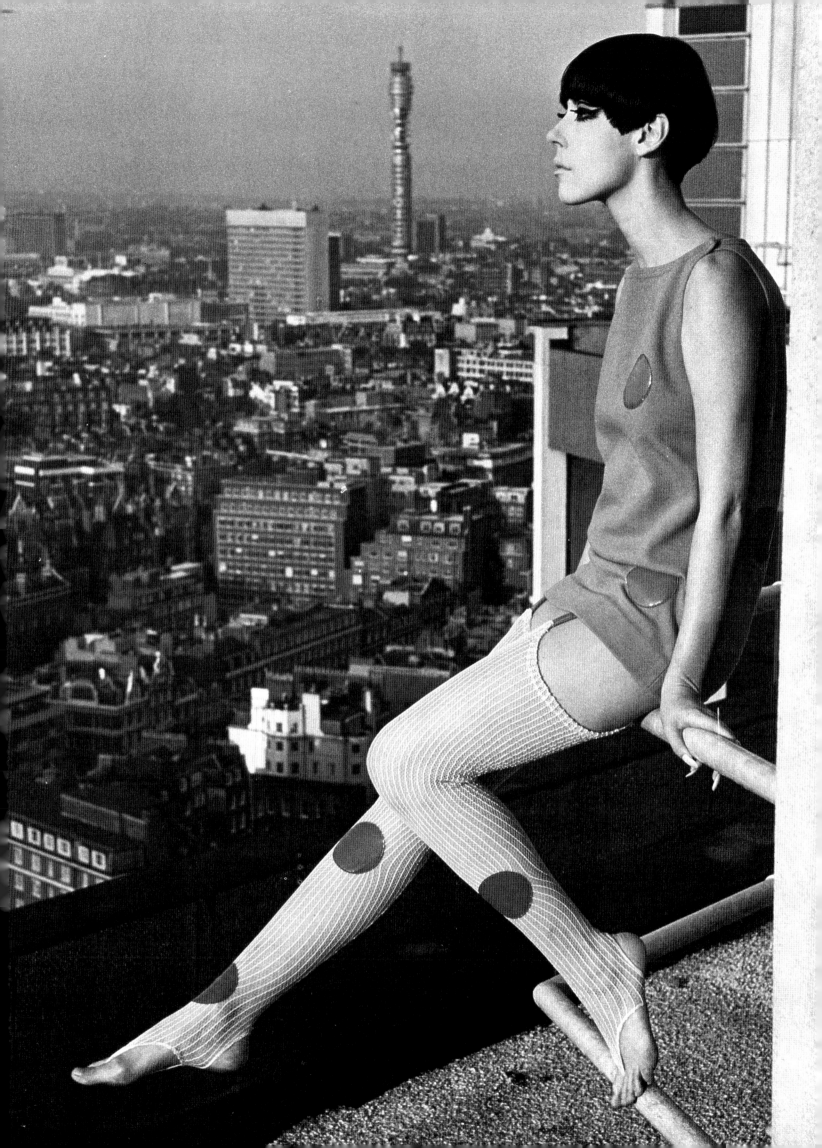

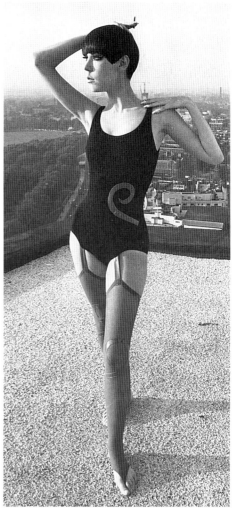

1965, upper and lower left, being tourists. (We were a wonderfully improbable trio as we walked around London: Bill is 6'5", Rudi was about 5'6", and I was in the middle with red eye shadow.)

1965, above, black wool-knit maillot with detachable red vinyl garters, red fishnet stockings, and red vinyl appliqués; right, synthetic knit gingham—blue and white top with pink and white bikini and sash.

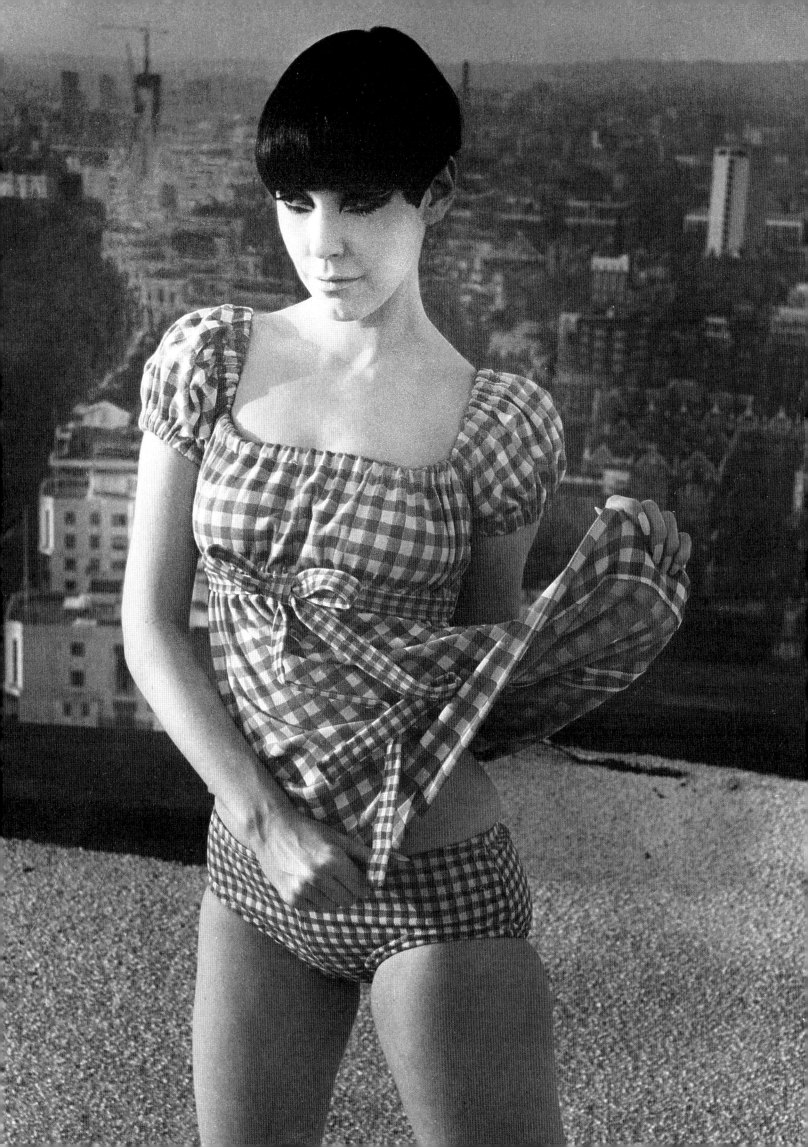

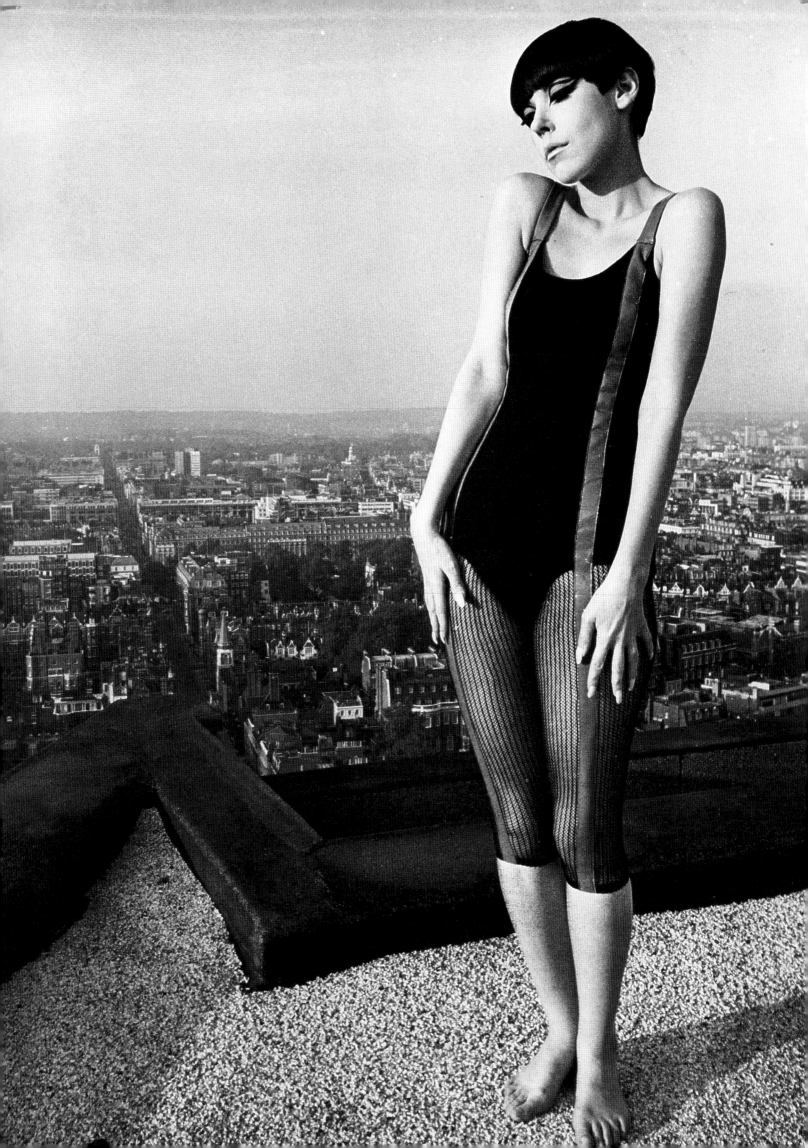

1965, Paris, above, Bill pays me a surprise visit in our more than modest hotel bathroom; right, being interviewed in Rudi's grander digs at the Hôtel de Crillon; overleaf, being photographed by Jeanloup Sieff.

1965, left, black wool-knit maillot with attached black fishnet stockings and red vinyl suspender stripes.

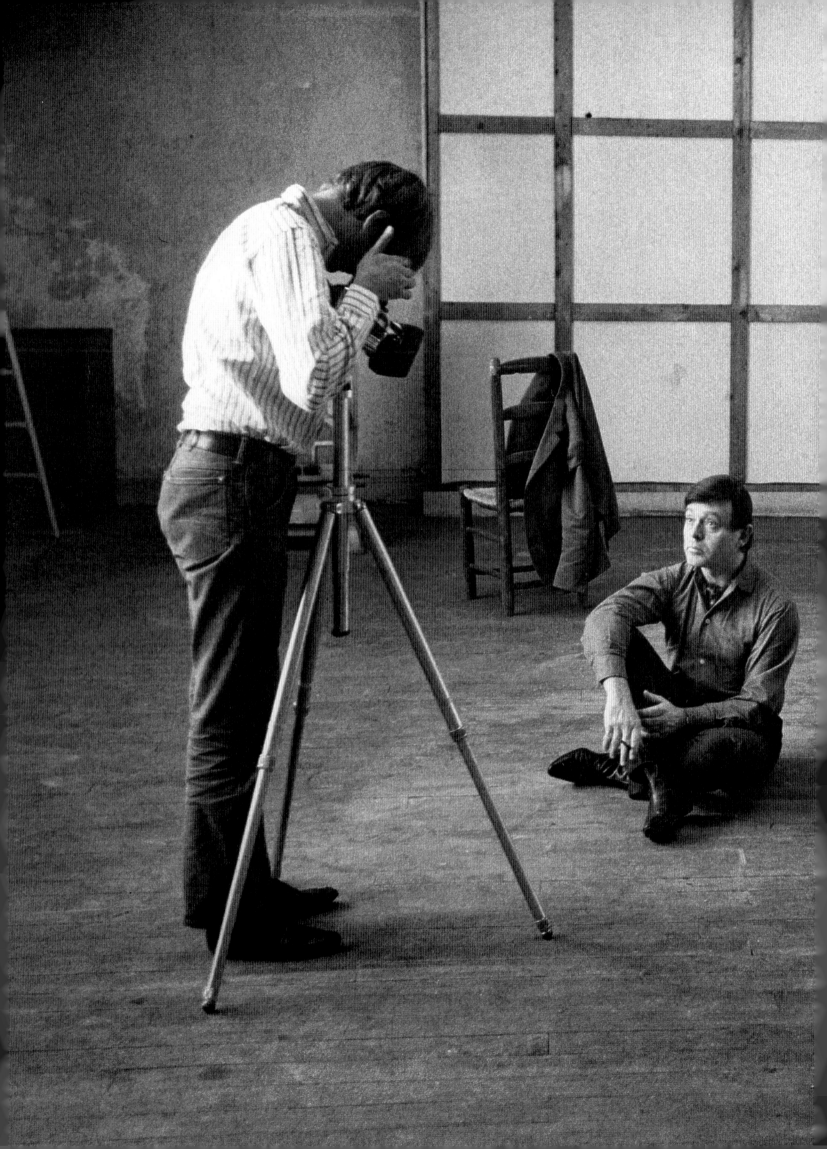

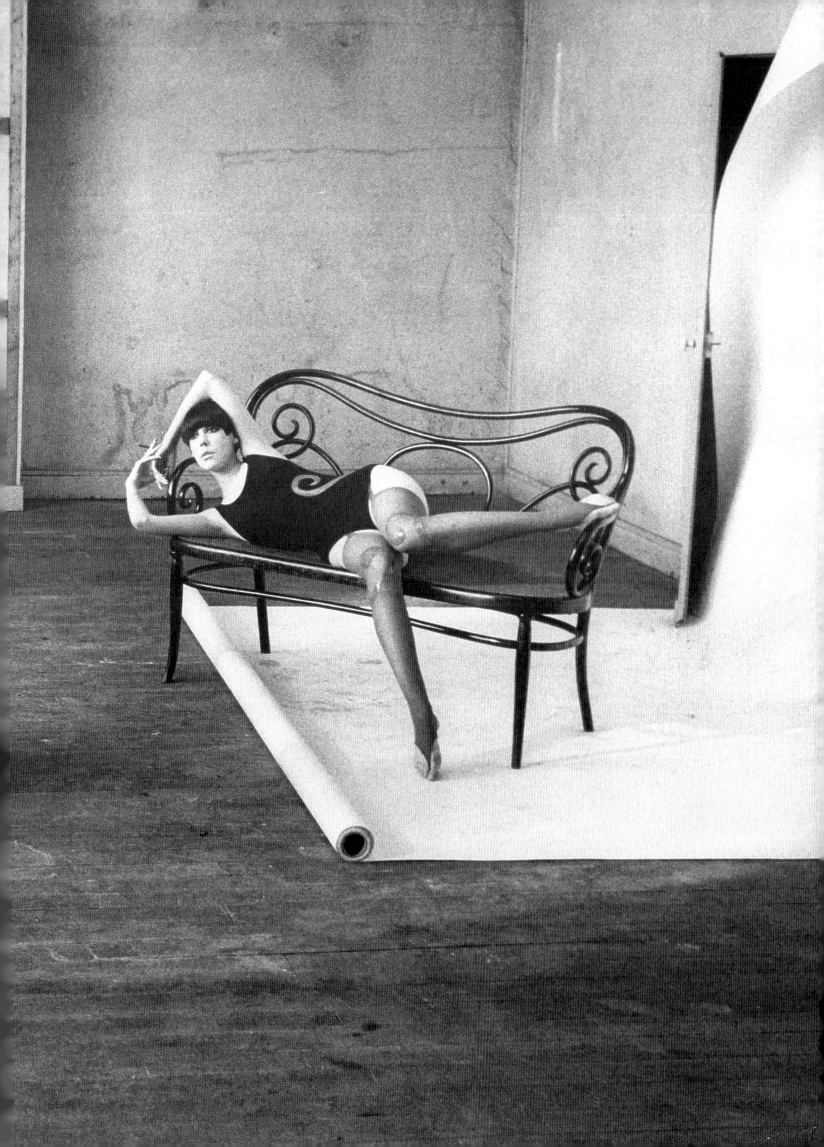

1966, London, pages 114–119, Bill and I shot a story for QUEEN magazine on Rudi's resort collection using Tzaims Luksus's lingerie satin fabrics. Vidal Sassoon designed the hair; below and right, long print evening shift that can be tied with a bow on the head or worn as a cowl neck.

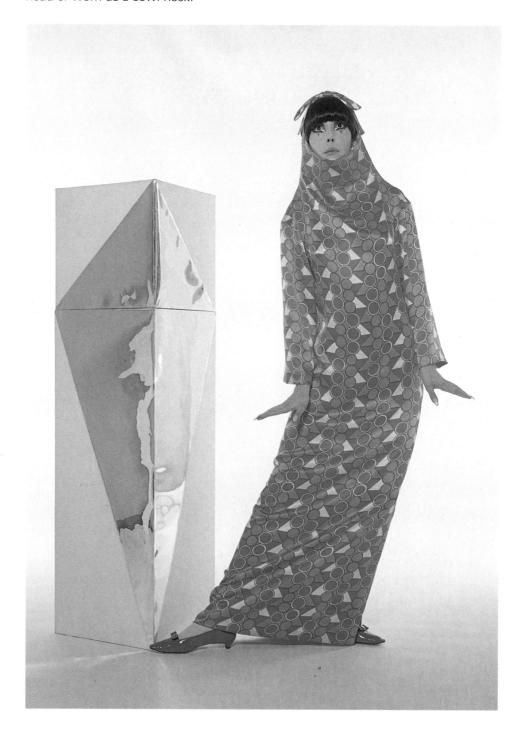

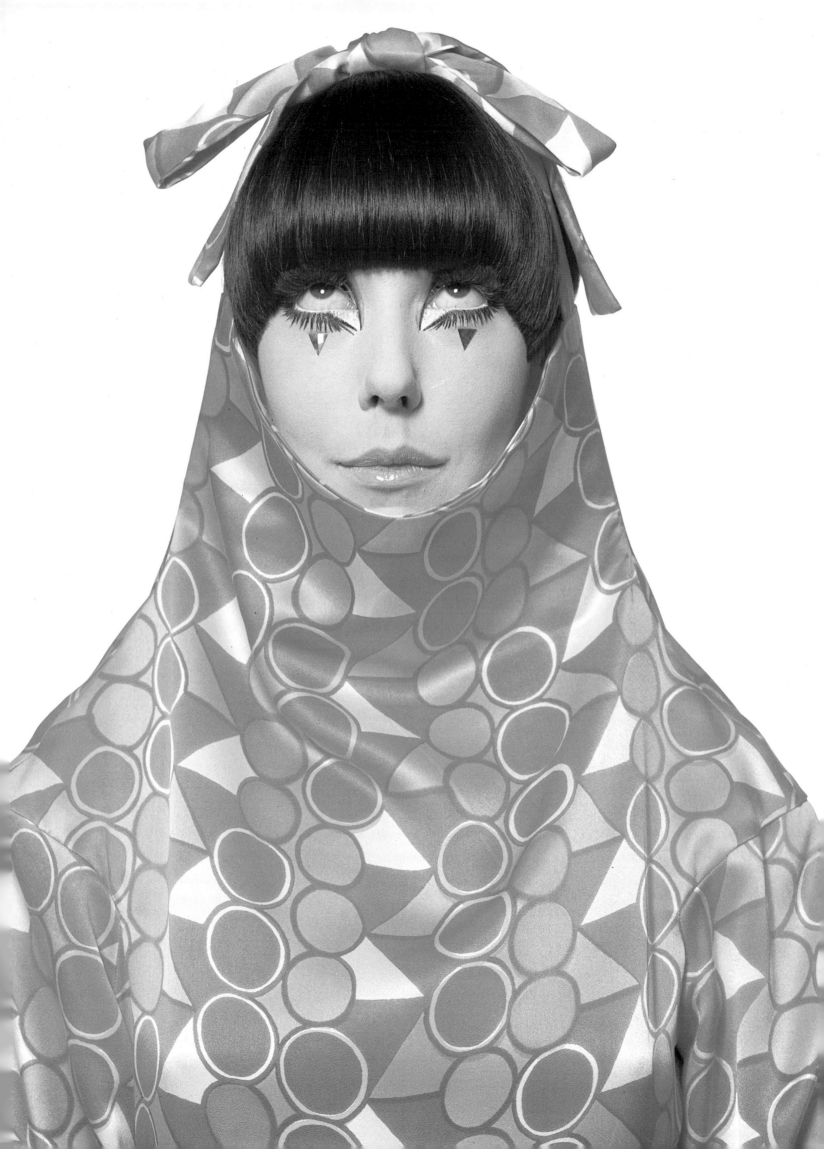

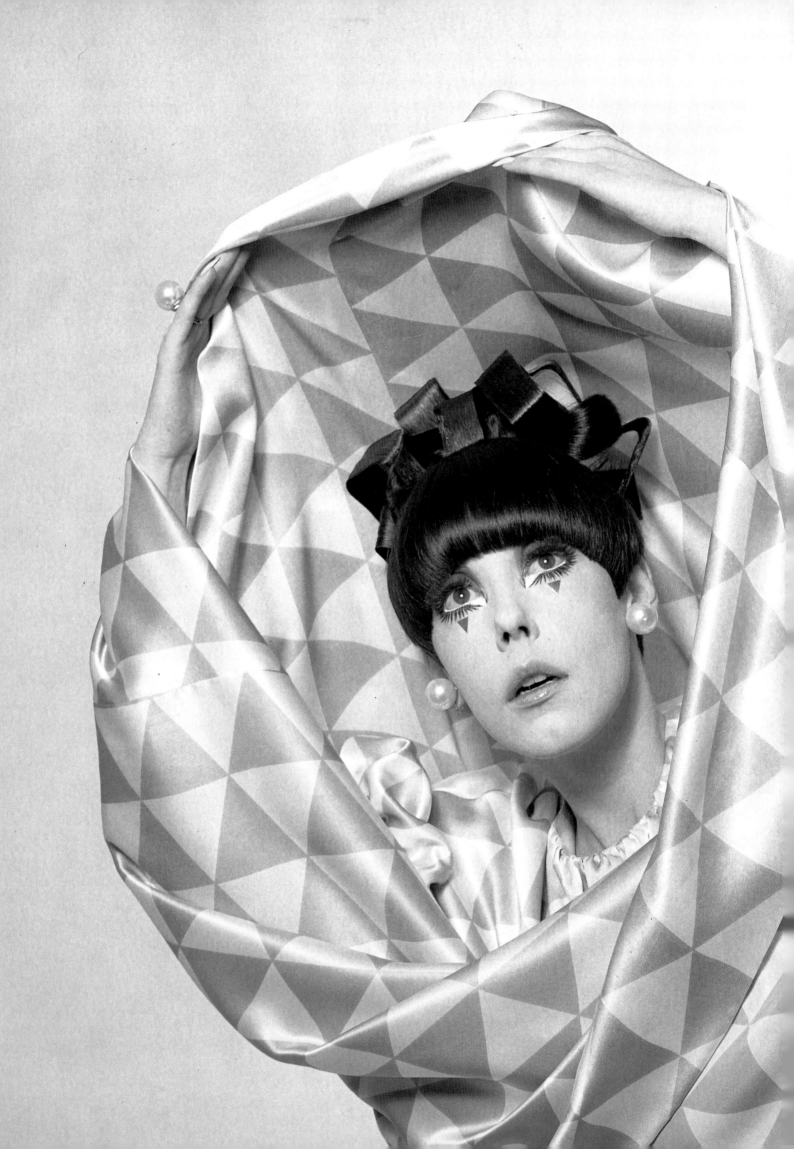

1966, left and below, silver and white triangle print empire evening dress; center, long orange and white "positive/negative" arrow print shirtdress.

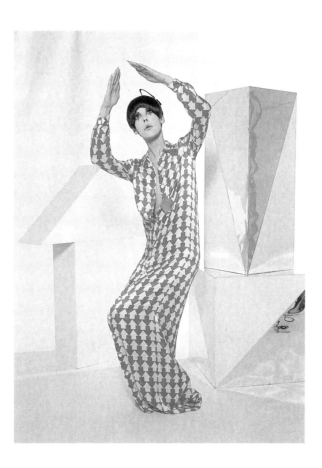

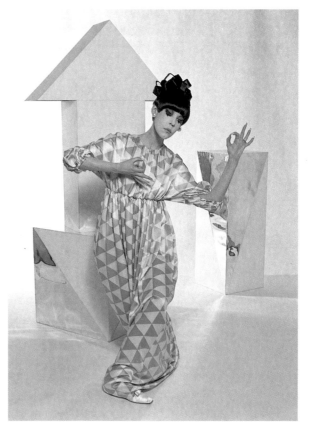

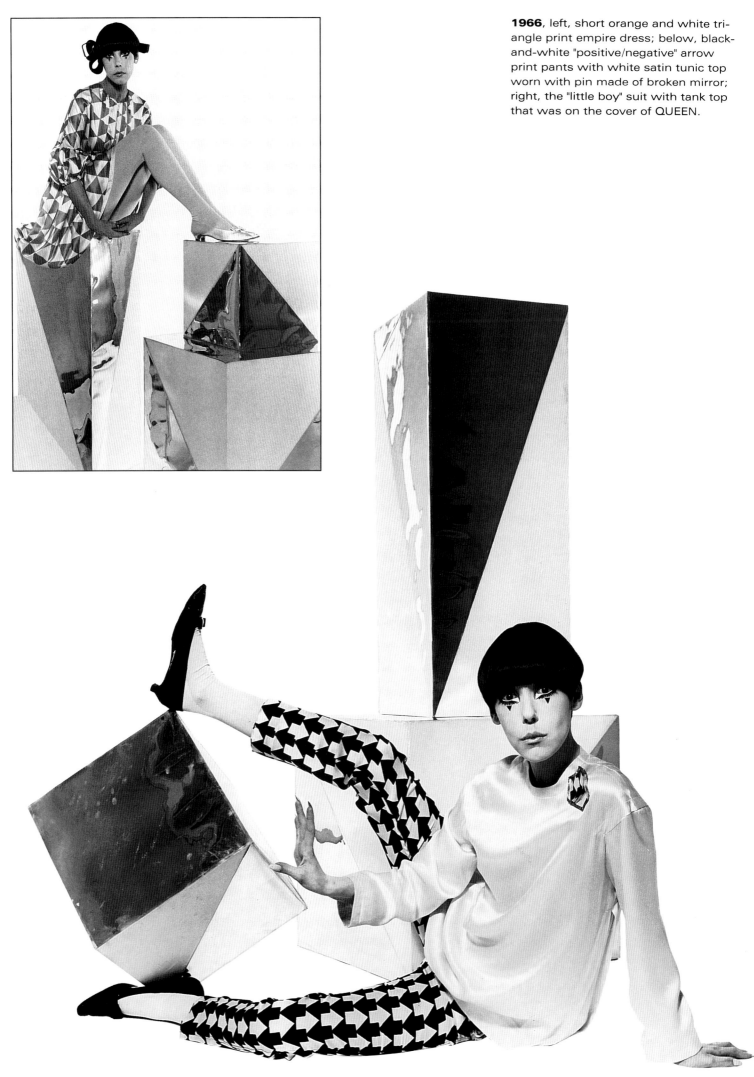

1966, left, short orange and white triangle print empire dress; below, black-and-white "positive/negative" arrow print pants with white satin tunic top worn with pin made of broken mirror; right, the "little boy" suit with tank top that was on the cover of QUEEN.

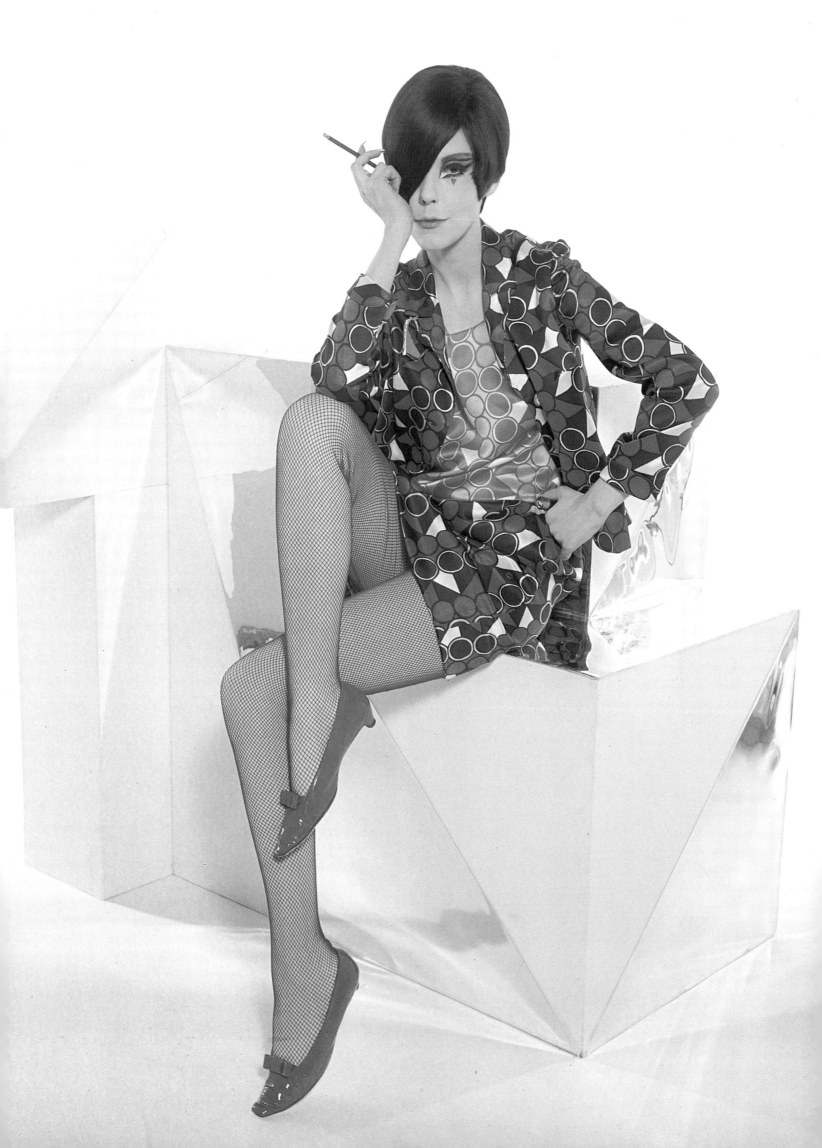

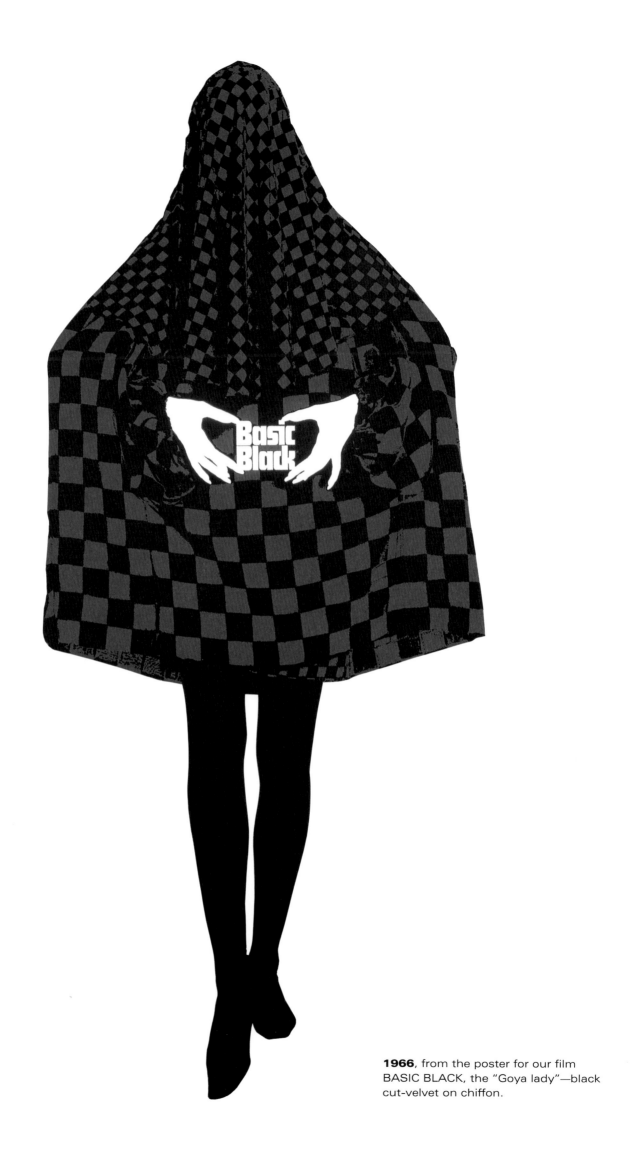

1966, from the poster for our film
BASIC BLACK, the "Goya lady"—black
cut-velvet on chiffon.

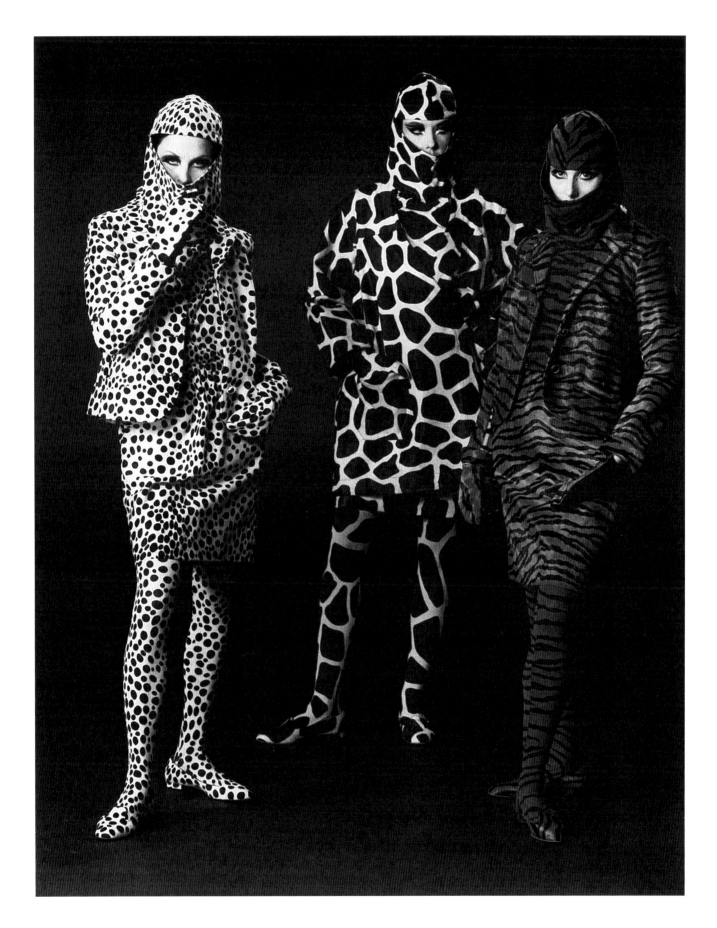

1966, pages 121–123, stills (with Léon
Bing and Ellen Harth) from the making
of the short film BASIC BLACK, which
demonstrated Rudi's "Total Look." The
"animals" took off stenciled calfskin
coats and suits to reveal matching
dresses—and then tights, underpants,
and bras. The clothing in the film won
Rudi his second Coty Award and the
film itself won many awards.

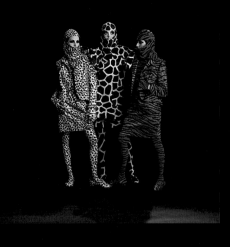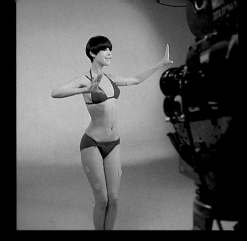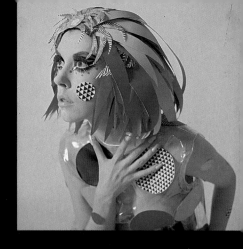
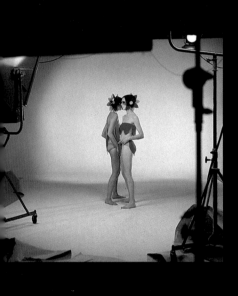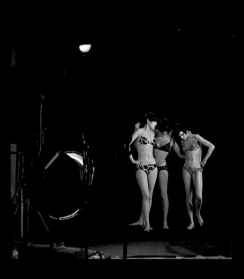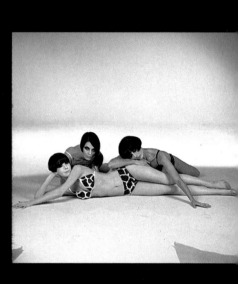
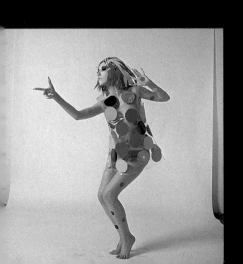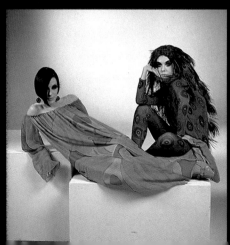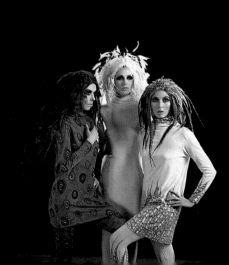

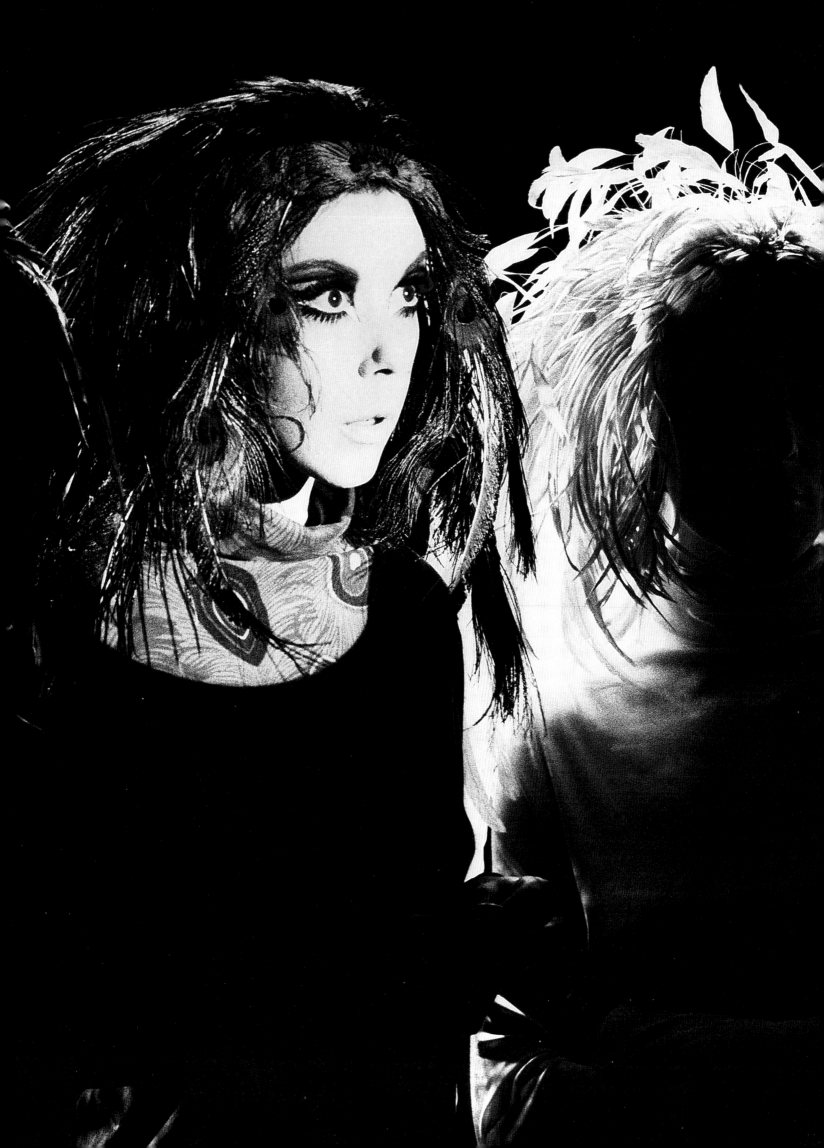

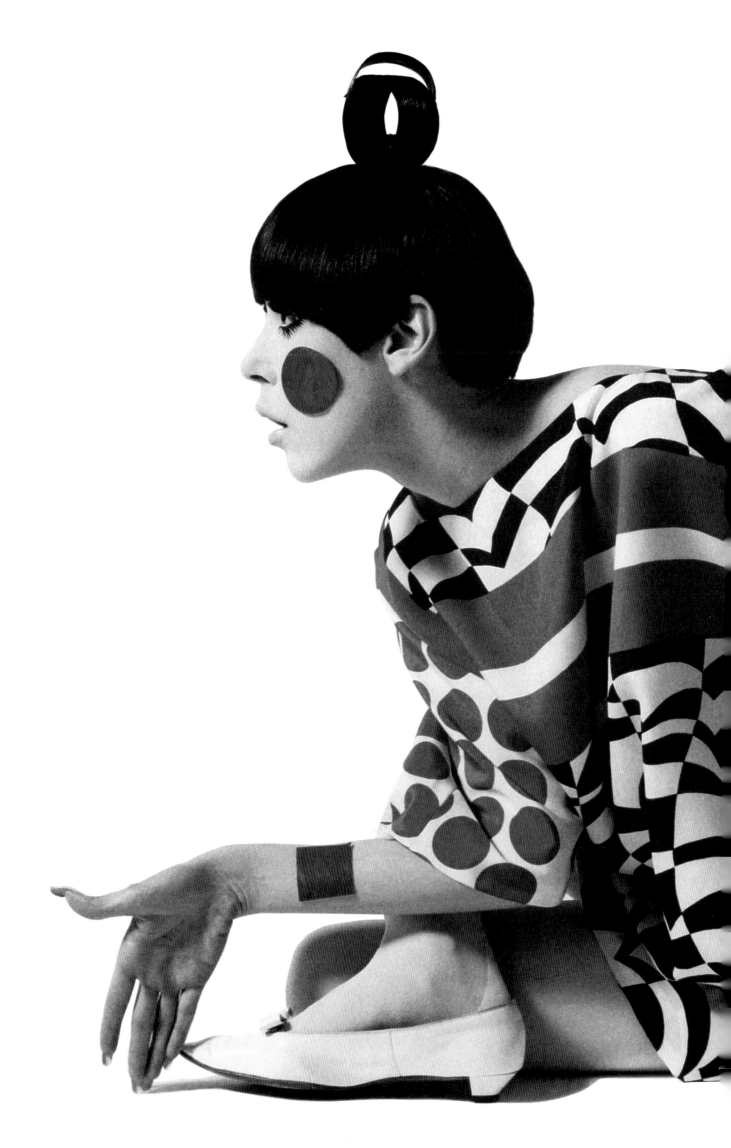

124

Resort 1967, red, white, and navy silk
"kite" dress worn with red vinyl decals.

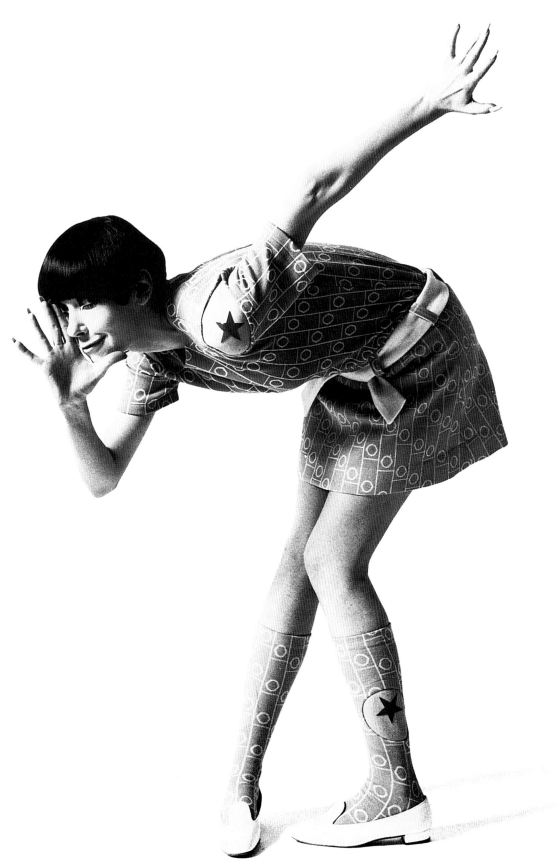

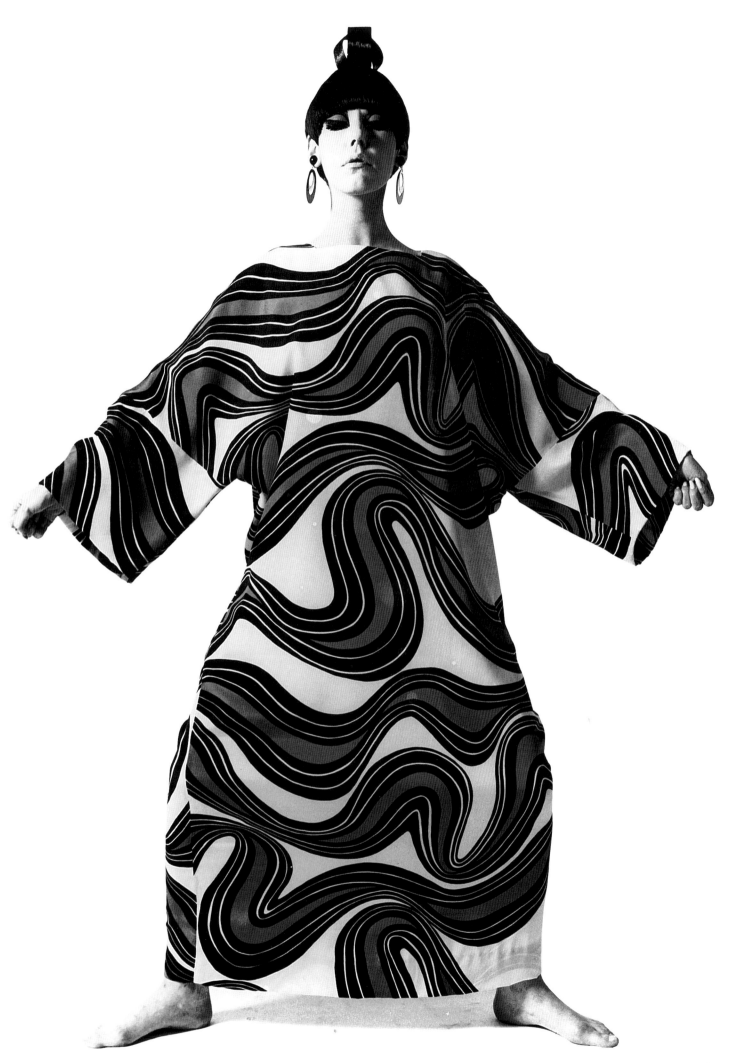

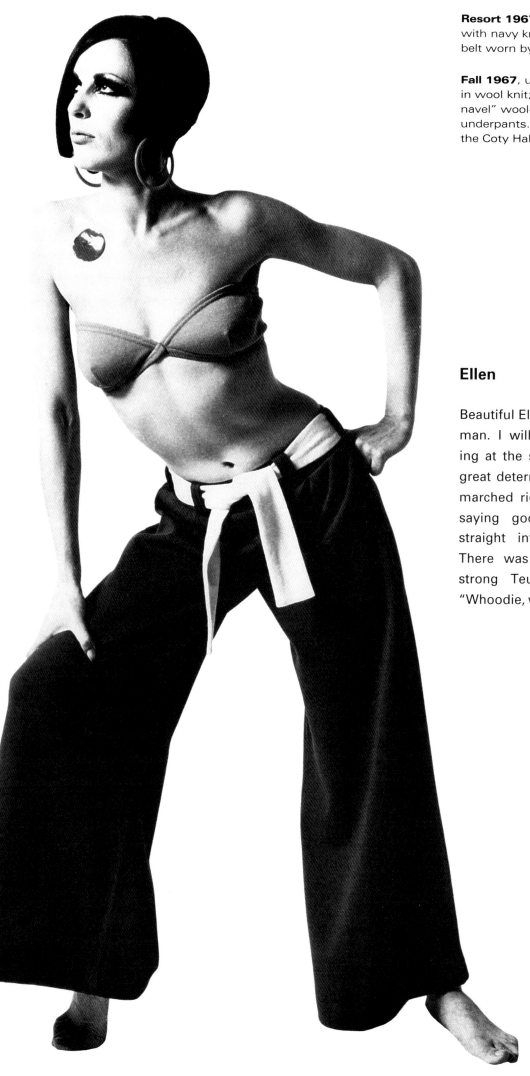

Resort 1967, left, red wool-knit bra with navy knit hip-huggers and white belt worn by Ellen Harth.

Fall 1967, upper right, color blocking in wool knit; lower right, "below-the-navel" wool-knit mini with attached underpants. This collection won Rudi the Coty Hall of Fame Award.

Ellen

Beautiful Ellen Harth, the divine German. I will never forget her arriving at the showroom one day with great determination in her eye. She marched right by all of us without saying good morning and went straight into the dressing room. There was a beat, and then her strong Teutonic voice rang out, "Whoodie, where is my wed dwess!"

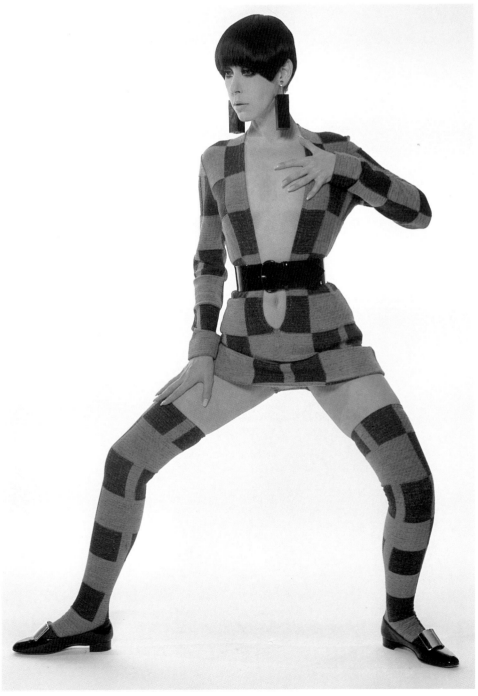

129

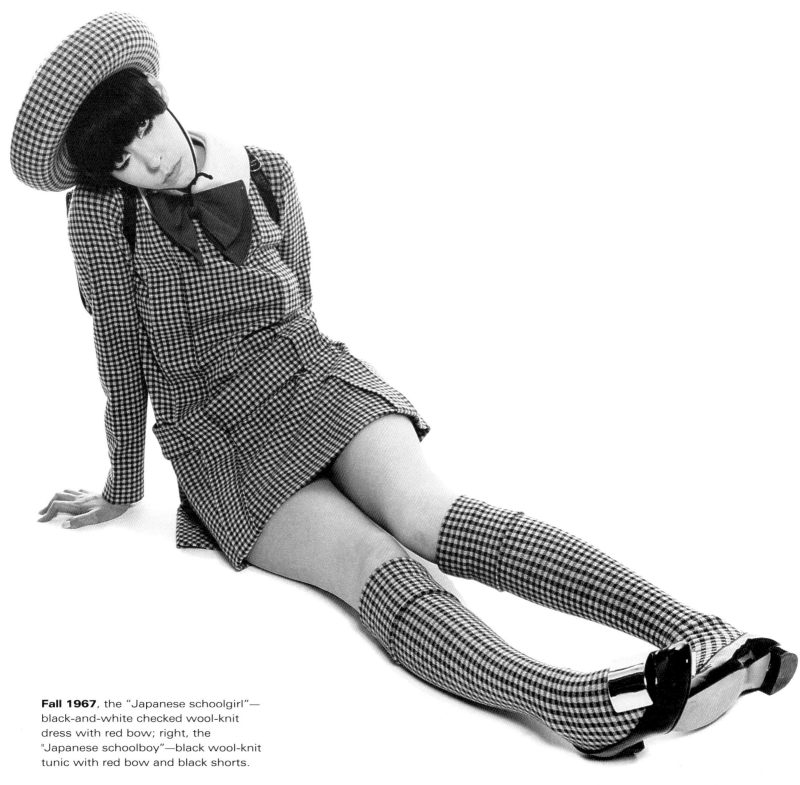

Fall 1967, the "Japanese schoolgirl"—
black-and-white checked wool-knit
dress with red bow; right, the
"Japanese schoolboy"—black wool-knit
tunic with red bow and black shorts.

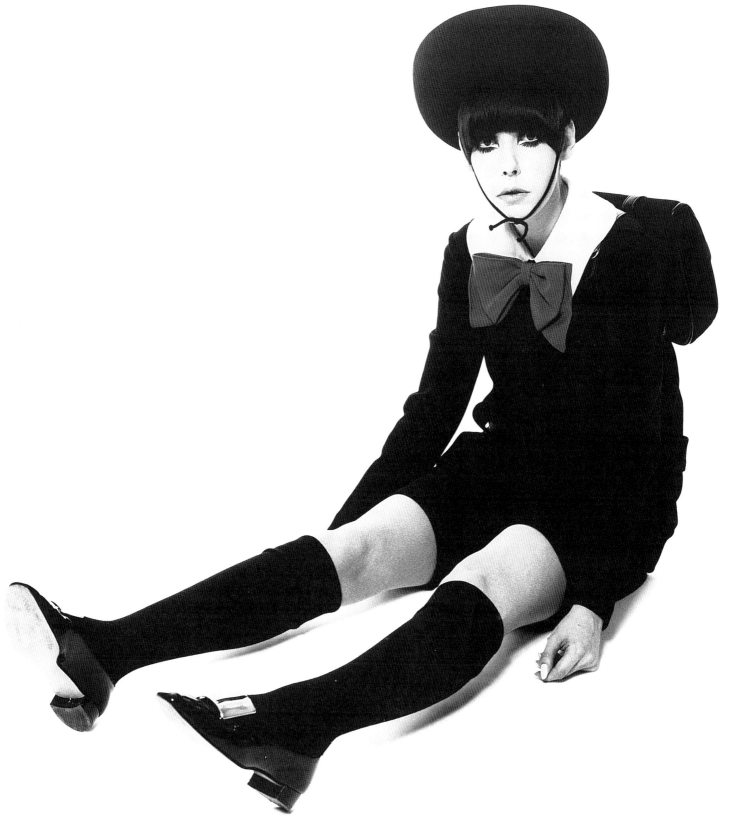

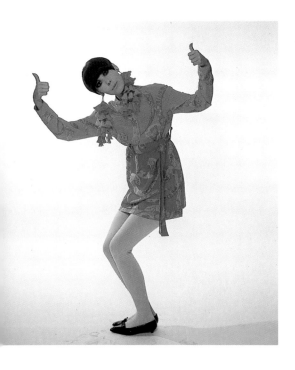

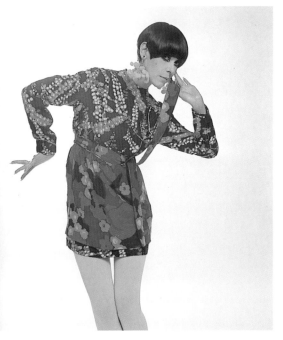

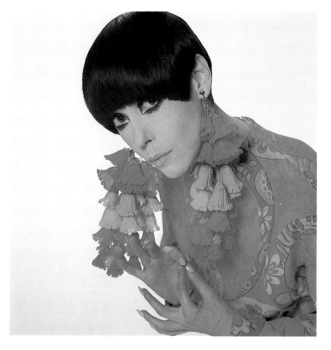

Fall 1967, "Chinese opera" group—
mixed print silk apron dresses and
jumpsuit with tunic; right, crepe
minidress with long organza flower
earrings.

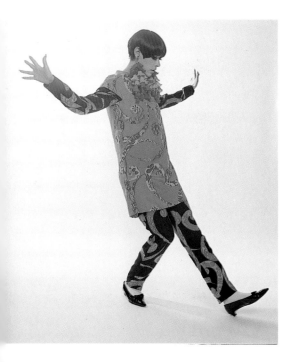

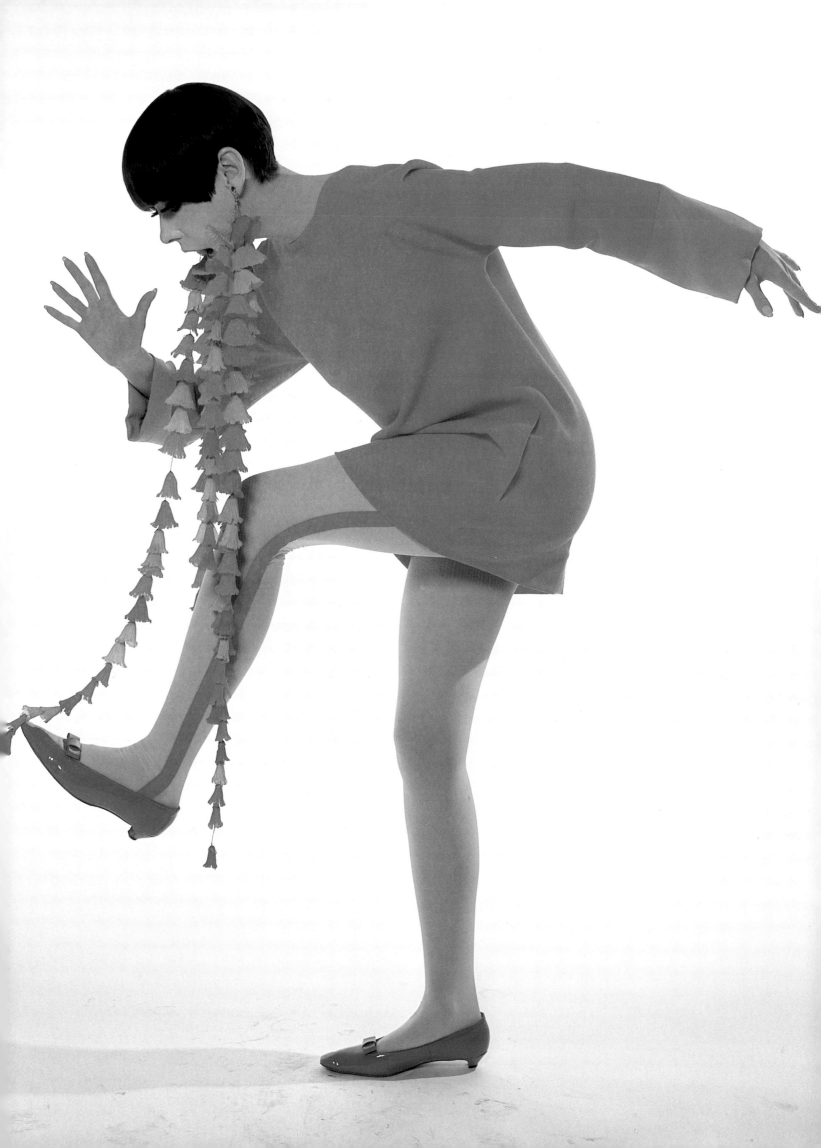

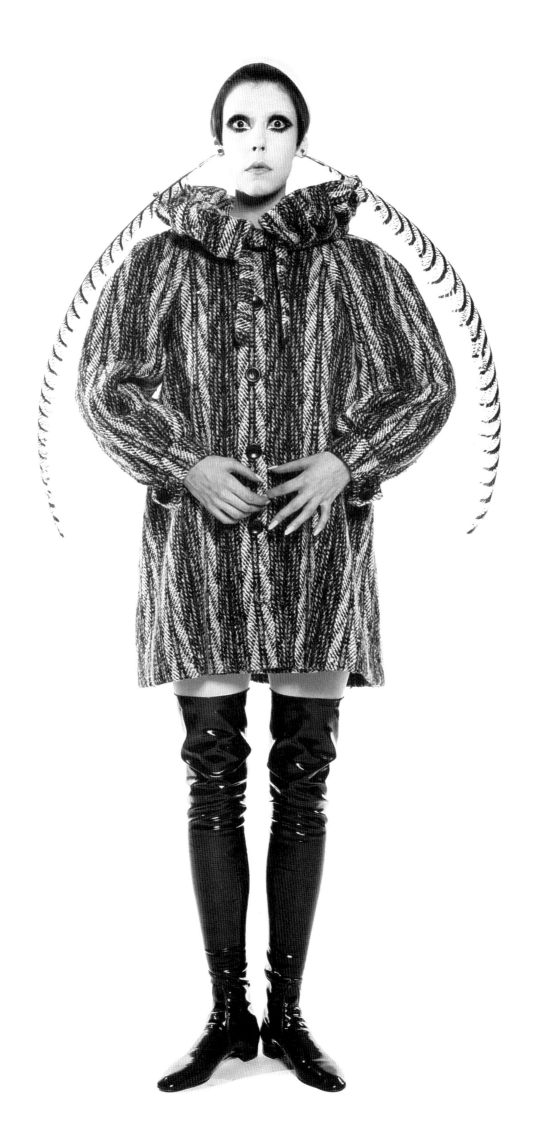

134

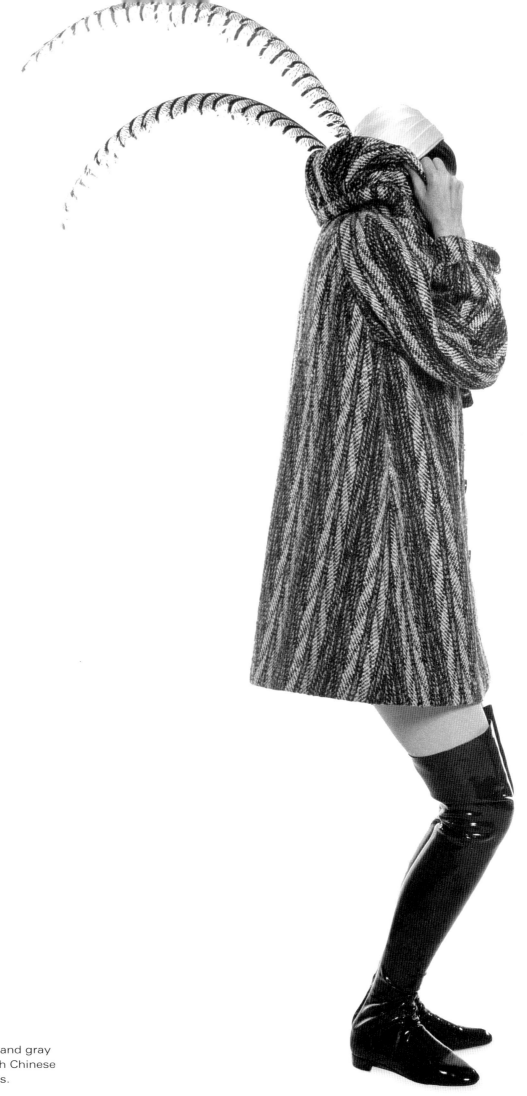

Fall 1967, black, white, and gray tweed "Pierrot" coat with Chinese pheasant feather earrings.

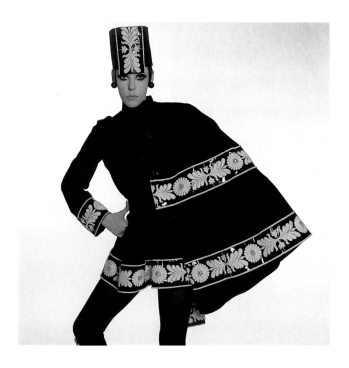

Fall 1967, upper left, black wool "Austrian cavalry officer" outfit with embroidered vinyl trim; lower left, "George Sand" pantsuit in eyeletted corduroy with satin blouse. The jacket is finished in tiny brass lionhead buttons.

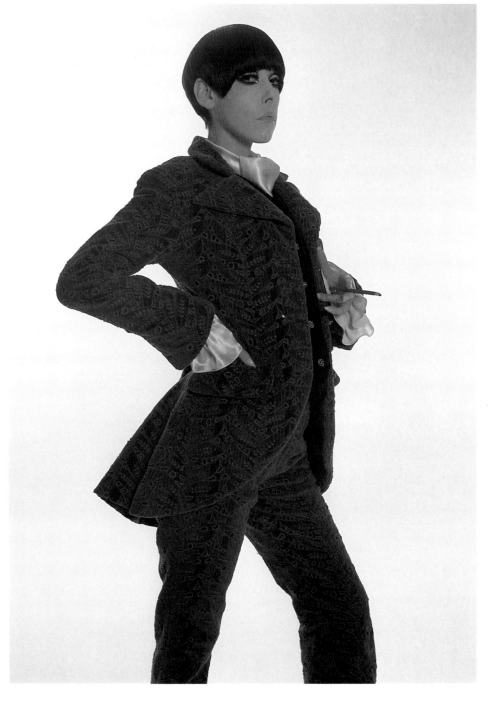

Fall 1967, right, see-through minidress in lacquered chiffon and wool crepe.

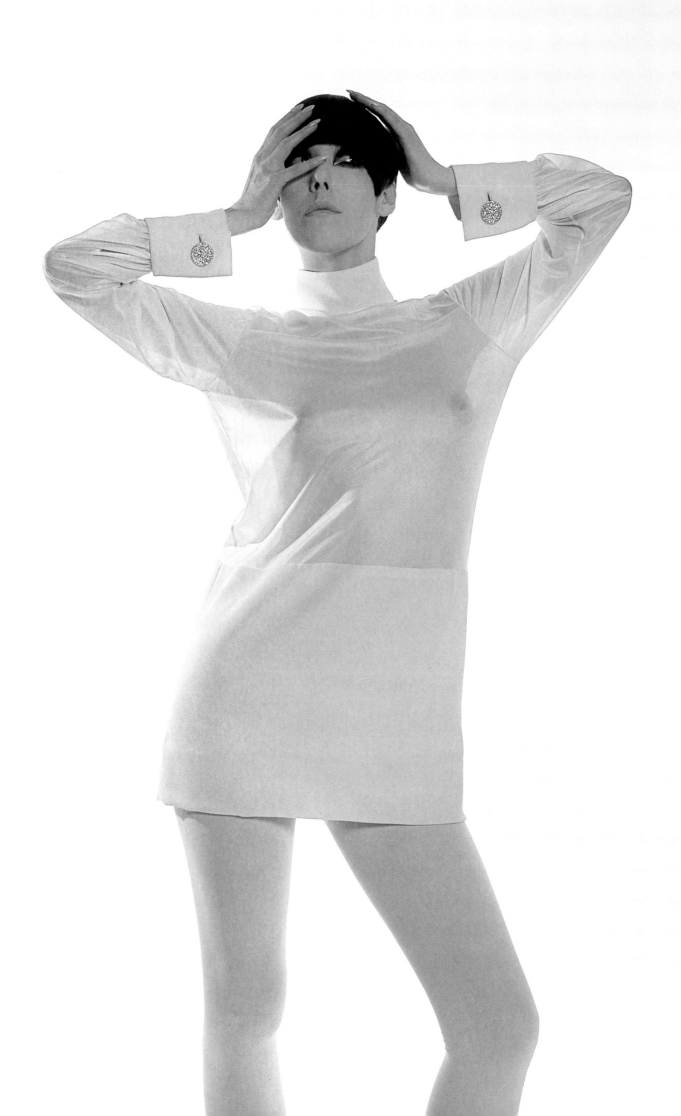

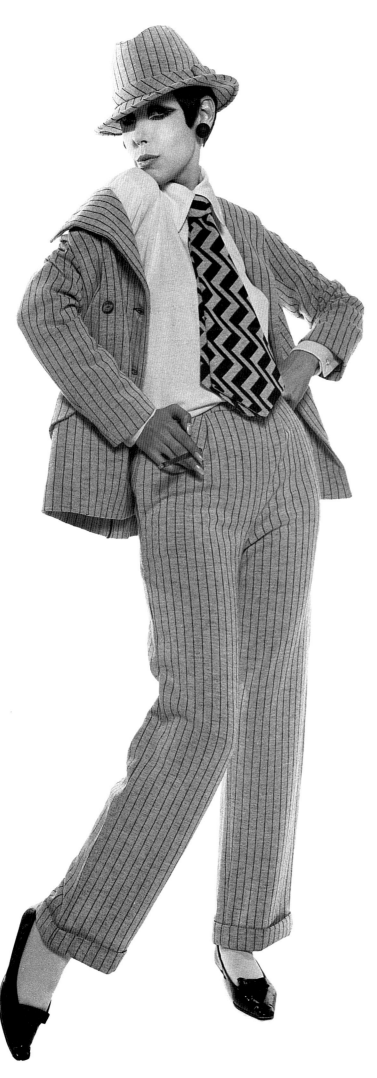

Fall 1967, left, gray and black pin-striped wool-knit "George Raft" pantsuit; upper left, green and black chiffon "Ophelia" shift; right, Léon Bing as a "Nun" in a white wool-knit shift worn with a black wool-knit jumper.

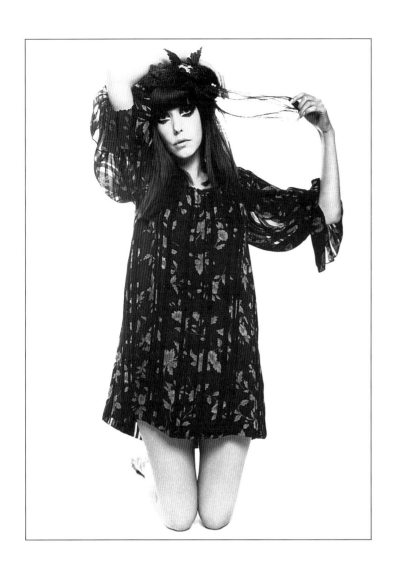

Léon

Rudi left no taboo unturned. Here is Léon Bing as a nun. The Sister of the Immaculate Mascara (not a silent order), Léon is known for her wisecracks and immensely enjoyed taking the cloth. The fashion, no matter how initially shocking, is really just two simple, pretty dresses worn together.

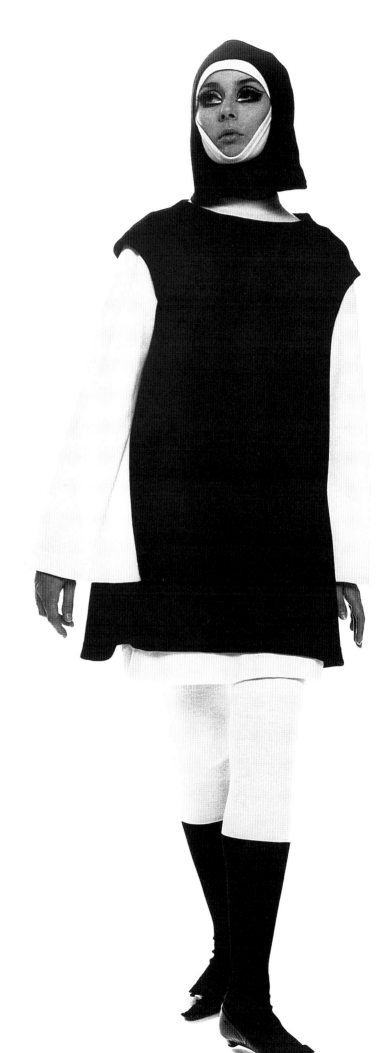

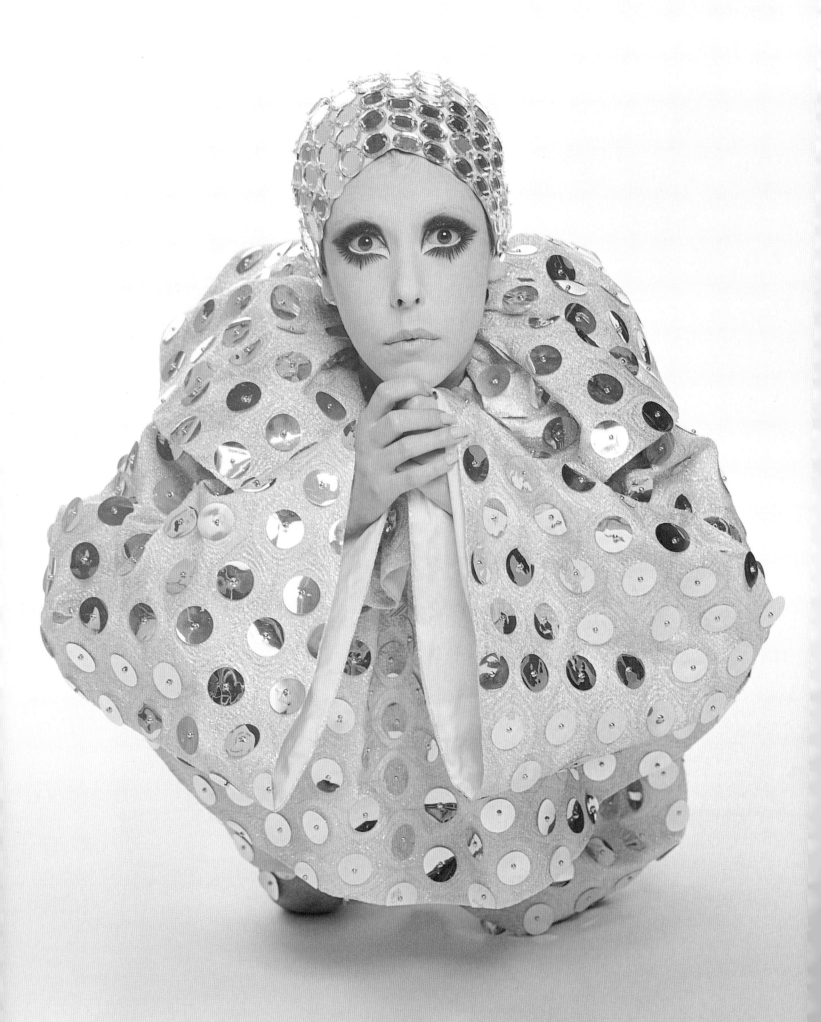

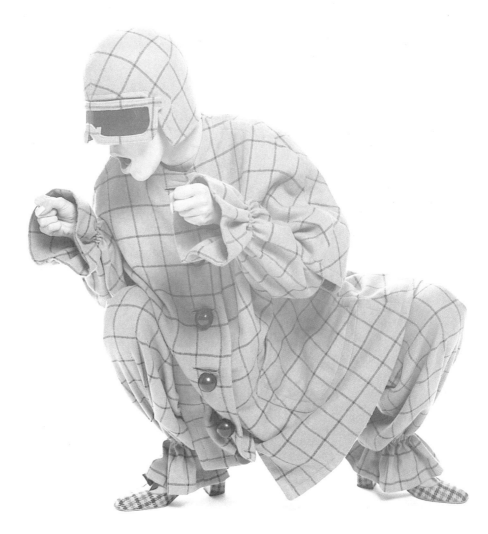

Fall 1967, left, heavily embroidered silver cotton "Pierrot" with Mylar paillettes. The hat is covered with mirrored pieces; right, black and camel windowpane plaid wool jumpsuit and jacket "motoring costume."

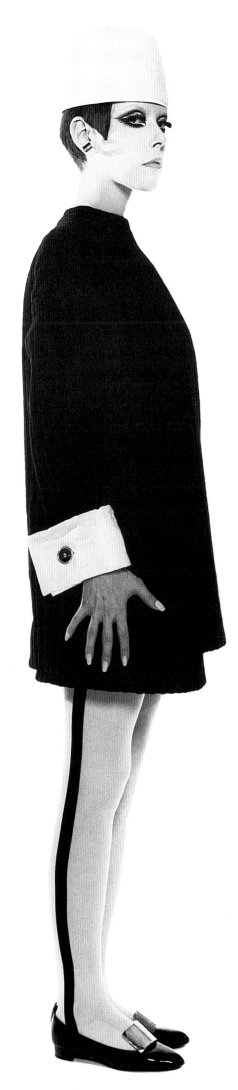

Making Up Is Hard To Do

Rudi's clothes inspired me so much that I designed my makeup to go with them. This was not always easy. The 1965 resort collection contained not only East Indian-inspired clothes but also Space age bathing suits, little chiffon dresses, linen dresses, and pantsuits. I solved that problem by using a removable caste mark for the Indian outfits.

For the 1967 Fall collection, I wanted to create a make-up based on the character "Death" in Ingmar Bergman's film "The Seventh Seal". Rudi had some pieces in his collection with rather sinister looks, and I thought that a sort of "skull" makeup would be effective. The only trouble was that the collection also featured Japanese girl and boy looks, an "Ophelia,", and dainty Chinese opera dresses. So, I bleached my eyebrows and painted enormous eyes in black (the skull), and when I had to be any of the sweet children, I combed my bangs over my eyebrows.

The most amazing example of our being on the same wavelength occurred with the 1968 resort collection. By this time I was living in New York and had no idea what Rudi's collection would look like. Just before he came to town something compelled me to design a very exotic Siamese face. When I saw the clothes and Rudi saw the makeup, neither of us could believe it. It looked like the same person had designed both. The makeup had red lines that encircled my eyes and went over the nose like a tattoo. Only some of the clothes in the collection were Siamese, however; the rest weren't Oriental at all. This meant I had to draw red lines in the middle of the show. I went to the dime store and bought a black

Halloween mask, cut it to the shape that I wanted, and used it as a stencil. That left only one problem. Rudi absolutely insisted that the last piece shown be a little black chiffon bubble-skirted dress with black feather earrings (and it wasn't Siamese). What to do? I put on the mask that I had used as a stencil, and the girl became the most glamorous cat thief in the world.

Rudi's last show in 1981 posed a more unique problem. It was to be given at a nightclub called La Cage aux Folles, and the producers of the fashion show suggested that Rudi use the female impersonators who worked there as his models. Rudi would have non of that idea and hated that his producers insisted on staging the show there. He asked me if I had any ideas. I suggested that I wear a mustache. He loved it— the very last dress I ever modeled for Rudi was a long, sexy gown worn with a mustache. The audience went wild and the female impersonators (who were in the audience) loved it most of all. I'm glad that our last professional appearance together ended with a wink.

Fall 1967, left, wide-wale black corduroy tunic and skirt with white satin cuffs; right, the "Sorceress"—black embroidered cotton with black paillettes.

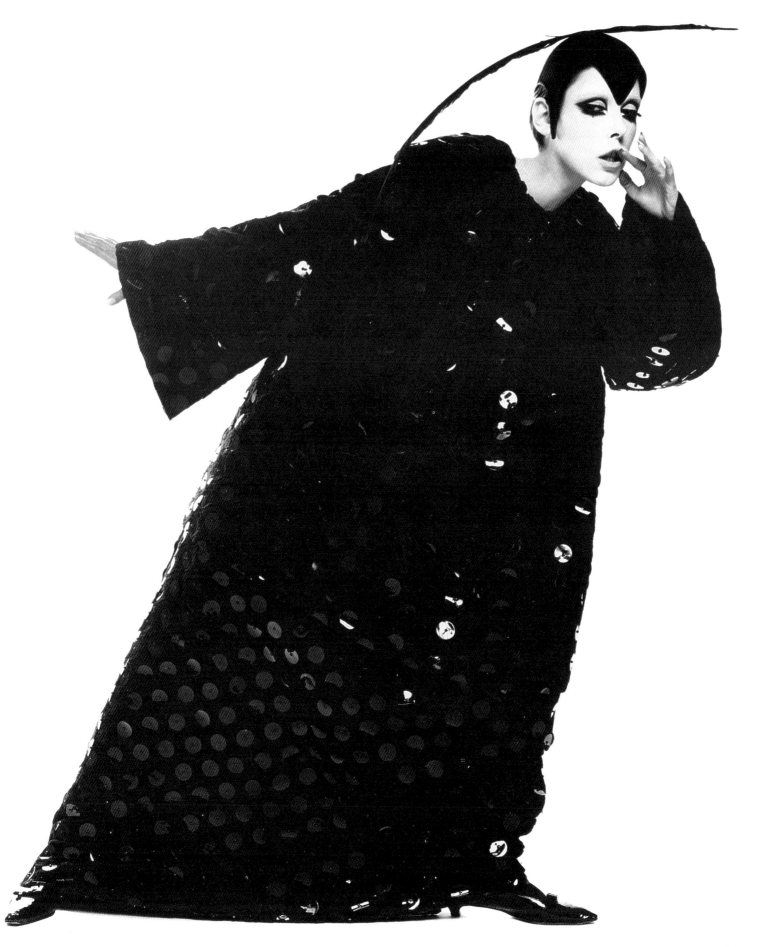

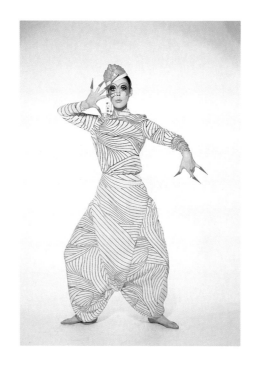

Resort 1968, right, long silk pants and blouse from the "Siamese" group.

Resort 1968, below, the panel of this silk shantung dress, worn between the legs, snapped onto the waist in back. When it was removed, what remained was a simple dress with no Siamese look whatsoever—Rudi was brilliant at paring a design down to its essence.

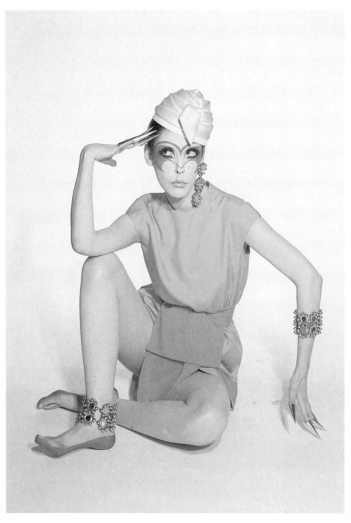

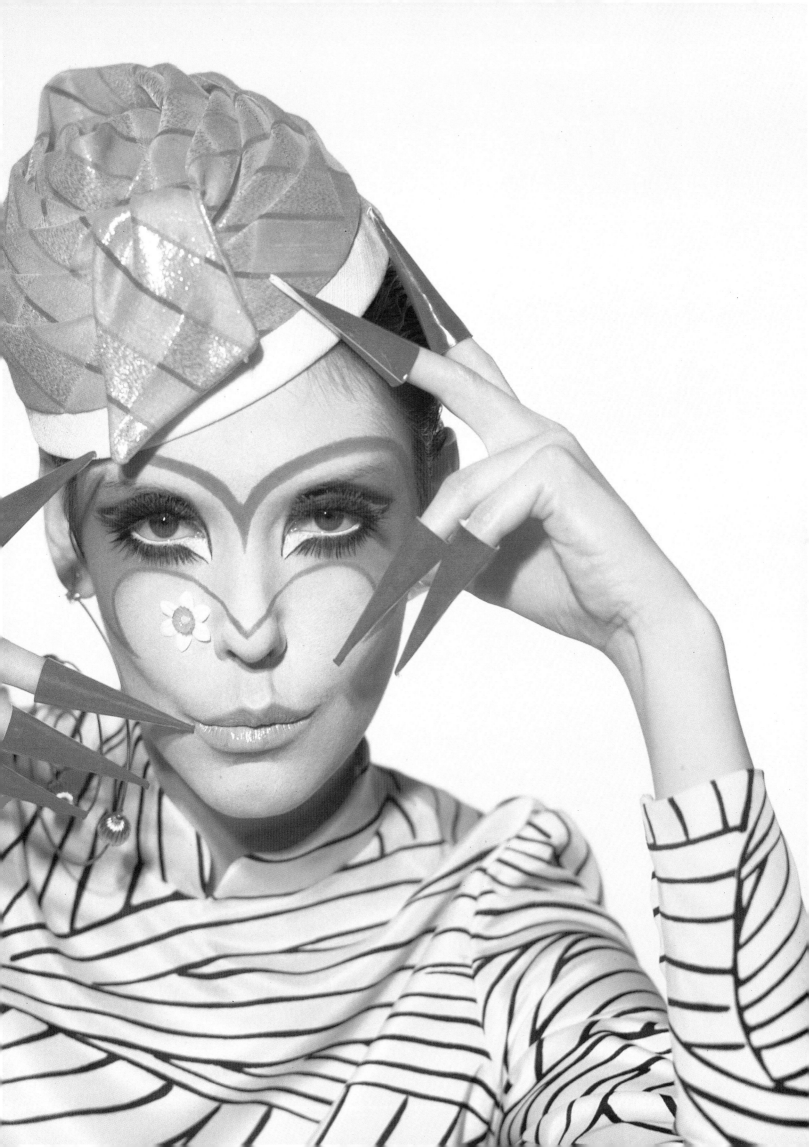

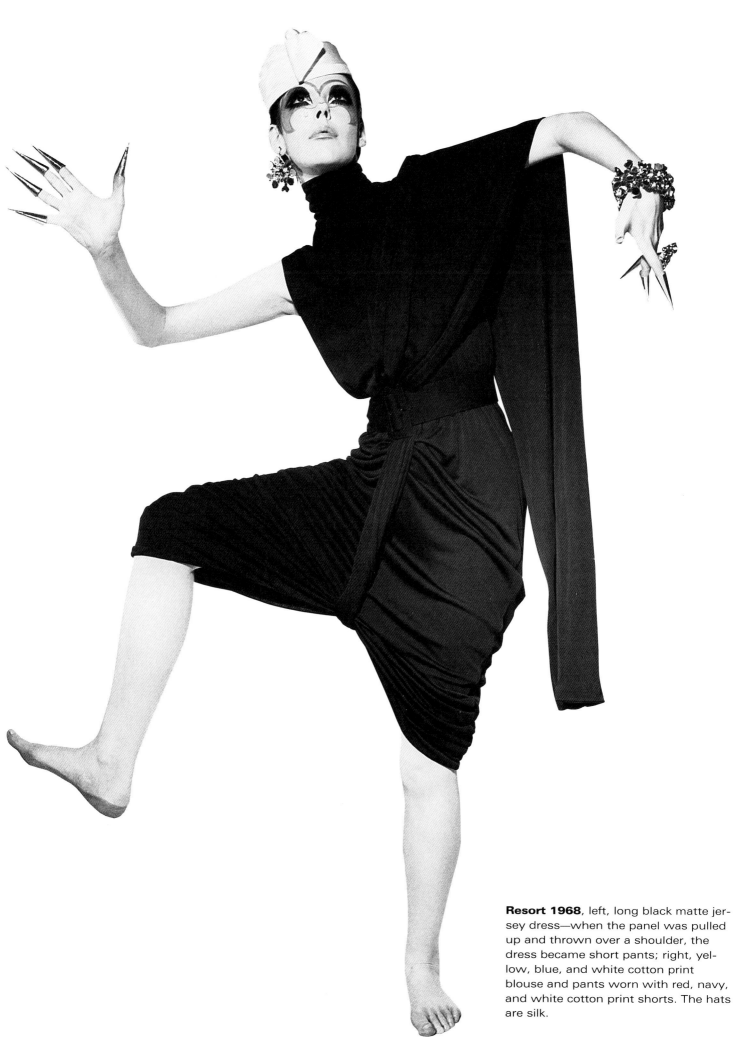

Resort 1968, left, long black matte jersey dress—when the panel was pulled up and thrown over a shoulder, the dress became short pants; right, yellow, blue, and white cotton print blouse and pants worn with red, navy, and white cotton print shorts. The hats are silk.

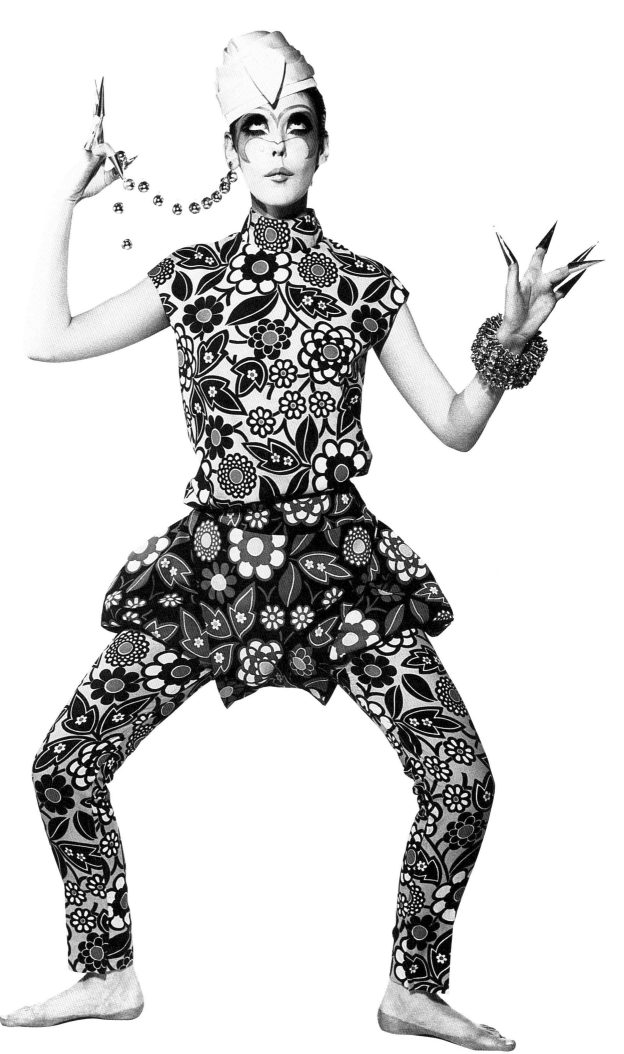

FUN CITY

In the late 1960's, New York City was going through great turmoil and was becoming a place that people were frightened to visit. The Chamber of Commerce decided to run an ad campaign showing what a delightful place it was, and they used the slogan "Fun City". The ads with this slogan were everywhere, in magazines, on buses and bill-boards. Everywhere you looked you saw "Fun City".

About this time, Bill and I came back from Europe. We decided to stay in New York and found an apartment on West 57th Street. This had one horrible side-effect for me. Instead of walking home after work with Rudi to the Algonquin Hotel, I had to go it alone through Times Square and the dreaded 42nd Street. Naturally, I would grab a cab if I found one, but I almost never did.

On one memorable occasion, I was standing at 42nd and 7th Avenue waiting for the light when I noticed the group of people on the other side of the street that I would have walk through. There were mid-night cowboys, prostitutes, trans-vestites, dope dealers, people covered in tatoos, people with bones through their noses and in the center a dwarf with no legs. He was sitting on a small board mounted on roller-skate wheels. Averting my eyes, I started crossing the street, whereupon the dwarf started pointing up at me and yelling to the crowd, "LOOK AT HER. LOOK AT HER. HOW FREAKY!"

Just another glamorous day in the life of a fashion model in "Fun City".

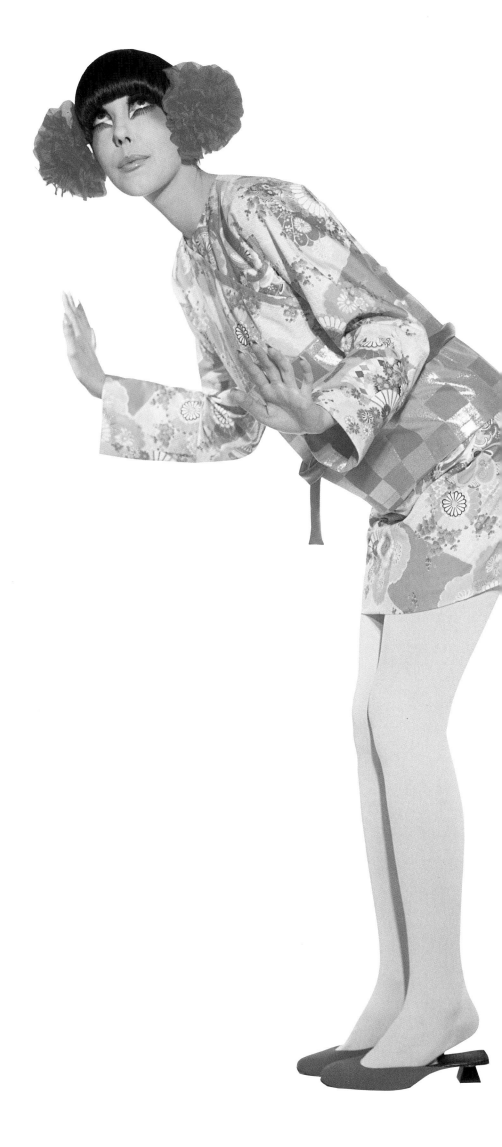

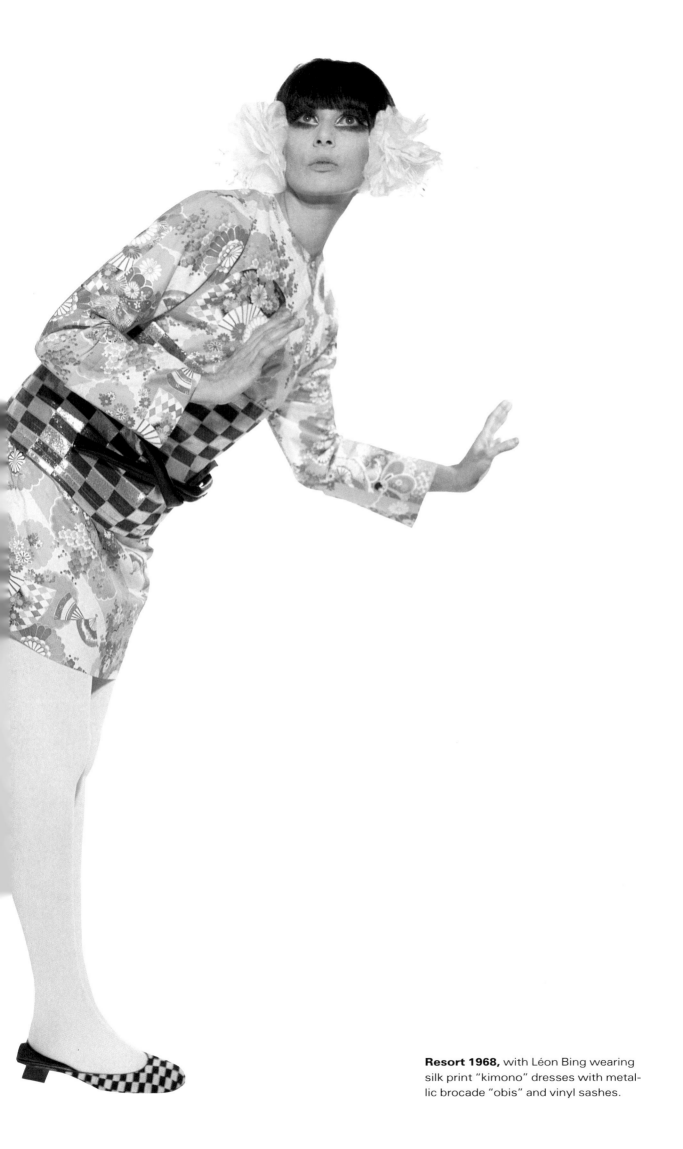

Resort 1968, with Léon Bing wearing silk print "kimono" dresses with metallic brocade "obis" and vinyl sashes.

149

Resort 1968, the "Zouaves": lower left, beige linen tunic with white cotton piqué bubble skirt; lower right, beige linen suit with taupe belt; right, beige and off-white windowpane plaid linen tunic and bloomers with white cotton blouse.

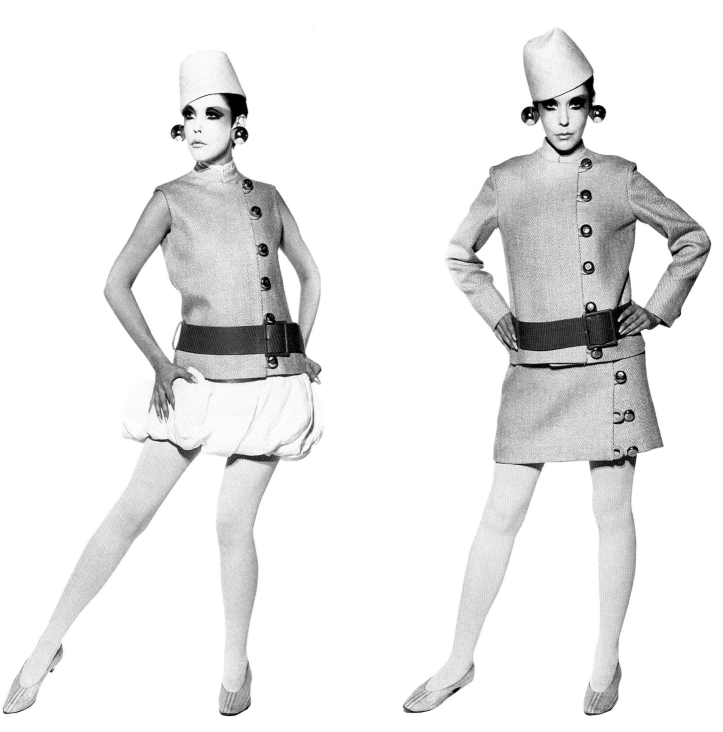

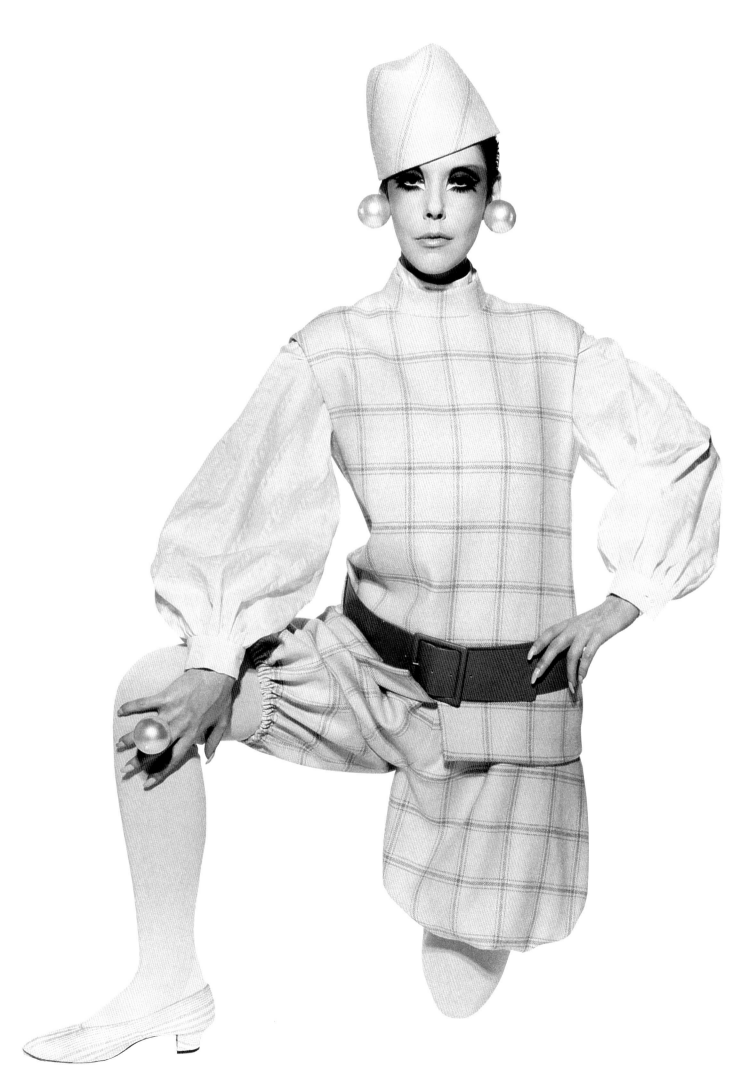

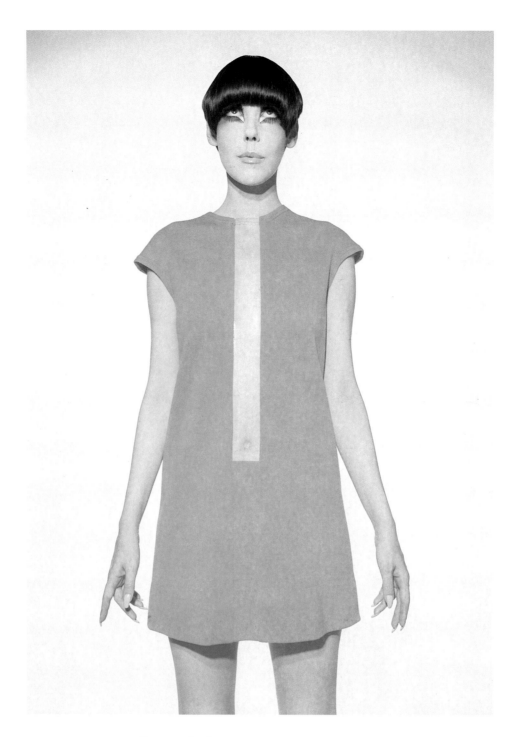

Seventh Avenue

Two tackily dressed buyers from a small-town store wandered into the showroom in New York the week that Rudi was on the cover of *Time*. They went up to Rudi, who happened to be standing there, and demanded, "Show us what ya got in jeweled sweaters." Ah, fame.

Resort 1968, above and right, from a wool-knit group with transparent vinyl inserts. These two dresses appeared with Rudi on the cover of TIME magazine.

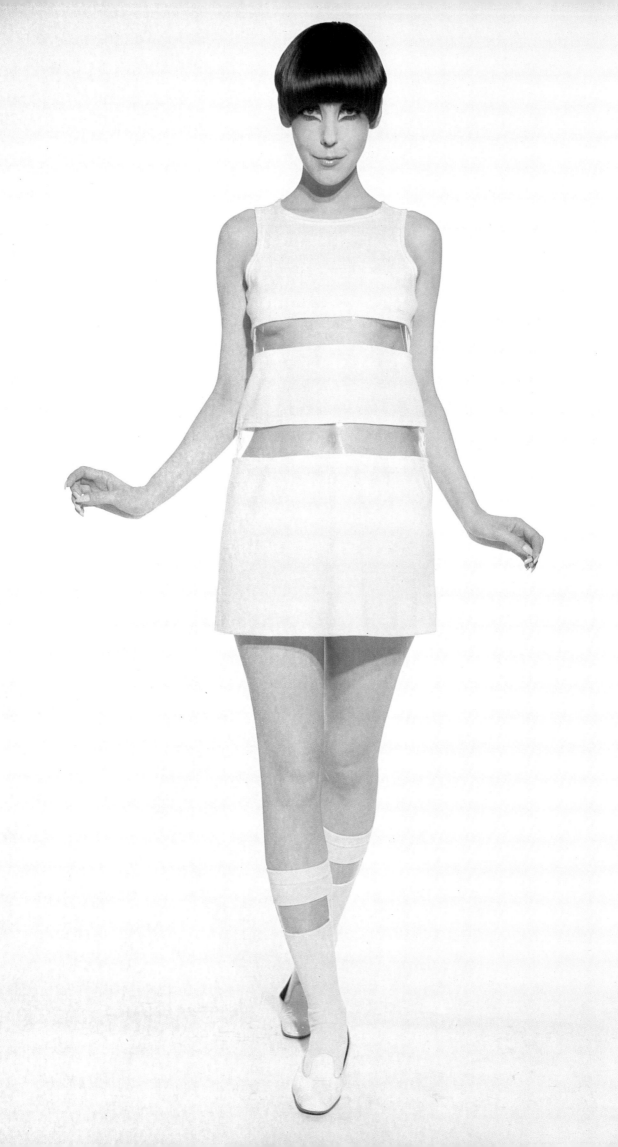

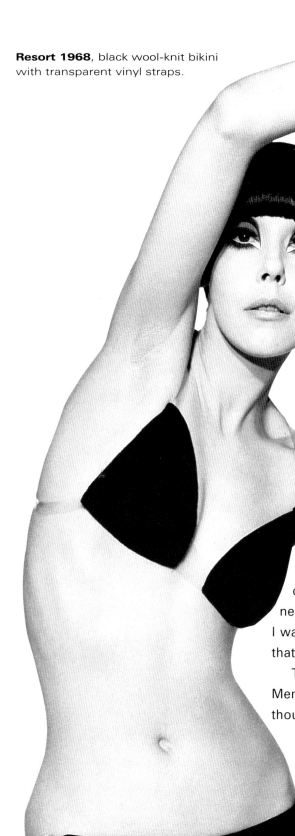

Resort 1968, black wool-knit bikini
with transparent vinyl straps.

Haute Comfort

Some of Rudi's critics accused
him of producing poorly made
clothes. They weren't poorly
made. They were beautifully made.
But they weren't made like couture.
Rudi didn't cover a snap in organza if
it didn't need to be covered. The dif-
ference in the two schools of thought
was brought home to me when I was
being photographed for the Paris col-
lections and I wore a caftan from one
of the great Parisian houses. It was
quite beautiful on the hanger, but

when I put it on, I discovered that inside
this loose shape was a corseted sheath
dress with lead weights hanging from the in-
ner dress. The weights slapped my ankles when
I walked, and the inner dress was so constricted
that I couldn't walk—only mince.

To me the whole point of a caftan is freedom.
Men have been striding across the desert for
thousands of years in them looking marvelous
and being comfortable. There is beauty and
sensuality in comfort; that is the caftan's ap-
peal. I'm sure many a seduction has taken
place while wearing a caftan. The advo-
cates of couture-style dressmaking (al-
most always men) have said to me for
years that such and such a dress is
wonderful because it is so stiff and
constructed that it can stand up on
the floor all by itself. My reply has al-
ways been, "Let it. It doesn't need
me to hold it up, and I don't need the
torture it will give me."

Here is one of Rudi's caftans. It
was made of silk and lined in China
silk. That's all. It slipped and slid
around the naked body and felt like a
thousand baby's hands caressing me.

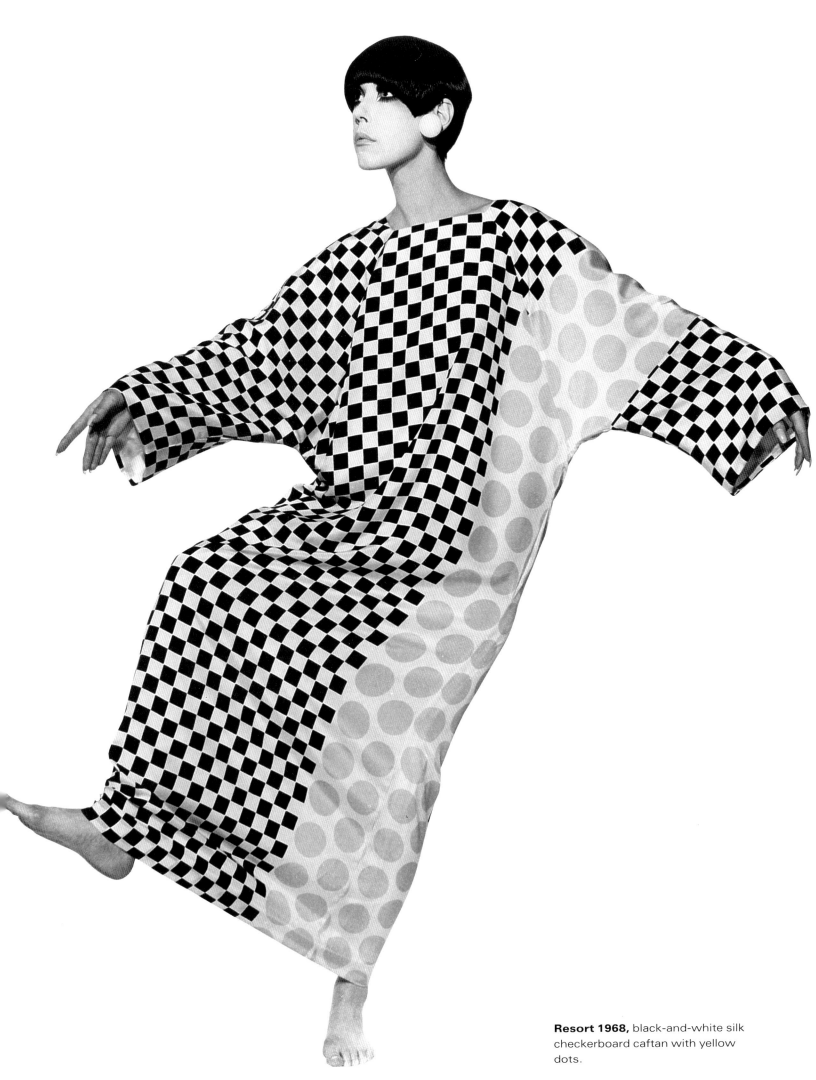

Resort 1968, black-and-white silk checkerboard caftan with yellow dots.

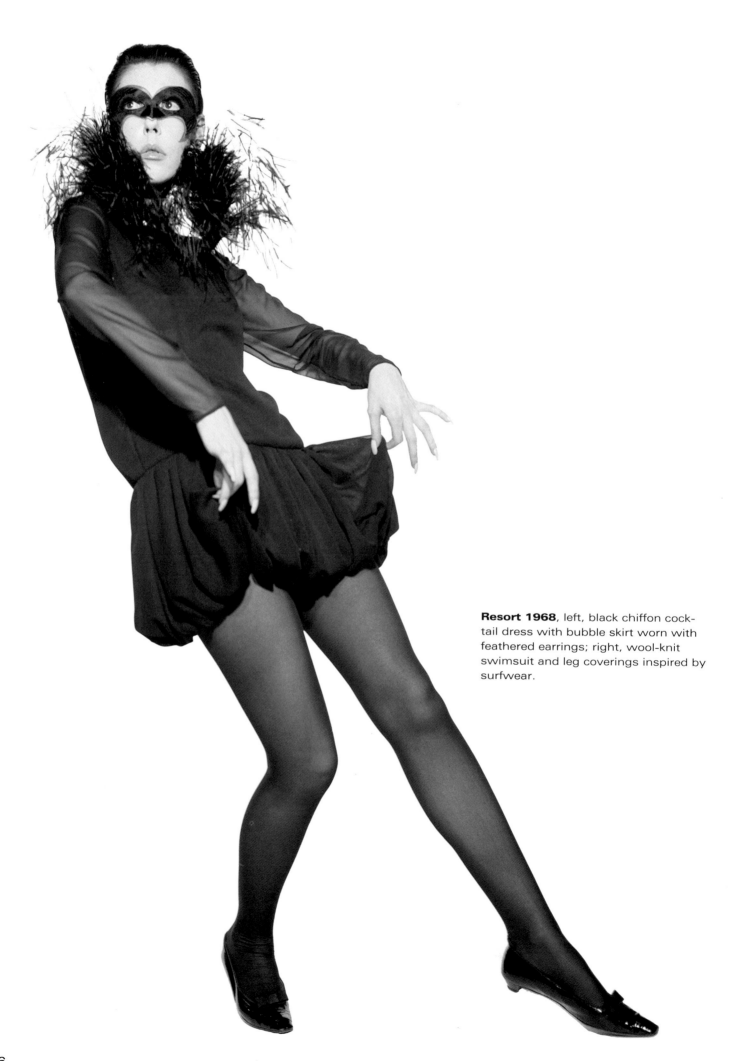

Resort 1968, left, black chiffon cocktail dress with bubble skirt worn with feathered earrings; right, wool-knit swimsuit and leg coverings inspired by surfwear.

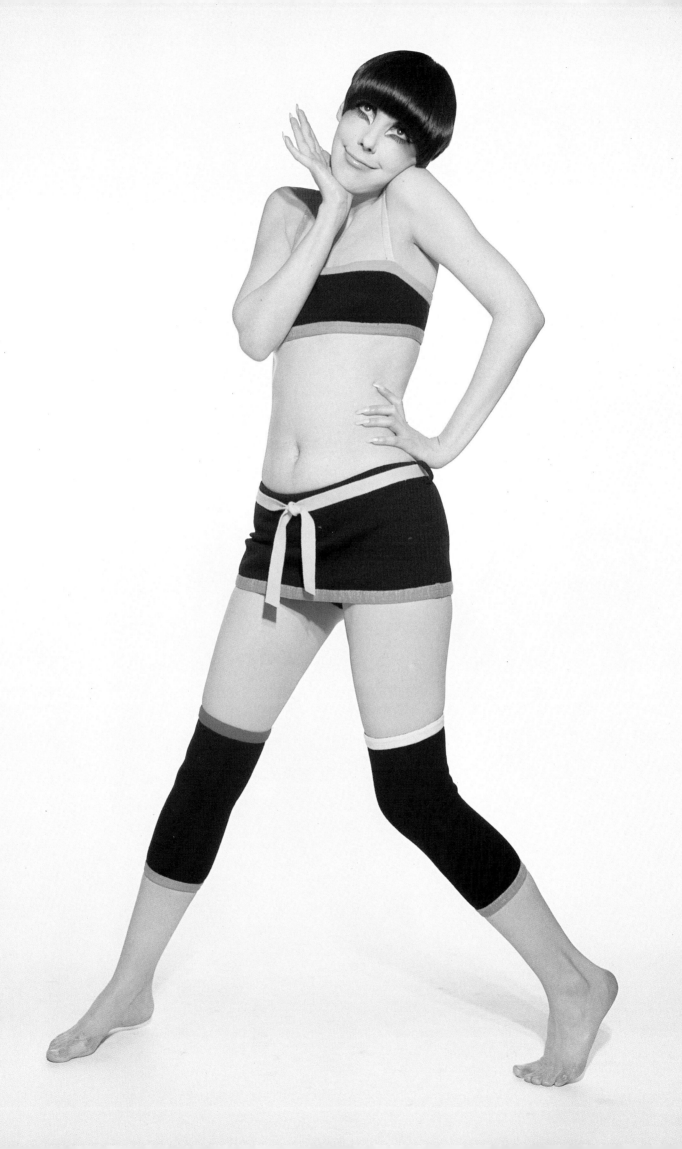

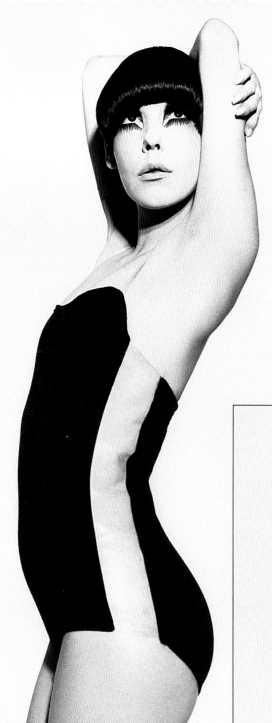

On the Beach

On a trip to Mexico, Rudi couldn't resist going to the local nude beach. While he was there, a beautiful naked girl came up to him and exclaimed, "Oh, Mr. Gernreich, I just love your swimsuits."

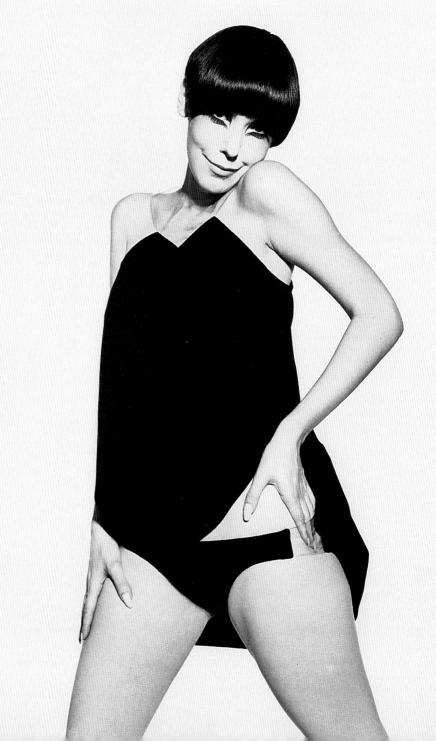

Resort 1968, above, black wool-knit swimsuit with transparent vinyl racing stripes; right, black wool-knit sundress with transparent vinyl collar and bikini with vinyl inserts.

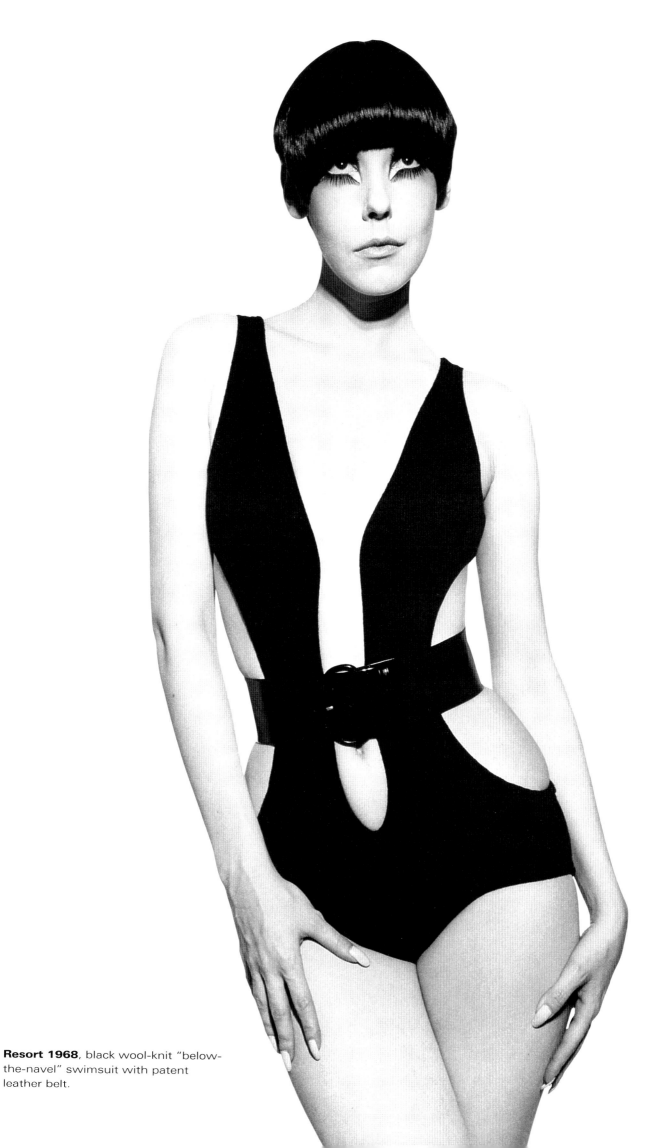

Resort 1968, black wool-knit "below-the-navel" swimsuit with patent leather belt.

Layne

When I returned from Europe in 1966, I was amazed at the development of the work of Rudi's assistant, Layne Nielson. The accessories he was making were just incredible—from the feathered hats worn in *Basic Black* to dress-length earrings made of starched and pressed organza flowers. He made finger guards out of lacquered paper for the Siamese group and all the inventive jewelry that went with it. There was a hat we never photographed that I will always remember. It was a tiny black beanie with one limp black feather coming straight out of the top. The feather was eighteen feet long. When the model who was wearing it left the room, it took the feather another minute and a half to leave. On the opposite page is one of Layne's feathered hats. He spent hours gluing the feathers on the matching boots (seen on page 162). Layne produced the delicious icing on Rudi's cake. This collection contained some of his most spectacular work.

Fall 1968, natural coq-feathered hat and boa.

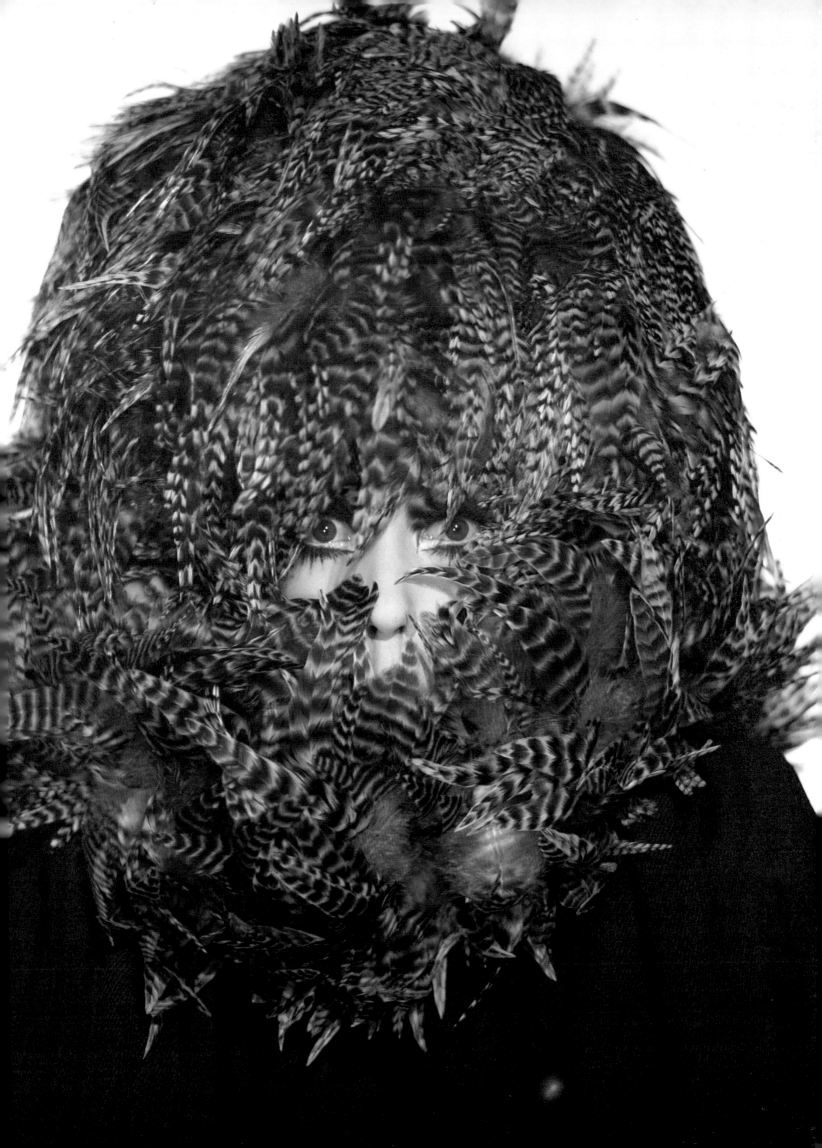

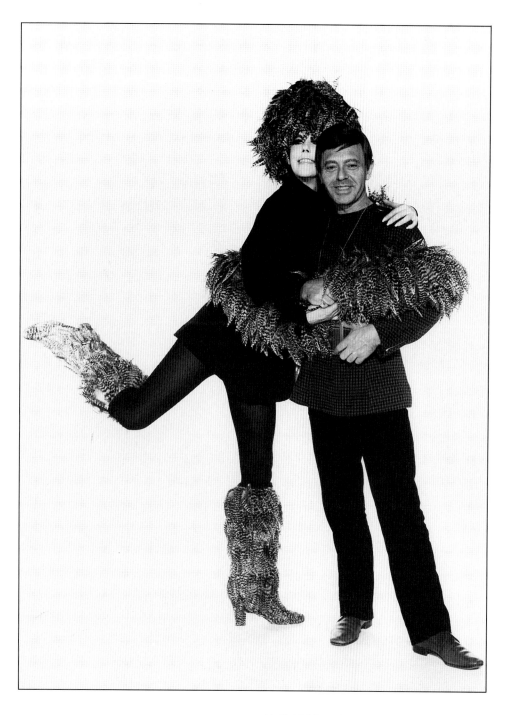

Fall 1968, with Rudi in black wool leg
o'mutton-sleeved tunic with feathered
hat, boa (from preceding pages), and
boots; right, plaid wool jacket, bloomer
jumpsuit, and hat in various shades of
gray.

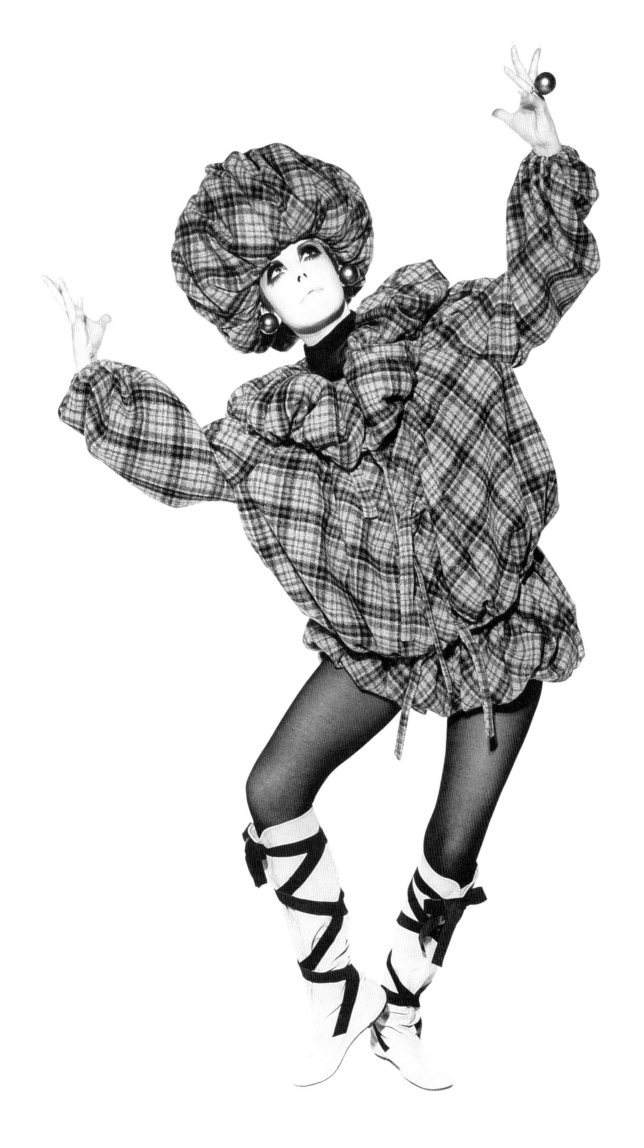

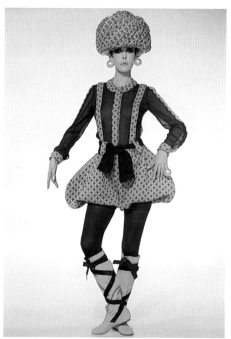

Fall 1968, a "Beardsley" group: above, plaid wool outfit shown on preceding page with jacket open to reveal black chiffon top of bloomer jumpsuit and (right) with jacket removed; center and below, tweed bloomers with chiffon and tweed blouse.

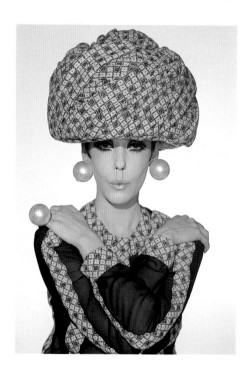

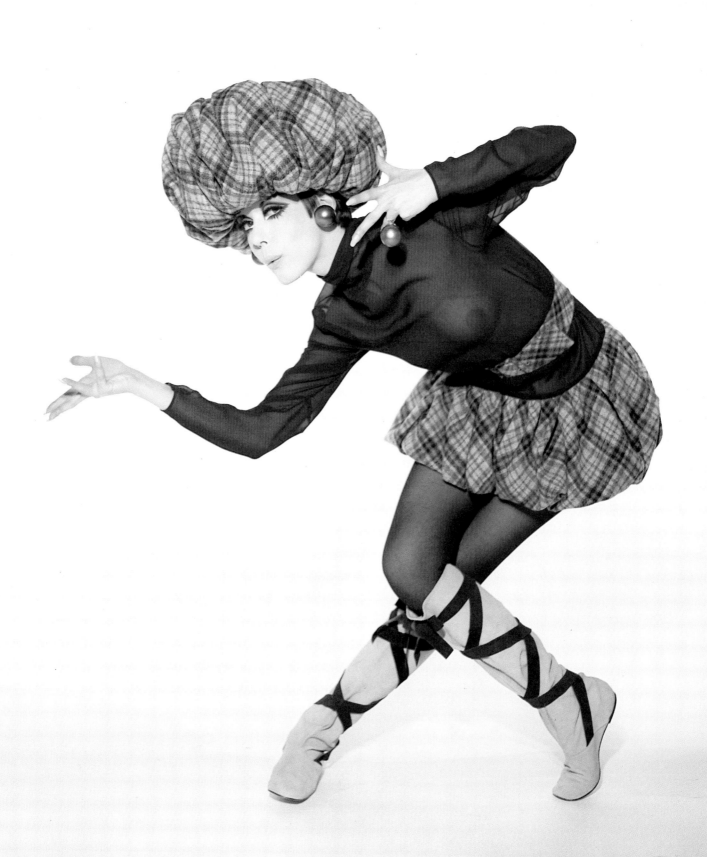

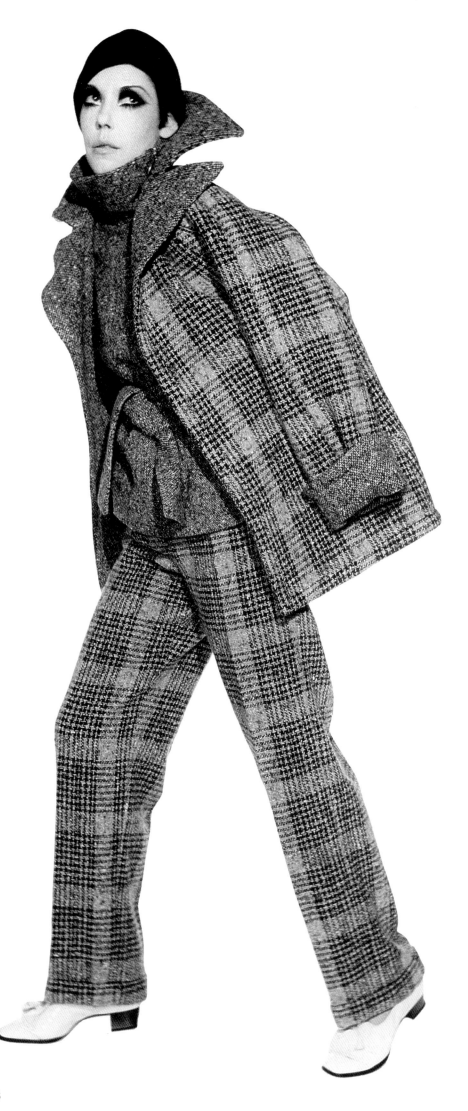

Fall **1968**, left, green and beige tweed "Duke of Windsor" pantsuit with reversible jacket; right, short gray flannel "Genghis Kahn" jodhpur jumpsuit with black vinyl and velvet spencer jacket under vinyl and canvas jacket.

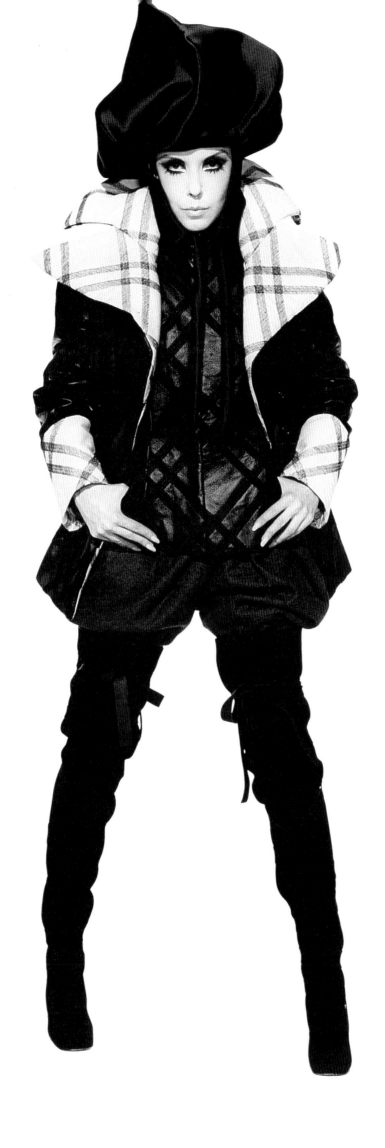

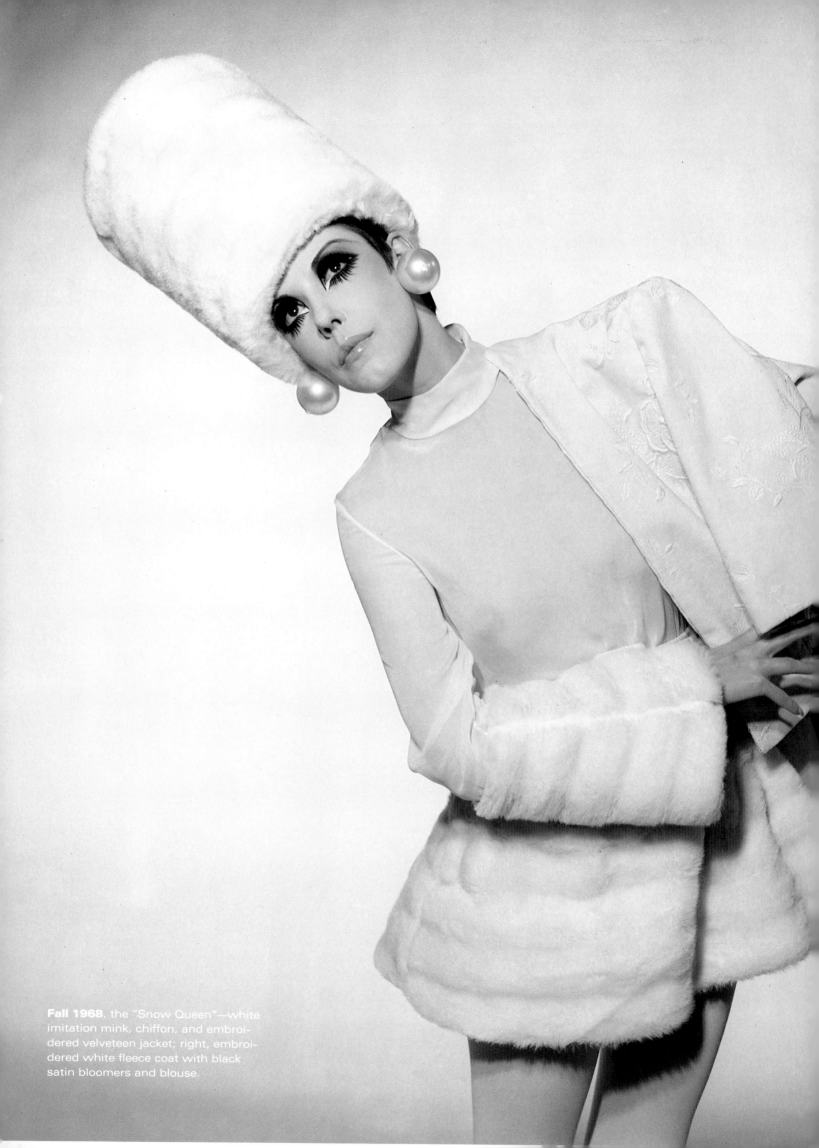

Fall 1968, the "Snow Queen"—white imitation mink, chiffon, and embroidered velveteen jacket; right, embroidered white fleece coat with black satin bloomers and blouse.

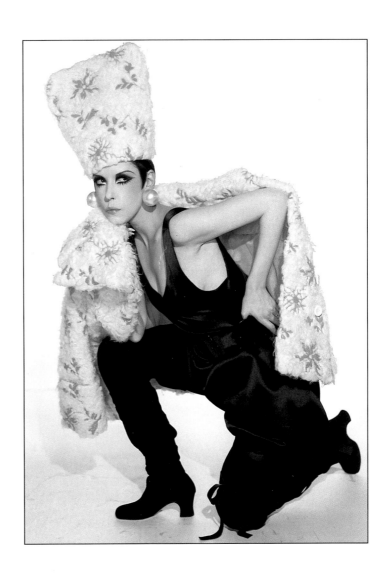

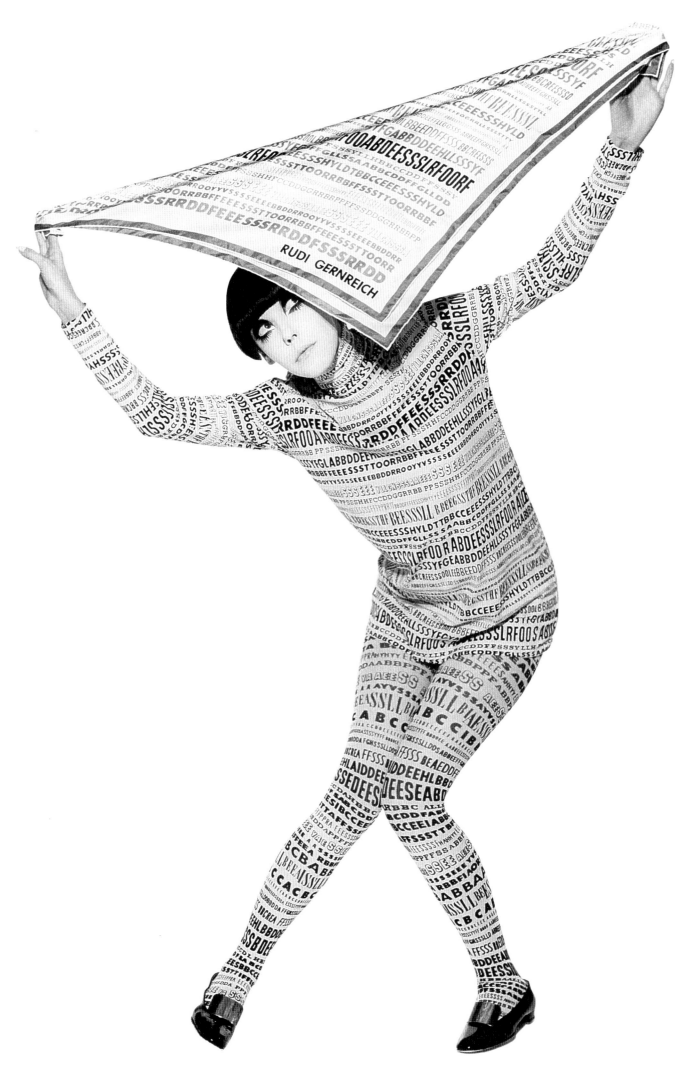

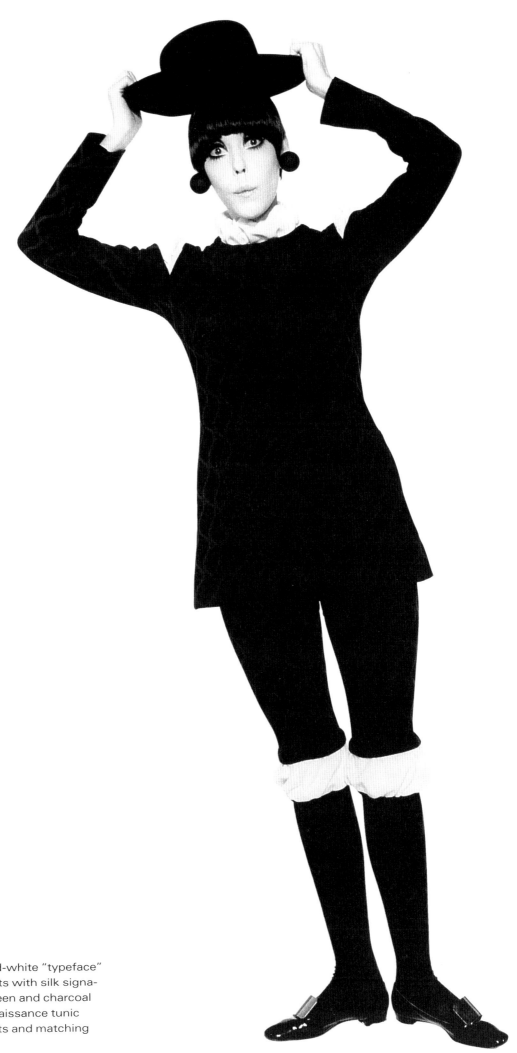

Fall 1968, left, black-and-white "typeface" dress and matching tights with silk signature scarf; right, gray-green and charcoal patterned wool-knit Renaissance tunic with off-white knit inserts and matching knit tights.

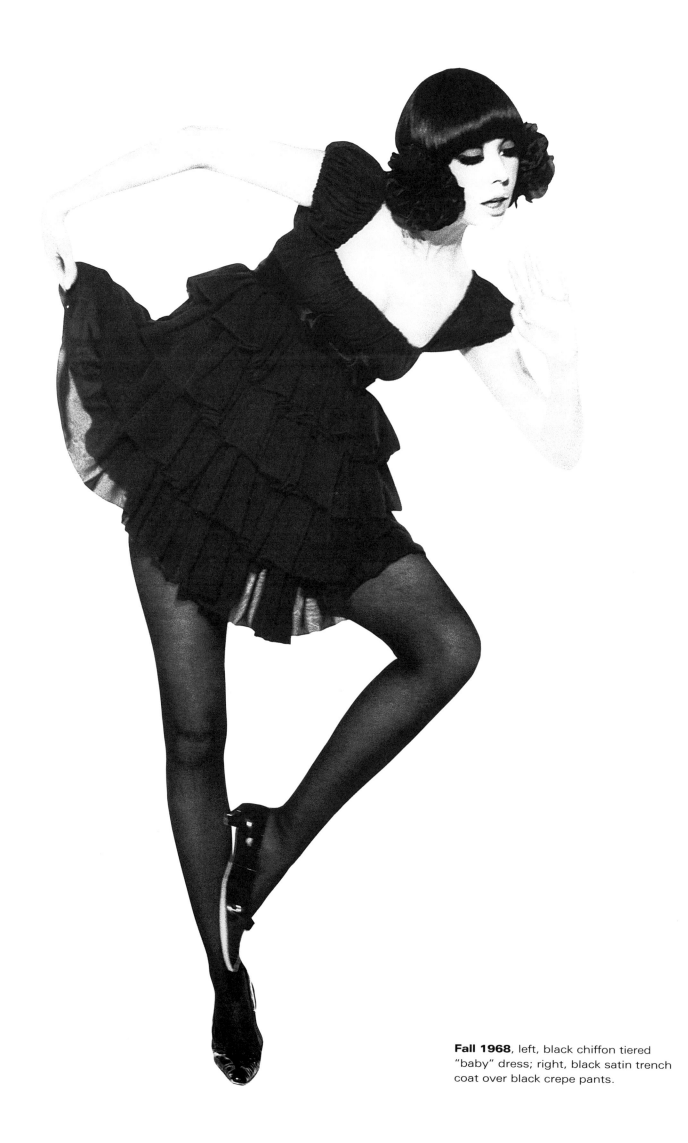

Fall **1968**, left, black chiffon tiered "baby" dress; right, black satin trench coat over black crepe pants.

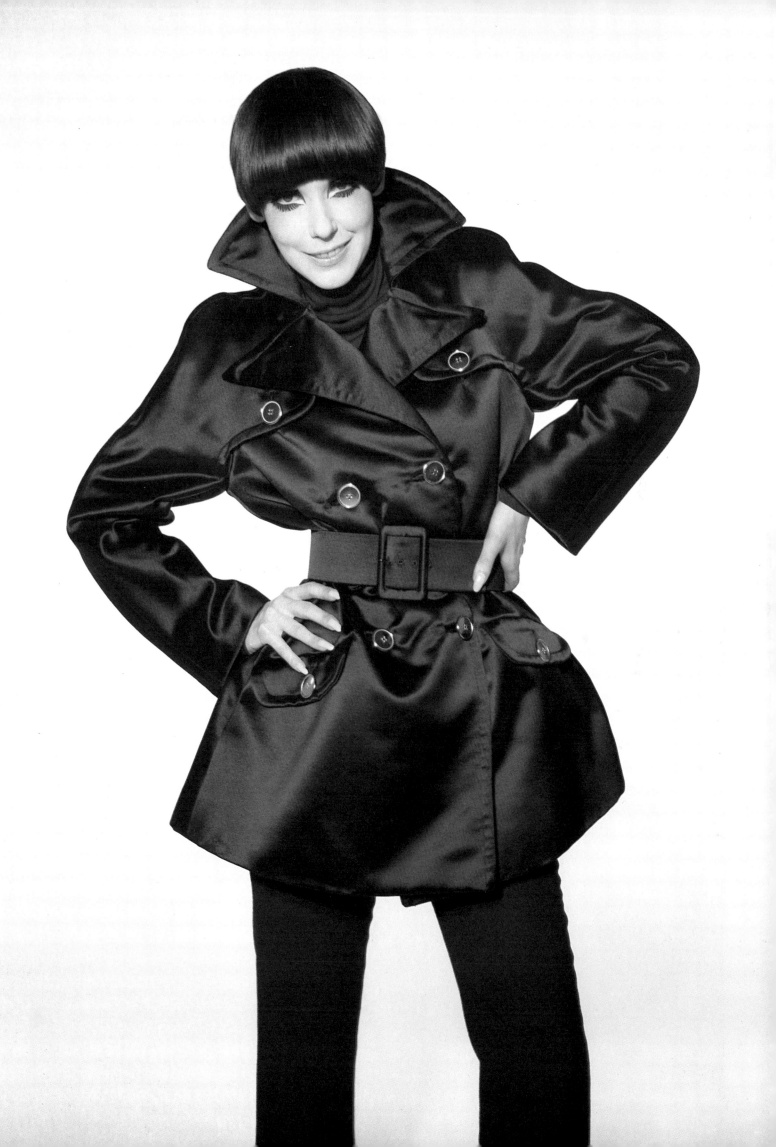

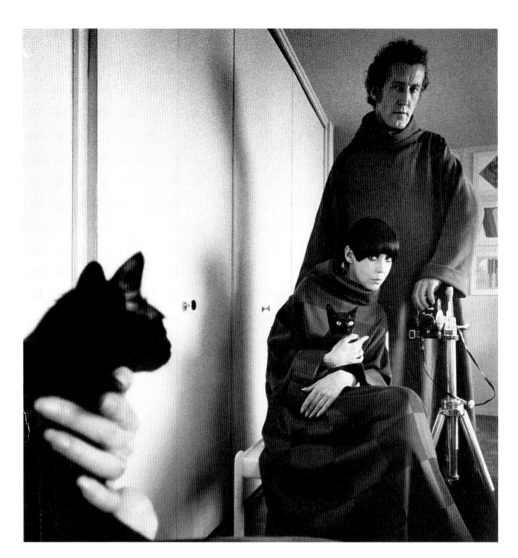

At home in New York, in 1970, right, with Bill, wearing Rudi's caftans; below, wearing a black-and-white wool-knit jumpsuit; far right, Rudi at work in Los Angeles in 1966.

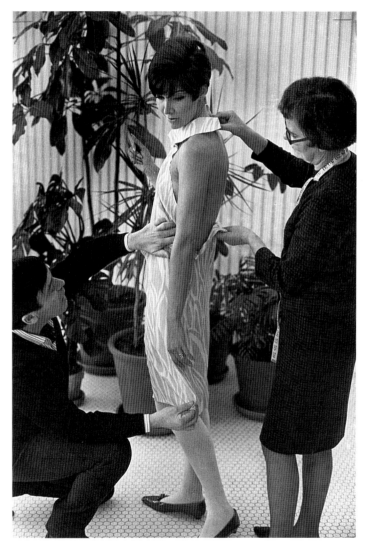

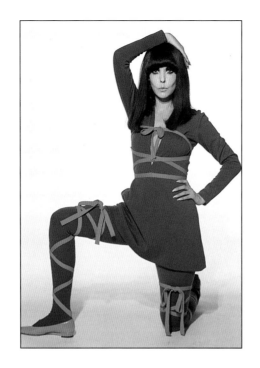

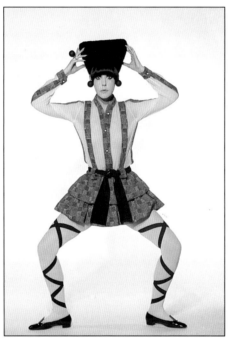

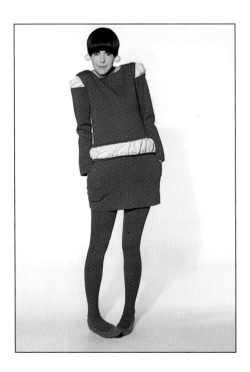

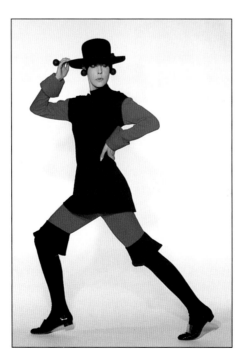

Fall 1968, above, wool-knit tunic with ties and matching tights; center, tweed tutu and tweed and chiffon shirt with elastic-tied tights; below left, Renaissance minidress with off-white inserts and matching tights; below right, wool-knit tunic and matching tights; right, sweater-knit top and pants with ruffled collar and cuffs.

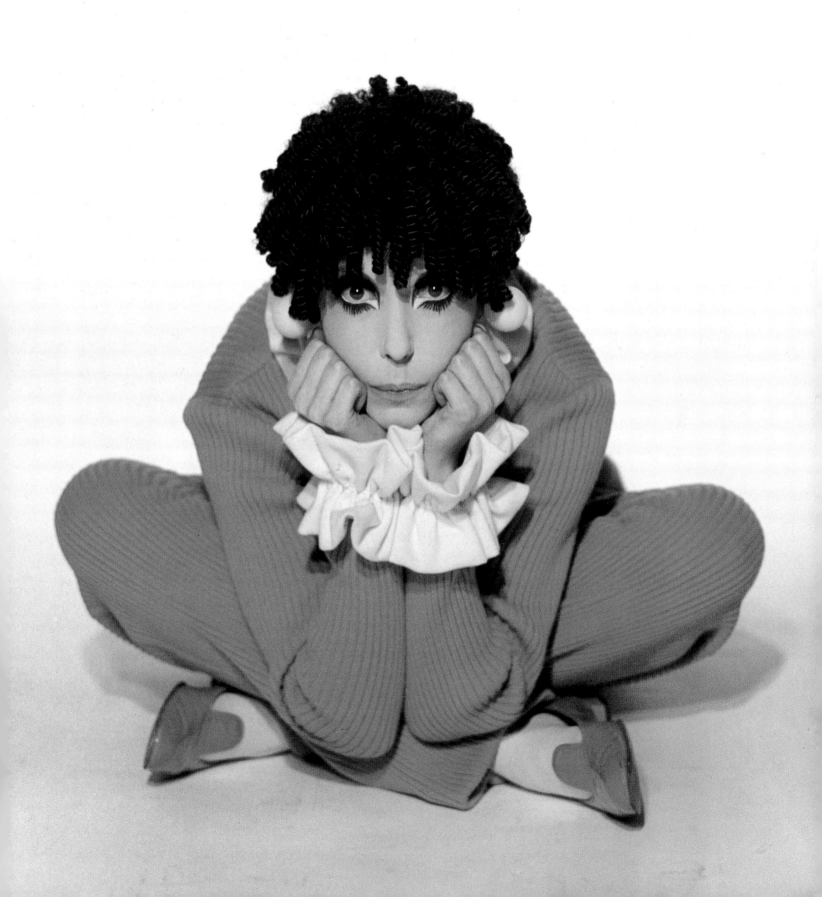

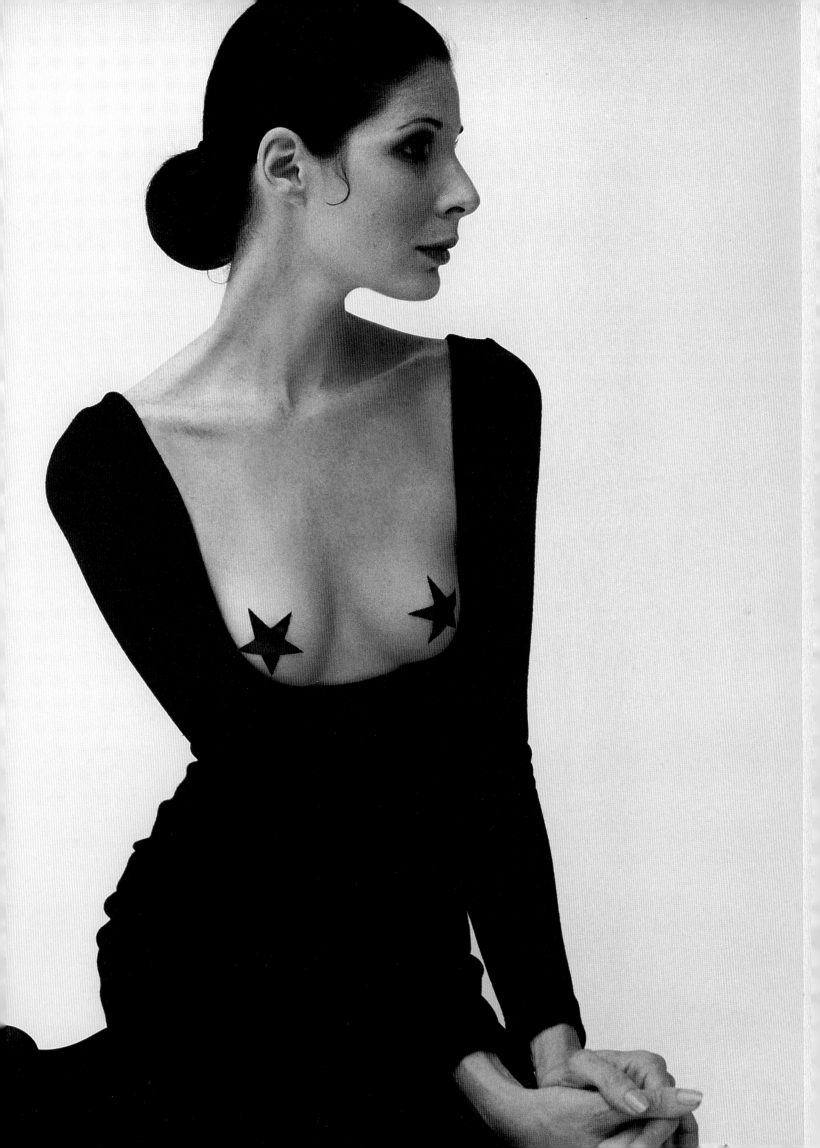

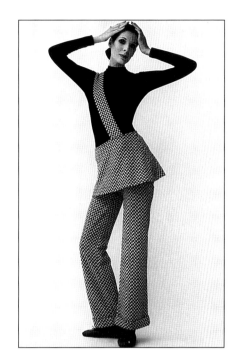

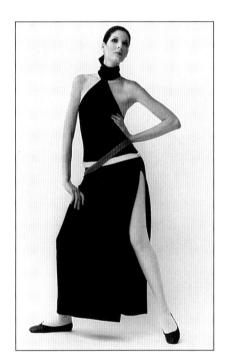

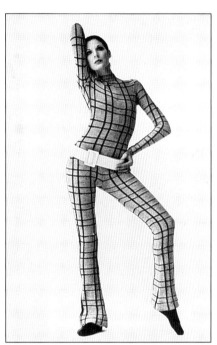

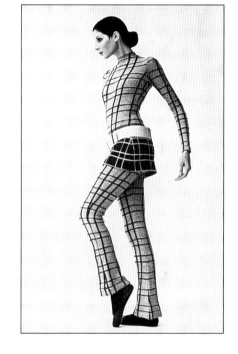

Fall 1970, knits, left, model Diana
Newman in a topless long black matte
jersey dress and decals; top, black
wool-knit jumpsuit worn with individu-
al removable pant legs and skirt with
one shoulder strap; above left, long
black wool-knit halter dress with red
and white belts; above center and
right, gray plaid wool-knit jumpsuit
and skirt. (Photographs © Patricia
Faure)

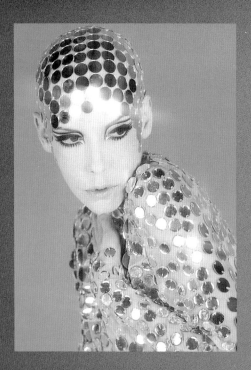

1969, nude chiffon jumpsuit paved in mirrors with mirrored skullcap and boots. The costume was designed and photographed for McCALL's magazine Christmas issue, but it never ran.

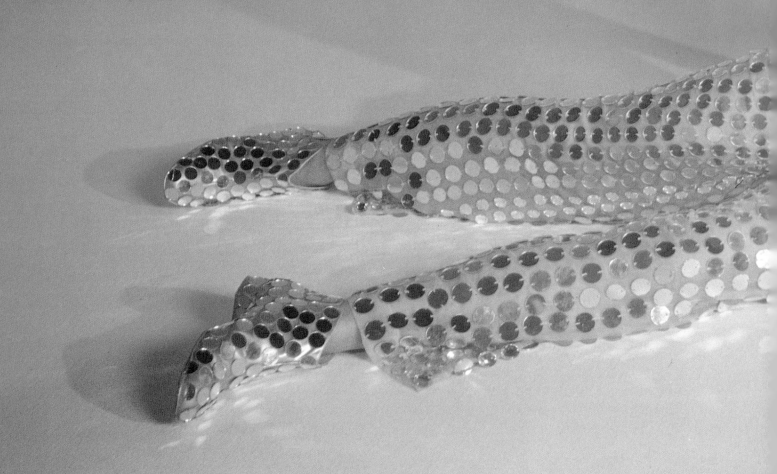

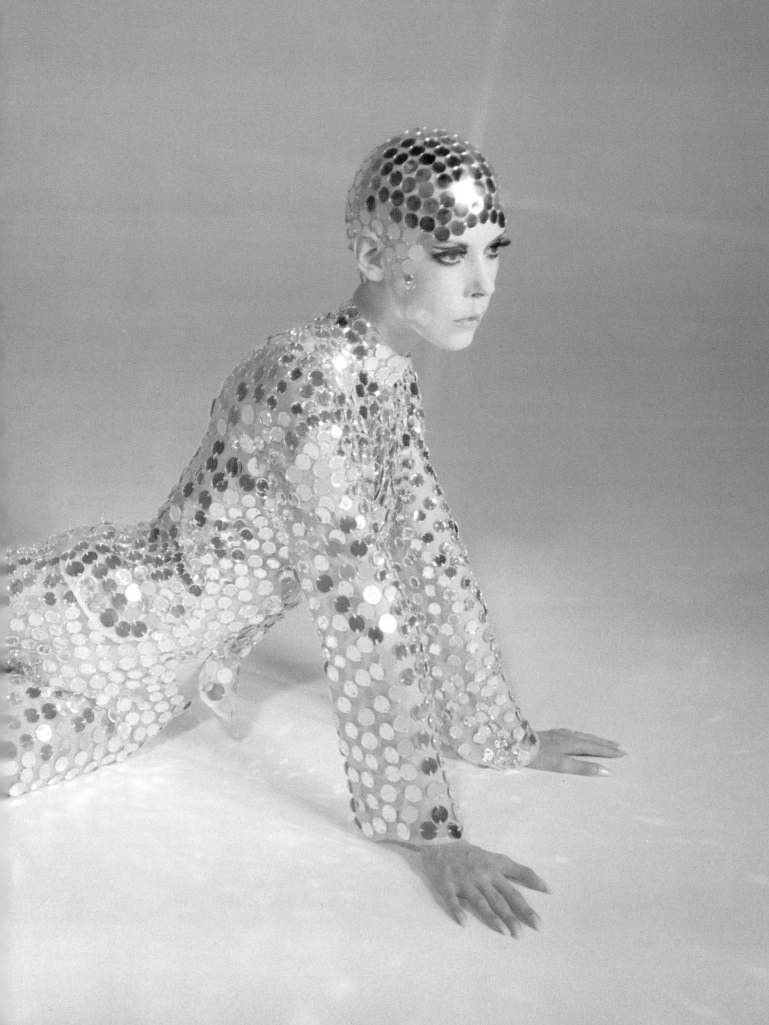

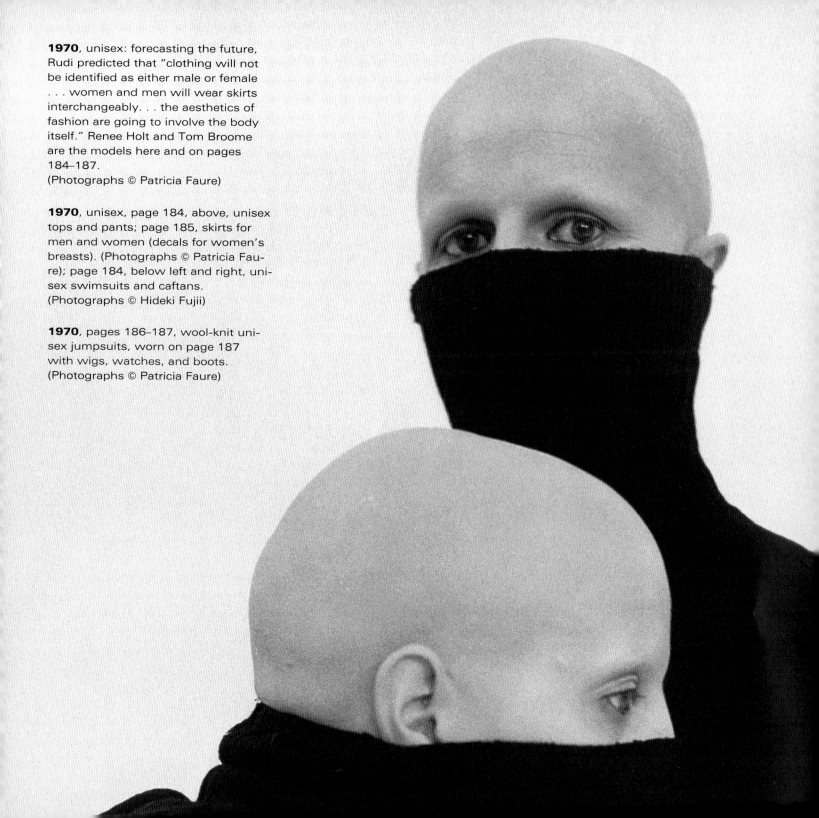

1970, unisex: forecasting the future, Rudi predicted that "clothing will not be identified as either male or female . . . women and men will wear skirts interchangeably. . . the aesthetics of fashion are going to involve the body itself." Renee Holt and Tom Broome are the models here and on pages 184–187.
(Photographs © Patricia Faure)

1970, unisex, page 184, above, unisex tops and pants; page 185, skirts for men and women (decals for women's breasts). (Photographs © Patricia Faure); page 184, below left and right, unisex swimsuits and caftans.
(Photographs © Hideki Fujii)

1970, pages 186–187, wool-knit unisex jumpsuits, worn on page 187 with wigs, watches, and boots.
(Photographs © Patricia Faure)

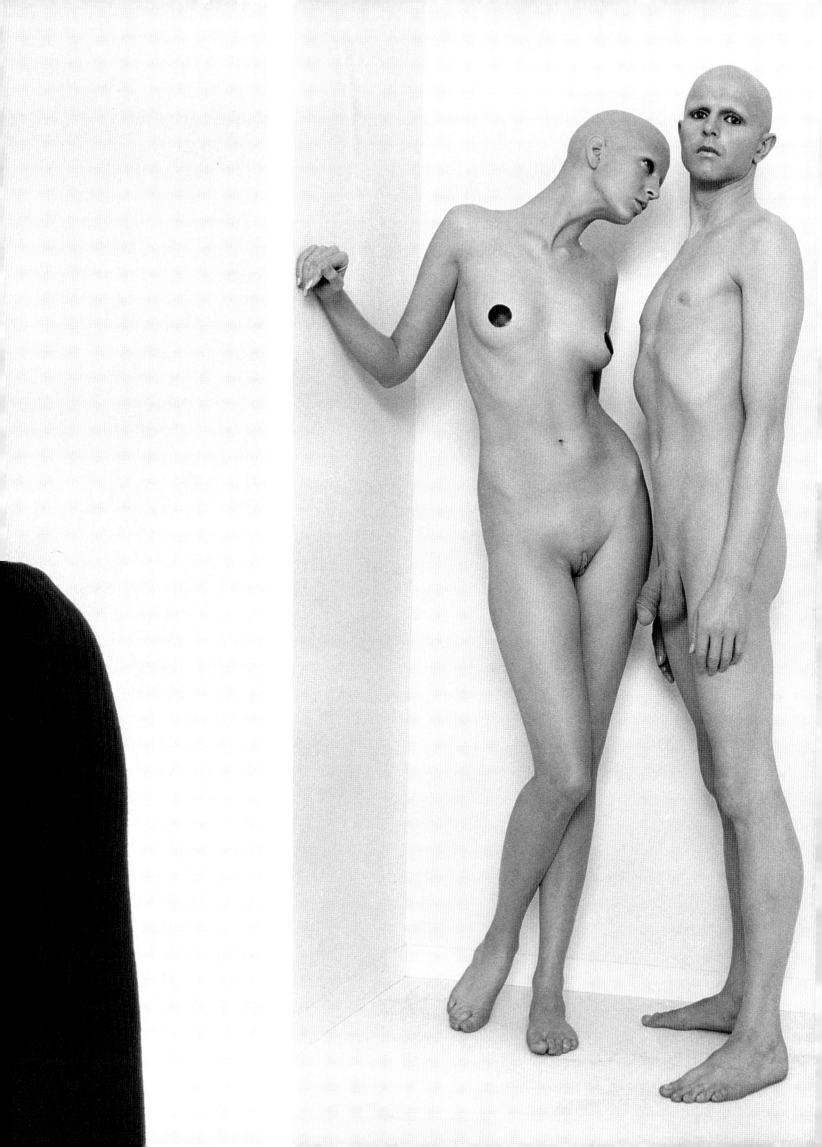

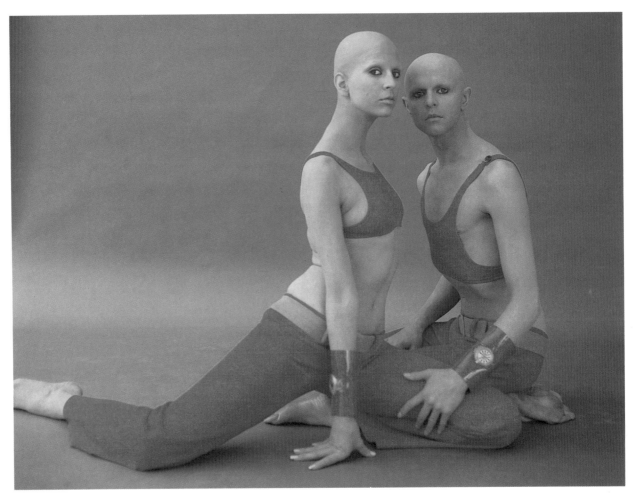

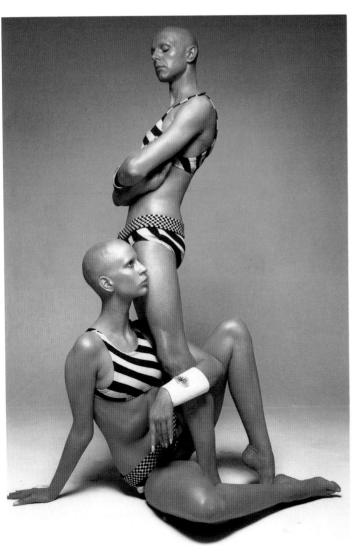

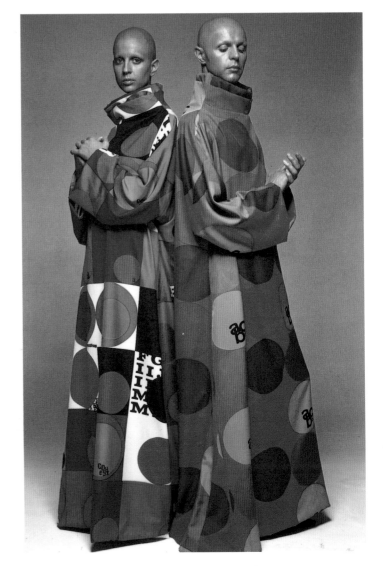

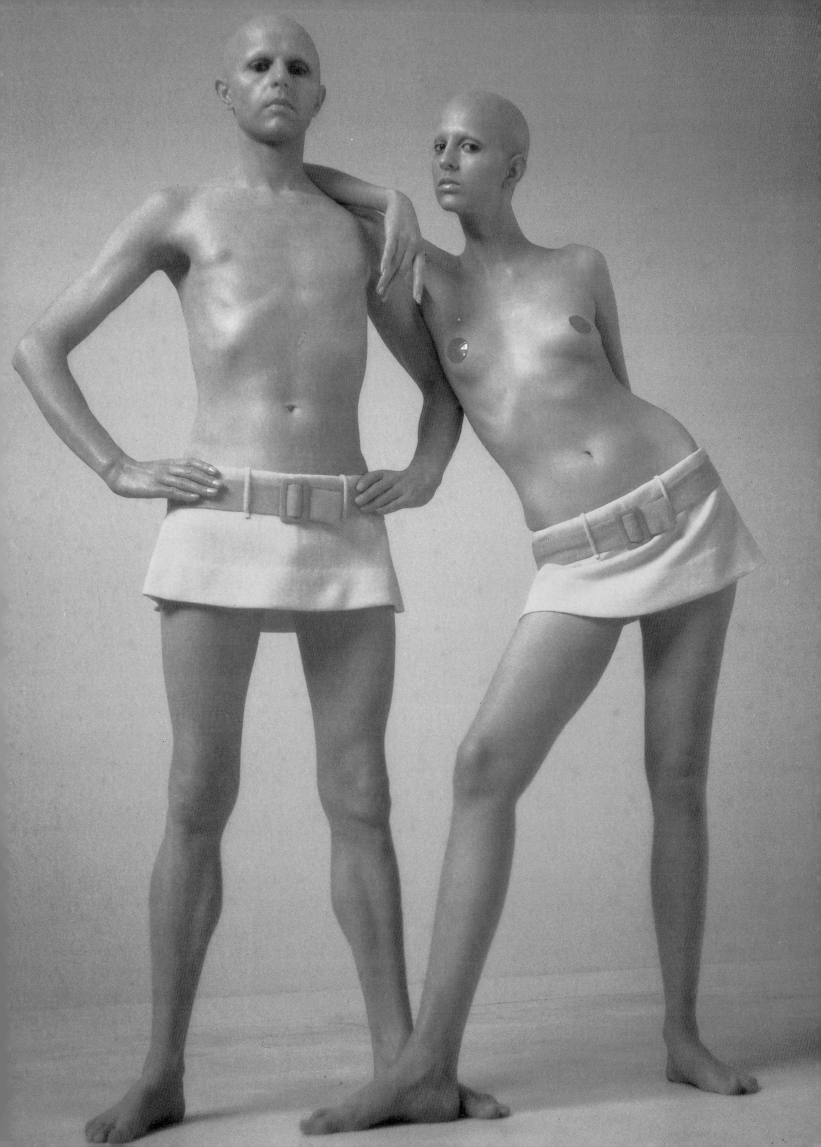

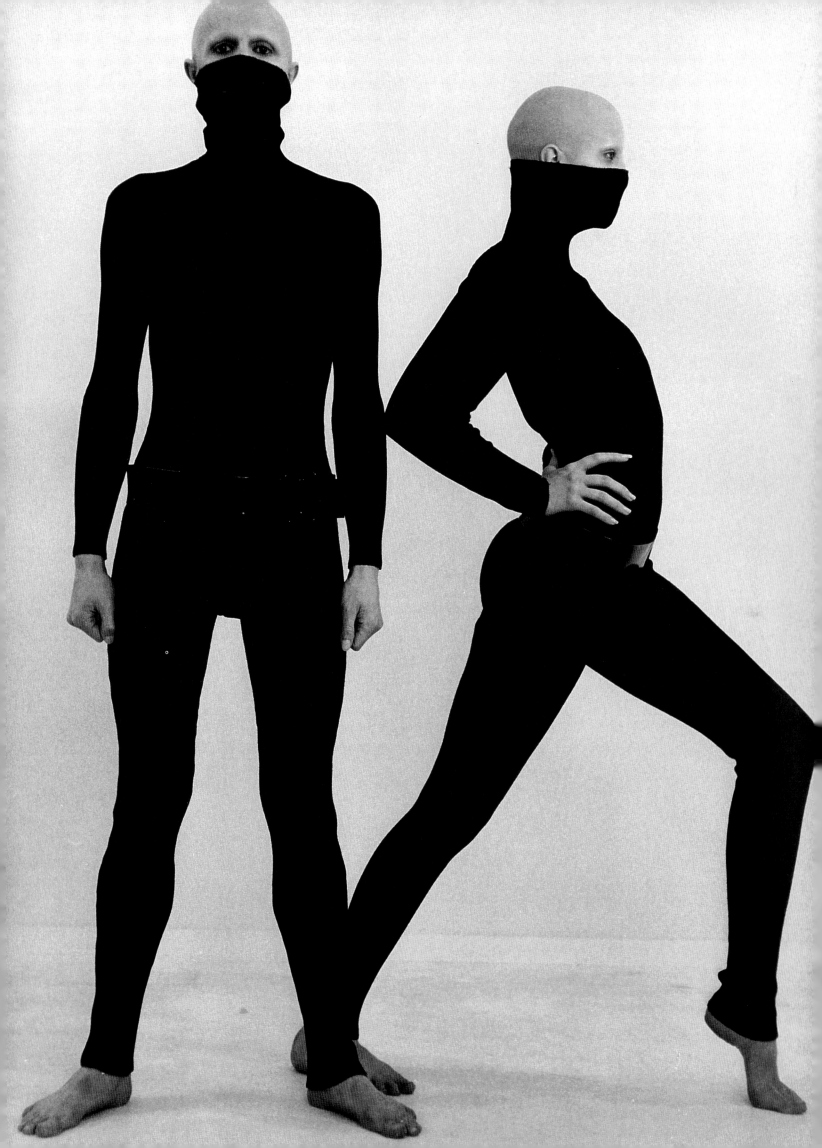

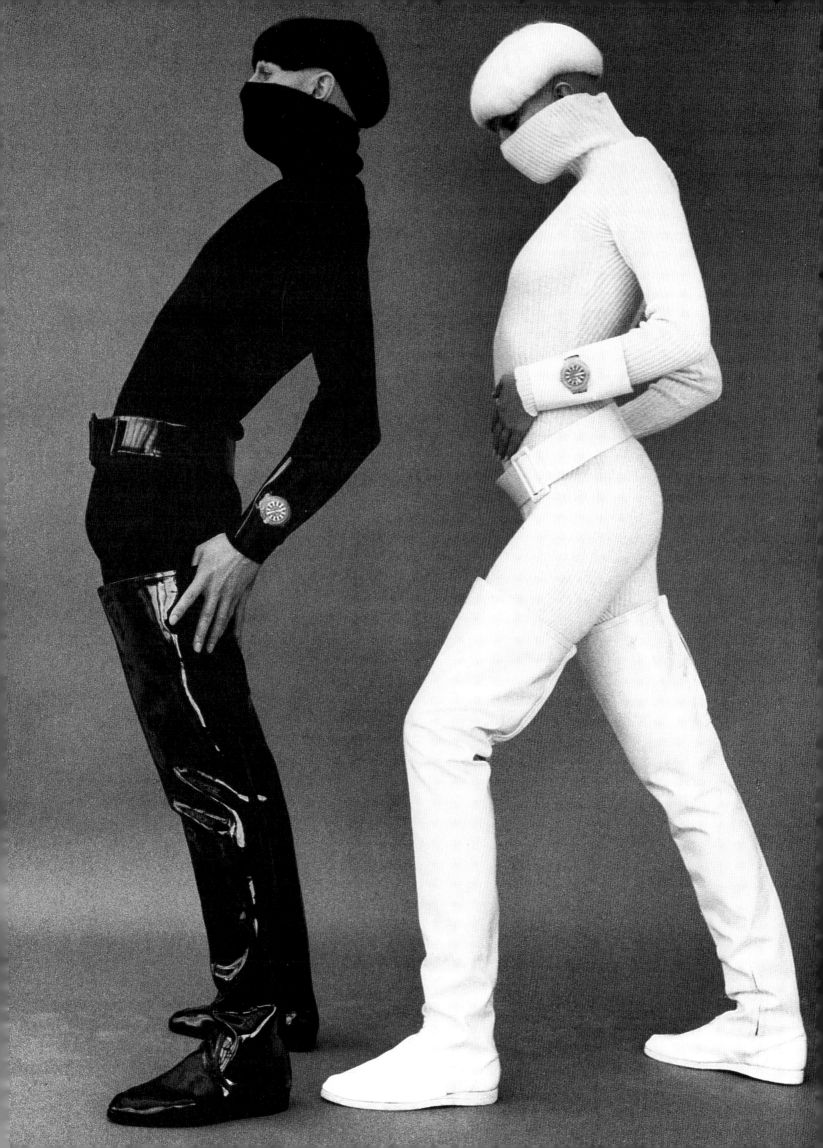

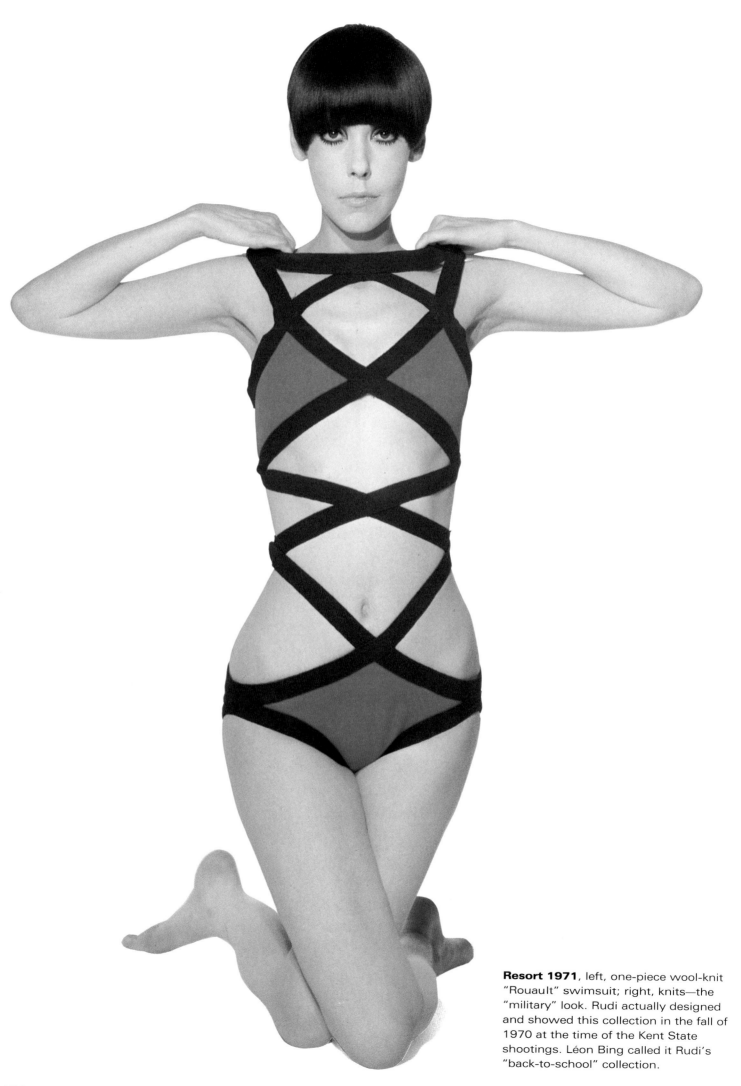

Resort 1971, left, one-piece wool-knit "Rouault" swimsuit; right, knits—the "military" look. Rudi actually designed and showed this collection in the fall of 1970 at the time of the Kent State shootings. Léon Bing called it Rudi's "back-to-school" collection.

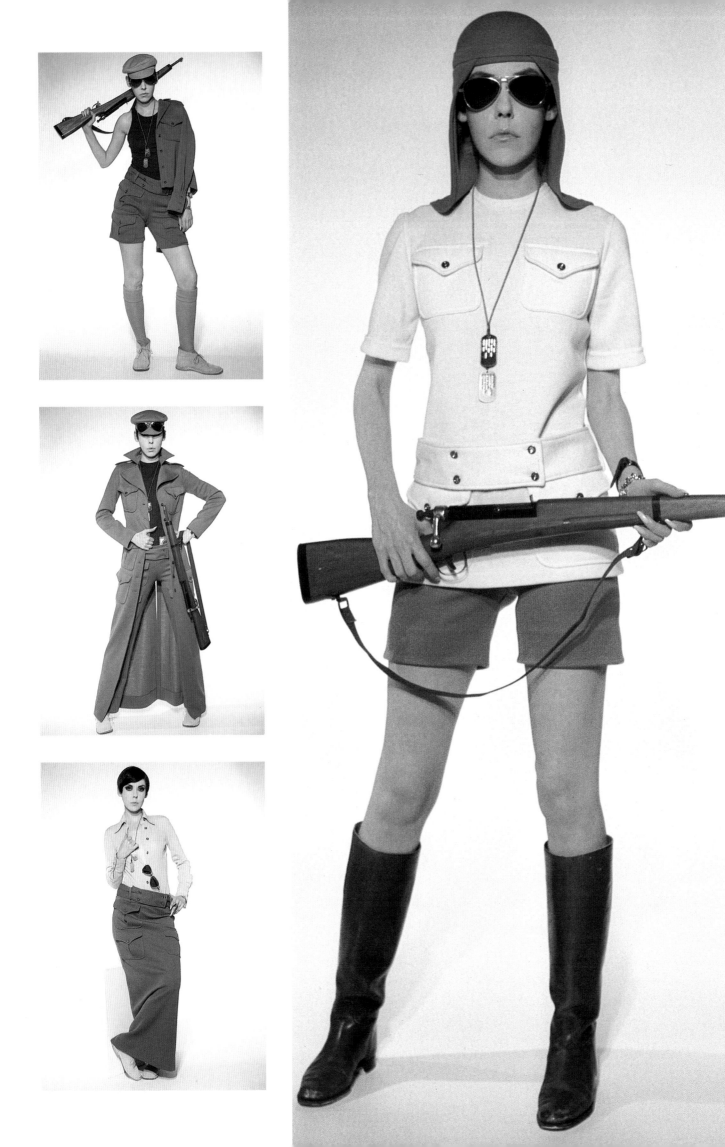

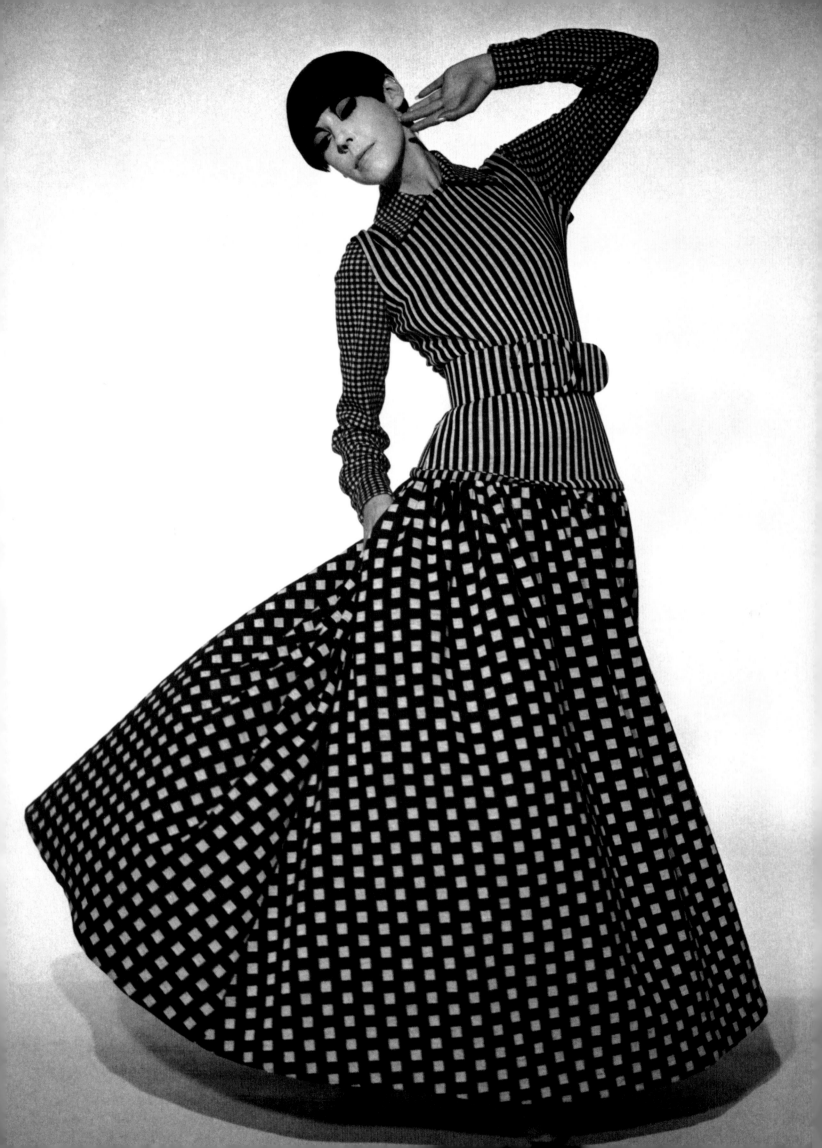

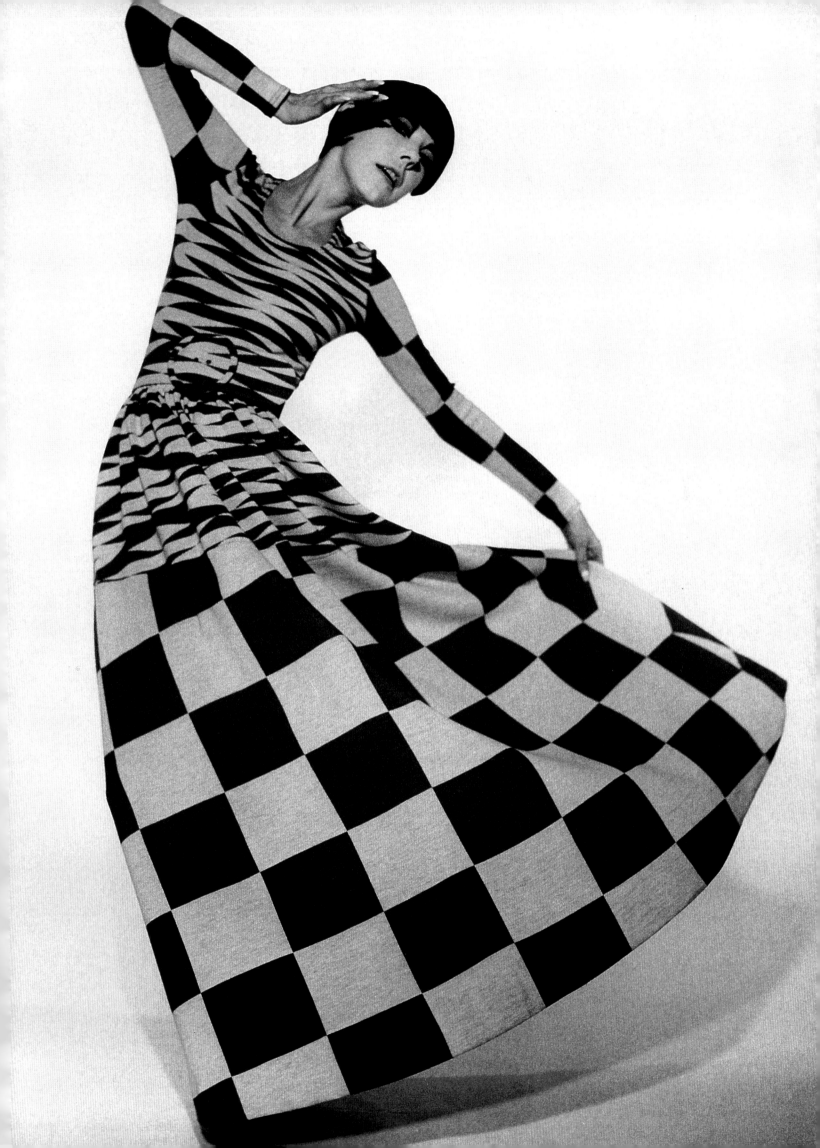

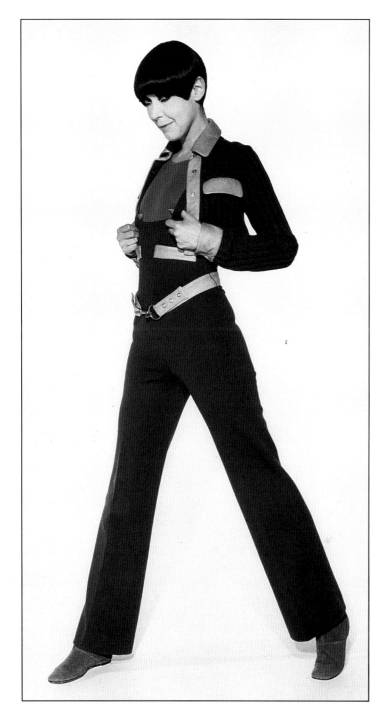
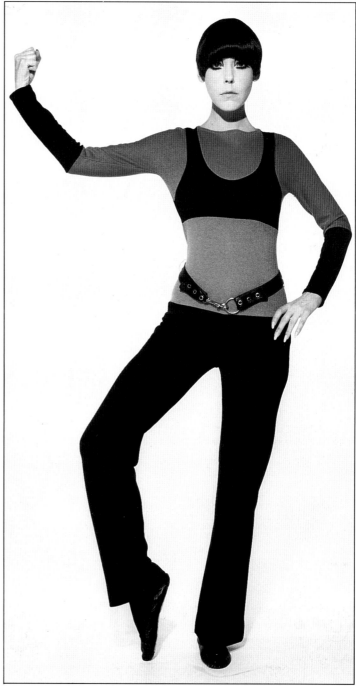

Fall 1971, preceding pages, long
black-and-white and gray-and-white
wool-knit trompe l'oeil dresses.

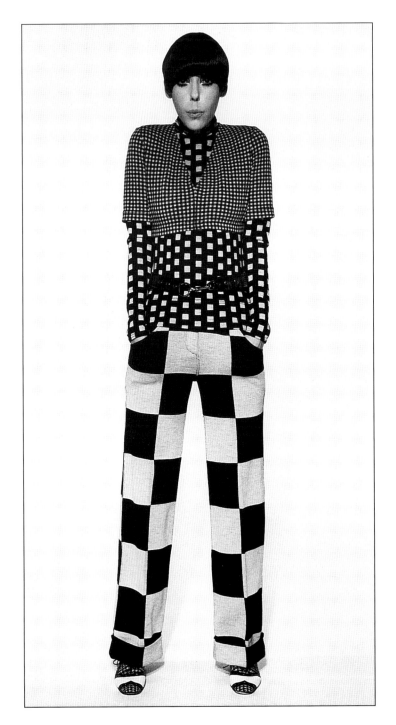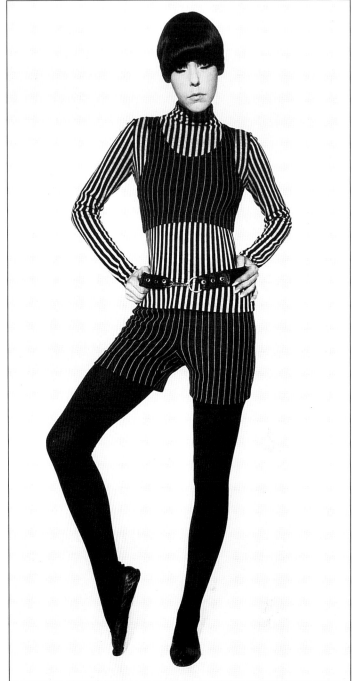

Fall 1971, far left, moss-green jacket and suspender pants trimmed in natural leather, with a moss-green matte jersey blouse; near left, taupe and black trompe l'oeil wool-knit jumpsuit; near right, three-piece black-and-white wool-knit multichecked pants outfit; far right, black-and-white wool-knit shorts, overblouse, and cropped tank top. All outfits are worn with dog leash belts.

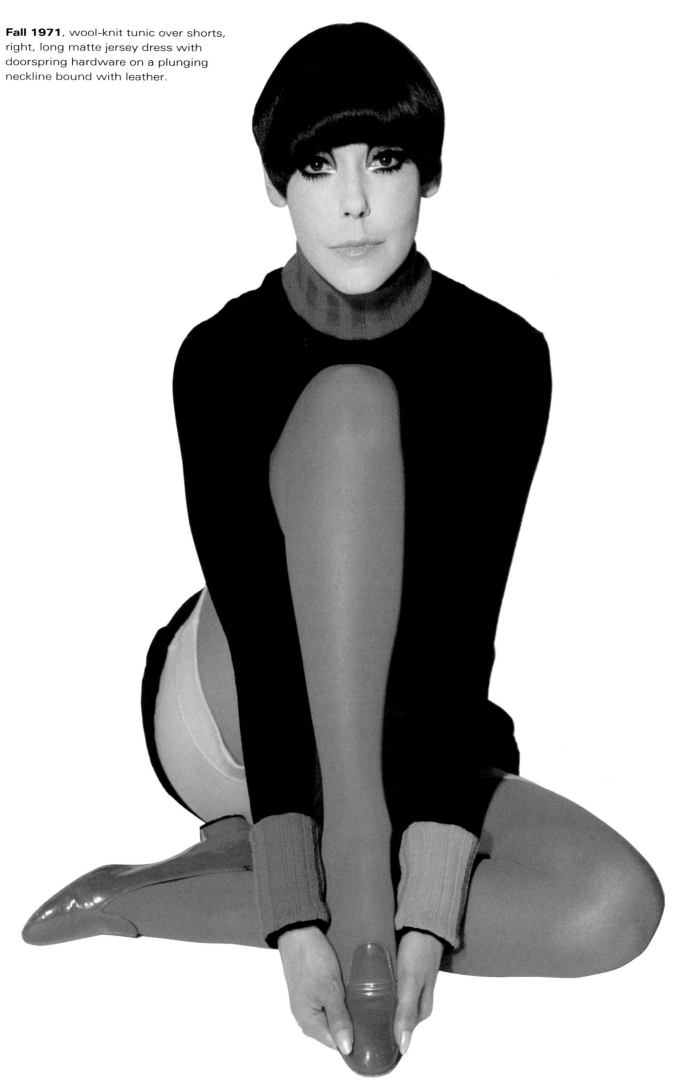

Fall 1971, wool-knit tunic over shorts, right, long matte jersey dress with doorspring hardware on a plunging neckline bound with leather.

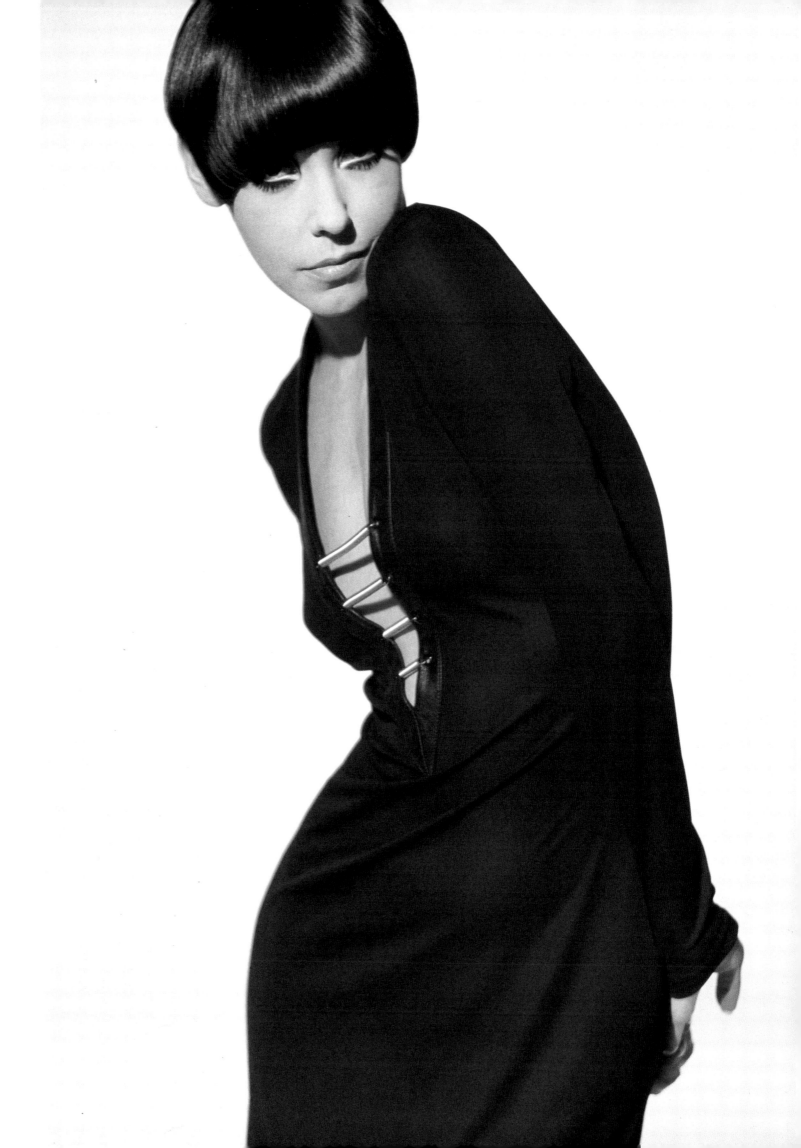

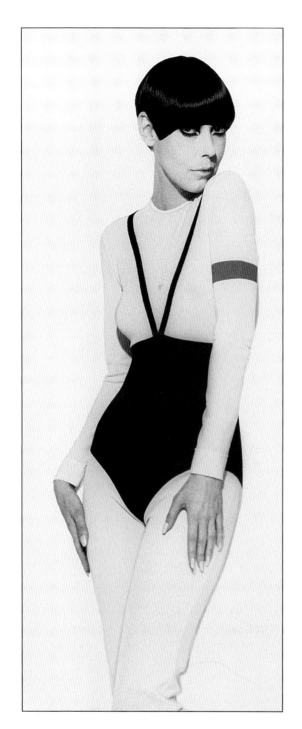

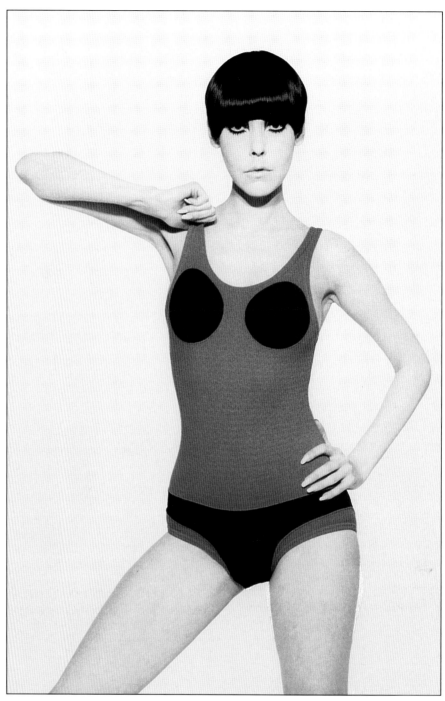

Spring/Summer 1972, far left, white matte jersey jumpsuit with "set-in" black wool-knit topless swimsuit and red band on sleeve (I called it The Red Badge of Courage); near left, one-piece red and black wool-knit trompe l'oeil swimsuit; near right, black wool-knit swimsuit on its way to the pubikini (designed so that the bra top and bottom could not be buttoned); far right, abstracted "message" T-shirt in black, white, and poison green matte jersey with black matte jersey shorts; below, long black matte jersey T-shirt with white inserts mimicking fabric folds.

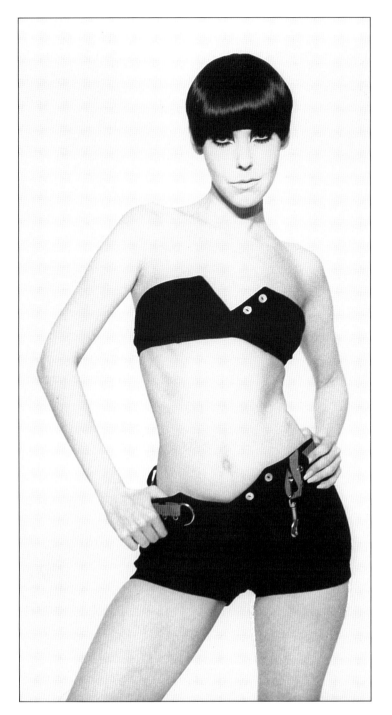
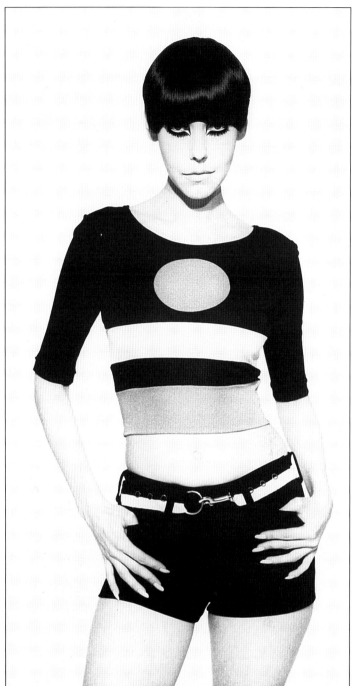
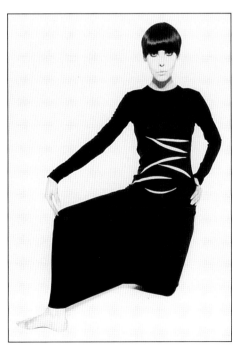

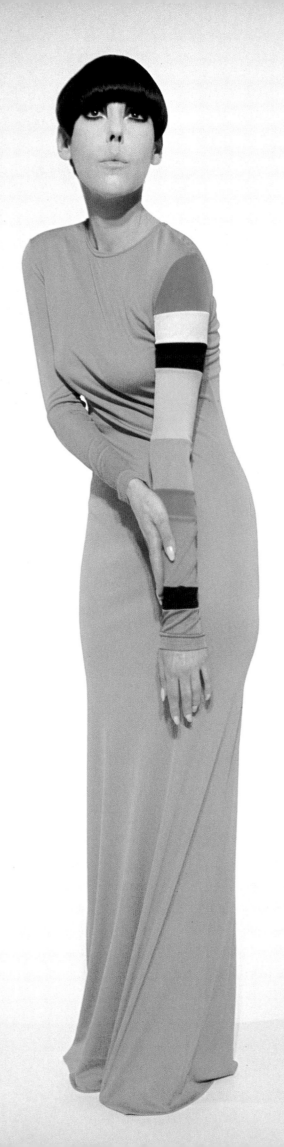
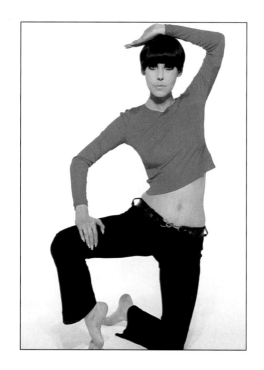
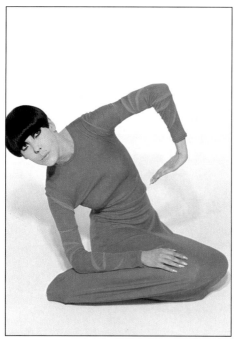
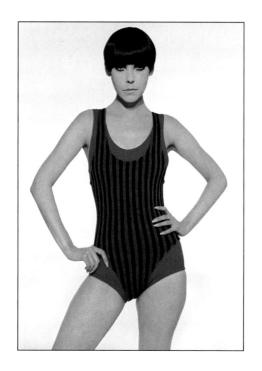

Spring/Summer 1972, far left, long poison green matte jersey T-shirt with one multicolor and one green sleeve; above, near left, black matte jersey jeans with cropped red T-shirt with hot pink inserts; center, near left, hot pink long matte jersey T-shirt with orange inserts; below, near left, red, purple, and black trompe l'oeil wool-knit swimsuit.

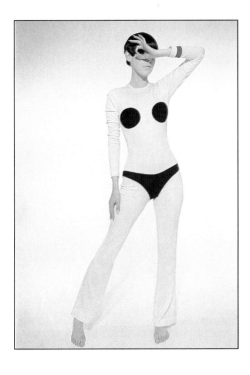

Spring/Summer 1972, right, long orange matte jersey T-shirt with hot pink insert on one sleeve; above, black-and-white matte jersey trompe l'oeil jumpsuit with wool-knit inserts.

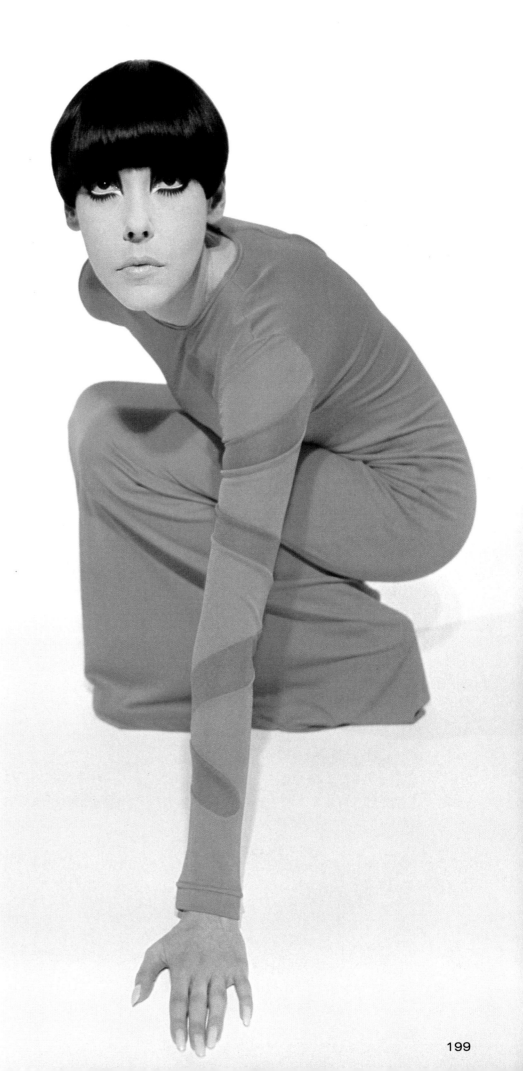

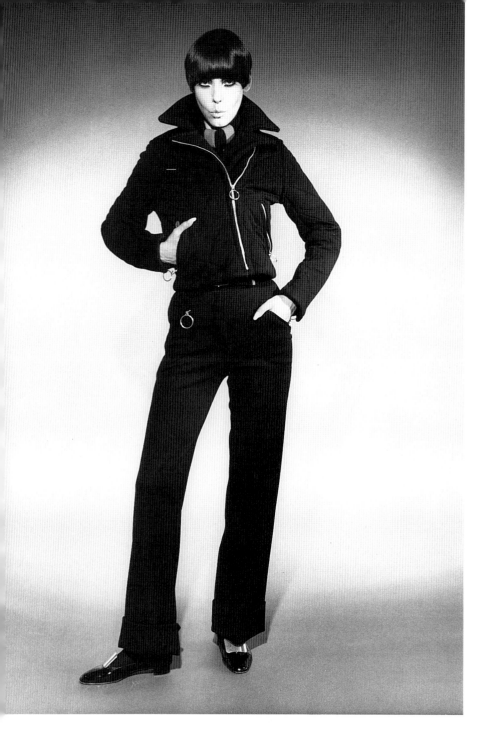

Fall 1972, above, quilted wool-knit
motorcycle jacket in black lined in red;
right, quilted black wool-knit midi coat
lined in mulberry with mulberry wool-
knit pants.

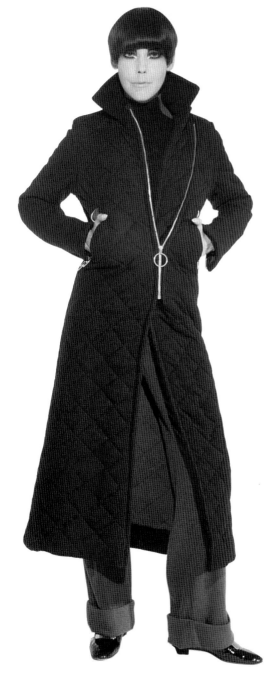

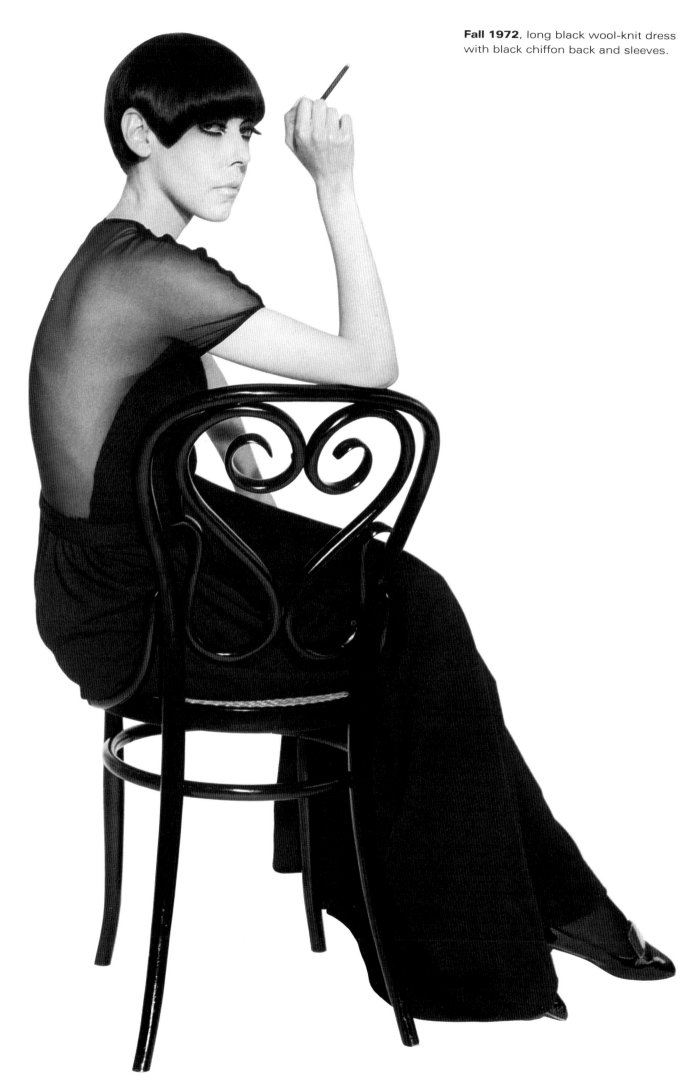

Fall 1972, long black wool-knit dress with black chiffon back and sleeves.

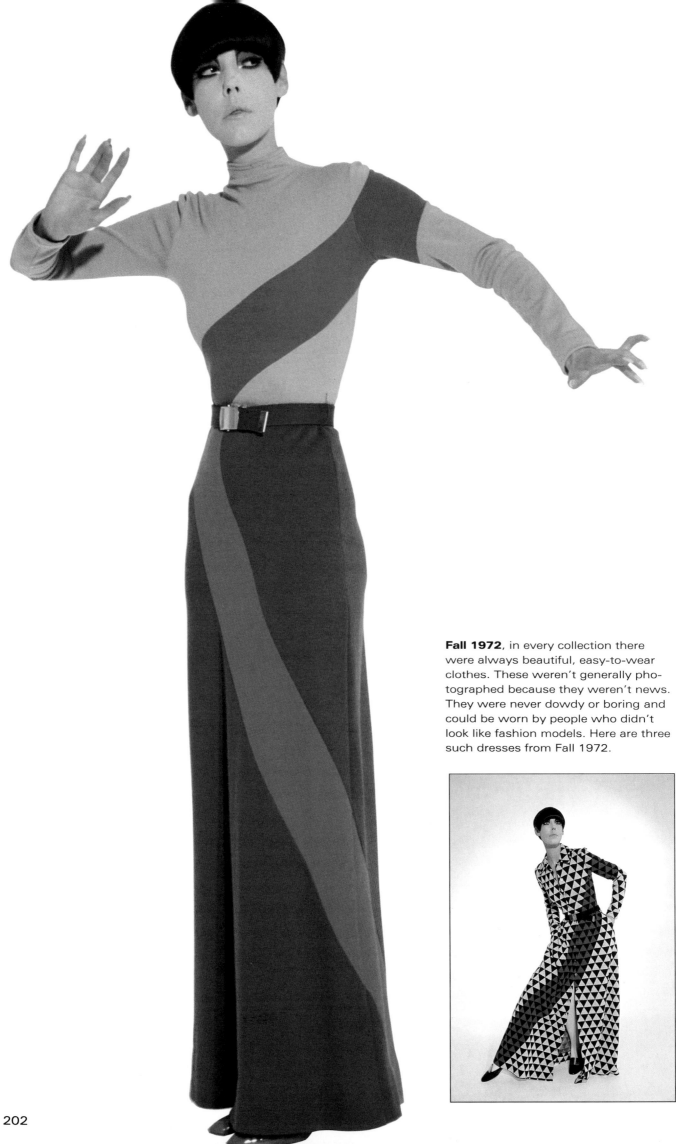

Fall 1972, in every collection there were always beautiful, easy-to-wear clothes. These weren't generally photographed because they weren't news. They were never dowdy or boring and could be worn by people who didn't look like fashion models. Here are three such dresses from Fall 1972.

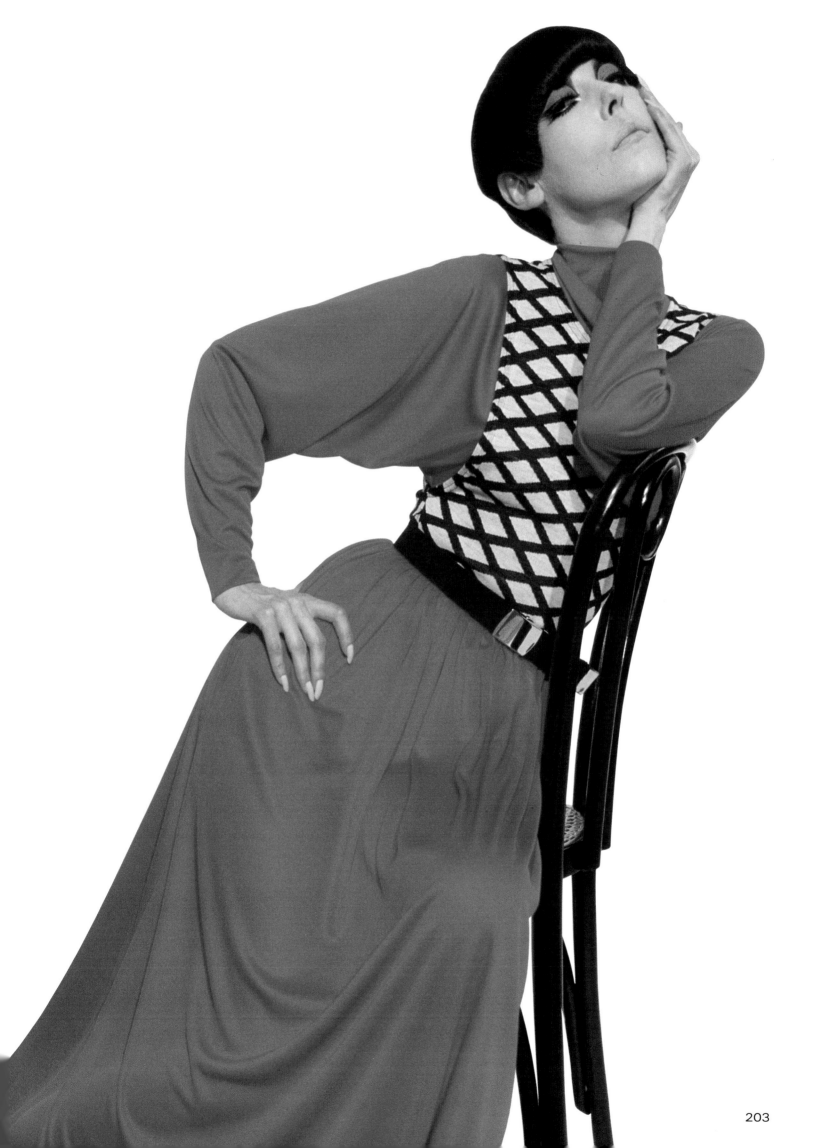

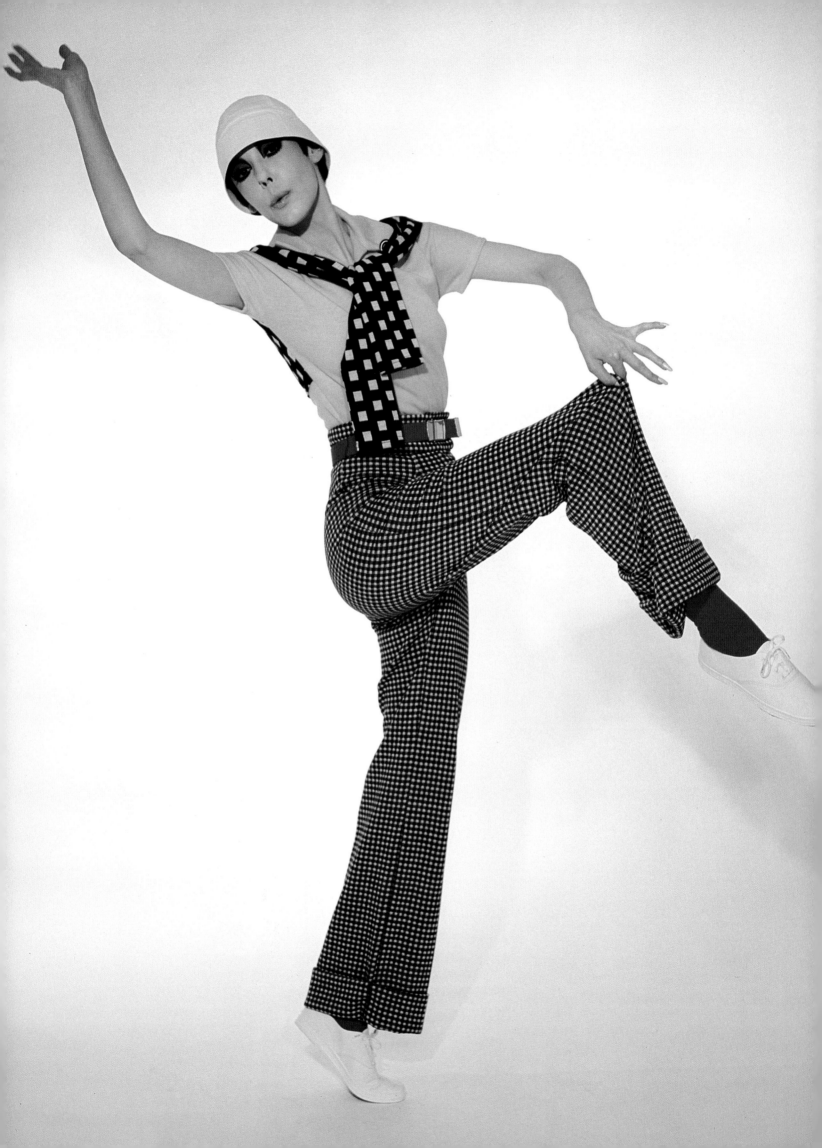

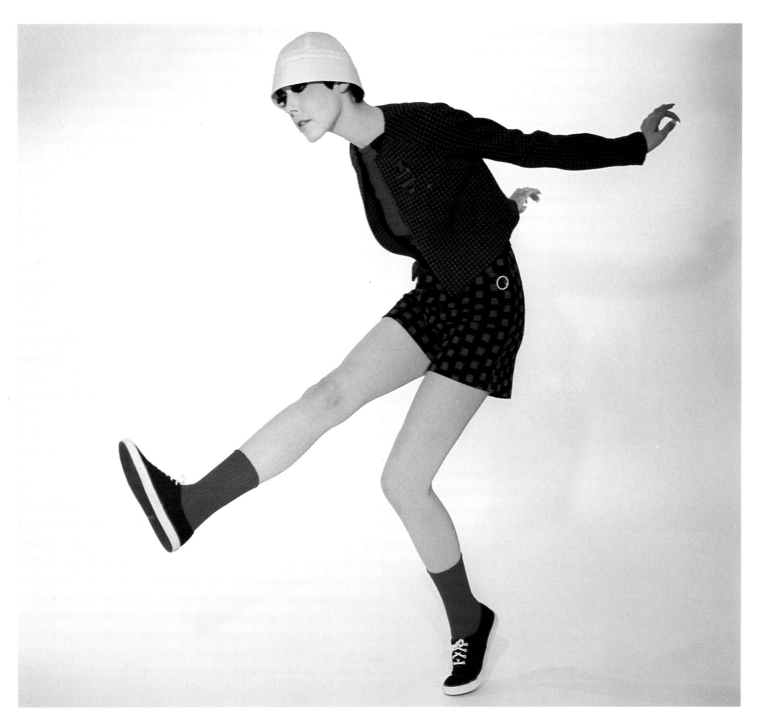

Spring/Summer 1973, pages
204–208, wool knits. On the left is
Rudi's spoof of Halston: a mock cardi-
gan sewn into a blouse.

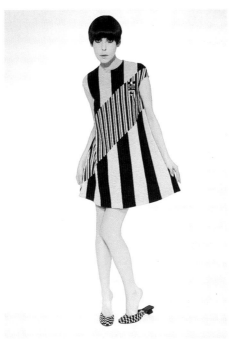

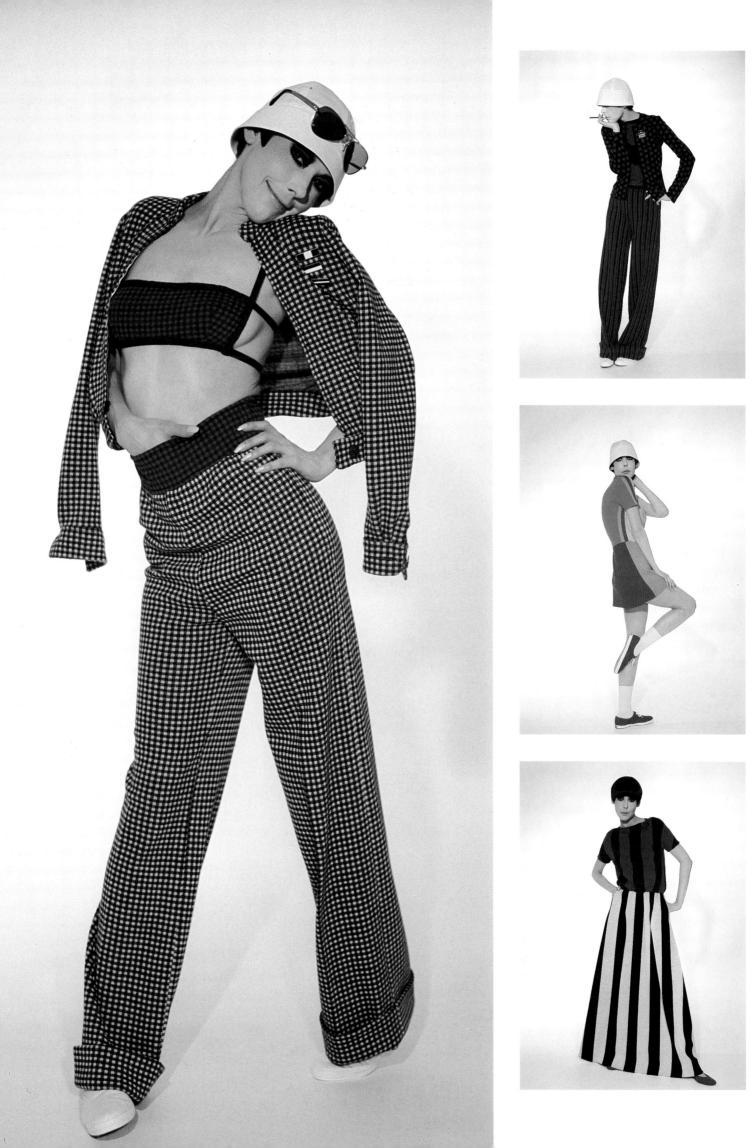

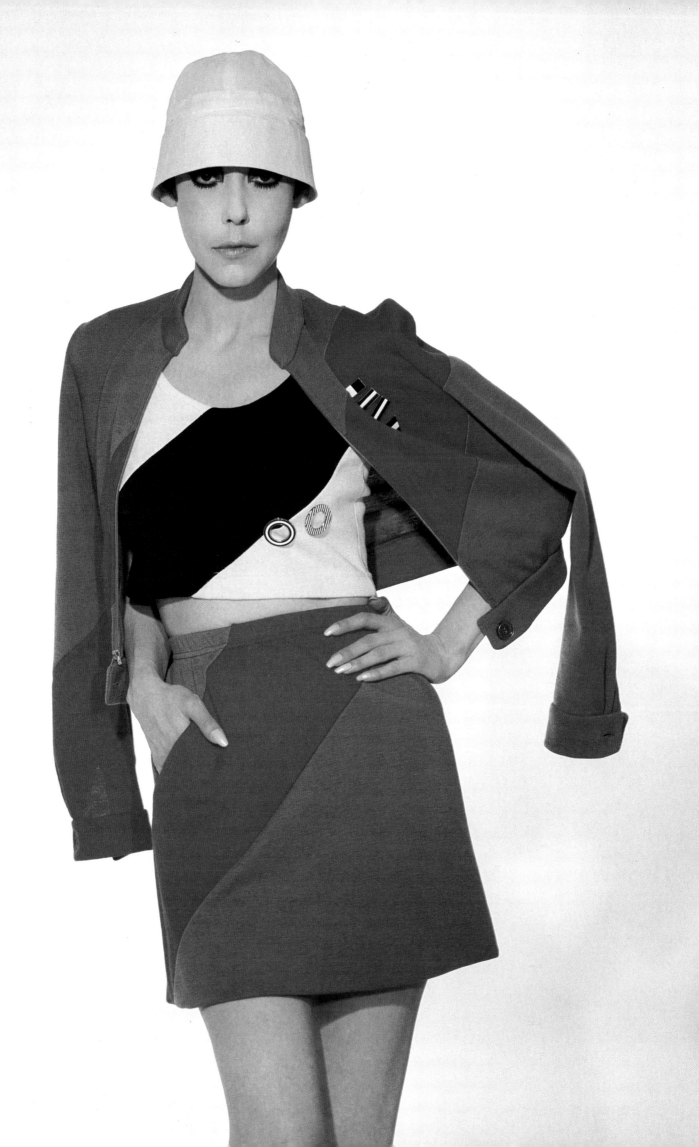

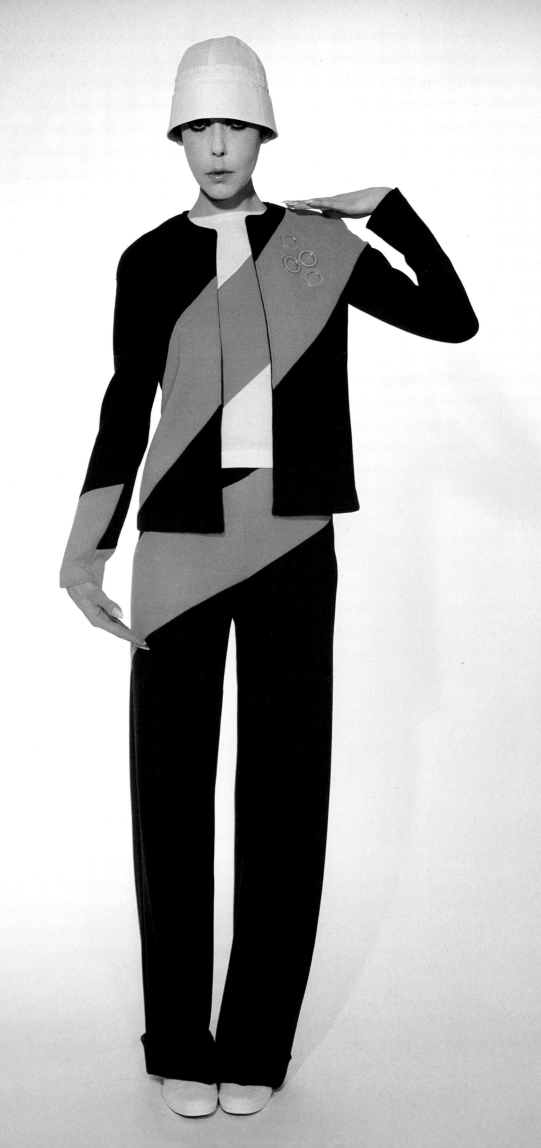

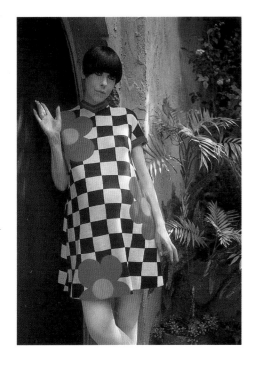

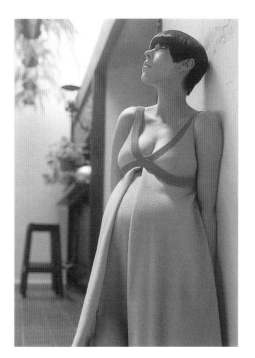

Fall 1973, a week before my son's birth. Rudi had several loose dresses in this collection, which I wore as maternity dresses. The checkerboard-and-flower dress has been copied countless times. The green and pink "cross-my-heart" dress was originally designed in the 1960s and proved so popular that it was often included in subsequent lines.

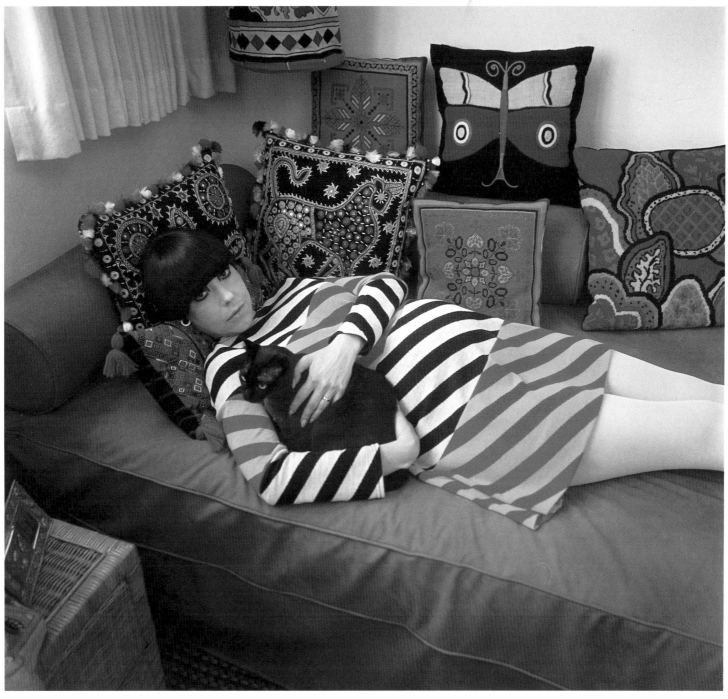

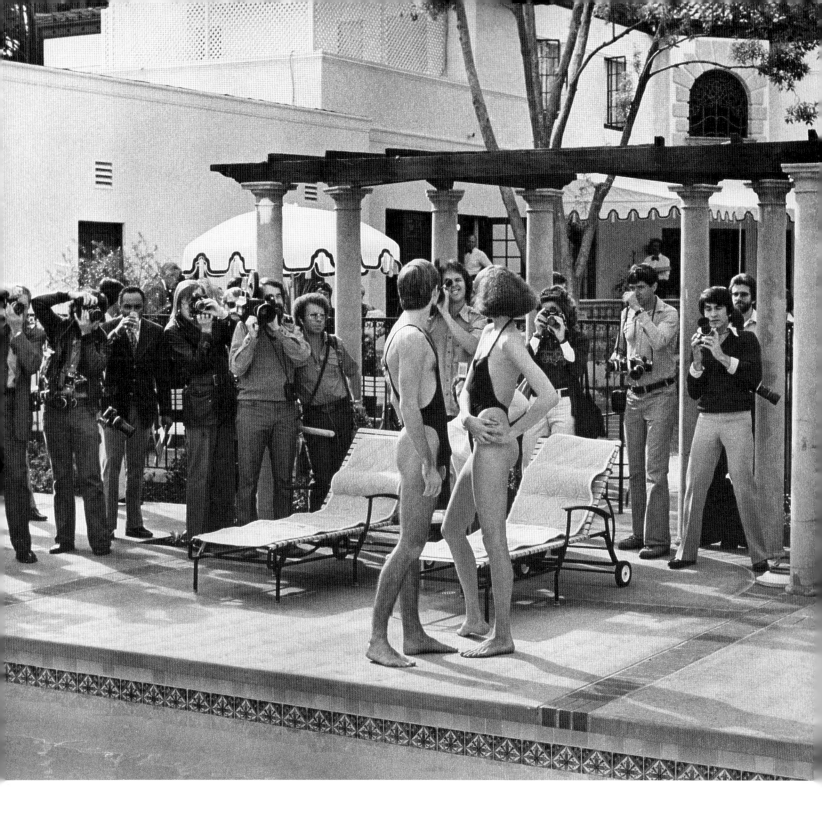

1974, the thong, left, media frenzy as Vidal Sassoon introduces the "thong" haircut at his home; below, Rudi with Vidal and thong models. Rudi's thong has since become a generic swimsuit design. (But in 1991 local authorities across America were still outlawing the thong from being worn on their beaches.); overleaf, the thong in its natural habitat.

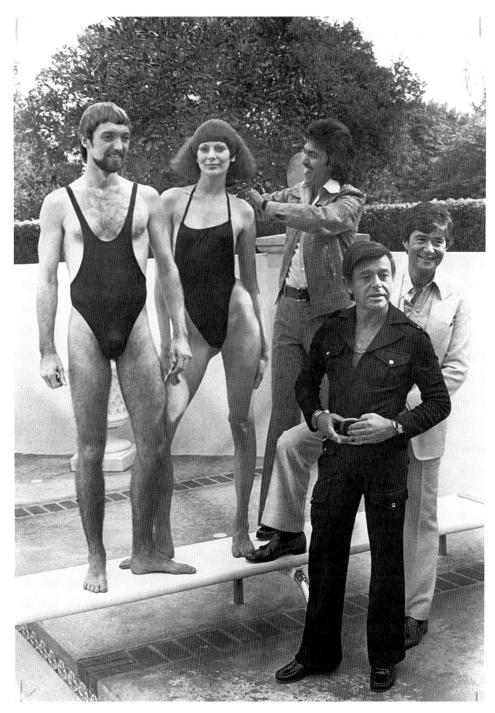

Spring 1975, black matte jersey dresses and pants and top connected to sculptured aluminum jewelry made by Christopher Den Blaker. The hat is black chiffon and aluminum.

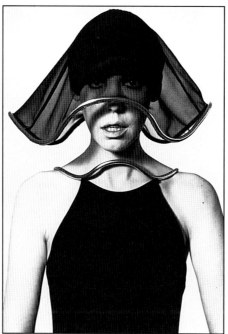

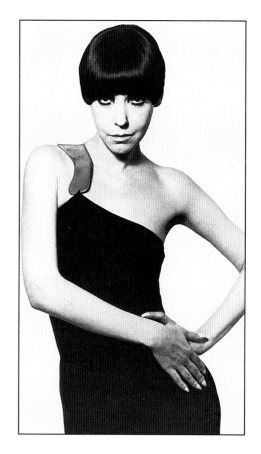

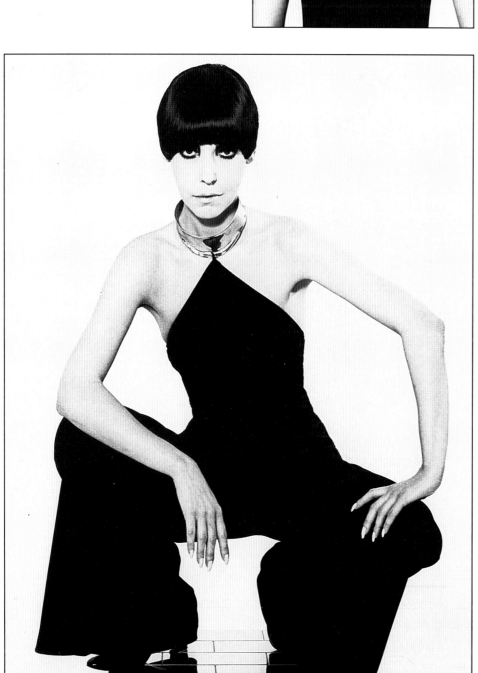

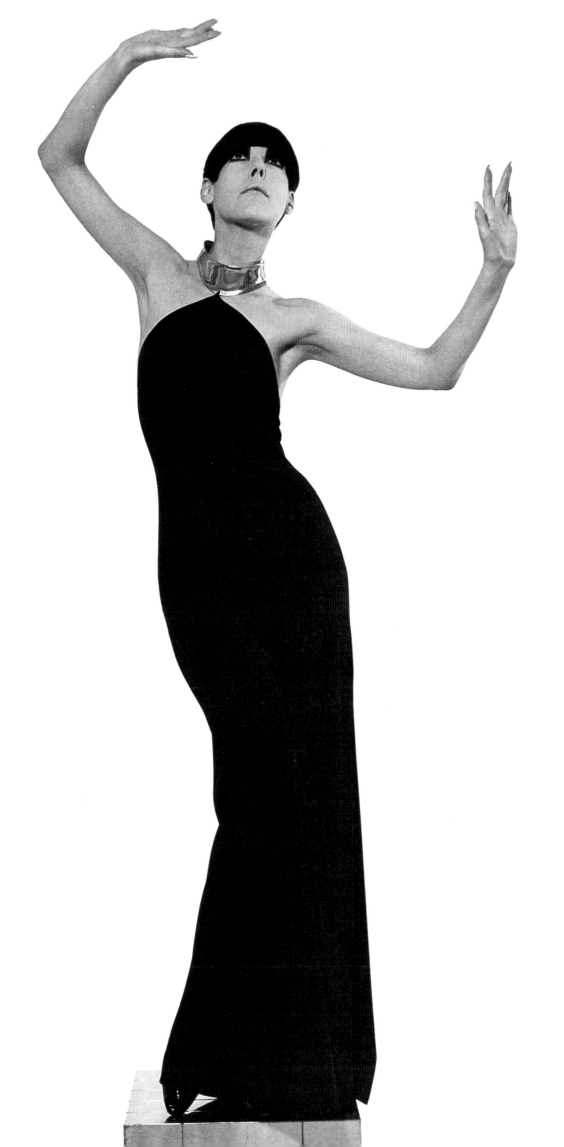

1976, Rudi designed the costumes for
several ballets by Bella Lewitsky.
These are from INSCAPE.
(Photographs © Dan Esgro)

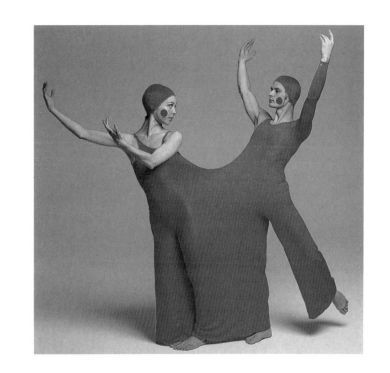

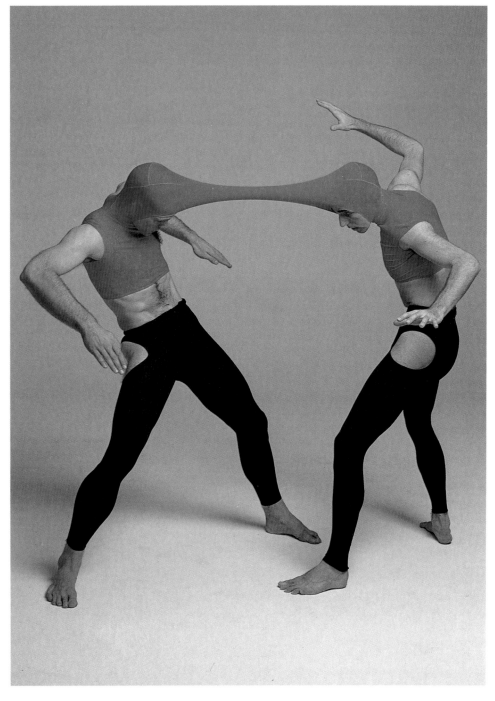

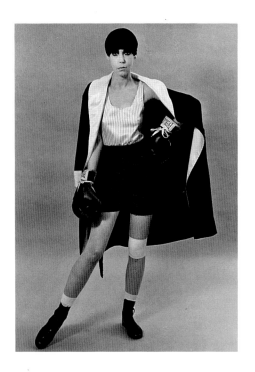

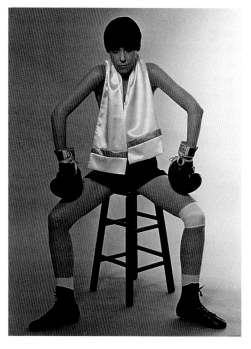

1976, intimate apparel collection designed for Lily of France, upper left, black-and-white satin boxer jumpsuit and fighter's robe; upper right, satin boxer jumpsuit and white satin towel; below, jockey shorts for women; right, boxer shorts and shirt in men's shirting.

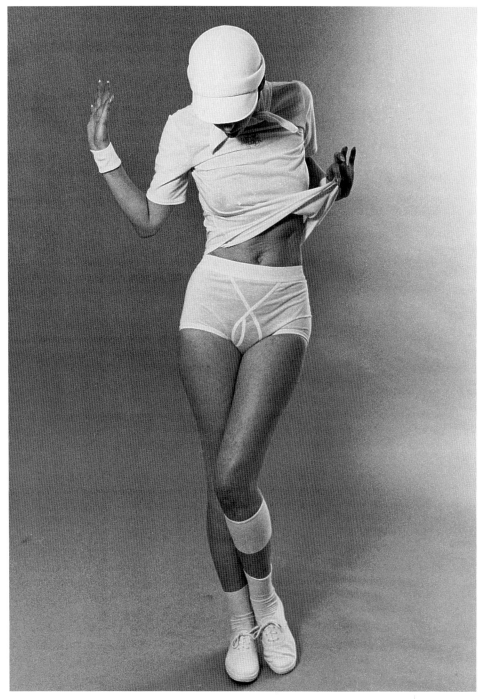

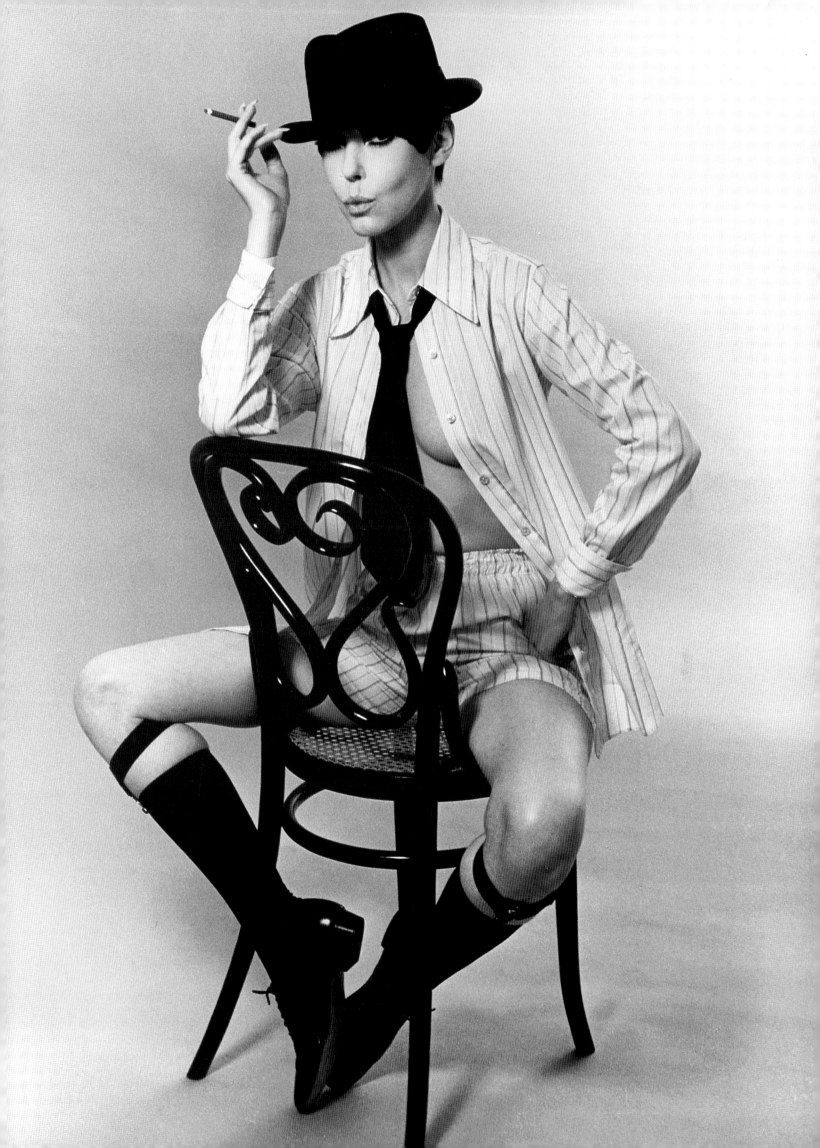

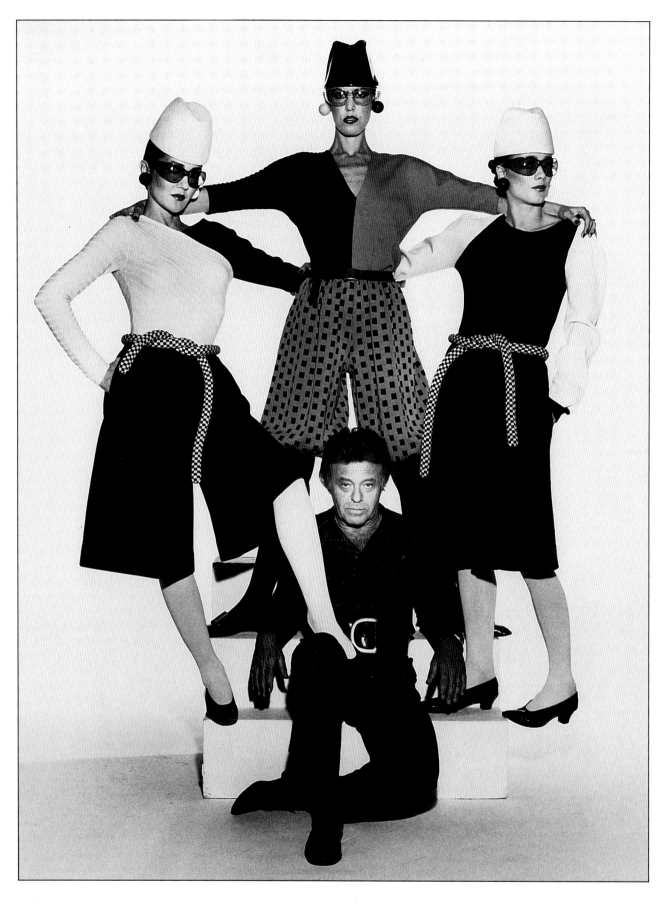

1981, Rudi with his last collection.
(Photograph © Tony Costa)

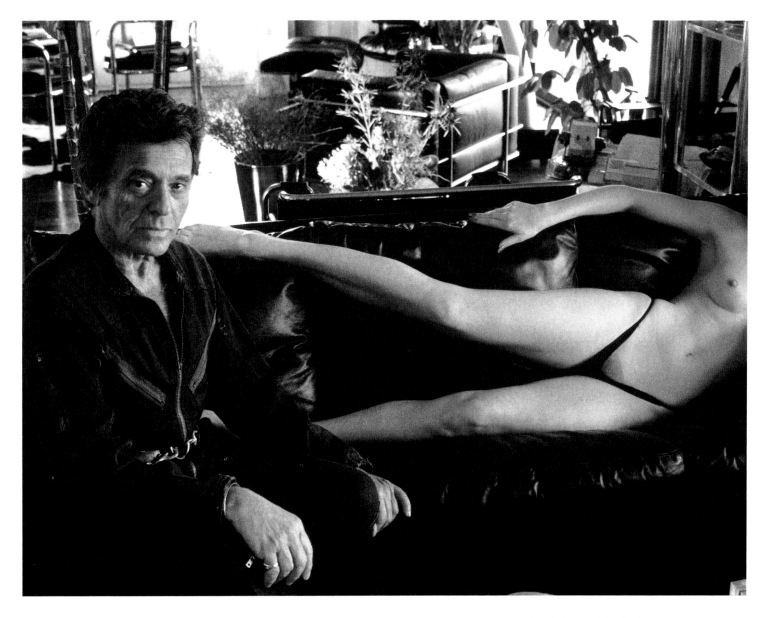

1985, the pubikini photographed at Rudi's home a month before his death. (Photograph © Helmut Newton)

The Phone Call

Early in 1985 my son Christopher and I were sharing a cup of tea and some huge joke that had both of us laughing hysterically, when the telephone rang. Christopher answered it and, handing it to me, said, "It's Rudi." Still laughing, I said, "Hi, Rudi." I guess the mirth was contagious because Rudi started laughing too and said, "Hi, you'll never guess where I am. . . in the hospital. It might be se-rious." I knew at that moment that he was dying.

The next morning Bill and I went to the hospital. We took him a book, and I picked him a large cymbidium orchid stalk from our garden. When we gave him the flower no one could find a vase for it. So Rudi plopped it into a bedpan urinal and said, "Now that's piss elegant."

237

233

229

238

234

230

232

235

231

1968, Rudi and the Snow Queen.

The Dream

Shortly before Rudi's death, he called me and said, "I had a dream last night that I was in a graveyard, and I saw my own tombstone. I went up to it, and it said, 'He was always ten years ahead of his time.'" It was hard for me, but I laughed. Rudi said, "I told you that because you're the only person who I knew would laugh."

He was wrong of course. He was always thirty years ahead of his time.

Pas de Deux

Without Rudi I would have been a gifted and innovative model. Without me he would have been an avant-garde designer of genius. We made each other better. We were each other's catalyst. We didn't invent each other—we played aesthetic pingpong together. One of us would say, or notice, or do something and the other would lob it back across the net. It was fun, it was invigorating, it was a true collaboration, and yes, it was love.

Seite 1:
Im 20. Jahrhundert hat es eine Handvoll von Genies gegeben, die mit ihren Innovationen dem Lauf ihrer Kunst für alle Zeit eine neue Richtung gegeben haben:
In der Malerei war es Picasso.
In der Musik war es Strawinsky.
Im Film war es Eisenstein.
Im Theater war es Stanislawskij.
Im Tanz war es Balanchine.
Im Jazz war es Charlie Parker.
Und im Modedesign war es Rudi Gernreich.
Peggy Moffitt

Seite 2:
Herbst 1971, kurzer Trompe-l'œil-Overall und Gürtel mit Hundeleinenkarabiner

Seite 6–9:
RUDI
Den größten Teil meines beruflichen Lebens habe ich Rudi Gernreich gewidmet; ich war völlig überzeugt von seinem Talent und hatte das große Privileg, ihn als einen lieben Freund zu kennen. Im Laufe der Jahre haben wir uns zu einem Team entwickelt. Es war eines der großen Zeichen seines Genies, daß es mir gestattet war, mein eigenes Talent voll zum Ausdruck zu bringen und so brauchte ich mich nie zurückzuhalten, wenn wir zusammenarbeiteten. Ich konnte Kritik oder Vorschläge äußern, ohne fürchten zu müssen, meine Kompetenzen zu überschreiten. Wir hatten unglaublichen Spaß zusammen und waren als kreatives berufliches Team unzertrennlich. Wir sagten immer, wenn er ein Model gewesen wäre, wäre er ich gewesen, und wäre ich Modedesignerin gewesen, wäre ich er gewesen. In den phantastischen Zeiten, in denen wir zusammenarbeiteten, gab es jede Menge Schlagzeilen und öffentliche Kontroversen. Das war natürlich damals sehr positiv und hilfreich, doch ich hatte immer den Eindruck, daß die Schlagzeilen Rudis großes Talent verdeckten. Nie war dieser Eindruck stärker als jetzt, da er nicht mehr unter uns ist. Es ist meine feste Überzeugung, daß Rudi Gernreich fast alles entworfen hat, was für moderne Leute entworfen werden kann. Seine Kreationen sind so logisch und konsequent, daß ein und derselbe Entwurf sowohl von einer älteren Frau als auch von einem jungen Mädchen getragen werden kann. Ich glaube, daß für die meisten Leute sein Werk »trendy« oder »typisch für die sechziger Jahre« ist, dabei ist es in Wirklichkeit universeller und klassischer als das von Chanel.

Rudi Gernreich war ein Avantgarde-Modedesigner, der in den vierziger Jahren begann, in den fünfziger Jahren als Erneuerer anerkannt und in den sechziger Jahren zu einem »Begriff« geworden war.
 Einem breiten Publikum bekannt geworden ist er durch den »Topless swimsuit« (Oben-ohne-Badeanzug), doch mit der Summe seiner Entwürfe und mit seiner Designphilosophie hat er den Lauf der Mode geändert und Modeschöpfer in aller Welt beeinflußt. Nach wie vor sind seine Konzepte für die Modeindustrie unverzichtbar; wie Chanel in der ersten, hat er der modernen Mode für die zweite Hälfte des 20. Jahrhunderts den Weg gewiesen.

Rudi Gernreich war ein großer Modedesigner, der
- den Badeanzug von der Miederkonstruktion befreite;
- als erster moderner Modeschöpfer knallige, sich beißende Farben miteinander kombinierte;
- Stoffe in überraschenden Kontexten einsetzte – Arbeiterhemden aus Chiffon oder Mechanikerjacken aus Seide;
- die ersten Strickschlauchkleider entwarf;
- als erster Löcher in Kleidungsstücke schnitt (»Bullaugen« in Badeanzügen und Kleidern);
- als erster Vinyl und Kunststoff für Kleidungsstücke verwendete;
- »street fashions« wie den »Leder-Look« für die Mode übernahm;
- verschiedenartige Muster wie Streifen, Karos und Punkte in einem Outfit zusammenmischte;
- ethnische und Arbeiterkleidung in die Mode integrierte;
- androgyne Elemente in die Damenmode einführte – Männeranzüge, -hüte usw.;

- den Topless swimsuit entwarf, der für die Damenmode ein Befreiungsschlag war;
- die ersten durchsichtigen Kleider entwarf;
- den ersten weichen, transparenten Büstenhalter entwarf – den »no-bra bra«;
- an Trikots und enganliegende Unterwäsche angelehnte »body clothes« erfand;
- die ersten auf ein Kleid abgestimmten Strümpfe entwarf;
- den »total look« begründete, wobei alles aufeinander bezogen war, von der Unterwäsche bis zu den Hüten, Handschuhen und Schuhen;
- den »military look« einführte;
- Metallteile (Reißverschlüsse, Hundeleinenschnallen usw.) als Dekorationselemente benutzte;
- die ersten Designer-Jeans entwarf;
- Trompe-l'œil-Kleidungsstücke entwarf (z. B. ein in Wirklichkeit einteiliges Kleid, das wie ein dreiteiliges aussah);
- den »Unisex-Look« einführte (Kleidungsstücke, die sowohl von Männern als auch von Frauen getragen werden konnten;
- den Tanga entwarf, den ersten Badeanzug, der auf den Oberschenkeln ausgeschnitten war und die Gesäßbacken freilegte;
- als erster Männerunterwäsche für Frauen entwarf;
- den ersten Badeanzug entwarf, der Schamhaar (»pubic hair«) sehen ließ, den »pubikini«.

Rudi Gernreich war ein Befürworter von Kleidung zu erschwinglichen Preisen und lehnte »Status«-Mode ab. Er war seit Dior der erste Modeschöpfer, der in aller Welt zu einem Begriff wurde. Die Kontroversen, die er auslöste, haben sich bis über seinen Tod hinaus fortgesetzt. Unbestritten ist, daß er das Vokabular der Mode des 20. Jahrhunderts verändert hat.

Peggy Moffitt
Beverly Hills, 1991

Seite 10–35:
RÜCKBLICK AUF EINEN FUTURISTEN
Marylou Luther

Rudi Gernreich entblößte Brüste und Schamhaar, ließ Köpfe und Körper rasieren und verteilte Schießeisen, alles im Namen der Mode. Geistliche geißelten seine mutigen Entwürfe von der Kanzel. Sein Topless swimsuit wurde vom Papst mit einem Verbot belegt, von der *Iswestija* angeprangert und in einer italienischen »Zeitkapsel« zwischen der Bibel und der Antibabypille deponiert. Für viele Menschen in der Modewelt war Gernreich ein Prophet, ein Seher mit einer unfehlbaren Modevision. Auch für seine Kritiker war er ein Prophet: ein Prophet des Häßlichen.
Gernreich sah sich selbst als zweifachen Modedesigner. Der eine war ein modeorientierter Designer, der zukunftsweisende Kleidung für das 20. Jahrhundert kreieren woll-

Rudi Gernreich, 1964

te. Das war der Gernreich, der mit jedem bedeutenden amerikanischen Modepreis ausgezeichnet wurde. Der andere Gernreich war ein Gesellschaftskritiker, der nur zufällig im Modebereich tätig war. In Gernreichs Worten: »Vor den sechziger Jahren war Kleidung Kleidung. Sonst nichts. Dann, als von der Straße neue Ideen in die Modewelt Einzug fanden, wurde mir klar, daß man mit Kleidern etwas sagen konnte. Design war nicht genug. Wahrscheinlich weil mein Topless swimsuit von 1964 für so viel Wirbel gesorgt hatte, begann ich mich verstärkt für Kleidung als eine Form der gesellschaftlichen Aussage zu interessieren. Ich denke, es ist wichtig, etwas auszusagen, was über das Medium hinausgeht.«
Durch seine Entwürfe sagte Gernreich eine ganze Menge, was nicht auf die Mode beschränkt war: Daß es an der Zeit war, die Körper der Frauen von den Zwängen zu befreien, derentwegen sie den Männern unterworfen blieben; daß Frauen und Männerkleidung austauschbar sein könnte; daß praktische Alltagsuniformen uns nicht mehr daran denken lassen, wie wir aussehen, so daß wir uns darauf konzentrieren können, wie wir handeln; daß die Mode kein Drama ist, sondern Unterhaltung; daß Nacktheit nichts mit Moral zu tun hat; daß die Art und Weise, wie wir uns kleiden, untrennbar mit unserer Lebensweise verbunden ist; daß Esprit und Humor in der sich allzu ernst nehmenden, manchmal hochnäsigen Welt der Mode immer zuletzt lachen werden.

Der Mann, den viele für den bedeutendsten amerikanischen Modedesigner überhaupt halten, wurde am 8. August 1922 in Wien geboren. Seinen ersten Einblick in die Welt der Haute Couture erhielt er in einem Bekleidungsgeschäft, das seine Tante, Hedwig Müller, betrieb. In diesem Geschäft, das Gernreich seine »Zuflucht vor der strengen, militaristischen Atmosphäre der Schule« nannte, zeichnete er stundenlang Entwürfe für die Wiener Gesellschaft und eignete sich ein gründliches Wissen über Stoffe an. Als er zwölf Jahre alt war, wurde der österreichische Modedesigner Ladislaus Zcettel auf seine Skizzen aufmerksam. Zcettel, der später nach Amerika kam, um Henri Bendels Couture-Studio in New York zu leiten, stand damals kurz vor seiner Abreise nach London, wo er Filmkostüme für Alexander Korda entwerfen sollte, und bot Gernreich eine Lehre in London an, doch seine Mutter hielt ihn für zu jung. (Sein Vater, Siegmund Gernreich, ein Strumpfwarenfabrikant, hatte 1930, als sein Sohn acht Jahre alt war, Selbstmord begangen.)
1938, nur sechs Monate nach dem am 13. März vollzogenen Anschluß Österreichs an das Deutsche Reich, reihten sich der sechzehnjährige Gernreich und seine Mutter in den Strom jüdischer Flüchtlinge ein und flohen nach Kalifornien. Seinen ersten Job in den Vereinigten Staaten fand er in einer Leichenhalle. »Ich wurde über Nacht erwachsen. Da war ich nun mit all diesen Toten. Und schließlich gewöhnte ich mich an die Leichen. Aber manchmal muß ich schmunzeln, wenn man mir sagt, daß meine Kleider so körperbewußt sind, daß ich Anatomie studiert haben muß. Und ob ich Anatomie studiert habe!«
Als Kunststudent am Los Angeles City College war Gernreich Hollywood geographisch nah; doch obwohl er in der Publicity-Abteilung der RKO Studios arbeitete und einmal einen Freund vertrat, der als Zeichner für die Kostümdesignerin Edith Head tätig war, wurde er nicht als Filmkostümdesigner bekannt. Hollywood sollte sein Zuhause werden, aber nicht sein Lebensinhalt.
 Nachdem er eine Aufführung von Martha Grahams modernem Tanzensemble gesehen hatte, gab Gernreich die Kunst und die Filmstudios zugunsten des Tanzes und des Theaters auf. Während seines Studiums bei dem Choreographen Lester Horton, den er als »eine Art Martha Graham der Westküste« bezeichnete, verlagerte sich sein Interesse immer mehr von den statischen Details von Kleidungsstücken auf die Frage, wie sie in Bewegung wirkten.
 Ab Mitte der vierziger Jahre entwarf Gernreich, der weiterhin seine Tanzkarriere verfolgte, nebenher freiberuflich Stoffe für Hoffman California Fabrics. Als er erkannte, daß er nie ein zweiter Lester Horton werden könne, verließ er 1949 die Truppe und ging nach New York, wo er einen Job bei einer Bekleidungsfirma namens George Carmel bekam. Gernreich hat das Modeklima dieser Zeit wie folgt beschrieben: »Alle mit einem gewissen

224

Talent – Modeschöpfer, Einzelhändler, Redakteure – fühlten sich der Haute Couture verpflichtet und waren Paris gegenüber bedingungslos loyal. Christian Dior, Jacques Fath, Cristobal Balenciaga waren Götter. Von ihren Vorgaben konnte man nicht abweichen. Hatten sie erst einmal eine überschnittene Schulter eingeführt, konnte ein amerikanischer Modeschöpfer nicht einfach einen eingesetzten Ärmel anbringen. Hatten sie erst einmal einen Saum festgesetzt, mußte man sich zentimetergenau daran halten. Die Seventh Avenue setzte ganz und gar auf ihre Entwürfe. Ich strotzte vor originellen Ideen, die aber immer zurückgewiesen wurden, weil sie nicht dem französischen Idiom entsprachen. Nach ungefähr einem halben Jahr kam es mir nur noch hoch, wenn ich über diesen Imperialismus nachzudenken begann. Ich entwarf schreckliche Dior-Versionen. Und schließlich ließ man mich gehen.« 1951 vermittelte ihm der mit dem »Academy Award« ausgezeichnete Modedesigner Jean Louis, »der einzige Modeschöpfer, der Empfehlungsbriefe für mich schrieb«, ein Treffen mit der New Yorker Modedesignerin Hattie Carnegie. Sie sagte ihm, er solle nach Kalifornien zurückkehren, einige Muster anfertigen und ihr zuschicken. Das tat er, und sie antwortete, indem sie ihm Schecks schickte – »keine andere Kommunikation, nur Schecks… Dann und wann entdeckte ich einen meiner Kragen oder eine meiner Taschen in ihren Entwürfen.«

Einige Monate später nahm Gernreich einen Job bei Morris Nagel Versatogs an, »einem Ramschladen mit einem passenden Namen.« Als er mit seiner Kollektion nach New York reiste, um sie Marjorie Griswold von Lord & Taylor zu zeigen, sagte sie, daß sie mit den Kleidern nichts anfangen könne. Gernreich war über diese Reaktion vor allem deshalb verärgert, weil Lord & Taylor das Kaufhaus war, das der amerikanischen Mode den Weg bereitet hatte (Gernreichs Idol, Claire McCardell, war ebenso von Lord & Taylor entdeckt worden wie Vera Maxwell und Clare Potter), und Dorothy Shaver, die Vorstandsvorsitzende, hatte als erste das ungeschriebene Gesetz übertreten, daß Mode mit französischer Mode gleichgesetzt werden müsse.

Das erfreuliche Ergebnis dieser Reise war Gernreichs erste Begegnung mit Diana Vreeland, damals Moderedakteurin bei *Harper's Bazaar*. »Ich bin schließlich einfach mit einer Tasche voller Muster hingegangen. Ich weiß noch, daß ich im falschen Stockwerk ausstieg, und daß ein bezauberndes kleines Botenmädchen mich ins richtige Stockwerk und zur richtigen Redakteurin brachte, die mich mit der für Modeleute typischen instinktiven Verachtung fragte: ›Was wollen Sie?‹ Als ich ihr antwortete, ich sei ein Modedesigner aus Kalifornien, sagte sie, ich solle ihr zeigen, was ich in meiner Tasche hätte. Ich sagte, ich bräuchte ein Model. Ihre Antwort war, sie kenne sich mit Kleidern aus, und ein Model wäre absolut nicht notwendig. Ich sagte, ohne ein Model würde ich ihr nichts zeigen. Da sie aber hart blieb, öffnete ich schließlich die Mustertasche und nahm ein paar Sachen heraus. Sie verschwand, und nur eine Sekunde später, so kam es mir jedenfalls vor, kam sie zurück und sagte, Mrs. Vreeland wolle mich sehen.

Ihre ersten Worte waren: ›Wer sind Sie, junger Mann? Sie sind sehr begabt.‹ Ich erzählte ihr von mir, zeigte ihr kurz meine Sachen, und sie sagte, ich solle mich bei ihr melden, falls ich je einen Job in New York bräuchte.« Als Gernreich nach Kalifornien zurückkehrte, teilte ihm Morris Nagel mit, seine Entwürfe seien zu fortschrittlich; er möge doch bitte konventionelle Bekleidung von der Art entwerfen, für die die Firma bekannt sei und die sich problemlos verkaufen lasse. Gernreich verließ die Firma.

Im Juli 1950 lernte Gernreich während einer öffentlichen Probe in Hortons Studio Harry Hay kennen, der in den fünfziger Jahren die Mattachine Society gründete, einen Vorläufer der heutigen Schwulenbewegung. Von 1950 bis 1952 waren Gernreich und Hay Lover ein Paar, und Gernreich gehörte zu den sieben Gründungsmitgliedern der Mattachine Society. (Mit dem für ihn typischen Witz machte er den Vorschlag, dem Mattachine-Mitteilungsblatt den Namen »The Gaily Homo Journal« zu geben.) Nach programmatischen Zerwürfnissen traten er und die anderen Gründungsmitglieder aus der Gesellschaft aus.

In Übereinstimmung mit dem Verschwiegenheitseid, den die Mattachine-Mitglieder geleistet hatten, enthüllte Hay Gernreichs Mitgliedschaft erst nach dessen Tod im Jahre 1985. Seither sind Photos, auf denen Gernreich zusammen mit Hay und anderen Gründungsmitgliedern zu sehen ist, in Stuart Timmons' Hay-Biographie, *The Trouble with Harry Hay, Founder of the Modern Gay Movement*, erschienen.

Daß der Mann, der mit seinen revolutionären Kleidern so viele Schranken niedergerissen hatte, sich zu seinen Lebzeiten nie zu seiner Homosexualität bekannte, sagt einiges über Gernreich und seine Zeit aus. In jenen Jahren war Homosexualität illegal, und Gernreich selbst war vor Gericht gestellt worden, bevor er sich den Mattachines anschloß. Wie Oreste Pucciani, 31 Jahre lang Gernreichs Lebensgefährte, sich erinnert: »Rudi erzählte mir, daß er fassungslos war, als er schuldig gesprochen wurde. Er hatte hartnäckig auf unschuldig plädiert und ein Geschworenenverfahren verlangt. Er schaute jedem

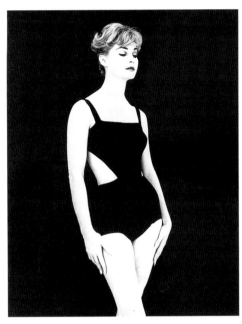

1958

einzelnen Geschworenen ins Gesicht, und eine Frau, die zuvor einen verständnisvollen Eindruck gemacht und mit deren Unterstützung Rudi gerechnet hatte, drehte sich zur Wand, um ihm nicht in die Augen schauen zu müssen.«

Peggy Moffitt, Gernreichs Muse und Modell, sagt, daß sie oft mit ihm über Sexualität gesprochen hat. »In seinen Kleidern ging es um Sexualität. Er erzählte mir, daß er Mitglied der Mattachine Society gewesen sei, aber er erzählte es nicht unter dem Siegel der Verschwiegenheit. Er sagte mir oft, daß man seine Sexualität sowieso nicht verbergen könne. Ich habe viele schwule Männer gekannt, die offenbar unter dem Zwang standen, immer auf ihre Homosexualität aufmerksam zu machen, nach dem Motto ›Bringen Sie mir bitte das Roastbeef, und natürlich bin ich schwul‹. Rudi gehörte nicht zu diesen Leuten. Ich glaube, daß es ihm gar nicht in den Sinn kam, sich zu outen, weil er seine sexuelle Orientierung für offensichtlich hielt. Seiner Sexualität wegen hätte er ebensowenig eine Pressekonferenz einberufen wie seiner braunen Augen wegen.«

Pucciani erklärt Gernreichs Weigerung, sich zu outen: »Sich selbst zu outen ist eine Sache. Geoutet zu werden, ist etwas anderes. Rudi hat sich nie offiziell geoutet. Er hatte nie das Bedürfnis. Bis ich 1979 meinen Abschied von der University of California in Los Angeles nahm, lebte ich nach dem Prinzip, nie darauf aufmerksam zu machen und es nie zu leugnen. Die intelligenten Leute konnten aus meiner Lebensweise schließen. Nach meiner Pensionierung gab ich der schwulen Zeitung der UCLA ein Interview. Rudi wußte von diesem Interview, und eines Morgens fragte er mich beim Frühstück, was ich davon halte. Er sagte mir, er halte es für ein gutes Interview, aber ›warum hast du es ihnen gegeben?‹ Ich sagte,

ich sei doch schließlich pensioniert, warum also nicht – was kann schon passieren? Dann fragte er mich, warum ich so lange damit gewartet hätte, und ich antwortete, ganz einfach – weil mich vorher niemand darum gebeten hatte. Als ich Rudi fragte, warum er sich nie geoutet habe, sagte er mit diesem singenden Tonfall, den er immer hatte, wenn er scherzte: ›Ganz einfach, schlecht fürs Geschäft.‹

Nach seinem Tod glaubte ich, seinen Standpunkt respektieren zu müssen. Die Lösung kam, als die American Civil Liberties Union bekanntgab, daß die ›Estates of Rudi Gernreich and Oreste Pucciani‹ eine Stiftung zur Finanzierung von Prozessen und Aufklärungskampagnen im Bereich der Rechte von Lesben und Schwulen eingerichtet hatten. Das also war Rudis postumes Coming-out.«

In den frühen fünfziger Jahren ging Gernreichs Karriere nicht so erfolgreich voran, wie er es sich erhofft hatte. Nachdem er zeitweise für ein Geschäft in Beverly Hills namens Matthews gearbeitet hatte, lernte er Walter Bass kennen, mit dem er 1952 eine achtjährige Geschäftsverbindung einging. »Ich hatte damals keine andere Chance«, sagte Gernreich über diese Zeit. »Meine Lage schien aussichtslos zu sein. Dann begegnete ich Walter, und obwohl wir nie miteinander auskamen und mir klar war, daß diese Verbindung zum Scheitern verurteilt war, nahm alles seinen Lauf.«

Und es nahm seinen Lauf. Durch Jimmy Mitchell, sein erstes Anprobemodell, erfuhr er von Jack Hanson und seinem kleinen Geschäft mit dem Namen JAX. »Ich sagte zu Jimmy, ich bräuchte einen Saks oder einen I. Magnin, um die Kollektion in Gang zu bringen, doch sie blieb beharrlich. Jimmy und ich trafen uns mit Jack Hanson, und wir zeigten ihm die Kollektion – hauptsächlich locker geschnittene, eng gegürtete Kleider aus Gingan und Baumwolltweed – und er schlug sofort zu. Ich brachte die erste Lieferung persönlich vorbei, und innerhalb einer Stunde war alles verkauft.«

Beflügelt durch diesen Erfolg reiste Gernreich mit der Kollektion nach New York. »Weil Walter die Reisekosten nicht tragen wollte, fuhr ich auf eigene Kosten, und es war ein voller Erfolg.« Sally Kirkland, damals Moderedakteurin bei *Life*, redete Gernreich zu, es noch einmal bei Marjorie Griswold von Lord & Taylor zu versuchen. »Diesmal war sie begeistert und ließ nicht locker und wollte die Kleider unbedingt haben. Irgendwann fragte sie mich, ob wir uns nicht schon einmal gesehen hätten. Ich konnte ihr einfach nicht die Wahrheit sagen und sagte nein. Jahre später habe ich ihr dann erzählt, wie wir uns wirklich begegnet sind, und wir konnten nach so vielen Jahren beide darüber lachen.«

Nach einem von schnellen und ständigen Verkaufserfolgen gekennzeichneten Jahr forderte Bass Gernreich auf, einen Siebenjahresvertrag zu unterzeichnen. »Als ich den Vertrag sah, bin ich fast vom Stuhl gefallen. Wir konnten schon auf eine Erfolgsgeschichte zurückblicken, aber der Vertrag räumte mir überhaupt keine Rechte ein. Ich war furchtbar verärgert über die Art und Weise, wie Walters Anwalt mich behandelte, und sagte, daß ich eines Tages viel wichtiger sein werde als Mainbocher. Ich war damals sehr arrogant und strotzte vor Selbstvertrauen, auch wenn es angesichts dieses Vertrags zerrüttet war. ›Wenn du wichtiger bist als Mainbocher,‹ sagte Bass, ›verhandeln wir neu.‹ Und ich unterschrieb.«

Im März 1952 kreierte Gernreich den Prototyp des ersten körbchenfreien Badeanzugs: aus elastischem Wolljersey, enganliegend und tief ausgeschnitten; sein Nachfolger brachte ihm seine erste Auszeichnung ein: 1956 verlieh ihm die Zeitschrift *Sports Illustrated* den »American Sportswear Design Award«.

Gernreich sollte einen großen Teil der fünfziger Jahre damit verbringen, Frauen von Kleidern zu befreien, den den Körper einengen. Sein gestricktes Schlauchkleid von 1953, dem er den ersten Bericht über ihn in einer Zeitschrift verdankte (*Glamour*, Februar 1953), war der Vorläufer der Stretch-Minis der späten achtziger und der neunziger Jahre. Das Outfit, über das *Life* in seinem ersten Artikel über ihn berichtete (27. April 1953), könnte als die Mutter der Pop/Op-Sprößlinge der sechziger Jahre betrachtet werden. Es bestand aus einer mit einem Sattelgurt gegürteten Tunika aus schwarzem Filz über einer Hose mit roten, orangenen und gelben Karos. Präsentiert wurde es von Lauren Bacall.

Seine ersten Badeanzüge entwarf er zwar für Bass, doch diejenigen, die ihn berühmt machen sollten, wurden für Westwood Knitting Mills gefertigt, die Firma, mit der er im März 1955 einen Vertrag abschloß. Von diesem Datum bis zum August 1960 gab es zwei Gernreich-Label: Sportswear für Bass und Swimwear für Westwood.

In den fünfziger Jahren konnte ein Modeschöpfer buchstäblich durch Magazine in den Ruhm katapultiert werden: *Harper's Bazaar*, *Vogue*, *Mademoiselle*, *Glamour*, *Charm*, *Life*, *Look* und *Sports Illustrated* – ihre Botschaft lautete: Ist der Artikel erst einmal erschienen, folgen die Modehäuser und Kunden von selbst.

Gernreich lernte diese Lektion früh und gut – so gut, daß Jack Hanson, der ihm für JAX seinen ersten großen Auftrag gab und der später eines Streits um Exklusivrech-

Grimassen schneiden für die Kamera, mit Oreste Pucciani, Malibu, 1965

te wegen alle Aufträge stornierte, nannte Gernreich »einen Publicity-Schweinehund«.

Für Westwood führte Gernreich Maillots (gestrickte, elastische Anzüge) ein, die dem Körper folgen statt aufzutragen. Diana Vreeland von *Harper's Bazaar* sah sie und schickte Gernreich ein Telegramm: »Ich kann Ihnen gar nicht sagen, wie schön gemacht und wie schön gestaltet sie sind und wie sehr wir sie bewundern. Wir werden alles daran setzen, sie so bald wie möglich vorstellen zu können.«

Einer dieser ersten gestrickten Badeanzüge, ein Tweed-Maillot mit einem tiefen V-Ausschnitt und einer Knopfleiste mit fünf Knöpfen am Vorderteil wurde noch 1959 von Gernreich neu interpretiert. Die Einkäufer kannten ihn zuerst als Style Number 6001, später als Style 601. 1969 wurde der Badeanzug von einem Preisträger des Coty Award kopiert. Dazu Gernreich: »Wenn ein Fabrikant eine Version von einem meiner Entwürfe herstellt, ist das sehr gut. Es ist immer eine Bestätigung. Wenn ein renommierter Modedesigner einen meiner bekanntesten Badeanzüge klaut, ist das eine Unverschämtheit.« Sogar 1990 noch tauchte Style 601 in den Kollektionen anderer Modedesigner wieder auf – eine neuerliche Bestätigung seines Talents und der Langlebigkeit seiner Entwürfe.

Gernreich erweiterte sein Entwurfsspektrum erneut im Juni 1955, als er die Kostüme für Sarah Churchill in der Broadway-Komödie *No Time for Comedy* entwarf, und im Juni 1956, als er seine ersten Entwürfe für Männer vorlegte. Sie wurden als »chinesische Kellnerjacken« bezeichnet und ursprünglich für das Personal von Gernreichs Lieblingschinarestaurant entworfen, dem »General Lee's Man Jen Low« in der Chinatown von Los Angeles. Als die Gäste den Kellnern diese Jacken im Lokal abzuschwatzen versuchten, beschloß Gernreich, sie als Strandjacken, Autojacken und Hemdjacken zu produzieren. *Life* stellte sie in seiner Ausgabe vom 6. August 1956 vor.

1957 erweiterte sich Gernreichs Designspektrum noch einmal, als er für die Ted-Saval-Abteilung der General Shoe Co. eine Schuhkollektion entwarf. Das Magazin

Vogue präsentierte seinen schwarzen T-Riemenschuh aus Kalbsleder mit einer darauf abgestimmten Satinschleife in seiner Ausgabe vom 1. Februar 1957.

In den Jahren 1958 und 1959, den letzten beiden Jahren seiner Zusammenarbeit mit Bass, beschäftigte sich Gernreich mehr und mehr mit Accessoires, und es wurde ihm klar, daß Mode mehr bedeutet als nur Kleider. Hier ein Auszug aus einer Einladung vom Mai 1958 zur Präsentation seiner Herbst-Kollektion:

»Heutzutage spielt sich etwas höchst Merkwürdiges ab – keine Taillen, hohe Taillen, tiefe Taillen, Schlankheit, Körperfülle, H-Silhouetten, A-Silhouetten – und nichts davon ist falsch. Der entscheidende Wandel ist kein äußerlicher, sondern einer der Einstellung.

In der Haltung eines Gesichts, eines Beins und Fußes hat sich im letzten Jahr ein radikalerer Wandel vollzogen als in der Form des Kleides. Im Brennpunkt stehen Kopf und Bein, so daß das Kleid zu einem Accessoire wird. Und um das Bewußtsein für diese Haltung zu wecken und zu stärken, habe ich es für notwendig gehalten, mein Bild zu vervollständigen und meine Kollektionen um Hüte und um Schuhe zu erweitern.«

Unter den ersten Hüten waren buntkarierte Südwester, Schlapphüte mit weicher Krempe, Filzhüte und eine mit Straß besetzte Glocke, passend zu einem Paar ebenso geschmückter Pumps mit kleinen Absätzen. Strümpfe kamen im Februar 1959 hinzu – die ersten mit Streifen und Karos auf reinem Nylon.

Der einzige andere Modeschöpfer in dieser Zeit, der ebenso viele Überbauten entfernte, ebenso viele Futter eliminierte, ebenso viele Stoffe leichter machte und ebenso viele Farben heller werden ließ, war der Italiener Emilio Pucci.

1964 führte Gernreich Pucci als einen der Gründe für seinen Entschluß an, den Topless swimsuit einzuführen. Am Vorabend der Präsentation seiner Herbstkollektion des Jahres 1963 wurde Pucci in einer Eugenia-Sheppard-Kolumne im *New York Herald Tribune* mit den folgenden Worten zitiert: »In 10 Jahren werden die Frauen die Oberteile ihrer Badeanzüge restlos abgelegt haben.« Gernreich, der inzwischen dafür eine fünfjährige Wartezeit vorhergesagt hatte, faßte den Entschluß, sich in diesem Mode-Wettschwimmen nicht von Pucci schlagen zu lassen.

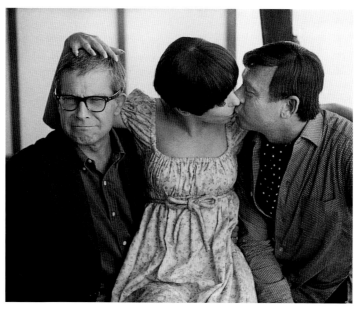

Obwohl er seinen Ruhm den sechziger Jahren verdankte, sagte Gernreich 1972 in einem Interview, daß er eigentlich nicht mit Stolz auf dieses Jahrzehnt zurückblicken könne. »Es entsetzt mich, daß ich mich mit aller Kraft auf etwas so Unwichtiges konzentrieren konnte. Es fällt mir schwer zu glauben, daß ich einmal Kollektionen zu Themen wie Ophelia, George Sand, Clowns, Cowboys, Kabuki-Tänzern, Nonnen, Gangstern, österreichischen Kavallerieoffizieren und Chinesischen Opern entwickelt habe. Alle diese imaginären Themen sind mir heute unerträglich. Sie waren mir auch 1971 zuwider, als ich glaubte, eine realistische Aussage zu machen, indem ich die Kleider mit Schießeisen und Hundemarken versah. Die New Yorker Publizistin Eleanor Lambert öffnete mir die Augen. ›Ist es nicht auch Schauspielerei, wenn du Models wie Soldaten ausstaffierst?‹, fragte sie. Und irgendwie hatte sie recht.«

Peggy Moffitt hält Gernreichs späteres Abrücken von diesen Entwürfen für völlig unberechtigt. »Tatsächlich war sein Ophelia-Look ein hübsches Chiffonkleid. Sein George-Sand-Look war ein sehr tragbarer Hosenanzug. Alle diese Ideen waren reines Design. Man konnte sie einfach als Kleider tragen, auch ohne an den thematischen Hintergrund zu denken.«

Zu Beginn der sechziger Jahre beendete Gernreich seine achtjährigen Geschäftsverbindungen mit Bass und mit Westwood Knitting Mills. Im August 1960, nur zwei Monate nachdem er erfahren hatte, daß er mit einem speziellen Coty Award für Bademode ausgezeichnet worden war, gab er bekannt, daß die Kollektion, die er zuvor für Bass entworfen hatte, von nun an in Los Angeles unter der Aufsicht seiner eigenen Firma, G. R. Designs, Inc., und daß die Strickwaren von Harmon Knitwear, Inc., in Marinette, Wisconsin, produziert werden würden. Der Inhaber dieser Firma war Harmon Juster, der sich von Westwood getrennt hatte.

In den Jahren 1960 und 1961 bereitete Gernreich der Pop und Op-Mode den Weg. Während First Lady Jacqueline Kennedy die Pillbox zu einer nationalen Kopfbedeckung machte und ihre Gäste in Schuhen mit niedrigen Absätzen und einem auf schlichte Komponenten reduzierten, zweiteiligen Kleid mit einer hochgeschlossenen Blusenjacke und einem schmalen Rock durch das Weiße Haus führte, ging es Gernreich um eine noch weitergehende Reduzierung und Entblößung. Das Magazin *Vogue* zeigte in seiner Ausgabe vom 1. Januar 1961 Gernreichs Badeanzug-Kleid mit seitlichen Ausschnitten, abgeleitet von einem Gernreich-Badeanzug, der bis auf den Rock damit identisch war.

Mit schockierenden Kombinationen von Rosa und Orange, Blau und Grün, Rot und Lila arrangierte er auch den Regenbogen neu. Er revolutionierte die Modegraphik, indem er Karos mit Punkten, Streifen mit Diagonalen kombinierte. Und er erschütterte die Welt der Stoffe, indem er Vinyl an den Strand brachte, spanische Decken auf den Mantelständer.

Obwohl Gernreich selbst das Phänomen des Minirocks als einen allmählichen, zentimeterweise erfolgenden Prozeß der Verkürzung bezeichnete, entblößte er bereits 1961 die Knie. Die *New York Times* berichtete am 2. Juni 1961: »Rudi Gernreich, Kaliforniens erfolgreichster Exportartikel seit der Orange, hat sich den ausgestellten Schnitt auf die Fahnen geschrieben. Kniescheiben zeigen sich (absichtlich), Röcke wirbeln und wogen, Kleider fallen frei und berühren den Körper nur an den Brüsten.«

Im Juni 1962 wurde Gernreich mit einem weiteren Modedesignpreis ausgezeichnet, diesmal von Woolknit Associates für »seine bahnbrechenden Silhouetten

und Stoffmanipulationen bei Strickkleidern.« Zusammen mit wendbaren Etuikleidern, Sweatern mit überschnittener Schulter, langärmeligen Hemdkleidern, Abendkleidern aus glänzendem Cellophanstoff und mit einem federnartigen Besatz versehenen Kleidern gehörte der Knaben-Look zu seinen Hauptthemen in diesem Jahr.

In seiner Rolle als Gesellschaftskommentator zeigte sich Gernreich 1963, als er am 22. Mai in der *New York Times* zitiert wurde: »Es gibt hier in Südkalifornien ein furchtbar starkes Element des schlechten Geschmacks. Hosen, die zu eng sind. Dekorierte Korbtaschen. Mit Edelsteinen besetzte Brillen. Kaschmirstrickjacken mit Nerzkragen. Vergoldete Vinylschlappen. Sie wissen schon – dieses schräge Element.

Positiv ist dagegen zu sehen, daß die Leute heute überall für Farben sehr viel aufgeschlossener sind, und dafür sind Kalifornien und Italien verantwortlich. Noch vor wenigen Jahren wäre es ausgeschlossen gewesen, in New York eine Frau in einem orangefarbenen Kleid zu sehen. Wenn die Einkäufer von der Ostküste und aus dem Mittleren Westen meine Kombinationen aus Messing und schockierendem Rosa sahen, rannten sie davon. Heute fragen sie danach.«

1963 war das Jahr, in dem das Wort »kooky« (ausgeflippt) in das Modevokabular Einzug hielt; es war das Jahr der Felle (etwa Gernreichs »Pferdehaut«), das Jahr der Kleine-Mädchen-Kittel, der Garbo-Comebacks und der Safari-Anzüge. Es war auch das Jahr, in dem Gernreich zwei weitere wichtige Preise erhielt – im Mai den »Sporting Look Award« der Zeitschrift *Sports Illustrated* und im Juni den »Coty American Fashion Critics Award«. Die Verleihung dieser Auszeichnung an Gernreich führte zu einem der größten Skandale in der Geschichte der Mode.

Als Protest gegen Gernreichs Prämierung gab Norman Norell seinen »Coty Hall of Fame Award« zurück und sagte in *Women's Wear Daily* (27. Juni 1963): »Der Preis bedeutet mir nichts mehr. Ich will ihn einfach nicht mehr vor Augen haben. Ich habe ein Kostüm von Rudi auf einem Photo gesehen; das eine Revers der Jacke war ein Schalkragen, und das andere war eingeschnitten – ich bitte Sie!« Und am folgenden Tag sagte er der *New York Herald Tribune*: »Die vielen Jurymitglieder von *Glamour* und *Seventeen* kriegen nie eine Haute-Couture-Kollektion zu sehen. Sie sind dafür verantwortlich, daß Gernreich den Preis bekommen hat.« Bonwit Teller konterte mit einer halbseitigen Anzeige mit der Schlagzeile: »Rudi Gernreich, wir würden Dir den Coty Award immer wieder geben!«

Bei der Coty-Award-Präsentation, auf der die siegreichen Modedesigner traditionell Kleider aus der Kollektion zeigen, der sie die Auszeichnung verdanken, sowie Kostproben aus ihren neuesten Kollektionen, sorgte Gernreich mit einem weißen Hosenanzug aus Dessous-Satin, den er als seinen Marlene-Dietrich-Anzug bezeichnete, erneut für helle Aufregung. Als Peggy Moffitt ihn während der Generalprobe trug, sagten Mitglieder der Coty-Jury, sie sehe wie eine Lesbe aus, und baten Gernreich, ihn nicht zu zeigen. Widerwillig folgte er dieser Bitte. Als im Jahr darauf der neue Coty-Award-Preisträger einen ähnlichen Anzug aus weißem leichten Satin zeigte, runzelte niemand die Stirn. »Ein Jahr später war die Idee akzeptabel, offensichtlich der toupierten Hochfrisur und der hohen Absätze wegen.« (Peggy Moffitt)

1964 sorgte dann der Topless Swimsuit weltweit für Aufsehen. Am 12. September 1962 hatte Gernreich der Reporterin von *Women's Wear Daily* in Los Angeles, Sylvia Sheppard, vorhergesagt, innerhalb der nächsten fünf Jahre würden Busen entblößt werden, später wiederholte er diese Vorhersage in der *Sports Illustrated*-Ausgabe vom 24. Dezember 1962. Gernreich schilderte die Ereignisse wie folgt: »1964 war ich bei den Swimwear-Ausschnitten an einem Punkt angelangt, der mich zu dem Schluß brachte, den Körper selbst – einschließlich der Brüste – zu einem integralen Bestandteil eines Badeanzugsentwurfs werden zu lassen.

Damals nahmen Brüste immer größere Dimensionen an, wenn nicht in körperlicher, so doch in kosmetischer und vor allem in gesellschaftlicher Hinsicht. Sie waren fast zum Gespött geworden. Jedes Mädchen, das ich kannte, war empört über die ›dirty little boy‹-Einstellung der amerikanischen Männer. Die wirklich schönen Brüste gehörten meines Erachtens zu den wirklich jungen Kör-

pern. Und es schien nur logisch zu sein, in einer Zeit zunehmender Liberalität, einer Zeit der Emanzipation der Frauen, diese Brüste zu entblößen.

Ich war mir dessen bewußt, daß die breiten Massen das als schockierend und unmoralisch betrachten würden, doch ich konnte auch das Heuchlerische nicht übersehen, das darin lag, daß etwas in einer Kultur als unmoralisch galt und in einer anderen völlig in Ordnung war. Die Brust war nicht aufgrund eines vorherbestimmten Plans der Natur zum Sexsymbol geworden, sondern weil wir sie dazu gemacht hatten.

Nach meinem Statement in *Women's Wear Daily* und der Schlagzeile in *Sports Illustrated* begannen die Leute mich zu fragen, ob ich meine Äußerungen wirklich ernst gemeint hätte. Je öfter sie fragten, desto sicherer wurde ich mir, daß die Idee richtig war. Gegen Ende des Jahres 1963 rief Susanne Kirtland vom Magazin *Look* mich an und sagte, sie wolle eine futuristische Trend-Story machen und hätte dafür gerne den NoTop-Badeanzug von mir. Ich sagte nein, die Zeit sei dafür noch nicht reif. Sie antwortete: ›Aber du mußt. Der Chefredakteur hat schon jetzt Okay gegeben.‹

Mein erster Gedanke war, wenn ich es nicht mache, wird sie Emilio Pucci oder jemand anderen fragen, weil

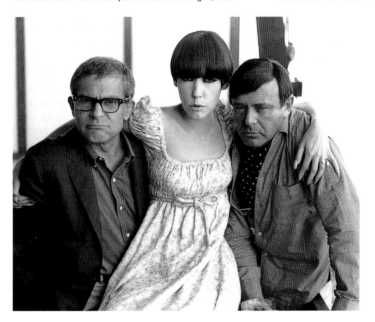

sie so fest entschlossen ist. Und es wäre furchtbar, wenn jemand anderes meine Vorhersage wahr machen, wenn mir jemand zuvorkommen würde.

Ich wußte, es könnte meine Karriere ruinieren, könnte mir den tiefsten Absturz einbringen, doch weil ich von der Richtigkeit der Sache überzeugt war und weil ich fürchtete, daß jemand mir zuvorkommen könnte, war ich einverstanden. Ich wußte, daß es ein wenig zu früh war, doch irgendwann in den nächsten Jahren würde es sowieso gemacht werden, so daß ich sogar das Timing rationalisieren würde.

Der erste Badeanzug, den ich ihr schickte, war ein balinesischer Sarong, der unmittelbar unter den Brüsten begann. Susanne sagte, sie halte ihn für nicht extrem genug, es müßte etwas Kühnes sein, fast wie ein Ausrufezeichen. Angeboten hätte sich sicherlich einfach ein Bikini-Unterteil, doch das wäre nur eine Evolution einer Idee und kein Entwurf gewesen. Und so kam ich auf den Badeanzug mit Nackenriemen, der später Geschichte machen sollte. Am 2. Juni 1964 erschien die Rückansicht in *Look*. Das Photo wurde auf den Bahamas mit einer Prostituierten als Modell aufgenommen.

Um keine Sensationsgier aufkommen zu lassen, faßten William Claxton, Peggy Moffitts Ehemann, Peggy und ich den Entschluß, unsere eigenen Photographien von Peggy in diesem Badeanzug aufzunehmen und sie den Mode- und Nachrichtenmagazinen zu präsentieren. Den *Playboy* und die Girlie-Hefte wollten wir umgehen. Zu unserer größten Verblüffung gerieten alle Leute in der Modewelt in Panik. Ob Sally Kirkland von *Life* oder Nancy White von *Harper's Bazaar* – niemand wollte etwas mit dem Badeanzug oder den Bildern zu tun haben. Schließ-

lich veröffentlichte Carol Bjorkman von *Women's Wear Daily* Bills Vorderansicht von Peggy am 3. Juni, und *Newsweek* brachte am 8. Juni eine Rückansicht.

Ich hatte nicht die Absicht, diesen Badeanzug auch tatsächlich zu produzieren und anzubieten, bis ich mit Diana Vreeland von *Vogue* sprach. Sie war die einzige Redakteurin, der ich das Modell persönlich zeigte. Peggy war mit mir gekommen, und sie trug den Badeanzug unter einem kleinen japanischen Kimono, den sie, ich glaube für acht Dollar, irgendwo auf dem Hollywood Boulevard gekauft hatte. Peggy kam in diesem Kimono, zog ihn aus und präsentierte den Badeanzug. Völlige Stille. Absolut keine Reaktion. Ich gab keinen Kommentar von mir. Als Peggy zur Tür hinausgehen wollte, brüllte Mrs. Vreeland mit dieser unvergeßlichen Stimme, ›Maaaaaaaaaaaahvelous (Heeeeeeeeeeeerrlicher) Kimono!‹ Ein paar Minuten später fragte sie mich, warum ich den Badeanzug gemacht hätte.

Ich antwortete, die Zeit sei jetzt meiner Meinung nach reif für Freiheit – in der Mode wie in allen anderen Aspekten des Lebens. Als sie mich fragte, ob ich den Badeanzug auf den Markt bringen würde, sagte ich nein, er sei nur ein Statement.

›Da machen Sie einen Fehler‹, sagte sie. ›Wenn man ihn auf einem Bild sehen kann, ist er eine Realität. Sie müssen ihn produzieren.‹ Als ich ins Hotel zurückkehrte, hatte Harmon schon angerufen, um mir mitzuteilen, daß Einkäufer den Badeanzug ordern wollten. Wir beschlossen, die Produktion aufzunehmen, und schließlich hatte jedes größere Kaufhaus in den Vereinigten Staaten ihn entweder vorrätig oder geordert und konnte ihn nicht verkaufen, weil die Kaufhauschefs moralische Einwände hatten.

Melvin Dawley von Lord & Taylor war einer von denen, die die Auslieferung verweigerten. Eine Boutique mit dem Namen Splendiferous übernahm daraufhin den Posten sofort. Hess Brothers in Allentown, Pennsylvania, wurde von Demonstranten belagert, und Milgrim's in Detroit bekam eine Bombendrohung.«

Der Topless Swimsuit machte Schlagzeilen, die in der amerikanischen Modegeschichte ohne Beispiel waren. *New York Times*, 22. Juni 1964: »Das sowjetische Regierungsorgan *Iswestija* berichtete über den neuen Badeanzug und fügte hinzu, daß in der amerikanischen Modeszene über Oben-ohne-Abendkleider spekuliert werde. ›Der American Way of life läßt keine Gelegenheit aus, zugunsten des Individualismus auf der Moral und dem Interessen der Gesellschaft herumzutrampeln. Der Zerfall der Geldbeutelgesellschaft setzt sich also fort.‹«

Los Angeles Herald Examiner, 14. Juli 1964: »In Schweden, Deutschland und Österreich ist der Badeanzug gesetzlich zugelassen, in Holland, Dänemark und Griechenland ist er verboten.«

New York Times, 2. Juli 1964: »Einen kurzen Augenblick lang hatten die Bürgermeister der Riviera eine Chance, sich zu erheben und als Männer zu erweisen, die für die Beibehaltung einer anständigen und normalen Lebensweise kämpfen. Frauen wurden rechtliche Maßnahmen angedroht, falls sie die Oberteile ihrer Bikinis – alle acht Zentimeter – ablegten. Das größte Verständnis für die Entrüsteten zeigte der Bürgermeister von SaintTropez. Wenn es Zeichen für Unruhe gäbe, so soll er gesagt haben, werde er Hubschrauber einsetzen, um die Strände zu überwachen und Straftäter ausfindig zu machen.« *Saturday Evening Post*, 31. Oktober 1964: »Natürliche Feinde wie die *Iswestija*, der *L'Osservatore Romano* und die Carroll Avenue Baptist Mission in Dallas beschwören die Heilige Schrift und Karl Marx und stimmen überein, daß er unmoralisch und asozial ist.«

New York Herald Tribune, 16. November 1964: »Italien reagierte nicht, nachdem der Badeanzug vom Papst mit einem Verbot belegt wurde.«

Von den dreitausend Frauen, die den Badeanzug kauften, trugen mindestens zwei ihn in der Öffentlichkeit. Carol Doda, eine Entertainerin aus San Francisco mit den Maßen 99–66–92, trug ihren während eines Auftritts im Condor Club. Der *Playboy* berichtete darüber in seiner Ausgabe vom April 1965. Die 19jährige Toni Lee Shelley wurde von einem Chicagoer Polizisten in Gewahrsam genommen, weil sie den Topless Swimsuit am Strand getragen hatte. Sie wurde wegen unangemessener Badekleidung angezeigt. Bei der Anklageerhebung bat sie um eine nur aus Männern zusammengesetzte Jury.

Peggy Moffitt schildert, welches Aufsehen durch die Photos erregt wurde, auf denen sie den Topless Swimsuit trug: »Als Rudi mir erzählte, daß er sich bereit erklärt habe, den Badeanzug für *Look* zu kreieren, fragte ich, wen er dafür als Modell nehmen wollte. Er sagte, ›dich‹. Ich darauf: ›Ha, ha, ha.‹ Später stimmte ich zu, für die Photos Modell zu stehen, die mein Mann aufnehmen sollte, weil ich einsah, daß es darum ging, die Sache der uneingeschränkten Ausdrucksfreiheit mit allen Mitteln zu vertreten. Ich stellte aber einige Bedingungen. Rudi und ich kamen überein, daß ich den Badeanzug nicht in der Öffentlichkeit tragen würde – daß das die ganze Sache nur aufheizen würde. Außerdem war ich nicht bereit, für andere Photographen Modell zu stehen.

Bill ging mit den Photos von mir zuerst zu *Life*. Sie sagten ihm, sie könnten sie nicht veröffentlichen, weil ›wir ein Familienmagazin sind, nackte Brüste nur gestattet sind, wenn es um Naturvölker geht‹. Weil sie die Story für schlagzeilenträchtig hielten – was sie damals ja auch wirklich war – baten sie Rudi, Bill und mich, ihnen dabei zu helfen, sie als eine historische Darstellung der Evolution der Brust in der Geschichte der Mode zu präsentieren. Also nahmen wir speziell für *Life* ein neues Photo, auf dem ich ihrem Wunsch entsprechend meine Brüste mit den Armen bedeckte.

Diese Photographie, die in *Life* erschien – auf der meine Brüste unter meinen Armen versteckt sind –, ist ein schmutziges Photo. Wenn man einen Badeanzug trägt, der bewußt als Topless Swimsuit entworfen worden ist, und die Arme über dem Busen verschränkt, folgt man genau der prüden, albernen Masche der Playboy-Bunnies.

Das Bild in *Women's Wear Daily*, das ich wirklich schön finde, hat der Madison Avenue einen schweren Schock versetzt. Wenn die Brust kein Sexsymbol mehr ist – und sobald man sie enthüllt hat, ist sie es nicht mehr –, wie soll man dann in Anzeigen damit locken? Wie soll man Zahnpasta verkaufen?«

Später legte Claxton seine Photos vom Topless Swimsuit *Paris Match* vor. Er erinnert sich: »Sie sagten haargenau dasselbe wie *Life* – *Paris Match* sei ein Familienmagazin und könne keine nackten Brüste auf dem Cover zeigen. Ich fand es immer sehr merkwürdig, daß auf dem Coverphoto der Ausgabe, die damals gerade erschienen war, eine bei einem Autounfall völlig zerfetzte Familie zu sehen war.«

Noch nach Gernreichs Tod setzte sich die Kontroverse um den Topless Swimsuit fort. Als die Los Angeles Fashion Group 1985 ihre Gernreich-Retrospektive, »Looking Back at a Futurist«, veranstaltete, drohte Peggy Moffitt, als künstlerische Leiterin der Ausstellung zurückzutreten, falls der Topless im Wiltern Theatre von einem Model präsentiert werden würde. Der *Los Angeles Times* (2. August 1985) sagte sie: »Rudi entwarf den Badeanzug als ein gesellschaftliches Statement. Er war als eine Provokation gedacht, in der Zusammenhang mit der Emanzipation der Frauen zu sehen ist. Für eine öffentliche Präsentation war er nie vorgesehen, und sobald ein Model ihn trägt, um seinen Körper zur Schau zu stellen, wird das ganze Konzept negiert. Ich habe mich darin photographieren lassen, weil ich an die gesellschaftskritische Aussage glaubte. Dieses Photo ging schließlich um die Welt, und wir drei – Rudi, Bill und ich – glaubten, daß es diese Aussage prägnant wiedergab. 1964 wurden mir für seine Veröffentlichung im *Playboy* 17.000 Dollar geboten. Ich habe dieses Angebot als undenkbar zurückgewiesen. Und ich lehne die Ausbeutung von Frauen heute genauso ab wie

Watts Towers, Los Angeles, 1965

damals. Die Aussage ist dieselbe geblieben. Es geht nach wie vor um den Freiheitsgedanken, nicht um die Befriedigung der Schaulust.«

Sara Worman, damals Vizepräsidentin von Robinson's und Regionaldirektorin der Fashion Group, kommentierte in der *Los Angeles Times*: »Ich kann es einfach nicht glauben: Wir sind ins Jahr 1964 zurückgeworfen! Auch für mich war der Badeanzug eine gesellschaftliche Aussage – die prophetischste, die je ein Modedesigner getroffen hat. Es war sein brillantestes Konzept. Alle möglichen Dinge, die wir heute für selbstverständlich halten, sind daraus hervorgegangen. Warum sollte ausgerechnet die wichtigste Idee, die er jemals hatte – die in der ganzen westlichen Welt die Art und Weise, wie Frauen sich kleiden, geändert hat, nicht präsentiert werden, wo wir doch alles andere, was er je entworfen hat, live auf die Bühne bringen?«

Peggy Moffitt setzte sich durch. Der Badeanzug wurde nicht präsentiert. Nur Photos davon wurden gezeigt.

Der Topless Swimsuit zeitigte auch ein weiterer Gernreich-Novum: den »no-bra bra«. Mehr als irgendein anderes einzelnes Unter- oder Oberbekleidungsstück hat dieser Büstenhalter wahrscheinlich zu einer neuen Paßformkonzeption beigetragen. Im Vergleich zu den gleichsam gepanzerten Büstenhaltern jener Tage (Gernreich verglich sie mit »etwas, was man sich zu Silvester auf den Kopf setzt«) war der für Exquisite Form hergestellte »no-bra bra« in der Tat revolutionär. Er befreite die Frauen von der Polsterung, den Stäbchen und der Stepperei – den typischen Merkmalen der BHs dieser Zeit –, und gab den Brüsten ein natürliches Erscheinungsbild. Er bestand aus zwei an Trägern befestigten weichen, transparenten Nylonkörbchen und einem schmalen Band aus elastischem Material, das den Brustkorb umgab.

Bis zum Frühjahr 1965 hatte sich der »no-bra bra« als ein Verkaufserfolg erwiesen, und bald schon folgten ihm der »nosides bra« (tief geschnitten, passend zu Kleidern mit tiefen Armausschnitten), der »nofront bra« (tief geschnitten, passend zu Ausschnitten, die bis zur Taille reichen) und der »noback bra« (nicht um den Brustkorb, sondern um die Taille herum befestigt).

Dem »no-bra bra« war es auch zu verdanken, daß Peggy Moffitt nach New York kam, wo sie in Richard Avedons Studio einem weiteren Modernisten dieser Zeit begegnete, dem Londoner Hair-Stylisten Vidal Sassoon. Als er einige Monate später nach Los Angeles kam, machte sie ihn mit Gernreich bekannt. Die beiden schlossen augenblicklich Freundschaft und entwickelten fortan gemeinsam neue Haar- und Kleiderschnitte.

Während die Mods und Rockers um die Vorherrschaft

in der Londoner Modewelt kämpften und die Beatles das »Hair Happening« in Gang setzten, erwies Gernreich Ringo Starr seine Reverenz, indem er im Herbst 1965 seinen Flanellnadelstreifenhosenanzug mit Weste als »Ringo-Look« bezeichnete. England revanchierte sich für dieses Kompliment, als die *London Sunday Times* Gernreich für seinen Beitrag zur »Einführung des natürlichen Looks in der heutigen internationalen Mode und den Einfluß, den er durch seine Sportswear und seine Dessous auf die amerikanische Damenmode ausgeübt hat« mit ihrem internationalen Modepreis auszeichnete. Moffitt und Claxton begleiteten Gernreich zur Preisverleihung nach England. Peggy Moffitt: »Nach der Show fuhren Rudi, Bill und ich nach Paris, wo ich Dorian Leigh begegnete. Sie redete mir zu, dort zu bleiben, um als Model für ihre Agentur zu arbeiten. Auch Rudi ermutigte mich, in Europa zu bleiben – er sagte, es wäre gut für meine Karriere. Also blieb ich dort und arbeitete fast ein Jahr lang in Paris und London. Jahre später erzählte Rudi mir, es sei ihm zwar klar gewesen, daß es für mich das Beste war, in Europa zu bleiben, daß er jedoch Angst gehabt habe, ohne mich nichts entwerfen zu können. Das gehörte zum Rührendsten, was er mir je gesagt hat.«

Im August 1965 trat in John Fairchilds Buch *The Fashionable Savages* (dt.: »Magier, Meister und Modelle. Modeschöpfer und Mode-Idole von heute«, Frankfurt am Main 1967) etwas zutage, was sich zu einer langjährigen Fehde mit Fairchilds Blatt *Women's Wear Daily* auswachsen sollte. In ihrer Rezension dieses Buches in der *New York Herald Tribune* schrieb Eugenia Sheppard: »Ich glaube, daß er (Fairchild) Rudi Gernreich, einen der wirklich kreativen Modeschöpfer, unterbewertet. Mit seinem Einwand, daß Gernreichs Kleider schlecht konstruiert sind, trifft er genau den Punkt – Gernreich steht für eine Rebellion gegen Haute-Couture-Mode, die für John Fairchild inakzeptabel ist.«

Die hohen Preise der Haute Couture waren für Gernreich tatsächlich ein großes Ärgernis. Am 3. Januar 1966 brach er das ungeschriebene Gesetz der amerikanischen Mode, daß renommierte Modeschöpfer nicht an Ladenketten liefern, und verpflichtete sich, für Montgomery Ward ein spezielles Sortiment an exklusiven Entwürfen zu kreieren. Der Vertrag ging über mehrere Saisons, und Gernreich und Montgomery Ward konnten beweisen, daß originelle Mode zu erschwinglichen Preisen ein Verkaufserfolg werden kann.

Während dieser Zeit wurde Gernreich von Montgomery Ward gebeten, in einem der Chicagoer Kaufhäuser der Kette persönlich zu erscheinen. Der Auftritt sollte zu einer Lektion in Bescheidenheit werden. »Es war ein ganz normaler Auftritt eines Modeschöpfers in einem Kaufhaus. Die Leute sollten kommen und Fragen stellen können – ganz harmlos. An einem der Pfeiler des Stockwerks hing ein kleines Plakat mit einem Bild von mir im Hintergrund. Stapel von Autogrammkarten lagen bereit, und der Bereich war mit Samtseilen abgegrenzt. Meine Anwesenheit war für zwischen zwölf und vierzehn Uhr angekündigt. Um zwölf kamen Scharen von Menschen aus dem Aufzug, und ich dachte, sie würden über mich herfallen. Aber niemand kam zu mir hinüber. Keine einzige Person wollte mich sehen. Und während ich da herumstand, kamen schließlich ein paar Damen auf mich zu, und ich dachte, na, jetzt geht's los. Und sie fragten, ›Wo ist die Damentoilette?‹ Das war alles.«

In seinen eigenen Kollektionen aus dieser Zeit führte Gernreich gestrickte Badeanzüge mit von Strumpfbändern aus Vinyl gehaltenen Gummistrümpfen mit Vinylapplikationen ein. Er entwarf das erste Chiffon-T-Shirtkleid. Er kreierte Helme, die sich über das ganze Gesicht erstreckten, Mäntel mit Kragen bis in Nasenhöhe, Badeanzüge, die wie Turtleneck-Skisweater aussahen. Er bedruckte matten Jersey mit einem Federmuster für Unterzieher und passende Strümpfe und machte Kopfbedeckungen aus Federn. 1966 wurde er mit einem zweiten Coty Award ausgezeichnet.

Im September 1966 übertrug Gernreich seinen ausgeprägten Sinn für graphische Muster unmittelbar auf den Körper und schuf die ersten modernen Tattoos, indem er Arme, Beine und Körper seiner mit einem Bikini bekleideten Modelle mit Dreiecken, Quadraten, Kreisen und Rechtecken bedeckte. Die auf der Haut haftenden Ornamente wurden in Plastikbeuteln seiner für Harmon Knit-

wear entworfenen Badeanzügen beigelegt. Peggy Moffitt erinnert sich an die Entstehungsgeschichte dieser ersten »body graphics«: »Für die indische Kollektion von 1965 wollte ich mir ein Kastenzeichen auf die Stirn auftragen, doch ich konnte keinen Lippenstift verwenden, weil ich unmittelbar darauf einen modernen Badeanzug präsentieren mußte, der nichts mit Indien zu tun hatte. Deshalb schnitt ich aus einem fuchsienfarbenen Streichholzheftchen einen Kreis aus und klebte ihn mit Augenwimperklebstoff auf. Aus dieser Idee gingen später die Abziehbilder hervor. Für die nächste Kollektion machte ich kleine geometrische Tränen aus Aluminiumfolie. Später, als ich aus Europa zurückkehrte, führte Rudi diese Idee bis zur äußersten Grenze: Ich trug ein rotes Bikini-Unterteil, und er beklebte meinen übrigen Körper mit schwarzen Vinyldreiecken.«

Ende 1966 wurden Gernreichs Entwürfe Gegenstand eines Kurzfilms, der als das erste Mode-Video bekannt werden sollte, *Basic Black*. William Claxton erzählt die Entstehungsgeschichte: »Nachdem Peggy und ich aus Europa zurückgekehrt waren, kam ein Produzent von Fernsehwerbespots auf mich zu, der einen Film haben wollte, um Beispiele meiner Arbeit zeigen zu können – einen Musterfilm sozusagen. Ich beschloß, die Dinge miteinander zu kombinieren, die ich am besten kannte – Rudis Kleider und meine Photographie. Peggy und mir schwebte ein abstrakter Modefilm vor, und wir schrieben ein entsprechendes Exposé. Für das nächste Wochenende mieteten wir ein Studio in New York, und mit Peggy, Léon Bing und Ellen Harth wurde das Projekt in zwei Tagen fertiggestellt. Rudi zeigte den Film oft im Rahmen seiner Shows in Südamerika und im Orient, und Vidal Sassoon benutzt ihn noch immer. Ich denke, es ist der erste Film, in dem Kleider für sich selbst sprachen, ohne Kommentar.«

Inzwischen wurde Gernreich von seinen einst eher reservierten Kollegen auf der Seventh Avenue so einmütig anerkannt, daß selbst Norman Norell einlenkte. »Er ist talentierter geworden«, so Norell zu einem Reporter des *Washington Star* (30. September 1966). »Heute hätte ich nichts mehr dagegen, daß ihm der bedeutende Coty-Preis verliehen wird.«

Der Showman Gernreich verblüffte das Publikum, als auf der Präsentation seiner Oktober-Kollektion ein Model ein gegürtetes Hemdblusenkleid trug, das ihre Knie bedeckte. Damit nicht genug, trug sie auch noch einen wattierten BH, Nylonstrümpfe und Pumps mit Pfennigabsätzen. Eine Tasche und Handschuhe komplettierten das Ganze. Bevor die Reporter und Einkäufer sich von diesem Schreck erholen konnten, trat Peggy Moffitt in einem wie das Hemdblusenkleid gemusterten schenkelhohen Mini und Schuhen mit niedrigen Absätzen auf den Laufsteg. »Ich wollte zeigen,« sagte Gernreich, »daß es in der Mode das Richtige oder Falsche nicht gab – daß es damals darauf ankam, wie Kleider zusammengesetzt waren.«

Um sicherzugehen, daß jeder seine Botschaft von 1967 verstehen würde, stellte Gernreich seiner Resort-Frühjahrskollektion dieses Statement voran: »Zum ersten Mal in der Geschichte der Welt – zumindest seit dem Kinderkreuzzug – weisen uns die jungen Leute den Weg. Heute gibt es eine ›Power Elite‹ der Jungen. Genauso wie sie zur Zeit ihre gesellschaftliche und politische Macht entdecken, entdecken sie auch ihre Macht in der Mode. Sie führen eine natürliche Fusion von Person und Bekleidung herbei. Und das Amüsante ist, daß die älteren Leute zu revoltieren beginnen. Das könnte in einigen Jahren, wenn die Jungen älter geworden sind, zu interessanten Konsequenzen in der Mode führen. Mehr als 300 Jahre hat die französische Frau die Mode diktiert. Jetzt endlich gelangt die amerikanische Frau auch diesbezüglich zu Reife und Freiheit.

Und nichts ist natürlich begrenzter als die Freiheit. Die Freiheit ist des Messers Schneide, eine haarfeine Linie, ein hauchdünner Grat. Freiheit ist Schönheit, aber Schönheit ist zuerst immer häßlich. Freiheit ist Sex-Appeal, aber Sex-Appeal ist immer asketisch. Freiheit ist Kunst, aber eine unbedeutende, keine große Kunst.«

Am 30. Juni 1967 wurde Gernreichs Modekunst insofern bedeutend, als die Coty American Fashion Critics ihn in

die Fashion Hall of Fame erhoben – die höchste Auszeichnung in dieser Zeit. Überreicht wurde sie ihm im Metropolitan Museum of Art in New York.

Auch die *New York Times* erwies ihm die Ehre: »Praktisch alle Innovationen in der amerikanischen Mode scheinen auf diesen 44jährigen Modeschöpfer zurückzugehen, der in Wien geboren wurde und in Kalifornien zu Hause ist. Sein bekanntester Entwurf ist der einzige Modegag, der sich nicht verkaufen ließ – der Topless Swimsuit. Mr. Gernreich hat es immer verstanden, Trends vorwegzunehmen. Er ist für seinen Hang zur Reduktion bekannt – von seinem ungefütterten Strickbadeanzug vor 15 Jahren bis hin zu den transparenten Kleidern oder den Kleidern der neueren Saisons mit ausgeschnittenen Löchern an den Seiten.«

1967 präsentierte Gernreich Hemdblusen und Kleider mit ungeahnt tiefen Ausschnitten – sie endeten zehn Zentimeter unterhalb eines breiten Ledergürtels. Er nannte die Kollektion »Beyond the Navel« (Jenseits des Nabels). Im Oktober war der Saum auf 30 Zentimeter oberhalb der Knie hinaufgerutscht, und Pierrot, Edith Sitwell und Diaghilew waren Rudimentäre Stilelemente geworden. Auch Pumphosen und Ballon-Röcke spielten in dieser Kollektion eine große Rolle. Eines von Gernreichs weißen Chiffonkleidern mit Ballon-Rock und passender Strumpfhose wurde dem Weißen Haus für die Hochzeit von Lynda Bird Johnson und Captain Charles S. Robb zur Verfügung gestellt. Die Besitzerin, Carol Channing, geriet ins Zentrum einer Kontroverse über das Verhältnis zwischen Mode und Anstand. In *Newsweek* sagte sie (25. Dezember 1967): »Für mich war es das, was man im Jahre 1967 zu einer Hochzeit trägt.«

Gernreichs größte journalistische Ehrung erfolgte am 1. Dezember 1967, als er zusammen mit Peggy Moffitt und Léon Bing auf dem Titelblatt des Magazins *Time* erschien, das ihn als »den exzentrischsten, avantgardistischsten Modedesigner in den USA« bezeichnete. Obgleich er auch 1968 seinen gestalterischen Wirkungskreis erweiterte – zunächst um Strümpfe für McCallum Boutique, später um Signaturschals für Glentex und Muster für

1968

McCall's –, zeigte er sich immer ernüchterter von der Richtung, die die Mode nahm. Im Januar 1968 ließ er Moderedakteure, die seine Show besuchten, wissen: »Der Einfluß, den ›Bonnie and Clyde‹ auf die Mode ausübt, ist einfach unerträglich. Der Film ist großartig – ein schöner, tragischer Film –, aber mit der Mode als solcher hat er nichts zu schaffen. Frühere historische Perioden kehren immer in der Mode zurück. Sie müssen jedoch immer neu interpretiert werden. Andernfalls handelt es sich um eine Flucht vor der Realität in Kostümnostalgie und Eskapismus. Die Geschichte muß benutzt, nicht einfach wiederhergestellt werden.«

Zu Gernreichs Modeideen dieses Jahres zählten siamesische Haremkleider, die sich zwischen den Beinen windelartig falteten, transparente Vinylbänder auf gestrickten Kleidern und Badeanzügen, Kosakenkleider, Stiefel mit weißen Federn und Strumpfhosen und Schals, die nicht mit Gernreichs Namen bedruckt waren (sogenannte Signaturschals mit dem Namen des Modeschöpfers waren damals sehr populär), sondern mit durcheinandergeworfenen Buchstaben, die keinen Sinn ergaben. Gernreich nannte ihn »the unsignature scarf«.

Mit einem Statement, dem andere Modeschöpfer später zustimmen sollten, stellte er im Mai wieder einmal seine seherischen Kräfte unter Beweis. »Die Zeit der Modediktatur ist vorbei«, verkündete er in einer Pressenotiz für die Besucher der Präsentation seiner Herbstkollektion, »und damit auch der autoritäre Ansatz in der Mode. Weltweit herrscht Verwirrung in allen Aspekten des Lebens, auch in der Mode. Überall brechen Strukturen zusammen. Die Verwirrung ist überall zu spüren, und der Modeschöpfer muß damit und dagegen arbeiten. Es ist interessant, aber ein furchtbares Durcheinander. Wir haben entdeckt, daß Nacktheit nicht unbedingt unmoralisch ist, daß sie eine eindeutige und nicht unanständige Bedeutung haben kann. Der Körper ist eine legitime Dimension der menschlichen Realität und steht für viele Dinge außerhalb der Sexualität zur Verfügung. Allmählich wird die Befreiung des Körpers unsere Gesellschaft von ihrem Sexkomplex

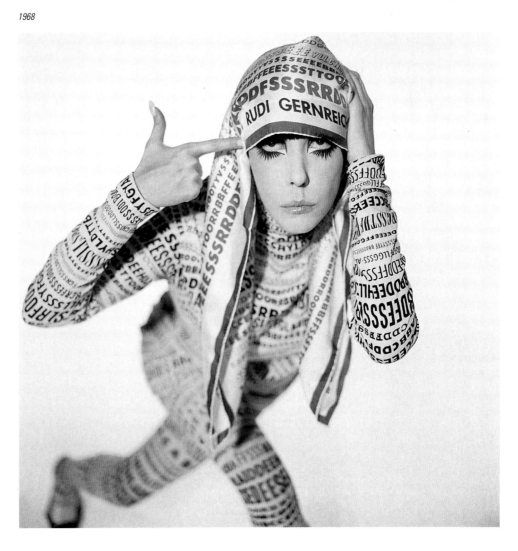

heilen. Heute werden unsere Vorstellungen vom Maskulinen und Femininen wie nie zuvor in Frage gestellt. Der wesentliche Reiz des Geschlechtlichen geht vom Menschen aus, nicht von ihrer Bekleidung. Wird ein Kleidungsstück aufs Wesentliche reduziert, kann es von beiden Geschlechtern getragen werden.«

Am Schluß seines Statements erklärte er den Rock für erledigt; Hosen und Hemdblusenkleider mit Strumpfhosen hätten ihn ersetzt. *Women's Wear Daily* widersprach. Laut einem am 12. Juni 1968 veröffentlichten Beitrag war nicht der Rock, sondern Gernreich selbst die bedrohte Modespezies. »Rudi Gernreich hat sich selbst ins Abseits manövriert. Jahrelang war er der avantgardistischste Modedesigner Amerikas und ist als solcher gerühmt worden. In dieser Saison jedoch lag Rudi mit seinen Gags, Kostümen und Scherzen aus früheren Kollektionen daneben. Seine Minihemdblusenkleider über zugeschnitten Beinbedeckkungen, sein geschichteter Look, der die Trägerin um Pfunde schwerer macht, und seine aufgeblähten Pumphosen sind weder von heute noch von morgen. Rudi sagt, daß wir heutzutage Spaß und Spiele brauchen, doch seine Kollektion sieht eher wie eine Komödie der Irrungen aus.«

Am 16. Oktober 1968, als Gernreich verlautbaren ließ,

1969, Photo: Peggy Moffitt

er werde eine einjährige Pause einlegen, hatten Spaß und Spiel ein Ende. In einer kurzen Pressemitteilung sagte er: »Es hat nicht viel zu bedeuten. Ich glaube einfach, es ist Zeit für eine längere Pause. Ich möchte einfach zur Ruhe kommen.«

Der eigentliche Grund für diese Entscheidung war komplexer: »Seit mehreren Jahren schon hatte ich gespürt, daß es mit der Haute Couture vorbei war, daß teure Kleider keinen Sinn mehr machten. Meine eigenen ›Rudi Gernreich‹-Entwürfe wurden fürchterlich exklusiv. Ein vollständig zusammengesetztes Outfit mit passenden Strümpfen, Schuhen und Kopfbedeckung war nicht nur teuer, sondern auch für den Handel schwierig zu handhaben. Die Läden waren nicht darauf eingerichtet, Strümpfe und Unterwäsche in derselben Abteilung zu verkaufen wie Kleider oder Röcke, so daß der Gesamtlook, der meinen Vorstellungen entsprach, nie wirklich als solcher angeboten wurde.

Es war mir klar, daß ich entweder expandieren mußte, um die Preise zu senken, oder klein bleiben und höhere Preise hinnehmen mußte. Der Gedanke an eine große geschäftliche Expansion schreckte mich ab. Ich wollte kein großer Hersteller mit allen damit verbundenen geschäftlichen Problemen werden. Dafür fühlte ich mich nicht berufen, daran hatte ich kein Interesse. Ich wollte weiterhin experimentieren, koste es, was es wolle, und das bedeutet zwangsläufig, daß man immer auf dem schmalen Grat zwischen Erfolg und Flop wandelt.

Darüber hinaus hatte ich Probleme mit meinen Mitarbeitern, Schwierigkeiten, die einen Neubeginn notwendig machten. Ich stand am Rande eines Nervenzusammenbruchs, war überarbeitet, stand unter zu hohem Druck, hatte die Nase voll. Meine letzte Kollektion war schrecklich extravagant gewesen, ein Statement von eher absurder Art. Sie stieß überall auf Kritik. Und ich war derart in die geschäftlichen Dinge einbezogen, daß ich nicht mehr genügend Zeit zum Entwerfen fand.

Die Strickwaren für Harmon entsprachen genau meinen Vorstellungen – sie waren praktisch, tragbar, und der Preis stimmte – aber auch aus dieser Geschäftsbeziehung wollte ich heraus, obwohl es, im Unterschied zu allen anderen Herstellern, mit denen ich zusammengearbeitet habe, mit Harmon nie ein Problem gegeben hatte.

Als ich Harmon meine Entscheidung mitteilte, reagierte er wunderbar – sehr, sehr verständnisvoll. Er sagte, ich solle mir drei Monate Zeit lassen, und dann sollten wir noch einmal darüber sprechen. Er versicherte mir, daß wir die ›Harmon Knitwear‹-Kollektion mit möglichst wenig Aufwand realisieren würden. Es wäre dumm von mir, unsere Geschäftsbeziehung aufzugeben, und da ich bereits eine Kollektion für ihn in Arbeit hatte, stellte ich sie fertig, bevor ich nach Marokko abreiste. Diese Kollektion war eine der profitabelsten, die ich je für ihn entwarf.

Sobald ich die Entscheidung getroffen hatte, war von der nervösen Erschöpfung nichts mehr zu spüren. Ich fühlte mich frei, erleichtert. Und ich mietete mir einen Traumpalast in Tanger, der Yves Vidal gehörte, dem Präsidenten von Knoll International. Ich reiste durch Marokko und auch durch Europa und war fast ein Jahr lang im Ausland. Die Entwürfe für Harmon gingen mir leicht von der Hand, und ich ließ keine Strickwaren-Kollektion aus. Als ich zurückkehrte, eröffnete sich mir ein völlig neues berufliches Leben.«

Das war im Herbst 1969. Es war das Jahr, in dem die Modeschöpfer in Europa den Midi hervorzuzaubern, um das neue Jahrzehnt zu begrüßen; das Jahr der Mondlandung und des Anfangs vom Ende des Vietnamkriegs. Für Gernreich war es auch das Todesjahr der Mode. Es war fast von symbolischer Bedeutung, daß *Life* ihn bat, den künftigen Weg der Mode vorherzusagen. Die Redakteurin Helen Blagden wollte von ihm wissen, was Männer und Frauen im Jahre 1980 tragen würden.

Wie schon im Falle von *Look* und des Topless Swimsuit sagte Gernreich, es sei unmöglich, eine visuelle Realität vorherzusagen, ohne zu einer Karikatur des Science-Fiction-Comicstrips Buck Rogers zu gelangen. Als er erfuhr, daß für die Sonderdoppelausgabe von *Life*, die unter dem Titel »Into the Seventies« zu Beginn des neuen Jahres erscheinen sollte, auch Spekulationen über die Konsequenzen der Mondlandung von Norman Mailer und eine Umfrage über die zukunftsbestimmenden gesellschaftlichen Koalitionen von Louis Harris vorgesehen waren, ließ Gernreich sich umstimmen und erklärte sich zu einer seiner Ansicht nach halbwegs realistischen Voraussage über die Mode der Zukunft bereit.

»Wenn man sich zu weit von etwas Plausiblem entfernt, verliert man genau das – die Plausibilität der Sache. Ich bin wirklich davon überzeugt, daß man nur die Gegenwart wahrnehmen kann, daß man in seine Zeit eingebunden ist. Meine Gedanken für *Life* waren zeitgebunden, doch ich bemühte mich darum, ihre zeitliche Begrenzung auf das Jahr 2000 auszudehnen.«

Diese Gedanken – rasierte Körper und eine auf das Allerwesentlichste reduzierte Kleidung – wurden von *Life* (1. Januar 1970) wie folgt zusammengefaßt: »Gernreich zufolge ist der nostalgische und zirkushafte Look der heutigen Kleidung ein Zeichen dafür, daß wir uns den Problemen des modernen Lebens nicht stellen wollen. Die Bekleidung der Zukunft wird funktional sein müssen. Laut Gernreich steht eine Zeit unmittelbar bevor, in der ›die Leute von Kleidung mit einem romantischen Touch nichts mehr wissen wollen‹. Die Frau von morgen wird sich ihres Schmucks, ihrer Kosmetik und ihrer Kleidung genauso entledigen wie der Mann von morgen. Die Mode wird aus der Mode verschwinden. Das ›Funktionalitätsprinzip‹ wird, so Gernreich, dazu führen, daß es uns gleichgültig wird, wie wir aussehen, und wir uns statt dessen auf wirklich wichtige Dinge konzentrieren können. Kleidung wird nicht als entweder männlich oder weiblich identifiziert werden. Sowohl Frauen als auch Männer werden Hosen und Röcke tragen. Und da Nacktheit nicht als peinlich empfunden werden wird, werden durchsichtige Bekleidungsstücke nur der Bequemlichkeit halber durchsichtig sein. Wenn das Wetter es erlaubt, werden beide Geschlechter barbrüstig herumlaufen, Frauen allerdings mit einfachen Schutzfolien. Die Modeästhetik wird den Körper selbst einbeziehen. Wir werden den Körper trainieren, um ihn selbst schön werden zu lassen, statt durch seine Bedeckung Schönheit hervorzubringen.«

Für die älteren Menschen sagte Gernreich kaftanartige Obergewänder voraus. »Der heutige Kult ewiger Jugend ist unehrlich und zweifellos unattraktiv. In einer Zeit, in der der Körper zur Konvention der Mode wird, werden sich die alten Leute in Uniformen kleiden, die ihrer Körperform entsprechen. Wenn ein Körper nicht mehr akzentuiert werden kann, sollte er abstrahiert werden. Die jungen Menschen werden keine bedruckten Stoffe tragen, die älteren dagegen schon, weil auffällig bedruckte Stoffe vom Körper ablenken. Die älteren Leute werden ihren eigenen Kult entwickeln, und niemand mehr wird sich seines Alters schämen.«

Nachdem der von Zeichnungen begleitete Artikel erschienen war, arrangierte Eugenia Butler, eine mit Gernreich bekannte Kunsthändlerin, eine Begegnung mit Maurice Tuchman, dem leitenden Kurator für moderne Kunst am Los Angeles County Museum of Art und Vorsitzenden der Auswahlkommission für amerikanische Kunst und Technologie für die Expo 70, die Weltausstellung im japanischen Osaka. Tuchman bat Gernreich um ein Special Event für die Expo – ein Kunst-in-Mode-Statement für Künstler und Redakteure von Kunstzeitschriften, die die japanische Weltausstellung besuchen würden.

Gernreich erklärte seine Entscheidung, seine Entwürfe in *Life* zu präsentieren, wie folgt: ›Ich ärgerte mich furchtbar über das, was in dieser Zeit passierte. Ich wollte die Leute aufrütteln. Ein starkes Anti-Statement war angebracht, und dafür war eine Zeichnung zu unbestimmt und unwirklich. Wenn ich diese Zeichnung in Kleider umsetzen würde, so glaubte ich, wäre das Ergebnis etwas Wirkliches, was einen Eindruck hinterlassen würde. Die meisten Leute sahen in dem *Life*-Artikel ein heftiges Antisex-Statement. Einige sahen darin etwas Lyrisches, glaubten, das Unisex-Statement stehe für ein friedliches Zusammenkommen. Ich war neugierig, wie die Leute auf die Verwirklichung reagieren würden.«

Zuerst bat er Peggy Moffitt, ihm als Modell zur Verfügung zu stehen. Sie lehnte ab. »Für mich war es völlig legitim, für die nächsten dreißig oder fünfzig Jahre einen Blick in die Zukunft zu werfen, aber nackte Menschen tatsächlich zu präsentieren, kam mir dann doch fragwürdig vor. Wenn man die Zukunft vorhersagt und das Vorhergesagte dann in der nächsten Woche zeigt, hat es nichts Futuristisches mehr. Ich wollte ihm sagen, daß man ihn persönlich angreifen würde, wenn er kahlgeschorene Menschen präsentieren sollte, wo er doch selbst seine Glatze mit einem Toupet bedeckt, aber ich konnte es nicht. Er brachte Gründe vor, weshalb er an der Idee festhalten wollte, seine Zeichnungen zum Leben zu bringen, doch ich wollte nichts damit zu tun haben.«

Nachdem auch Léon Bing nein gesagt hatte, machte sich Gernreich auf die Suche nach einem jungen Mann und einer jungen Frau, die bereit waren, ihre Körper und Köpfe rasieren zu lassen und ihn zur Expo 70 zu begleiten. Die Frau war schließlich Renee Holt, ein 22jähriges Model, der Mann der 30jährige Tom Broo-

Unisex, 1970, Photo: Patricia Faure

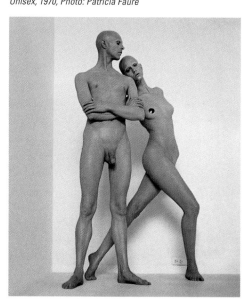

me, Manager einer Boutique in Los Angeles namens Chequer West.

Time berichtete über das Rasier-Event in seiner Ausgabe vom 26. Januar 1970: »Zuallererst mußten die Köpfe und Körper seiner beiden Modelle rasiert werden. ›Das Haar verbirgt eine ganze Menge‹, erklärte Gernreich, ›und die Körperbehaarung hat eine zu große sexuelle Bedeutung. Ich möchte die Idee der Freiheit nicht mit sexueller Nacktheit durcheinanderbringen. Offenheit und Ehrlichkeit verlangen keinerlei Bedeckung.‹

Für Thomas Broome war es keine schreckliche Vorstellung, am ganzen Körper enthaart zu werden: ›Ich wollte meine Haare schon lange loswerden. Ich habe diese Theorie, daß, wenn ich das tue, ich anderes loswerden kann – vielleicht meine Hemmungen.‹ Renee Holt dagegen sah ihrem Friseurtermin mit Angst entgegen. Liebevoll streichelte sie ihre langen goldenen Locken und sagte tapfer: ›Irgendwie ist langes Haar eine Krücke für eine Frau. Ist das Haar erst einmal kurz, kann man vielleicht andere Dinge wie etwa den Intellekt weiterentwickeln. Aber ich muß immer daran denken, was mein Vater wohl sagen wird.‹

Eine Stunde später tauchten Tom und Renee unter ihren Frisiermänteln hervor und betraten getrennte Badezimmer, um sich jede Spur von Körperhaar abzurasieren. ›Ihr seht toll aus, einfach toll‹, schwärmte Rudi, als sie zurückkehrten. Eine Kosmetikerin trug eine dünne Schicht fleischfarbenen Make-ups auf ihre nackten Körper auf, und dann war es Zeit, so, wie sie waren, in ihre Kostüme zu kommen. Beide zogen dasselbe an: schwarzweiße Monokinis und darüber weiße ausgestellte Strickhosen und schwarzweiße ›Tank-tops‹, rippenlange, enganliegende Unterhemden. Während die Photographen Aufnahmen machten und Gernreich Anweisungen gab, probten die Modelle ihren Auftritt, der am 20. Januar in Eugenia Butlers Haus in Hancock Park und später in ihrer Galerie stattfinden sollte. Weg mit den Tank-tops. Runter mit den Hosen. Langsam glitten die Monokinis zu Boden. Nach einem Schritt zur Seite standen Tom und Renee still – Statuen – oder Insassen eines Konzentrationslagers.«

Gernreichs gespannte Erwartung, wie die Leute auf Tom und Renee reagieren würden, schlug auf der Veranstaltung bei Butler in einen Schock um. Während er die Modelle durch die johlende Menge der Besucher führte, erschien plötzlich ein Mann, der seine Genitalien entblößte und ein Phallus-Spottsymbol in Form einer gelben Bettwurst trug. Als Gernreich zu hören bekam, daß der Flitzer Paul Cotton war, einer von Mrs. Butlers Künstlern, und daß sie das ganze Spektakel inszeniert habe, stellte er sie zur Rede; sie bestritt, etwas davon gewußt zu haben. Als sie später zusammen mit einem entblößten Cotton in der Warteschlange vor dem amerikanischen Pavillon in Osaka verhaftet wurde, erkannte Gernreich, daß er hintergangen worden war. Und als Cotton bei der Präsentation in Tuchmans Haus bei Kioto seine Performance wiederholte, indem er bis auf eine Körperbemalung mit Silberfarbe völlig nackt auftrat, mußte Gernreich erkennen, daß er erneut verspottet werden sollte.

Während die internationale Presse Gernreichs Mode-Statements der sechziger Jahre immer wieder ausführlich kommentiert hatte, machte sein Anti-Statement von 1970 kaum Schlagzeilen. *Women's Wear Daily* berichtete darüber unter der Rubrik »Arts & Pleasures«. Die meisten Zeitungen und Zeitschriften interessierten sich mehr für die damals kürzer werdenden Röcke und Kleider als für abrasiertes Haar.

Los Angeles Times, 22. Januar 1970: »Rudi Gernreichs ›Projection 1970‹ ist eher eine philosophische Aussage als ein klares Statement über die Zukunft der Mode. Tatsächlich ist es ein Anti-Mode-Statement. Hinter der reißerischen Nacktheit völlig haarloser Körper ist Gernreichs Projektion eine ehrliche Auseinandersetzung mit seinen Zukunftserwartungen und deren Auswirkungen auf das Erscheinungsbild der Menschen.«

Los Angeles Herald Examiner, 21. Januar 1970: »Die Aktionen waren eigentümlich freudlos. Als alles vorbei war, fehlte sehr viel mehr als nur Kleidung und Körperhaar. Verschwunden waren auch Phantasie, sogenannte ›Anstandskomplexe‹, traditionelle Geschlechterrollen, von den Profiterwartungen der Modeindustrie, der Stoffproduzenten und der chemischen Reinigungen gar nicht erst zu reden.«

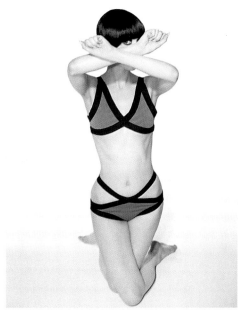

1971

Fashion Week, 26. Januar 1970: »Ist 2001 auch nur eine Spur weniger schön und ehrfurchtgebietend, weil Kubrick nicht da ist? Nein. Wir sind in die Zukunft involviert. Und es könnte unsere Rettung sein, daß es einen gibt, dem es ernst damit ist.«

Women's Wear Daily, 22. Januar 1970: »Der Modedesigner Gernreich hatte für mehrere Monate eine Pause eingelegt, um seine kreativen Batterien aufzuladen. Schade, daß er zu früh ans Zeichenbrett zurückgekehrt ist.«

Gernreich schloß aus den Kommentaren und Reaktionen, daß die Leute nicht mehr so leicht zu beeindrucken waren. »Sie haben sich an ungewöhnliche Statements gewöhnt. Es gibt noch einige, die leicht zu schockieren sind, aber nicht mehr viele. Ich habe einige haßerfüllte Briefe bekommen, aber die schweigende Mehrheit war stiller als in früheren Jahren.«

Von allen, die sich gegen Gernreichs kahles Statement aussprachen, ging nur das Ponce College of Beauty im kalifornischen Palo Alto zu Protestaktionen über. Das Kosmetikinstitut schaltete eine halbseitige Anzeige in der *Palo Alto Times* mit der Schlagzeile »Help Stamp Out Rudi Gernreich« (Rudi Gernreich muß das Handwerk gelegt werden). Der Auftritt in Japan, der nicht zum offiziellen Expo-Programm gehörte, wurde von Max Factor finanziert. Dieses Sponsoren wegen erweiterte Gernreich seine ursprüngliche Projektion für *Life* um eine Make-up-Schicht, die den Körper vor der Sonne und vor der Kälte schützen sollte. Die Unisex-Bekleidungsstücke, die zu dieser Präsentation gehörten – Hosen, Röcke, Bikinis, Overalls –, entstammten alle früheren Gernreich-Kollektionen. Die Stiefel waren 1965 von Capezio für ihn gefertigt worden. Falls die Kleider einen neuen und bizarren Eindruck machten, dann nur deshalb, so Gernreich, weil sie von zwei kahlen Menschen getragen wurden. »Das trifft für alle Kleider zu – wer sie anzieht, macht sie zu dem, was sie sind.«

Als Gernreich die Kleider seiner Frühjahrskollektion 1971 von mit Schießeisen, Hundemarken und Kampfstiefeln ausgestatteten Models präsentieren ließ, war dies abermals eine gezielte Provokation. Bei den Kleidern selbst – die im Oktober 1970 vorbesichtigt werden konnten, kurz nach den Schüssen der amerikanischen Nationalgarde auf Studenten der Kent State University in Ohio, die friedlich gegen den Vietnamkrieg demonstriert hatten – handelte es sich um gestrickte Einzelteile, doch die Pistolen, die die Modelle trugen, waren eindeutig auf die Modeindustrie selbst gerichtet.

»Die Frauen sind auf dem Kriegspfad«, äußerte sich Gernreich auf der Präsentation vor der Presse und den Einkäufern. »Sie haben es satt, Sexobjekte zu sein.« Darauf ließ er einen Rundumschlag gegen die Modeschöpfer folgen, die die Kleidung russischer Bäuerinnen und anderer Heldinnen aus den Geschichtsbüchern zeigten: »Man

kann 1970 nicht einfach Kleider für Tschechow-Heroinen entwerfen! Die Mode von heute muß für die Frau von heute relevant sein. In dieser Kollektion gibt es keine ›Flucht in die Nostalgie‹, weil es keine Flucht vor der Gegenwart gibt. Wer sich in die Vergangenheit zurücksehnt, verneint sowohl die Gegenwart als auch die Zukunft.«

In Übereinstimmung mit der realistischen Thematik der Kollektion kostete keines der Kleidungsstücke mehr als neunzig Dollar. Und in einer Zeit, als die meisten renommierten Modeschöpfer den Midi zeigten, beließ Gernreich seine Säume weit oberhalb der Knie.

Im Herbst 1971 dehnte Gernreich seinen Angriff auf den, wie er es nannte, »Nostalgiekult« aus. »Für mich stellen sich die heutigen Bedingungen wie folgt dar: Anonymität, Universalität, Unisex, Nacktheit als Tatsache und nicht als Kick, und vor allem Realität. Mit Realität meine ich die Verwendung realer Dinge: Blue jeans, Polohemden, T-Shirts, Overalls. Mit der Statusmode ist es vorbei. Was bleibt? Etwas, was ich als Authentizität bezeichnen muß. Das Grundprinzip ist Bequemlichkeit. Gutes Aussehen hängt nicht so sehr von der Kleidung als vielmehr von der Person ab. Die Kleidung ist nur ein Instrument für die individuelle Körperbotschaft. Die Preise müssen niedriggehalten werden. Schluß mit dem Prestigekonsum. ›Teuer‹ ist heute das, was einmal ›billig‹ war: das Kennzeichen einer eingefleischten Vulgarität. Und endlich gibt es ein wirkliches Altersbewußtsein – ein Zeichen für ein wirklich aufgeklärtes Bewußtsein. Endlich braucht sich eine Frau, die die 25 überschritten hat, nicht mehr verpflichtet zu fühlen, wie ein Teenager auszusehen. Es beginnt sich eine Trennlinie zwischen den Altersstufen zu zeigen. Allein schon das eröffnet zahllose Möglichkeiten.«

In den siebziger Jahren schockierte Gernreich vor allem damit, daß er nichts mehr über die Zukunft zu sagen hatte. Der führende Futurist der Mode wurde zum Verfechter des »Hier und Jetzt«. Erstaunlicherweise stand er in den frühen siebziger Jahren mit seinen Entwürfen ebenso allein wie mit seinen Prognosen in den sechziger Jahren.

Während der größte Teil der Modewelt vom Nostalgiefieber befallen war, immunisierte Gernreich sich und seine Anhänger mit gewaltigen Dosen jener Medizin, die er als »Uniformen« bezeichnete – einfache, funktionale gestrickte Ober- und Unterteile, die die Persönlichkeit der Männer und Frauen annahmen, die sie trugen. »Können Sie eine Gernreich-Handschrift in diesen Kleidern entdecken?«, pflegte er die Einkäufer zu fragen. War die Antwort ja, verzog sich sein Gesicht. Nichts wünschte er sich in dieser Zeit mehr, als daß die von ihm entworfenen Kleider einen anonymen Eindruck machten.

Peggy Moffitt erinnert sich an eine aufschlußreiche Begebenheit aus dieser Zeit: »Es war 1972, Bill und ich waren eben erst wieder nach Los Angeles gezogen. Ich war von der Modeszene in New York enttäuscht und wollte mehr mit Rudi zusammenarbeiten. Er und ich aßen gegenüber vom Los Angeles County Museum of Art zu Mittag und sprachen darüber, wie dumm es doch war, daß *Women's Wear Daily* so begeistert davon war, daß Halston um die Schultern verknotete Strickjacken-Sweater zeigte. Ich sagte: ›Wenn sie das so toll finden, warum sollte man dann nicht einfach einen Sweater direkt in das Kleid einbauen?!‹ Rudi schaute völlig verblüfft drein und sagte: ›Woher wußtest du das? Genau das ist es, was ich gerade mache.‹ Dann wurde er ganz ernst und sagte: ›Ich möchte jetzt nicht mit dir zusammenarbeiten. Du inspirierst mich, und ich möchte nicht inspiriert werden.‹ Niedergeschlagen ging ich nach Hause und beschloß, ein Kind zu bekommen. Zwei Monate später stürzte ein überschäumender Rudi in mein Wohnzimmer und bat mich, die futuristische Rüstung zu präsentieren, die er für eine Max-Factor-Werbekampagne im Juli entwerfen werde. Als ich ihn daran erinnerte, daß ich dann im achten Monat sein würde, meinte er, ich könnte es doch trotzdem machen. Das war Rudi. Alles hatte sich geändert, und jetzt war es okay, inspiriert zu werden. Ich habe zwar für die Rüstung nicht als Modell zur Verfügung gestanden, doch nach der Geburt meines Sohnes Christopher habe ich wieder ständig mit ihm zusammengearbeitet, bis 1981, als seine letzte Kollektion erschien.«

231

Gernreich war davon überzeugt, daß »die Zeit der Kreativität in der Mode vorbei ist«, und er glaubte, daß der nächste Durchbruch technologischer Natur sein werde. »Sobald die Nähmaschine überflüssig geworden oder keine Nähmaschine im eigentlichen Sinne mehr ist, sobald Kleider auf den Körper aufgesprüht oder projiziert werden können, werden sich neue Dinge ergeben«, sagte er 1971.

»Der Modeschöpfer der Zukunft wird weniger ein Künstler als vielmehr ein Techniker sein. Er wird so etwas wie ein Architekt oder ein Ingenieur sein, mit gründlichen Kenntnissen in Chemie. Näher oder Zuschneider werden überflüssig werden. Maschinen werden ihre Arbeit übernehmen. Technisches Wissen, zum Beispiel über Computer, wird deshalb unentbehrlich sein.

Seit unsere Technologie es möglich gemacht hat, Menschen auf den Mond zu schicken, hat sich alles so schnell entwickelt, daß die Leute einfach nicht mehr mitkommen. Sie suchten Zuflucht in der Vergangenheit. Die Vergangenheit wurde zum Sicherheitsnetz der Gegenwart. Niemand spricht heute über die Gegenwart. Für die meisten Menschen ist sie verschwunden. Statt dessen versuchen sie, sich auf die Zukunft einzustellen. Früher dachten wir nur an die Gegenwart. Aber die Gegenwart von heute ist die Vergangenheit, und die Zukunft ist nur ein flüchtiger Moment.«

Gernreichs Ansicht nach war der futuristische, lunare Look möglich gewesen, weil zu Beginn der sechziger Jahre der Mond noch eine vage Vorstellung war und somit als ein Designthema abstrahiert werden konnte. Nach der Mondlandung gaben die Modedesigner diesen Look dann auf und kehrten zur Vergangenheit zurück.

»Sobald der Mond eine Realität geworden war, sobald wir die Möglichkeit sahen, uns direkt auf ihn zu beziehen, wurde es furchterregend. Für die meisten Menschen ist der Mond immer noch weit entfernt und hat nichts mit unseren täglichen Problemen zu tun. In gewisser Hinsicht empfinden viele die Leere des Mondes als langweilig. Manche – so auch ich – sind sogar angewidert. Es war schon eine phänomenale Leistung, einen Menschen auf den Mond zu bringen, das will ich nicht leugnen. Aber die Gelder, die dafür aufgebracht wurden, hätten doch wohl besser für die Lösung irdischer Probleme ausgegeben werden können. Ich glaube noch immer, daß das Hier und Jetzt die Hauptsache ist – nicht die Zukunft, nicht die Vergangenheit. Wenn die erste Raumstation eine Tatsache geworden ist, wird der Mond vielleicht zu einer stärker wahrgenommenen Realität werden und einen realistischeren Einfluß bekommen können. Zur Zeit gibt es keinen Spielraum für eine Beschäftigung mit dem Mond.«

Hingegen gab es einen Spielraum für weitere Entwürfe für die siebziger Jahre und für die Ausdehnung der Grenzen des Modedesigns auf andere Designbereiche. Im Herbst 1971 führte Gernreich eine Möbelkollektion für Fortress ein. Zu den aus Glas, Leder und poliertem Aluminium zusammengesetzten Objekten gehörten ein Couchtisch, der eine Tür imitierte, Beistelltische, die wie Apfelsinenkisten aussahen, und Tische, die Tragbahren glichen. 1971 kreierte er Steppmuster für Knoll International, in denen die Graphik aller Strickmuster zu finden waren, die er bisher in seinen Entwürfen benutzt hatte. Sie wurden im Pariser Louvre ausgestellt. 1974, zehn Jahre nach der Einführung des Topless Swimsuit, brachte er ein Rudi-Gernreich-Parfum auf den Markt, das von American Essence produziert und in Meßzylinder abgefüllt wurde. Nach einer kurzen Erfolgsstory, die nicht zuletzt seinem persönlichen Einsatz zu verdanken war, ging die Firma ein, und zusammen mit dem Anne-Klein-Parfum, das etwa zur selben Zeit eingeführt worden war, verschwand auch Gernreichs Parfum vom Markt.

Im weiteren Verlauf des Jahres 1974 kreierte Gernreich ein weiteres Paradebeispiel für das »Weniger-ist-mehr«-Prinzip, den Tanga, den er als »thong« (Riemen) bezeichnete – ein dünner Stoffstreifen zwischen den ansonsten nackten Gesäßbacken in verschiedenen Versionen für Männer und Frauen. Wie Gernreich sagte, entwarf er den Tanga, um »den Menschen das unbestreitbare Behagen und die Freude an der Nacktheit« zu bieten. Er betrachtete ihn als einen Kompromiß zwischen Freiheit und Legalität, da er die Freizügigkeit des Nudismus gewährte, ohne die an öffentlichen Stränden geltenden gesetzlichen Vor-

schriften zu verletzen. Nie hätte er es sich träumen lassen, daß seine Kreation 16 Jahre nach ihrer Entstehung als unanständig und ungesetzlich betrachtet werden würde. Im Juni 1990 verabschiedete das siebenköpfige Kabinett des Staates Florida in Tallahassee eine Verordnung, die das Tragen von Tangas an öffentlichen Stränden untersagte. Das Verbot trat am 22. Juni in Kraft und setzte in den USA eine landesweite Kontroverse über den »Fall der Afterfurche« – so die Gesetzgeber von Florida – in Gang. Sogar Phil Donahue griff in seiner Talkshow in die Debatte ein und interviewte zwei junge Tangaträger, die am Strand von Sarasota festgenommen worden waren. Sie präsentierten ihre Tangas in dieser überregional ausgestrahlten Fernsehsendung.

Ebenfalls 1974 schuf Gernreich seine ersten Ballettkostüme für Bella Lewitzky, mit der er fast dreißig Jahre zuvor in Lester Hortons Truppe in *Salome* getanzt hatte. Seine außergewöhnlichen Kostüme für Lewitzkys Produktion von *Inscape* waren oft sowohl ein integraler Bestandteil des Bühnenbilds als auch des Plots. Die Köpfe seiner »siamesischen« Ringer waren zum Beispiel durch dehnbare Kapuzen miteinander verbunden, so daß die Tänzer sowohl im wörtlichen wie auch im übertragenen Sinne zusammengeschlossen waren. Gernreich setzte in den folgenden Jahren seine Zusammenarbeit mit Lewitz-

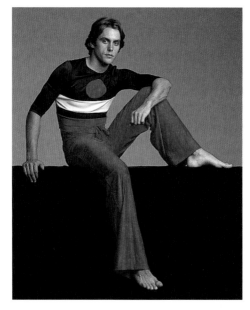

Herrenkleidung, 1972

ky fort und gestaltete Bühnenbilder und Kostüme für *Pas de Bach* (1977), *Rituals* (1979), *Changes and Choices* (1981) und *Confines* (1982).

Gernreichs Idee, die Kostüme für *Inscape* miteinander zu verbinden, ging auch in seine Mode ein: 1975 kreierte er schwarze Schlauchkleider aus Nylon-Jersey, die an plastischen Aluminiumschmuck von Christopher Den Blaker befestigt waren. Frei gestaltete Halsketten verliehen zum Beispiel rückenfreien Kleidern ihren Sitz, und breite Armreifen bildeten Manschetten. Im selben Jahr entwarf Gernreich auch für Lily of France die ersten jockey-artigen Slips und Boxer Shorts für Frauen und nahm damit Calvin Kleins Modelle von 1983 um sieben Jahre vorweg. Rudi-Gernreich-Kosmetikartikel für Redken Laboratories kamen 1976 auf den Markt, Rudi-Gernreich-Trikots für Ballet Makers, Inc. 1977, Rudi-Gernreich-Haushaltszubehör, Handtücher und Sets für Barth & Dreyfuss 1977, Rudi-Gernreich-Teppiche für Regal Rugs 1978 und Rudi-Gernreich-Badezimmereinrichtungen aus Keramik für Wicker Wear, Inc. ebenfalls 1978.

Die letzte Rudi-Gernreich-Strickwarenkollektion erschien 1981. Sein letztes Projekt außerhalb der Modewelt, Gourmet-Suppen, wurde 1982 in Angriff genommen und bis kurz vor seinem Tod fortgesetzt. Sein letztes Mode-Statement war der den »menschlichen Körper völlig befreiende« Pubikini. Dokumentiert wurde es von dem Photographen Helmut Newton: »Rudi erzählte mir von diesem Projekt und fragte mich, ob ich ein Photo machen würde. Von einem ›final look‹ oder etwas in der Art war keine

Rede. Er meinte, ich sollte zu ihm in sein Haus kommen, und er hätte dann ein Modell bereit. Es war ein früher Nachmittag im März.

Das Modell, Sue Jackson, war schon für die Aufnahmen zurechtgemacht; ihr Schamhaar war von dem Friseur Rodney Washington aus Los Angeles gestaltet, rasiert und giftgrün gefärbt worden. Er war der Linie gefolgt, die Gernreich mit einem Fettstift auf ihren Körper gezogen hatte. Die Visagistin Angelika Schubert legte dem Modell ein Körper-Make-up auf und gab ihm leuchtend rote Lippen und Nägel. Sue Jackson, die auch in ihrem Haar eine leuchtend grüne Strähne hatte, trug einen winzigen Streifen Stoff, der sich V-förmig von den Hüften bis zum Schritt erstreckte und das Dreieck grüngefärbten Schamhaars freilegte.

Ich plazierte sie auf der Couch, und Rudi saß neben ihr. Er legte ihr noch etwas Farbstoff auf; seine ganze aufgeregte Aufmerksamkeit galt dem Design. Dieser Pubikini mit dem grünen Schamhaar ist seither für mich immer ein viel aktuellerer Ausdruck von Nacktheit gewesen als wenn man einfach eine Brust heraushängen läßt, wie es Yves Saint Laurents Modelle 1989 taten. Ich fand es rührend und wunderbar, daß er zu diesem Zeitpunkt so engagiert mit der Sache beschäftigt war.«

Einen Monat später, am 21. April 1985, starb Rudi Gernreich an Lungenkrebs.

EPILOG

Ich lernte Rudi Gernreich 1957 kennen, als ich in Los Angeles war, um für die *Chicago Tribune* eine Story zu schreiben. Bis 1969, als ich nach Los Angeles zog, nannte ich ihn Mr. GERN-rike. Kein einziges Mal korrigierte er meine falsche Aussprache. Ich bemerkte meinen Fehler erst, nachdem ich mehrmals in seinem Büro am Santa Monica Boulevard angerufen und Fumi, seine Sekretärin, mit »Rudi GERN-rick« geantwortet hatte.

Jemand, der so nachsichtig war, mich all die Jahre nie zu korrigieren, mußte, so schien mir immer, ein ganz besonderer Mensch sein. Und Rudi war sicherlich ein ganz besonderer Mensch. Er war nicht der einzige Modeschöpfer, der eine Vision hatte. Aber er war der erste, der seinen Blick über die Salons hinaus auf die Straßen richtete, der nicht nur die »beautiful people« und ihre Dinner-Parties im Blick hatte, sondern auch den Bauarbeiter, der in der Mittagspause sein Sandwich ißt.

Er war ein Künstler, Soziologe, Ökonom, Humorist, ein Mensch mit übersinnlicher Wahrnehmung, ein Löwe und wahrscheinlich der einzige Revolutionär mit zwei Autos in der Garage, der Gucci-Schuhe trug. Selbst in der Zeit seiner Antistatus-Statements fuhr er in einem großen, weißen 64er Bentley zur Arbeit, und mit Haßliebe war er seinem 53er Nash Healy zugetan, der dauernd in der Werkstatt stand.

Christian Dior sagte, seine besten Einfälle habe er im Badezimmer oder der im Bett, und seine »Inkubationszeit« – die zwei Wochen, die er auf dem Land verbrachte, bevor er eine neue Kollektion in Angriff nahm – verglich er mit der Laichwanderung der Aale zur Sargassosee.

Gernreichs Inkubator war sein Verstand. Er war ein intellektueller und ein visueller Mensch, ein Mensch mit Verstand und Herz. Dem entsprachen seine Kleider. Sie verführten, neckten, quälten und reizten die Phantasie. Manchmal machten sie den Menschen sogar angst.

Gernreich war ungemein geistreich, witzig und schlagfertig. Er war ein großer Spaßvogel. Ich kann mich zum Beispiel daran erinnern, wie ich kichern und dann lauthals lachen mußte, als er Halstons Twin-Sweatersets parodierte – die damals modische Vorliebe, einen um die Schultern verknoteten Sweater über einem identischen Sweater zu tragen. Gernreichs Parodie hatte vier Ärmel – zwei für die Arme und zwei, die um die Schultern verknotet werden konnten.

Rudi hatte eine starke Präsenz, die über seine Körpergröße – er maß nur 1,68 Meter – hinwegtäuschte. Wenn er im Mittelpunkt stand, fühlte er sich wohl. Wenn nicht, brachte er sich in den Mittelpunkt – für gewöhnlich mit einer amüsanten Geschichte –, oder er ging. Und obwohl sein Körperbau stark und kompakt war, bewegte er sich mit der Anmut eines Tänzers, auch dann noch, als er mit zunehmendem Alter in die Breite ging. Der brillante Kolo-

rist Gernreich trug immer Schwarz, damit er »sich selbst denken hören« konnte.

Er sprach mit einer bühnenreifen Diktion, leicht, eloquent und oft mit einem Schuß selbstironischen Humor. Er liebte es, Geschichten zu erzählen. In einer meiner Lieblingsgeschichten ging es um das Zimmermädchen im Algonquin Hotel in New York, wo Gernreich über Jahre hinweg logierte. Zufällig hatte er mitgehört, wie sie einem der Einkäufer, die sie viele Male während seiner Musterpräsentationen in der Suite gesehen hatte, erzählte: »Der arme Mr. Gernreich, er kommt mindestens viermal im Jahr hierher. Er tut alles, was er kann, um seine Kleider zu verkaufen, er zeigt sie immer wieder, und nie kauft ihm jemand etwas ab. Immer muß er alles wieder einpacken und nach Kalifornien zurückbringen.«

Die Gernreich-Zentrale am Santa Monica Boulevard 8460 war ein kastenförmiges Haus mit khakifarbener Stuckfassade – ein modernes, fast mysteriöses Gebäude, das ganz für sich allein an einer verkehrsreichen Straße stand. Für mich war es immer ein Symbol für Rudis Ausnahmestellung in der Welt der Mode.

Der einzige Schmuck des Gebäudes war das 3,70 Meter hohe geschnitzte Flügeltor, auf dem in serifenlosen Großbuchstaben aus Chrom der Name des Modeschöpfers stand. Die Inneneinrichtung war teils Bauhaus, teils »2001«, teils präökologisch (auf dem Boden lag ein Zebrafellteppich), teils unprätentiös (ein einziges mit seinem Bild bedrucktes T-Shirt war an die Wand angeheftet, die einst mit Gernreichs Titelblatt von *Time* bedeckt war). Im Showroom war alles entweder weiß (drei Wände und der Boden aus hexagonalen Badezimmerfliesen), schwarz (das Leder der verchromten Stahlrohr-Sitzgarnitur von Marcel Breuer) oder khaki (eine mit Juteleinen bespannte Wand). Die einzigen Farbtupfer waren der grüne, vom Boden bis zur Decke reichende Dschungel aus Palmen und Zierpflanzen und das Rot und Grün in

Trompe-l'œil-Jumpsuit

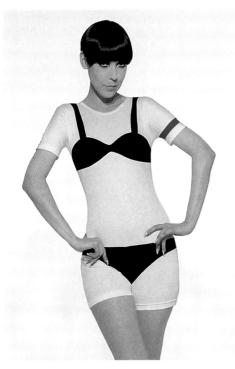

den Lithographien von Carmi. Keine Familienphotos, keine Photoalben, keine Reisemitbringsel, keine versteckte Bar, die Schlag halb sechs geöffnet wurde, nicht einmal eine goldene Reproduktion seines einmillionsten »no-bra bra«. Gernreichs Privatbüro war eine Welt warmer Brauntöne; ein Kontrast zur öffentlicheren Atmosphäre des in Schwarz und Weiß gehaltenen Showrooms. Ein Charles-Eames-Stuhl, ein Lederschwein, ein Schildplatt-Telefon, eine Pilzlampe – all diese Sepiatöne gaben dem Raum das Erscheinungsbild einer alten Kupfertiefdruckbeilage einer Sonntagszeitung im modernen Gewand. Die einzige Konzession an die Vergangenheit war eine mexikanische Truhe mit Einlegearbeiten aus Knochen. In ihr bewahrte er seine vielen Auszeichnungen auf.

Hinter der marokkanischen Mauer, die das Haus im

Laurel Canyon in Hollywood umgab, das er zusammen mit Oreste Pucciani bewohnte, gab sich Rudi zugleich offen und verschlossen bzgl. seiner Beziehung zu seinem Lover: Ohne weiteres lud er heterosexuelle Gäste zu Dinner-Parties ein, die er zusammen mit Oreste gab, doch er brachte sein Sexualleben nicht zur Sprache – zumindest nicht in meiner Gegenwart. Ich wußte, daß er schwul war, und ich glaube, er wußte, daß ich es wußte, doch weder er noch ich haben dieses Thema je angesprochen.

Zu Beginn einer jeden neuen Saison nahm Rudi die kleinen, schnell hingeworfenen Skizzen, auf denen er seine Ideen notierte, wann und wo auch immer sie ihm kamen, und arbeitete sie zu detaillierten Zeichnungen aus, die er mit Stoff und Farbmustern komplettierte. Auch zufällige Beobachtungen konnten sich in solchen Skizzen niederschlagen. So gingen beispielsweise seine Badeanzüge von 1970 unmittelbar auf die Beobachtung von Kindern zurück, die »mit ihren Kleidern in einen Swimmingpool sprangen. Die nassen Kleider, die an ihren Körpern klebten, als sie aus dem Wasser auftauchten, hatten einen Sex-Appeal, mit dem kein Bikini mithalten konnte.«

Rudi sagte, daß seine Ideen ihm oft kurz vor dem Aufwachen oder kurz vor dem Einschlafen gekommen seien. Ihm kamen diese Momente ein wenig mystisch vor; sie entsprachen dem fast tranceartigen Zustand, in den er immer dann fiel, wenn eine Kollektion kurz vor der Präsentation stand.

Rudis spontanste Kritiker waren seine drei Anprobemodelle, Jimmy Mitchell, Peggy Moffitt und Léon Bing. »Es interessiert mich sehr, was das Modell denkt,« sagte Rudi mir in einem Interview über den Einfluß seiner Modelle auf seine Arbeit. »Ich arbeite nur mit Modellen, die ich mag und respektiere, und ihre Reaktionen sind äußerst wichtig für mich. Ich bin begeistert, wenn ich eine ehrliche und spontane Reaktion erhalte. Reagiert das Modell unterkühlt, sagt sie, daß irgend etwas nicht ganz stimmt oder daß etwas einfach nur okay ist, dann merke ich, daß ich nicht wirklich am Ball bin. Es macht mir nicht allzuviel aus, wenn ihr ein bestimmter Entwurf nicht gefällt, aber es gibt mir sehr zu denken, wenn sie sich darin nicht wohl fühlt.«

Wie wird Rudi Gernreich in die Geschichte der Mode eingehen? Ist er besser als Chanel? Dior? Balenciaga? Givenchy? Pucci? Cardin? Courrèges? Saint Laurent? Weil das übermächtige Paris mit all der dazugehörigen Publicity nie seine Bühne war, ist es schwierig, ihn auf internationaler Ebene einzuordnen. Doch sein fortwährender Einfluß auf die internationale Mode zeigte sich noch 1991, als seine Modegraphik wieder up to date wurde. Seine später von ihm wieder verworfenen Entwürfe für das Zeitalter der Raumfahrt erlebten auf den Laufstegen von Mailand bis New York erneut einen raketenhaften Aufstieg. Sämtliche Gernreich-Attribute der sechziger Jahre – skinny, mini, neo, geo, pop, op – kehrten in die Sprache der internationalen Mode zurück. Die einfachen Formen, die 1961 für futuristisch gehalten wurden, waren dreißig Jahre später plötzlich »modern«, ebenso der Esprit, den Gernreich in die Mode hineingebracht hatte. Unisex gehörte zum Alltag. Die historischen Kostüme, die Rudi in den siebziger Jahren als überholt abgetan hatte, waren schließlich zwanzig Jahre später für viele Leute nicht mehr zeitgemäß.

Die mir liebste Würdigung seines Talents hat Bernadine Morris formuliert, die Modeberichterstatterin der *New York Times*: »Gernreichs großer Beitrag war nicht der Schnitt eines Ärmels oder eine bestimmte Farbe oder eines dieser Details des Schneiderns, die den Modeleuten so sehr am Herzen liegen, jenen Leuten, die so gerne zu den guten alten Zeiten zurückkehren, die sie so gut verstanden. Sein großer Beitrag war ein mutiges, neues, mitreißendes Konzept – daß Kleider bequem sein sollten. Und ein kleines bißchen Spaß machen sollten.«

Was mich betrifft, war Rudi mein erster Held der Mode. Für mich war er ein Genie.

Seite 10:
Rudi bei der Arbeit, Los Angeles, **1966**.

Seite 12:
Frühe fünfziger Jahre, wollener Sarongrock. (Photo © Christa)

1953, schwarzes Peplum (schwingender Kurzmantel mit breitem Taillengürtel) und Hose mit mehrfarbigem Karomuster. (Photo © Christa)
Frühe fünfziger Jahre, Wollmantel. (Photo © Christa)

Seite 13:
Rechts, Rudi als junger Tänzer in den frühen vierziger Jahren. (Photo © William Ricco, Sammlung Lilly Fenichel)

Seite 14:
1956, Chinesische Kellnerjacken aus Baumwollsegeltuch (Photo © Christa, Courtesy *Life magazine*)

Seite 15:
1952, erster unverstärkter Badeanzug. (Photo © Tommy Mitchell Estate)

Seite 16:
1953, erstes Schlauchkleid. (Photo © Alex dePaola)
Mitte der fünfziger Jahre, Kamelhaarkostüm. (Photo © Alex dePaola)
1954, rechts, weißes Kunststoffkleid. (Photo © Tommy Mitchell Estate)

Seite 18:
Späte fünfziger Jahre, links, ausgeschnittener Badeanzug. (Photo © Tommy Mitchell Estate)
1956, Mitte, Hosteßkleid und Trompe-l'œil-Strandshirts. (Photo © Christa)
1957, unten links und rechts, Badeanzüge, darunter einer mit Lochausschnitten in Leiteroptik auf dem Rücken. (Photo © William Claxton)

Seite 20:
1964, Strickkostüm und Strümpfe aus brauner und schwarzer Wolle. (Sammlung der Autorin)

Seite 22:
1965, oben, geometrische Tränen. (Photo © William Claxton)
1966, oben rechts, Entwürfe aus Vinyl für Montgomery Ward. (Sammlung der Autorin)
1966, unten rechts, geometrische »Aufkleber« aus Vinyl und Bikini. (Photograph unbekannt)
1966, in London im »Ringo«-Anzug (mit Dennis Deagan und Sir Mark Palmer). (Photo © William Claxton)

Seite 24:
1966, links, aus lilafarbener Wolle gestrickte Kinderkleidung mit gelben Vinylpunkten.
1965, rechts, beige-schwarzer »Ringo«-Anzug aus Wolle.

Seite 25:
Resort 1967, Mrs. Square und Miss Hip. [Der Begriff »resort« steht für eine für den amerikanischen Markt spezifische »Urlaubszwischensaison«.]

Seite 26:
1971, für Knoll International gefertigter Quilt.
1971, rechts, Trompe-l'œil-Strickminikleid.

Seite 28:
1970, Unisex. (Photo © Patricia Faure)

Seite 29:
1973, umseitig, für eine Max-Factor-Werbekampagne entworfene Kunststoffrüstungen.

Seite 32:
1974, oben, mit einem für American Essence hergestellten Parfum.
1983, rechts, Rudi als Gastchefkoch im Cadillac Café, Los Angeles.

Seite 35:
1974, oben, der Tanga. (Photo © William Claxton)
Links oben, Parodie auf den Topless Swimsuit in einer Anzeige von 1970. (Courtesy J. Walter Thompson Advertising Agency)
Mitte, Titelblatt des *TIME magazine* vom 1. Dezember 1967. (Copyright © 1967 Time Warner Inc. Nachdruck mit freundlicher Genehmigung)

1976, links unten, der Verlag Rizzoli bat mehrere prominente Modedesigner, phantastische Kleidungsstücke für eine Ausstellung zu entwerfen. Rudi »bekleidete« ein Paar mit Bestandteilen eines Fahrrads. (Photo © William Claxton)

Seite 36:
DER KREIS IM QUADRAT
Vor vielen Jahren ging in Wien ein kleiner Junge in den Kindergarten, wo die Kindergärtnerin die Kinder aufforderte, ein Blatt Papier zu nehmen und ein Quadrat zu zeichnen und in das Quadrat einen Kreis hineinzuzeichnen. Der Junge nahm seinen Bleistift und zeichnete einen riesigen Kreis, der nur die Ränder des Blatts berührte. Als er fertig war, lief er stolz zur Kindergärtnerin. Sie sah sich seine Zeichnung an und sagte, »Aber Rudi, das ist aber nicht das, was du machen solltest.« Und er antwortete, »Nein, aber ist es nicht schön?«

Jahre später, und auf der anderen Seite der Welt, zog ein kleines, schwarzhaariges, vier Jahre altes Mädchen die viel zu großen Schuhe ihrer älteren Schwester an, ein langes rosarotes Kleid und ein dunkelblaues Cape. Dann stapfte es durch die Straßen und rief allen Leuten zu, »Ich bin Schneewittchen!«

Dieses Buch ist in großen Teilen eine liebevolle Erinnerung in Bildern an das, was geschah, als sich diese beiden Menschen begegneten.

1955, oben, der Badeanzug mit fünfknöpfiger Knopfleiste, Style Number 6001, wahrscheinlich der am meisten kopierte Badeanzug in der Modegeschichte. Photo © William Claxton); rechts, das Model Jimmy Mitchell trägt den fünfknöpfigen Badeanzug. Photo © Tommy Mitchell Estate)

Seite 37:
JIMMY
Jimmy Mitchell sah ich zum ersten Mal, als ich als Teenager nach der Schule bei JAX in Beverly Hills arbeitete. An einem Samstag betrat das außergewöhnliche Paar das Geschäft. Er sah aus wie eine kleine, hübsche Version von Peter Lorre, und sie wie Cheetah in menschlicher Gestalt. Es waren Rudi und Jimmy Mitchell. Jimmy half ihm, seine Karriere aufzubauen, und blieb bis zu seinem Tod mit ihm befreundet. Sie sieht noch immer wie Cheetah aus.

Seite 38:
Mitte der fünfziger Jahre, Männerkleidung nachempfundene unverstärkte Badeanzüge (Photo © Tommy Mitchell Estate)

Seite 40:
JAX
Als Teenager entdeckte ich einen phantastischen Laden in Beverly Hills, der JAX hieß. Mein Blick fiel auf ein Kleid im Schaufenster, und aus heiterem Himmel traf mich ein gewaltiger Blitzschlag, der für mein ganzes weiteres Leben von entscheidender Bedeutung war: Ich sah ein Kleid, das man heute als Kaftan bezeichnen würde. Es war ein kurzes schwarzes Crêpe-Kleid mit zwei Streifen, die von der linken Schulter bis zum Saum verliefen. Der eine Streifen war ocker-, der andere orangefarben. Das Kleid hatte weder Brustabnäher noch einen Taillenbund. Es war flach wie ein Kimono und hing an einem Drahtbügel. Ich sah nur den Körper, der nicht in dem Kleid steckte und was dieses Kleid für einen Körper tun konnte – ihm Bewegungsfreiheit geben, ihn umhüllen und enthüllen. Dieses Kleid war von jemandem entworfen worden, der Körper liebte. Diese Person mußte ein Tänzer sein. Verglichen mit den anderen Kleidern, die es damals gab, war es ein richtiger Schock. Von der Haute Couture bis zum Sears-Versandhauskatalog, alles beruhte auf dem »New Look« von Dior. Die Frauenkleidung in aller Welt war mit einer Million Abnähern, Nähten, Wespentaillen, Petticoats, Miedern, die die Brüste einzwängten, und Polstern für die Hüften befrachtet. Sogar Magersüchtige trugen »Lustige Witwe«-Korsetts, um sich eine »Sanduhrfigur« zu geben. Und hier war plötzlich diese ungemein elegante, einfache, erotische Widerlegung all dessen – dieses perfekte Kleid, diese völlig logische, verführerische Möglichkeit, eine Frau zu sein. Bei dem Kleid an diesem Bügel ging es nur um Arme, Beine und Hälse und um Bewe-

gung, und dennoch hing es da – statisch – und wartete auf einen Körper, den es optimal zur Geltung bringen konnte, statt ihn zu beherrschen und zu verzerren.

Während ich dieses Kleid betrachtete, dachte ich, »Ich weiß nicht, wer es entworfen hat, aber eines Tages werde ich ihn heiraten oder mit ihm zusammenarbeiten oder jedenfalls irgendwie mit ihm zu tun haben.«

1958, oben links, buntkarierter Südwester. (Photos © Patricia Faure); Seite 41: oben rechts, Filzglocke im Bubikopf-Schnitt; Mitte, gefiederte Glocke. (Photo © Tommy Mitchell Estate); unten, straßbesetzte Glocke (Photo © William Claxton)

1960, links, Präsentation eines typischen Rudi-Maillots im Schaufenster von JAX. (Photo © William Claxton)

Seite 42:
1963, oben links, Herren-Wollstrickjacke mit Patchworkmuster; oben rechts, karierte Wollstrickhose und Strickjacke.
1962, unten, Badeanzüge in für Rudi typischen Farben auf einer PR-Aufnahme mit dem Kunsthändler Irving Blum für die Ferus Gallery, Los Angeles; rechts, am Pool eines Freundes in einem der von Rudi für Männer entworfenen Badeanzüge mit Unterhemdträgern.

Seite 44:
Resort 1962, oben links, Badeanzüge mit Ausschnitten und »Bullaugen«; oben rechts, Kostüme aus irischem Leinen; Mitte links, einärmeliges Kleid aus grauem Flanell und Seide; Mitte rechts, schwarzweißes Op-art-Seidenkleid; unten links, »Sporttaucher«-Badeanzüge; unten rechts, blauweißes Tischtuchdamastkostüm mit Ginganbluse. (Photos © Tommy Mitchell Estate)

Seite 46:
DAS KLEINE SCHWARZE KLEID
1963 präsentierten Rudi und ich seine Kollektion in seiner Suite im Gotham Hotel in New York. Eines Tages kam ein Einkäufer zu uns und sagte: »ich habe überall gesucht, aber ich kann nirgendwo ein gutes schwarzes Cocktailkleid finden.« Wir hatten ein schwarzes Seidenmatelassékleid, das in der Taille mit einer in das Kleid integrierten Schärpe gebunden wurde. Ich zog es an und zeigte es ihm. Er sagte: »Das gefällt mir.« Als ich zum Umkleideraum zurückkehrte, hatte ich eine Idee. Als Rudi sagte, »mach schon, Peggy, mach schon«, nahm ich die Schärpe und band sie wie den Gürtel eines Kimono um meinen Körper, ging hinaus und zeigte es dem Mann, als ob es ein völlig neues Outfit wäre. Rudi mußte sein Lachen unterdrücken, als wir zum Umkleideraum zurückkehrten. Dann zog ich dasselbe Kleid mit dem Rückenteil nach vorn an, ließ den Reißverschluß ganz geöffnet, gürtete die Schärpe fest um meine Taille und präsentierte das Kleid ein drittes Mal. Diesmal war der Einkäufer sprachlos. Schließlich sagte er: »Ich kann es nicht glauben. Da habe ich die ganze Stadt nach dem perfekten kleinen schwarzen Kleid abgesucht, und Sie zeigen mir gleich drei! Ich weiß nicht, welches ich ordern soll!«

Rudi und ich konnten uns vor Lachen nicht mehr halten und klärten den Einkäufer auf. Rudi war der einzige Modedesigner, den ich kannte, dessen Kleider mit dem Rückenteil nach vorn und der Innenseite nach außen getragen werden konnten und immer wunderbar aussahen.

1963, Wir wurden Freunde. Hier trage ich eines seiner Patchworkkleider.

Seite 48:
1963, oben links, Badeanzug mit einem braunen Oberteil aus Vinyl und einer schwarzen Badehose; Mitte, Strick-Patchworkbikini; unten links, Badeanzug in Gelb und Orange mit Vinylgürtel; unten rechts, einteiliger Hosenträgerbadeanzug in Schwarz und Rot; rechts, gelber Badeanzug aus Vinyl.
1963, umseitig, schwarze Badeanzüge aus Vinyl.

Seite 53:
Herbst 1963, links, für diese Kollektion bekam Rudi den Coty Award. Das gewaltige Plaid-Kostüm aus Wolle mit fallendem Revers auf der einen und Schalkragen auf der

anderen Seite, das Norman Norell so in Rage brachte, wird hier mit einem umkehrbaren Pferdefellmantel präsentiert. Die Hüte wurden von Leon Bennett gefertigt.
Herbst 1963, »Chicago« – breitschultrige Tunika über einem schwarzgrauen Flanellrock.

Seite 55:
Herbst 1963, »Kabuki«-Wollstrickkleider (oben links und rechts, Photos © William Claxton; unten, Photo © Peter James Samerjan)
Herbst 1963, links, Don Bachardy zeichnet in unserem Studio-Apartment in Hollywood eines der »Kabuki«-Kleider.

Seite 56:
Herbst 1963, rechts, »Actors Studio« – breitschultriger Hosenanzug aus tabakfarbenem Vicuña.
Herbst 1963, unten links, schwarzbraunes Wollstrickkleid mit Jockeykappe; unten rechts, »High Noon« in grauem Flanell. Der Witz dabei war, daß die Weste über den Jackett getragen wurde. Wenn also das Jackett scheinbar abgelegt wurde, trug man immer noch ein Jackett. Die Hemdbluse und das Futter waren aus gestreifter Baumwolle.

Seite 59:
Resort 1963, mit verschiedenen Schwarzweißmustern bedruckter Seidencrêpe.

Seite 60:
Resort 1964, links, aus der »Van Dongen«-Kollektion – rosa, türkis, grün und schwarz bedrucktes Seidenkleid; rechts, der weiße »Dietrich«-Satinanzug, der vom Modekomitee aus der Coty-Show verbannt wurde (weil ich darin ihrer Meinung nach wie eine Lesbe aussah).

Seite 61:
MEIN TAGESABLAUF
Als ich 1962 mit Rudi zu arbeiten begann, lebte ich in Los Angeles. Ich war sowohl sein Anprobe- als auch sein Präsentationsmodell. Das bedeutete, daß ich mehrmals im Jahr nach New York reisen und im Gotham Hotel logieren mußte, wo Rudi regelmäßig eine Suite mietete, um seine Kollektion zu zeigen.

Mein Tagesablauf sah so aus: Ich stand um 6:00 auf, badete und wusch mir das Haar. Während ich mir ein kompliziertes Make-up auftrug und mich ankleidete, trank ich einen Kaffee. Dann ging ich die zwei Treppen hoch zu Rudis Suite und plauderte mit ihm, während er seinen Kaffee trank und ein weichgekochtes Ei aß. Unsere Termine begannen um 8:30 oder 9:00 und setzten sich den ganzen Tag lang fort. Wir präsentierten die Kollektion Einkäufern und Redakteuren, oft gleichzeitig, und für gewöhnlich war ich das einzige Modell, konnte mich also mit niemandem ablösen. Drei Dinge bewahrten mich davor, durch diese ermüdende und langweilige Routine völlig verrückt zu werden: Rudi war als Freund und als Modeschöpfer ein faszinierender Partner, die Kleider waren so großartig, daß es immer eine Freude war, sie zu tragen, und ich unterhielt mich selbst und das Publikum, indem ich die Kollektion als ein Theaterstück betrachtete, in dem jedes Outfit eine neue Szene oder ein neuer Charakter war. Die Kollektion hatte also einen theatralischen Anfang, eine Mitte und ein Ende – mit Dramatik, Späßen, Spannung und Slapstick. Statt die Kleider einfach zu präsentieren, inszenierte ich sie.

Nach einem langen Arbeitstag gingen wir dann zusammen aus. Oft trafen wir uns mit Leuten aus der Modeszene. Einmal gingen wir in den Russischen Zirkus, manchmal ins Kino oder ins Theater, aber meistens gingen wir einfach nur essen. Gelegentlich in noble Restaurants wie Lutèce, meistens aber in ruhige und einfache. Eines unserer Lieblingsrestaurants war ein griechisches namens Pantheon in der Nähe der 42nd Street. Nach dem Abendessen gingen wir an Huren und Zuhältern vorbei zu Fuß nach Hause und sangen dabei. Rudis Lieblingslied war *Falling in Love Again* (Ich bin von Kopf bis Fuß auf Liebe eingestellt). Er sang es immer mindestens einmal auf dem Nachhauseweg.

Seite 63:
Resort 1964, »Van Dongen«-Kleider aus Seide mit integrierten Schals und Rüschenärmeln.

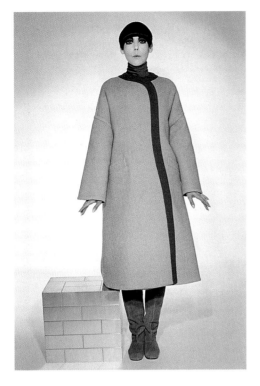
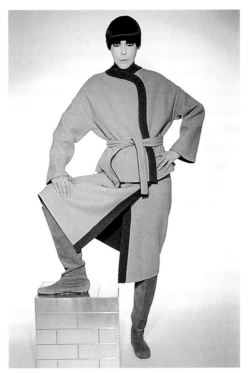
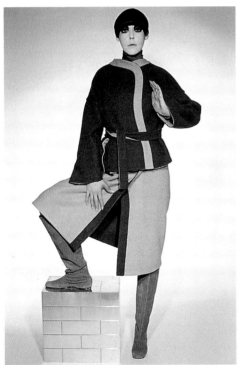
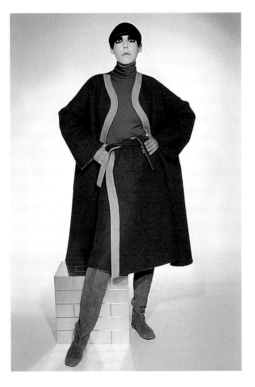

Wendbarer Mantel und Kostüm, 1976

Seite 65:
Resort 1964, rechts, in jeder Kollektion gab es clowneske Themen – hier ein Art-déco-Clown aus weißem gekräuseltem Baumwollstoff mit schwarzen verschwommenen Punkten; Seite 64, rechts, Aufnahme des »Dietrich«-Anzugs aus weißem Wäschesatin mit weißer Seidenbluse; oben links, schwarz, weiß und rot bedrucktes Seidenkleid; unten links, hellbeige Crêpetunika über schwarzem Crêperock.
1964, umseitig, Jux mit Rudi und Bill in der Photokabine auf dem Santa Monica Pier.

Seite 70:
DAS PHOTO, DAS UM DIE WELT GING
Stellen Sie sich vor: Es gibt etwas in Ihrem Leben, wofür Sie eine sechzigstel Sekunde gebraucht haben. Und für den Rest Ihres Lebens müssen Sie darüber reden. Hier sehen Sie den Topless Swimsuit – wahrscheinlich das berühmteste Modephoto aller Zeiten und das Schreckgespenst, das mich seither verfolgt.
Ich halte es noch immer für ein wunderschönes

Photo, aber ich will einfach nicht mehr darüber reden.
1964, oben, das erste Modell des Topless Swimsuit; rechts, das zweite Modell des Topless swimsuit – er wurde weltberühmt.

Seite 72:
Herbst 1964, Ich hatte die erste Ausstellung der wiederentdeckten Photographien Jacques Henri Lartigues im Museum of Modern Art gesehen und war so begeistert, daß ich zusammen mit Rudi noch einmal dorthin ging. Rudi war sehr beeindruckt und sagte, als wir gingen: »Ich wollte eine indische Kollektion machen, aber das kann ich jetzt nicht mehr, obwohl die Stoffe schon bestellt sind.« Das Ergebnis war diese Kollektion – Rudis Lieblingskollektion. Die Lartigue-Photographien sind eine hervorragende Bestandsaufnahme der Belle Époque aus der Sicht eines Kindes. Rudi griff diese Kleider aus der Zeit um die Jahrhundertwende auf und gestaltete sie zu faszinierenden modernen Entwürfen um. Rudi hat es immer bedauert, daß der Wirbel, den der Topless Swimsuit ver-

ursachte, diese Kollektion überschattete, die seiner Ansicht nach unter allen seinen Kollektionen die meisten innovativen Ideen aufzuweisen hatte.

Herbst 1964, links, wendbarer Kamelhaarmantel mit schwarzer Abseite und ein schwarzer »Jaschmak«-Filzhut. Sämtliche Hüte in dieser Kollektion wurden von Leon Bennett gefertigt; rechts, das unter dem links zu sehenden Mantel getragene Kamelhaarkleid, ebenfalls durchgängig mit schwarzer Abseite.

Seite 75:
OUT OF THE CLOSET
In den ersten Jahren, in denen ich Rudis Kleider in New York präsentierte, halfen mir Rudi und eine Anziehhilfe beim Umkleiden, und anstandshalber trug ich immer einen BH. (Wenn ich seine Kleider privat trug, trug ich nie einen BH.) Nach einigen Saisons sagte ich zu ihm: »Ich tue deinen Kleidern keinen Gefallen, wenn ich einen BH trage. Ohne BH sehen sie so viel besser aus. Von jetzt an werde ich mich in der Kabine umziehen, und du kannst mir den Reißverschluß zuziehen, wenn ich herauskomme.« Tagtäglich verbrachte ich dann Stunden damit, in die Kabine rein und rauszugehen, und oft genug geriet ich an den Rand der Erschöpfung, weil die Kleider immer komplizierter anzuziehen waren. Zu der Zeit, als das Photo des Topless Swimsuit veröffentlicht wurde, war es völlig unmöglich, die Kleider der Kollektion, die wir damals zeigten, schnell ohne Hilfe zu wechseln. Jedesmal hatte ich es mit Strumpfhosen, Leggings, Stiefeln mit Reißverschluß, Tuniken, Kleidern, das Gesicht bedeckenden Hüten, wendbaren Mänteln zu tun, mit allem, was man sich vorstellen kann. Deshalb gab ich vor Rudi und der Anziehhilfe die hochoffizielle Erklärung ab, daß ich mich fortan vor ihren Augen umziehen würde, weil ich – Anstand hin oder her – ihre Hilfe brauchte. Alle anderen Models, die am Eröffnungstag neben mir auftreten sollten, kamen zur Anprobe, und da sie alle das Photo gesehen hatten, auf der ich den Topless trug, zogen sie sich ohne mit der Wimper zu zukken bis auf die Unterhosen aus. Der ganze Raum war mit BHs übersät, einige hingen vom Kronleuchter herunter. Rudi war entzückt. Das war *meine* Emanzipation.

Herbst 1964, links, Flieger-Overall aus Kamelhaar mit wendbarem Kamelhaarmantel; rechts, das erste Strickoutfit mit entsprechenden Kniestrümpfen in Marineblau und Perlweiß und giftgrünen Schuhen.

Seite 77:
Herbst 1964, Seite 76, links, eine moderne »Marie Antoinette« – ein langes schwarzes Kleid aus leichtem Stoff mit rosa Rosenknospen (der Rock ist in den Gürtel eingesteckt, um die ebenso gemusterten hautengen Hosen freizulegen); rechts, goldbestickte rote Chiffonbluse mit goldbestickter schwarzer Chiffonpumphose; Seite 77, links, ein »japanischer Soldat« in einem grauen und lavendelfarbenen Wollkaro mit entsprechenden Halbgamaschen; rechts, »Mozart«-Hose und Gehrock aus braunem, beigem und schwarzem Tweed.

Seite 78:
Herbst 1964, links, giftgrün-schokoladenbraunes Abendkleid aus mattem Jersey; rechts, schwarzer Lack-Hosenanzug mit schwarzem durchsichtigem Hemd aus lackiertem Chiffon.

Seite 80:
Herbst 1964, aus Barbra Streisands erstem Mode-Shooting, das als Titelstory in der Zeitschrift *Show* veröffentlicht wurde; oben, in einem Webpelzkleid und einem mit Lammfellimitat gefütterten schwarzweißen Fischgrat-Tweedmantel; unten, Rudi mit Barbra in einem wendbaren Kamelhaar-Outfit; rechts, mit schwarzem Hahnenfederhut.

Seite 82:
Herbst 1964, oben, übergroßer Tweedmantel mit kleinerem Tweedkleid und einem gefederten Hut (Photo © David Bailey, Sammlung der Autorin); in der Manier einer Lartigue-Photographie; links, Flieger-Overall aus Kamelhaar; rechts, Shift-Cocktailkleid aus schwarz bedrucktem Chiffon mit entsprechendem Schleier. (Photos © Jerry Schatzberg, Sammlung der Autorin)

Seite 84:
Resort 1965, oben, mit Lydia Fields und Léon Bing – wir tragen von Layne Nielson gefertigte Sonnenblenden; rechts, Badeanzug mit Unterhemdträgern, hüfthohe Stiefel aus Vinyl und Sonnenvisier. Wie alle Stiefel und Schuhe zu Rudis Entwürfen, wurden auch diese Stiefel von Capezio geliefert.

Seite 86:
Resort 1965, links, schwarzer Maillot mit schwarzem Lackledergürtel, schwarzen hüfthohen Vinylstiefeln und lila Sonnenvisier; rechts, ockerfarbener gestrickter Wollbikini mit giftgrünen hüfthohen Vinylstiefeln, orangenem Vinylgürtel und gelbem Sonnenvisier.

Seite 88:
Resort 1965, oben links, in Brooke Haywards und Dennis Hoppers Haus werden »Klimt«-Chiffoncocktailkleider photographiert – mit dem Fernsehproduzenten Bert Berman, dem Kunsthändler Irving Blum und dem Maler Billy Al Bengston. Auf dem Boden sitzen Brookes Sohn und Dennis Hopper; oben rechts, in einem »Little Boy«-Seidenkostüm mit Steve McQueen; unten, mit den Byrds in einer Safarijacke und Hose aus Leinen und einer Hemdbluse aus Seide; rechts, Kleider mit »Kandinsky«-Mustern, im Restaurant La Scala in Los Angeles mit dem Besitzer Jean Leon.

Seite 90:
DER »TOTAL LOOK«
In den frühen sechziger Jahren traf ich Rudi ständig auf Parties und Veranstaltungen. Ich bewunderte ihn zutiefst, und eines Abends sagte ich es ihm. Ich hatte aber einen Vorbehalt – seine Kleider, die ich für so geistreich und amüsant hielt, wurden, wie ich fand, zu humorlos präsentiert. Es gab damals ein Idealbild von der amerikanischen Frau, das ganz und gar auf Geld, Country Clubs und »Wonder Bread« (eine mit Vitaminen und Mineralien angereicherte Weißbrotmarke) beschränkt war. In Rudis Entwürfen sah ich ein europäisches Augenzwinkern und eine orientalische Reinheit der Form.

Eines Tages rief Rudi mich an und sagte, er wolle eine Juniorkollektion entwerfen und mich dafür als Anprobemodell haben. (Für seine reguläre Kollektion hatte er mich für zu jung gehalten.) Ich sagte zu, und weil seine Kleider für Jugendliche genauso aussahen wie die aus seiner regulären Kollektion, begann ich alle seine Kleider für ihn zu präsentieren.

Es funkte sofort zwischen uns. Wir hatten dieselben Vorstellungen und tauschten unsere Ideen aus. Was mich zu Beginn unserer Zusammenarbeit am meisten störte, war eine gewisse »Kunsthandwerklichkeit« in seinen Präsentationen. Es war ihm ziemlich egal, ob ein wunderschönes, innovatives Tweedkostüm barfuß präsentiert wurde oder ein perfektes Seidenkleid einen ungeraden Saum hatte – mir allerdings nicht, und ich sagte ihm, daß ein Paar Schuhe (vielleicht sogar ein passendes) dem Ganzen ein völlig anderes Gesicht geben würden. Rudi nahm sich diese Bemerkung zu Herzen, und so entstand der »Total Look«: Von der Unterhose über die Strümpfe bis zum Hut war alles auf das Kleid abgestimmt. Jeder andere Modedesigner hätte mir einfach nur ein passendes Paar Schuhe gegeben.

Resort 1965, »Gauguin«-Oberteil und Hose aus Chiffon in Kalk, Türkis, Aqua, Rosa, Gelb und Aprikose. Die Hose war wie eine Blue jeans geschnitten.

Seite 93:
Resort 1965, Rudi kam endlich zu seiner indischen Kollektion; links, orangefarbene Leinentunika mit rosafarbener Leinenhose (Photo © William Claxton); rechts, safrangelbe Nehru-Jacke aus Seide; oben, Spiegelohrringe von Layne Nielson. (Photos © Peter James Samerjan)

Seite 95:
Sommer 1965, »Unitards« (Unterzieh-Einteiler) aus mattem Jersey in leuchtenden Farben mit überlangen Ärmeln und Beinen. Die beiden Abbildungen rechts zeigen über den Unitards getragene schwarzweiße, farbig gesäumte Crêpeoberteile.

Seite 96:
Resort 1965, oben, indische Anzüge in den Watts Towers in Los Angeles. Zum rosafarbenen Anzug gehörte ein Rock, der über einer Hose getragen wurde. In der Mitte ist der Schauspieler James Coburn zu sehen, unten links Layne Nielson (Layne fertigte seit 1965 für viele Jahre alle Accessoires für Rudi); rechts, zusammen mit Lydia Fields und Léon Bing. Wir tragen die Kastenzeichen, die ich aus Streichholzheftchen ausgeschnitten hatte und die Rudi später zu den Aufklebern inspirierten.

1965, umseitig, die »No-bra bra«-Anzeige. (Photos © Richard Avedon, Courtesy Exquisite Form)

Seite 100:
Herbst 1965, rechts, schwarzblaues gestricktes Kittelkleid mit dazugehörigen Strümpfen; Seite 101, schwarzweißes Wollstrickkleid mit giftgrünen Streifen und schwarzen, grün gestreiften Strümpfen.

Seite 103:
Herbst 1965, Seite 102, links oben und unten, Rudis »Tausendundeine Nacht« – der wendbaren Kombination aus Jacke und Rock entspricht ein wendbarer schwarzgrauorangener Wollmantel; links, Jacquard-Wollstrickkleid in Schwarzgrau und Grau mit entsprechenden Kniestrümpfen; rechts, wendbares Hahnentrittcape in Beige und Braunschattierungen.

Seite 104:
KNÖPFE UND SCHLEIFEN
Die meisten Modeschöpfer sind eigentlich »Kleidermacher« oder »Damenschneider«. Die guten können schöne und ausgearbeitete Kleider machen – mit einer kleinen Rundung hier, einer großen Girlande dort, einer Seidenkamelie im Nacken. Sie könnten genausogut teure Lampenschirme machen. Die Kleider, die sie machen, sind zeit- und gesellschaftsbedingt aufs Alter und die finanziellen Mittel der Frauen, für die sie arbeiten, und die zur Verfügung stehenden Materialien abgestimmt. Diese Kleidermacher produzieren das, was man »Mode« nennt. Das, was sie herstellen, kann nicht in andere Stoffe übertragen werden, ohne die wesentlichen Eigenschaften des Kleidungsstücks zu opfern, ohne daß die Integrität des Entwurfs auf der Strecke bleibt. Man stelle sich nur ein prächtiges Ballkleid aus mit Zentifolien bedrucktem Taft vor. Ein solches Kleid aus Harris-Tweed ist einfach nicht denkbar.

Design dagegen ist etwas ganz anderes. Ist der Entwurf stimmig und funktional, kann er in verschiedenen Materialien interpretiert und immer wieder verwendet werden. Mode veraltet, gutes Design nicht. Mode schafft Probleme, Design löst sie.

Das rechts abgebildete dreigestufte Kleid wurde nach demselben Entwurf gefertigt wie das auf Seite 45. Dort ist es in beigem, braunem und schwarzen Chiffon zu sehen. Es war, als ob man eine Wolke trägt. Hier ist es ein Strickkleid aus Wolle mit verschiedenen Mustern. Es sah ganz anders aus und trug sich völlig anders. Es hatte den exzentrischen Look und Swing der sechziger Jahre (der Zeit, die es reflektierte). Seines puritischen Designs wegen konnte es in vielen verschiedenen Stoffen und Längen gefertigt werden und machte immer einen modernen Eindruck. Das war der wichtigste Aspekt von Rudis Talent. Seine Entwürfe konnten endlos neu interpretiert werden.

Seite 105:
Herbst 1965, links, schwarzweiße Wollstricktunika mit schwarzweißer Hose und ebensolchen Socken; dreigestuftes Strickkleid aus Wolle mit entsprechenden Strümpfen in gebrochenem Weiß, Grau und Schwarz.

Seite 106:
»Babies«
Mir scheint, daß alle wirklich großen, klassischen Formen in der Damenmode auf Bekleidungsstücke für Männer zurückgehen. Von Togas, Sarongs, Kilts und Mönchsroben bis hin zu Hemdkleidern und Trenchcoats wurde alles ursprünglich von Männern getragen. Nur das Empirekleid ist eine Ausnahme. Es ist wunderschön und durch und durch feminin. Rudi entwarf Hunderte solcher Kleider, und wir nannten sie »Baby«-Kleider.

1965, oben, an Bord der *Queen Elizabeth,* zwei Seeleute und ein »Baby«-Kleid.
1965, rechts, Badeanzug, lavendelfarbenes gestricktes Oberteil mit roten Vinylpunkten und lavendelfarbener Bikini mit abnehmbaren roten Strumpfbändern aus Vinyl und Netzstrümpfen in gebrochenem Weiß.
1965, London, Seite 107–110, die Badeanzüge, die auf der *London Sunday Times*-Awards-Modeschau präsentiert wurden. (Rudi deponierte sie in meinem Gepäck, weil er Angst hatte, im Gefängnis zu landen, wenn der Zoll sie bei ihm finden würde.)

Seite 108:
1965, links oben und unten, als Touristen in London. (Wir waren ein herrliche Trio, wenn wir durch London liefen: Bill ist 1,96 Meter groß, Rudi maß ungefähr 1,68 Meter, und ich in der Mitte – mit rotem Lidschatten).
1965, oben, schwarzer Wollstrickmaillot mit abnehmbaren roten Vinylstrumpfbändern, roten Netzstrümpfen und roten Vinylapplikationen; rechts, synthetischer Strick in Gingan-Optik – Oberteil in Blau und Weiß, Bikini und Schärpe in Rosa und Weiß.

Seite 111:
1965, Paris, oben, Bill überrascht mich in unserem mehr als bescheidenen Badezimmer; rechts, in Rudis vornehmerer Bude im Hôtel de Crillon; umseitig, ich werde von Jeanloup Sieff photographiert.

1965, links, schwarzer Wollstrickmaillot mit schwarzen Netzstrümpfen und roten Vinylstreifen in Hosenträger und Strumpfhalteroptik.

Seite 114:
1966, London, Seite 114–119, für eine Photostory über Rudis Resort-Kollektion, die Bill und ich für die Zeitschrift *Queen* aufnahmen, verwendeten wir Tzaims Luksus' Dessous-Satingewebe. Vidal Sassoon gestaltete die Frisur; unten und rechts, langes bedrucktes Abendhemdkleid, das mit einer Schleife am Kopf festgebunden oder als Schalkragen getragen werden kann.

Seite 117:
1966, links und unten, mit Dreiecksmustern bedrucktes Empire-Abendkleid in Silber und Weiß; Mitte, langes, mit Pfeilen bedrucktes Hemdkleid in Orange und Weiß.

Seite 118:
1966, links, kurzes, mit Dreiecksmustern bedrucktes Empirekleid in Orange und Weiß; unten, schwarzweißes mit »Positiv/Negativ«-Pfeilen bedruckte Hose mit weißem

Kleid und Hut mit Metallbesatz, 1975

Satin-Tunikaoberteil, das mit einer aus einem zerbrochenen Spiegel gefertigten Brosche getragen wird; rechts, das »Little Boy«-Kostüm mit Hemdchen-Top, das auf dem Cover von *Queen* zu sehen war.

Seite 120:
1966, aus dem Plakat für unseren Film *Basic Black*, die »Goya Lady« – schwarzer geflockter Samt auf Chiffon.

Seite 121:
1966, Seite 121–123, Standbilder (mit Léon Bing und Ellen Harth) aus den Aufnahmen zu dem Kurzfilm *Basic Black*, der Rudis »Total Look« demonstrierte. Die »Tiere« zogen ihre schablonierten Kalbsledermäntel und -kostüme aus, um entsprechende Kleider – und dann Strumpfhosen, Unterhosen und Büstenhalter – freizulegen. Für die in diesem Film zu sehenden Entwürfe erhielt Rudi seinen zweiten Coty Award, und auch der Film selbst wurde mit vielen Preisen ausgezeichnet.

Seite 125:
Resort 1967, rautenförmiges Seidenkleid in Rot, Weiß und Marineblau mit roten Aufklebern aus Vinyl.

Seite 126:
Resort 1967, links, rosafarbene Strickbluse mit grünem Strickmini, Unterhose und entsprechenden Kniestrümpfen; rechts, »Sumo«-Kaftan aus Seide in Lila, Orange und Weiß.

Seite 128:
Ellen
Beautiful Ellen Harth, die göttliche Deutsche. Ich werde nie vergessen, wie sie eines Tages mit großer Entschlossenheit im Blick den Showroom betrat. Ohne Guten Morgen zu sagen marschierte sie an uns allen vorbei geradewegs ins Umkleidezimmer. Man hörte einen Schlag, und dann erhob sich ihre kräftige teutonische Stimme wie die eines störrischen Kindes: »Woody, where is my wed dwess?« (Rudi, wo ist mein rotes Kleid!)

Resort 1967, links, roter gestrickter Büstenhalter mit weiter, Hüfthose in Marineblau und weißem Gürtel, präsentiert von Ellen Harth.
Herbst 1967, rechts oben, Strickkleid mit Color-Blocking; rechts unten, nabelfreier Wollstrickmini mit eingearbeiteter Unterhose. Für diese Kollektion wurde Rudi mit dem Coty Hall of Fame Award ausgezeichnet.

Seite 130:
Herbst 1967, das »japanische Schulmädchen« – schwarz-weiß kariertes Strickkleid mit roter Schleife; rechts, der »japanische Schuljunge« – schwarze Stricktunika mit roter Schleife und schwarzen Shorts.

Seite 132:
Herbst 1967, »Chinesische Oper«-Gruppe – Schürzenkleider und Jumpsuit mit Tunika aus mit verschiedenen Mustern bedruckter Seide; rechts, Crêpe-Minidress mit langen Organza-Blumenohrringen.

Seite 135:
Herbst 1967, »Pierrot«-Tweedmantel in Schwarz, Weiß und Grau, mit Ohrringen aus chinesischen Fasanenfedern.

Seite 136:
Herbst 1967, links oben, schwarzes »Kavallerieoffizier der k. u. k. Armee«-Outfit aus Wolle mit besticktem Vinylbesatz; links unten, »George Sand«-Hosenanzug in Kordsamt mit Satinbluse. Das Jackett ist mit winzigen Löwenkopfknöpfen aus Messing versehen.
Herbst 1967, rechts, durchsichtiges Minikleid aus lackiertem Chiffon und Wollcrêpe.

Seite 138:
Herbst 1967, links, grauer »George Raft«-Hosenanzug mit schwarzen Nadelstreifen; Seite 139, oben links, »Ophelia«-Shiftkleid aus Chiffon in Grün und Schwarz; rechts, Léon Bing als »Nonne« in einem weißen Shiftkleid und darüber einem schwarzen Strickträgerrock.

Seite 139:
LÉON
Rudi ließ kein Tabu unangetastet. Hier ist Léon Bing als Nonne zu sehen. Léon, die Schwester vom Orden der Unbefleckten Mascara (kein Schweigeorden), ist für ihren spöttischen Humor bekannt und genoß es ungemein, dieses Gewand zu tragen. So schockierend der Entwurf auf den ersten Blick auch ist – eigentlich stellt er nichts anderes dar als zwei einfache, hübsche Kleider, die übereinander getragen werden.

Seite 141:
Herbst 1967, links, mit Mylar-Pailletten bestickter silberner Baumwoll-»Pierrot«. Der Hut ist mit Spiegelstücken bedeckt; rechts, aus einem Overall und einer Jacke kombiniertes schwarzes und kamelhaarfarbenes »Motorsportkostüm« aus Wolle mit Karomuster.

Seite 142:
EIN HARTES STÜCK ARBEIT: DAS MAKE-UP
Rudis Kleider beeinflußten mich so sehr, daß ich mein Make-up nach ihnen ausrichtete. Das war nicht immer einfach. Die Resort-Kollektion von 1965 umfaßte nicht nur von der indischen Kultur inspirierte Kleider, sondern auch Raumzeitalter-Badeanzüge, kleine Chiffonkleider, Leinenkleider und Hosenanzüge. Ich löste das Problem, indem ich für die indischen Outfits entfernbare Kastenzeichen verwendete.

Für die Herbstkollektion von 1967 wollte ich ein Make-up auf der Grundlage der Gestalt des Todes in Ingmar Bergmans Film »Das siebente Siegel« kreieren. Rudi hatte einige Stücke in seiner Kollektion, die einen ziemlich finsteren Eindruck machten, und ich glaubte, eine Art »Schädel«-Make-up würde wirkungsvoll sein. Das Dumme war nur, daß ich für diese Kollektion auch in die Rolle japanischer Schulmädchen und -jungen zu schlüpfen hatte, in die der »Ophelia« und in zierliche Kleider, die der chinesischen Oper nachempfunden waren. Was war zu tun? Ich bleichte meine Augenbrauen und malte mir große schwarze Augenhöhlen, und wenn ich eines der süßen Kinder zu sein hatte, kämmte ich mir meine Ponyfransen über die Augenbrauen.

Das verblüffendste Beispiel dafür, daß wir die gleiche Wellenlänge hatten, ergab sich im Rahmen der Resort-Kollektion von 1968. Ich lebte damals in New York und hatte keine Ahnung, wie Rudis Kollektion aussehen würde. Unmittelbar bevor er nach New York kam, fühlte ich mich irgendwie gezwungen, mir ein ganz exotisches siamesisches Gesicht aufzuschminken.

Als ich die Kleider und Rudi das Make-up sah, trauten wir unseren Augen nicht: Man hätte glauben können, die Kleider und das Make-up seien von ein und derselben Person gestaltet worden. Zu meinem Make-up gehörten rote Linien, die meine Augen umgaben und sich wie ein Tattoo über die Nase zogen. Allerdings machten »siamesische« Kleider nur einen Teil der Kollektion aus; die übrigen hatten gar nichts Fernöstliches an sich. Das bedeutete, daß ich mir mitten in der Show rote Linien auftragen mußte. Ich ging ins nächst beste Billigkaufhaus und kaufte eine schwarze Halloween-Maske, schnitt sie meinen Vorstellungen entsprechend zurecht und benutzte sie als Schablone. Jetzt gab es nur noch ein Problem: Rudi bestand darauf, daß die Show mit einem kleinen schwarzen Chiffonkleid mit Ballonrock und schwarzen Federohrringen abgeschlossen wurde – und daran war nichts Siamesisches. Was tun? Ich setzte die Maske, die ich als Schablone benutzt hatte, und das Mädchen wurde zur betörendsten Raubkatze auf der ganzen Welt.

Rudis letzte Show, 1981, stellte uns vor ein schwerwiegenderes Problem. Sie sollte in einem Nachtclub stattfinden, der La Cage aux Folles hieß, und die Produzenten der Modeschau schlugen Rudi vor, die »Damen-Imitatoren«, die dort arbeiteten, als Modelle zu nehmen. Rudi wollte davon nichts wissen, und es ärgerte ihn, daß die Produzenten darauf bestanden, die Show dort auf die Bühne zu bringen. Er fragte mich, ob ich eine Idee hätte. Ich schlug vor, mit einem Schnurrbart aufzutreten. Er war begeistert – das allerletzte Kleid, das ich für Rudi präsentierte, war ein langes, erotisches Abendkleid, das zu einem Schnurrbart getragen wurde. Das Publikum raste vor Begeisterung. Ich bin froh, daß unser letzter gemein-

Rudi zu Hause, 1975

samer professioneller Auftritt so lustig und erfolgreich verlief.

Herbst 1967, links, Tunika und Rock aus breitrippigem schwarzem Kordsamt mit weißen Satinmanschetten; rechts, die »Hexe« – schwarzer, mit schwarzen Pailletten bestickter Baumwollstoff.

Seite 144:
Resort 1968, rechts, lange Seidenhose und bluse aus der »siamesischen« Gruppe.
Resort 1968, unten, der zwischen den Beinen getragene Einsatz dieses Shantungkleides wurde hinten an der Taille mit einem Druckknopf befestigt. Wurde der Einsatz entfernt, blieb ein einfaches Kleid übrig, das gar nichts Siamesisches mehr hatte – Rudi war brillant, wenn es darum ging, einen Entwurf auf das Wesentliche zu reduzieren.

Seite 146:
Resort 1968, links, langes schwarzes Kleid aus mattem Jersey – wenn der Einsatz hochgezogen und über eine Schulter geworfen wurde, verwandelte sich das Kleid zu einer kurzen Hose; rechts, gelb, blau und weiß bedruckte Baumwollbluse und -hose und rot, marineblau und weiß bedruckte Baumwollshorts. Die Hüte sind aus Seide.

Seite 148:
FUN CITY
Die späten sechziger Jahre waren für New York City eine sehr chaotische Zeit, und die Leute bekamen Angst, die Stadt zu besuchen. Die Handelskammer beschloß, eine Anzeigenkampagne zu starten, die zeigen sollte, was für eine wunderbare Stadt es war, und sie wählten den Slogan »Fun City«. Die Anzeigen waren überall, in Zeitschriften, auf Bussen und Reklametafeln. Wohin man auch blickte, überall sah man »Fun City«.

In dieser Zeit kamen Bill und ich aus Europa zurück. Wir entschlossen uns, in New York zu bleiben, und fanden eine Wohnung in der West 57th Street. Für mich hatte das einen schrecklichen Nebeneffekt. Statt nach der Arbeit zusammen mit Rudi zu Fuß zum Algonquin Hotel zu laufen, mußte ich jetzt allein über den Times Square und die gefürchtete 42nd Street nach Hause gehen. Natürlich nahm ich ein Taxi, wenn ich eins bekam, aber das war fast nie der Fall. Eines denkwürdigen Tages stand ich an der Kreuzung 42nd Street/7th Avenue an der Ampel und sah die Leute, die auf der anderen Straßenseite standen und an denen ich vorbeigehen mußte: Midnight Cowboys, Prostituierte, Transvestiten, Dealer; Leute, die am ganzen Körper tätowiert waren und sich Knochen durch ihre Nasen gezogen hatten; in ihrer Mitte ein Zwerg, der keine Beine hatte. Er saß auf einem kleinen Brett mit Rollen. Als

Zu Hause, 1975

ich mit abgewandtem Blick die Straße überquerte, zeigte der Zwerg mit dem Finger auf mich und schrie den anderen zu: »Guckt euch die an, guckt euch die an! So was Ausgeflipptes!« Die glamourösen Tage im Leben eines Mannequins in »Fun City«!

Seite 149:
Resort 1968, Léon Bing und ich tragen bedruckte »Kimono«-Seidenkleider mit breiten Gürteln aus Brokat und Schärpen aus Vinyl.

Seite 150:
Resort 1968, die »Zuaven«: unten links, beige Leinentunika mit Ballonrock aus weißem Baumwollpikee; unten rechts, beiges Leinenkostüm mit taupefarbenem Gürtel; rechts, Tunika und Pumphose aus Leinen mit Karomustern in Beige und gebrochenem Weiß und weiße Baumwollbluse.

Seite 152:
Seventh Avenue
In der Woche, in der Rudi auf dem Titelblatt von *Time* zu sehen war, erschienen zwei billig gekleidete Einkäufer von einem Kaufhaus in der Provinz im Showroom in New York. Sie gingen auf Rudi zu, der zufällig dort stand, und verlangten, »Was habense denn an besetzten Pullovern, lassense mal sehn.« Ach, der Ruhm!

Resort 1968, oben und rechts, aus einer Wollstrickgruppe mit transparenten Vinyleinsätzen. Diese beiden Kleider erschienen zusammen mit Rudi auf dem Titelblatt des *TIME magazine*.

Seite 154:
HAUTE COMFORT
Einige seiner Kritiker warfen Rudi vor, seine Kleider seien schlecht gemacht. Zwar waren sie nicht nachlässig gefertigt, aber auch nicht »Haute Couture«. Ein in Organza eingesetzter Druckknopf wurde nicht überdeckt, wenn es keinen guten Grund dafür gab. Der Unterschied zwischen Rudis Denkweise und der der Haute Couture wurde mir klar, als ich für die Pariser Kollektionen in einem Kaftan von einem der großen Pariser Modehäuser photographiert wurde. Auf dem Kleiderbügel sah er sehr schön aus, doch als ich ihn anzog, entdeckte ich, daß sich in dieser lockeren Form ein geschnürtes Kleid befand, an dessen Saum Bleigewichte hingen. Die Gewichte schlugen an meine Knöchel, und das innere Kleid zwängte mich so ein, daß ich nur noch trippeln konnte.

Für mich bedeutet ein Kaftan nichts anderes als Freiheit. Seit Tausenden von Jahren sind Männer darin durch die Wüste geschritten. Der Kaftan gab ihnen Bewegungsfreiheit, und sie sahen großartig darin aus. Im Komfort liegt Schönheit und Sinnlichkeit; darum ist der Kaftan so reizvoll. Wenn man sich verführen lassen will, sollte man

am besten einen Kaftan tragen, da bin ich mir ganz sicher. Die Fürsprecher der Haute Couture (fast immer Männer) haben mir jahrelang erzählt, daß dieses und jenes Kleid wunderbar ist, weil es so steif konstruiert ist, daß man es auf den Boden stellen kann. Meine Antwort war immer: »Soll's doch. Dann braucht es mich nicht mehr, um es herumzutragen, und ich brauche mich nicht damit herumzuquälen.«

Hier ist einer von Rudis Kaftanen. Er wurde aus Seide gefertigt und ist mit Pongéseide gefüttert. Das ist alles. Der Stoff umfloß den nackten Körper und es fühlte sich an, als ob tausend Babyhände mich streichelten.

Resort 1968, schwarzer Bikini mit transparenten Vinylriemen.

Seite 155:
Resort 1968, schwarzweißer Schachbrett-Kaftan aus Seide mit gelben Punkten.

Seite 156:
Resort 1968, links, schwarzes Chiffoncocktailkleid mit Ballonrock und Ohrringen aus Federn; rechts, von Surf-Kleidung inspirierter gestrickter Bikini und gestrickte Beinkleider.

Seite 158:
AM STRAND
Auf einem Ausflug an die mexikanische Küste konnte Rudi der Versuchung nicht widerstehen, an einen Nacktbadestrand zu gehen. Dort kam ein wunderschönes nacktes Mädchen auf ihn zu und rief: »Oh, Mr. Gernreich, ich liebe Ihre Badeanzüge!«

Resort 1968, oben, schwarzer Badeanzug mit transparenten Seitenstreifen aus Vinyl; rechts, schwarzes Strandkleid mit transparentem Vinylkragen und Bikini mit Vinyleinsätzen.

Seite 159:
Resort 1968, nabelfreier schwarzer Badeanzug mit Lackledergürtel.

Seite 160:
LAYNE
Als ich 1966 aus Europa zurückkehrte, war ich völlig überrascht über die Entwicklung, die Rudis Assistent, Layne Nielson, genommen hatte. Er machte schier unglaubliche Accessoires – von den gefiederten Hüten, die in *Basic Black* getragen wurden, bis hin zu den Ohrringen in Kleiderlänge aus gestärkten und gepreßten Organza-Blumen. Aus Lackpapier fertigte er Fingerschützer für die siamesische Gruppe und all die ausgefallenen Schmuckstücke, die zu diesen Kleidern gehörten.

Es gab einen Hut, der nie photographiert wurde, den ich aber nie vergessen werde. Es war ein winziges schwarzes Scheitelkäppchen, aus dessen Spitze eine biegsame schwarze Feder herausragte. Diese Feder war fünfeinhalb Meter lang. Wenn das Model, das diesen Hut trug, den Raum verließ, dauerte es noch anderthalb Minuten, bis auch die Feder nicht mehr zu sehen war. Auf der gegenüberliegenden Seite ist einer von Laynes Federhüten zu sehen. Er verbrachte Stunden damit, die dazu passenden Stiefel mit Federn zu bekleben (siehe Seite 162). Für diese Kollektion kreierte er einige seiner spektakulärsten Arbeiten.

Herbst 1968, Hut und Boa aus Hahnenfedern.

Seite 162:
Herbst 1968, mit Rudi, in einer schwarzen Tunika mit Keulenärmeln und mit Federhut, Federboa (von den vorhergehenden Seiten) und Federstiefeln; rechts, karierte Wolljacke, Pumphosen-Jumpsuit und Hut in verschiedenen Grauschattierungen.

Seite 164:
Herbst 1968, eine »Beardsley«-Gruppe: oben, das auf der vorhergehenden Seite abgebildete karierte Woll-Outfit mit offener Jacke, um das schwarze Chiffonoberteil des Pumphosen-Jumpsuits zu zeigen, und (rechts) mit abgelegter Jacke; Mitte und unten, Tweedpumphose und Chiffonbluse mit Tweedbesatz.

Seite 166:
Herbst 1968, links, »Duke of Windsor«-Hosenanzug aus grünem und beigem Tweed mit wendbarer Jacke; rechts, kurzer grauer »Dschingis-Khan«-Flanellreithosenanzug mit Spenzer aus Vinyl und Samt unter einer Jacke aus Vinyl und Leinen.

Seite 168:
Herbst 1968, die »Schneekönigin« – Jacke aus Kunstnerz, Chiffon und besticktem Veloursamt; rechts, bestickter weißer Webpelzmantel mit Pumphose und Bluse aus schwarzem Satin.

Seite 171:
Herbst 1968, links, schwarzweißes Kleid mit Buchstabendruck, mit entsprechender Strumpfhose und Signaturschal aus Seide; rechts, graugrün und schwarzgrau gemusterte Renaissance-Tunika aus Wollstrick und entsprechende Strickstrumpfhose mit gebrochen weißen Strickeinsätzen.

Seite 172:
Herbst 1968, links, schwarzes gestuftes »Baby«-Kleid aus Chiffon; rechts, schwarzer Satintrenchcoat über schwarzer Crêpehose.

Seite 174:
Zu Hause in New York, 1970, rechts, Bill und ich tragen Kaftane von Rudi; unten, in einem schwarzweißen Wollstrick-Jumpsuit; S. 175, Rudi bei der Arbeit in Los Angeles, 1966.

Seite 176:
Herbst 1968, oben, gestrickte Tunika aus Wolle mit Bändern und passender Strumpfhose; Mitte, Tweedröckchen und Hemdbluse aus Chiffon mit Tweed und elastisch geschnürter Strumpfhose; unten links, Renaissance-Minikleid mit Einsätzen in gebrochenem Weiß und passender Strumpfhose; unten rechts, Wollstricktunika und passende Strumpfhose; rechts, Strickpullover und -hose mit Rüschenkragen und -manschetten.

Seite 179:
Herbst 1970, Strickteile, links, das Model Diana Newman in einem oberteillosen langen schwarzen Kleid aus mattem Jersey mit Aufklebern; weiter oben, schwarzer gestrickter Jumpsuit mit einzeln ablegbaren Hosenbeinen und einem Rock mit einem Träger; oben links, langes schwarzes rückenfreies Kleid mit Rollkragen und roten und weißen Gürteln; oben Mitte und rechts, grauer karierter gestrickter Jumpsuit mit Rock. (Photos © Patricia Faure)

Seite 180:
1969, mit Spiegeln besetzter Overall aus Chiffon; das Scheitelkäppchen und die Stiefel sind ebenfalls mit Spiegeln besetzt. Das Kostüm wurde für die Weihnachtsausgabe der Zeitschrift *McCALL's* entworfen und photographiert, blieb aber unveröffentlicht.

Seite 182:
1970, Unisex: Für die Zukunft sagte Rudi voraus, daß »Kleidung nicht mehr als entweder männlich oder weiblich identifiziert werden wird… Frauen und Männer werden die gleichen Röcke tragen… die Modeästhetik wird den Körper selbst einbeziehen. Auf den Seiten 184–187 sind Renee Holt und Tom Broome zu sehen. (Photos © Patricia Faure)
1970, Unisex, Seite 184, oben, Unisex-Oberteile und Hosen; Seite 185, Röcke für Männer und Frauen (Aufkleber für Frauenbrüste). (Photos © Patricia Faure); Seite 1984, unten links und rechts, Unisex-Badeanzüge und Kaftane. (Photos © Hideki Fujii)
1970, Seite 186–187, Wollstrick-Unisexoveralls, auf Seite 187 mit Perücken, Armbanduhren und Stiefeln getragen. (Photos © Patricia Faure)
Resort 1971, links, einteiliger gestrickter »Rouault«-Badeanzug; rechts, Strickteile – der »military« Look. Rudi entwarf und zeigte diese Kollektion im Herbst 1970, als an der Kent State University in Ohio gegen den Vietnamkrieg demonstrierende Studenten von der amerikanischen Nationalgarde erschossen wurden. Léon Bing nannte diese Kollektion Rudis »back-to-school«-Kollektion.

Seite 192:
Herbst 1971, vorhergehende Seiten, lange schwarzweiße und grauweiße Trompe-l'œil-Strickkleider.

Seite 193:
Herbst 1971, Seite 192, links, moosgrüne Jacke, mit Naturleder besetzte Hose mit Hosenträger und moosgrüne Bluse aus mattem Jersey; rechts, grau-schwarzer Trompe-l'œil-Overall; oben links, dreiteiliges schwarzweißes Outfit mit Hose aus verschieden gestrickten Karos; oben rechts, schwarzweiße Wollshorts, Shirt und darüber getragenes kurzes Unterhemd (Bustier). Zu zallen Outfits werden Gürtel mit Hundeleinenkarabiner getragen.

Seite 194:
Herbst 1971, gestrickte Wolltunika über Shorts; rechts, langes Kleid aus mattem Jersey mit Federn aus Metall auf einem tiefen, mit Leder eingefaßten Ausschnitt.

Seite 196:
Frühjahr/Sommer 1972, oben links, weißer Overall aus mattem Jersey mit »eingesetztem« schwarzen Wollstrick-Topless Swimsuit und einem roten Streifen auf dem Ärmel (ich nannte ihn »das rote Tapferkeitsabzeichen«); oben rechts, einteiliger gestrickter Trompe-l'œil-Badeanzug in Rot und Schwarz; Seite 197, oben links, schwarzer gestrickter Badeanzug – der erste Schritt zum Pubikini (das BH-Oberteil und das Höschen konnten nicht geknöpft werden); oben rechts, abstrahiertes »Message«-T-Shirt aus mattem Jersey in Schwarz, Weiß und Giftgrün mit schwarzen Shorts aus mattem Jersey; links unten, langes schwarzes T-Shirt-Kleid aus mattem Jersey mit weißen Stoffalten vortäuschenden Einsätzen.

Seite 199:
Frühjahr/Sommer 1972, Seite 198, links, langes giftgrünes T-Shirt-Kleid aus mattem Jersey mit einem vielfarbigen und einem grünen Ärmel; rechts oben, Jeans aus schwarzem mattem Jersey mit kurzem roten T-Shirt mit Einsätzen in Pink; rechts Mitte, langes T-Shirt-Kleid aus mattem Jersey in Pink mit orangenen Einsätzen; rechts unten, gestrickter Trompe-l'œil-Badeanzug in Rot, Lila und Schwarz.
Frühjahr/Sommer 1972, rechts, langes oranges T-Shirt-Kleid mit pinkfarbenem Einsatz auf einem der Ärmel; oben, schwarzweißer Trompe-l'œil-Overall aus mattem Jersey mit Wollstrickeinsätzen.

Seite 200:
Herbst 1972, oben, wattierte Motorradjacke in Schwarz mit roter Fütterung; rechts, wattierter schwarzer Wollstrick-Midimantel mit auberginenfarbener Fütterung und auberginenfarbener Wollstrickhose.

Seite 201:
Herbst 1972, langes schwarzes Wollstrickkleid mit Rückenteil und Ärmeln aus schwarzem Chiffon.

Seite 202:
Herbst 1972, in allen Kollektionen fanden sich schöne und bequeme Kleider, die für gewöhnlich nicht photographiert wurden, weil sie keine Neuheiten darstellten. Sie waren nie unelegant oder langweilig und konnten auch von Frauen getragen werden, die nicht wie Models aussahen. Hier sind drei solcher Kleider aus der Herbstkollektion 1972 zu sehen.

Seite 205:
Frühjahr/Sommer 1973, Seite 204–208, Wollstrickteile. Links ist Rudis Halston-Parodie zu sehen: eine in eine Bluse eingenähte Scheinstrickjacke.

Seite 209:
Herbst 1973, eine Woche vor der Geburt meines Sohnes. Rudi hatte verschiedene weite Kleider in dieser Kollektion, die ich als Umstandskleider trug. Das Kleid mit Schachbrett und Blumenmuster ist zahllose Male kopiert worden. Das grüne und rosarote »Crossmyheart«-Kleid war ursprünglich in den sechziger Jahren entworfen worden und hatte sich als so populär erwiesen, daß es oft in späteren Kollektionen wieder aufgenommen wurde.

Seite 211:
1974, Rudis Tanga, der »Thong« (Riemen); links, unter großem Medienrummel stellt Vidal Sassoon in seinem Haus den »Thong«-Haarschnitt vor; links, Rudi mit Vidal und Thong-Models. Rudis Thong ist inzwischen zu einem Standardmodell der Bademode geworden. (Doch noch 1991 wurde er an öffentlichen Stränden in den Vereinigten Staaten von örtlichen Behörden verboten.); umseitig, der Thong in seiner natürlichen Umgebung.

Seite 214:
Frühjahr 1975, an Aluminiumschmuck von Christopher Den Blaker befestigte Kleider; Hose und Oberteil aus schwarzem mattem Jersey; Hut aus schwarzem Chiffon und Aluminium.

Zu Hause, 1975

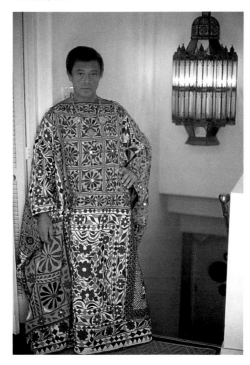

Seite 216:
1976, für verschiedene Ballettproduktionen von Bella Lewitsky entwarf Rudi die Kostüme, so zum Beispiel diese hier für *Inscape*. (Photos © Dan Esgro)

Seite 218:
1976, für Lily of France entworfene intime Kollektion, oben links, schwarzweißer Boxer-Jumpsuit aus Satin und Kampfsportmantel; oben rechts, Boxer-Jumpsuit aus Satin und weißes Satin-Handtuch; unten, Jockey-Shorts für Frauen; rechts, Boxer-Shorts und Hemd aus Männerhemdenstoff.

Seite 220:
1981, Rudi mit seiner letzten Kollektion. (Photo © Tony Costa)

Seite 221:
DER ANRUF
An einem Tag gegen Ende März oder Anfang April 1985 saßen mein Sohn Christopher und ich bei einer Tasse Tee und lachten beide aus vollem Halse über einen super guten Witz, als das Telefon klingelte. Christopher ging ran, gab mir den Hörer und sagte, »Es ist Rudi«. Ich lachte immer noch und sagte, »Hi, Rudi«. Mein Lachen muß ansteckend gewesen sein, denn auch Rudi fing an zu lachen und sagte, »Hi, du wirst nie raten, wo ich bin… im Krankenhaus. Es könnte ernst sein.« In dem Moment wußte ich, daß er nicht mehr lange leben würde. Am nächsten Morgen gingen Bill und ich ins Krankenhaus. Wir brachten ihm ein Buch und eine große Cymbidium-Orchidee aus unserem Garten mit. Als wir ihm die Blume gaben, konnte niemand eine Vase dafür finden. Also steckte Rudi sie in ein Urinal und sagte: »Na, das ist doch piss-elegant.«

1985, der Pubikini, einen Monat vor Rudis Tod in seinem Haus photographiert. (Photo © Helmut Newton)

Seite 222:
DER TRAUM
Kurz vor seinem Tod rief Rudi mich an und sagte: »Ich habe letzte Nacht geträumt, daß ich auf einem Friedhof war und meinen eigenen Grabstein sah. Ich ging darauf zu und las, ›Er war seiner Zeit immer um zehn Jahre voraus.‹« So schwer es mir auch fiel, ich mußte einfach lachen. Rudi sagte: »Ich habe dir das erzählt, weil ich wußte, daß du der einzige Mensch bist, der lachen würde.«
Er hatte sich natürlich geirrt. Er war seiner Zeit immer um dreißig Jahre voraus.

PAS DE DEUX
Ohne Rudi wäre ich ein begabtes und innovatives Model gewesen. Ohne mich wäre er ein genialer Avantgarde-Modedesigner gewesen. Wir waren Katalysatoren füreinander, die perfekte Synthese. Wir haben uns nicht gegenseitig erfunden, wir spielten ästhetisches Pingpong miteinander. Einer von uns sagte oder tat etwas, und der andere schlug es über das Netz zurück. Es machte Spaß, es war belebend, es war eine wahre Zusammenarbeit, und, ja, es war Liebe.

1968, Rudi und die Schneekönigin.

Seite 256:
Das dekorative Alphabet, das in diesem Buch verwendet wird, wurde von Peggy Moffitt als eine Huldigung an Rudi Gernreich gestaltet. Es heißt »Rudi Bold«. Künstlerisch ausgeführt wurde es von Joe Goebel.

Page 1:
Au vingtième siècle, il y a eu une poignée de génies dont les innovations ont changé le cours de l'art de leur temps :
En peinture, Picasso.
En musique, Stravinsky.
Au cinéma, Eisenstein.
Au théâtre, Stanislavsky.
En danse, Balanchine.
En jazz, Parker.
Et dans le stylisme de mode, Rudi Gernreich.
Peggy Moffitt

Page 2:
Automne 1971, combinaison-short en trompe-l'œil avec ceinture-laisse de chien

Pages 6–9:
RUDI
J'ai consacré l'essentiel de ma vie professionnelle à Rudi Gernreich. Je croyais totalement en son talent et j'ai eu le grand privilège de le compter parmi mes amis intimes. Au fil des années, nous nous sommes mis à fonctionner en tandem. Un des signes majeurs de son génie est de m'avoir permis d'exprimer pleinement mon propre talent. Je n'ai jamais eu à me censurer quand nous travaillions ensemble. Je pouvais émettre des critiques ou des suggestions sans craindre d'outrepasser mon rôle. Nous avons éprouvé un plaisir indescriptible à travailler ensemble et vécu une idylle de collaboration créative. Nous disions toujours que s'il avait été mannequin il aurait été moi et que si j'avais été styliste, j'aurais été lui. Durant notre longue collaboration, le travail de Rudi a bénéficié d'une abondante publicité et fait l'objet de multiples controverses. Ce qui fut bien sûr très positif et utile à l'époque. Mais j'ai toujours senti que les gros titres des articles qui paraissaient masquaient le grand talent de Rudi. Je ne l'ai jamais senti aussi fortement qu'aujourd'hui qu'il est décédé. J'ai la conviction que Rudi Gernreich a imaginé presque tout ce qu'on pouvait créer pour des êtres modernes. Ses modèles sont si logiques et si purs qu'ils conviennent aussi bien à des femmes mûres qu'à des adolescentes. Il me semble que la plupart des gens assimilent son travail aux « années soixante » ou à des « tendances », alors qu'en fait son travail était plus universel et classique que celui de Chanel.

Rudi Gernreich était un styliste de mode d'avant-garde qui commença à travailler dans les années quarante, fut reconnu comme un innovateur dans les années cinquante devint devenu une marque célèbre dans les années soixante. C'est son modèle de *topless swimsuit* (monokini) qui lui a assuré la plus grande notoriété, mais son travail et sa philosophie du stylisme ont changé le cours de la mode et influencé des créateurs du monde entier. L'industrie de la mode n'a cessé de puiser dans ses concepts et il a inventé une façon moderne de se vêtir pour la seconde moitié du vingtième siècle, exactement comme Chanel l'avait fait pour la première.

Rudi Gernreich
• a supprimé l'armature intérieure des maillots de bain ;
• a été le premier styliste moderne à mélanger des couleurs audacieuses et réputées incompatibles ;
• a employé les tissus de façon audacieuse – blouses de travail masculines en mousseline de soie ou vestes de mécaniciens en soie ;
• a imaginé la première robe tubulaire en tricot ;
• a été le premier à recourir aux fenêtres dans les vêtements (trous « hublots » dans les maillots de bain et les robes) ;
• a été le premier à utiliser le vinyle et le plastique dans les vêtements ;
• a adapté les « modes de la rue » comme le « look cuir » et les a intégrées dans la mode ;
• a mélangé les motifs, rayures, carreaux et pois ;
• a introduit le concept des vêtements ethniques et des vêtements de travail dans la mode ;
• a introduit l'androgynie – costumes d'hommes, chapeaux, etc., pour les femmes ;
• a créé le premier « topless swimsuit » qui a libéré la mode féminine ;
• a créé les premiers vêtements transparents ;

• a créé le premier soutien-gorge souple et transparent, « l'anti-soutien-gorge » ;
• a inventé les premiers vêtements moulants à base de collants et de caleçons ;
• a conçu les premiers collants assortis ou complémentaires d'une robe ;
• est à l'origine du « look total » qui englobe tout, des sous-vêtements au chapeau, aux gants et aux chaussures ;
• a lancé le look militaire ;
• a utilisé des articles de mercerie (fermetures éclair, fermoirs de laisses de chien) comme accessoires ;
• a créé les premiers jeans de styliste ;
• a développé les vêtements en trompe-l'œil (une robe qui donne l'illusion d'un ensemble trois pièces et est en fait un seul vêtement, etc.)
• a inventé le look unisexe (vêtements portables aussi bien par les hommes que par les femmes, jupes pour hommes, etc.) ;
• a créé le *thong*, le maillot de bain échancré très haut sur la cuisse et qui découvre les fesses ;
• a le premier créé des sous-vêtements masculins pour les femmes ;
• a créé le premier maillot de bain qui dévoile les poils pubiens, le « pubikini ».

Rudi Gernreich a proposé des vêtements à des prix raisonnables et s'opposait à la mode comme emblème de « standing ». Il a aussi été le premier styliste après Dior à avoir créé une marque connue dans le monde entier. La controverse dont il a été l'objet n'a pas cessé avec sa mort. Mais un fait demeure : il a transformé le vocabulaire de la mode du vingtième siècle.

Peggy Moffitt
Beverly Hills, 1991

Pages 10–35:
REGARD RÉTROSPECTIF SUR UN FUTURISTE
Marylou Luther

Rudi Gernreich a dénudé les seins, exhibé les poils pubiens, rasé les têtes et les corps, et armé ses mannequins de revolvers, tout cela au nom de la mode. Des ecclésiastiques ont dénoncé en chaire ses recherches créatives. Son *topless swimsuit* a été excommunié par le pape, dénoncé par *Izvestia* et enchâssé dans une capsule témoin entre la Bible et la pilule contraceptive. Pour beaucoup d'acteurs du monde de la mode, Gernreich fut un prophète, un visionnaire doté d'une capacité inouïe de projection dans l'avenir. Pour ses détracteurs, il fut aussi un prophète : l'oracle de l'horrible.

Rudi Gernreich au travail, Los Angeles, 1966

Gernreich portait deux stylistes en lui. Le premier était un précurseur motivé par le besoin de créer des vêtements modernes pour le vingtième siècle et au-delà. Tel est le Gernreich qui a remporté tous les grands prix que les officiels de la mode américains pouvaient décerner. L'autre Gernreich était un critique social qui avait choisi le vêtement comme moyen d'expression. Selon les termes de Gernreich : « Avant les années soixante, les vêtements se limitaient pas à la mode. Rien d'autre. Puis quand ils ont commencé à venir de la rue, j'ai compris qu'on pouvait dire des choses avec des vêtements. La beauté d'un dessin ne suffisait plus. Probablement à cause de l'impact de mon *topless swimsuit* de 1964, je me suis de plus en plus intéressé aux vêtements comme propositions sociologiques. J'ai le sentiment qu'il est important de dire quelque chose qui ne reste pas limité à son médium. »

A travers ses modèles, Gernreich a dit beaucoup de choses qui ne se limitaient pas à la mode : que le corps des femmes méritait d'être libéré des contraintes qui traduisaient leur soumission aux hommes ; que les vêtements féminins et masculins pouvaient être interchangeables, ce qui assurait une véritable égalité des sexes ; que les uniformes utilitaires nous évitaient de penser à notre apparence et nous permettaient de nous concentrer sur nos actes ; que la mode n'est pas une tragédie, mais un divertissement ; que la nudité ne doit plus être appréhendée en termes moraux ; que la façon dont nous nous habillons est étroitement liée à la façon dont nous vivons ; que l'esprit et l'humour auront toujours le dernier rire dans l'univers imbu de sérieux et souvent prétentieux de la mode.

L'homme que beaucoup considèrent comme le styliste américain par excellence est né à Vienne, en Autriche, le 8 août 1922. Il a découvert le monde de la haute couture dans un magasin qui appartenait à sa tante, Hedwig Mueller. Dans la boutique qu'il appelait « son sanctuaire contre l'atmosphère rigide et militariste de l'école », Gernreich a passé des heures à dessiner des esquisses pour la haute société viennoise et à apprendre tout ce qu'il pouvait sur les tissus. A l'âge de douze ans, ses dessins de mode attirèrent l'attention du styliste autrichien Ladislaus Zcettel qui partait pour Londres où il devait dessiner les costumes d'un film d'Alexandre Korda. (Zcettel immigra plus tard en Amérique pour diriger l'atelier de couture d'Henri Bendel à New York). Il proposa à Gernreich de le suivre à Londres comme assistant, mais sa mère refusa, estimant qu'il était trop jeune pour quitter son foyer. (Siegmund Gernreich, le père de Rudi, un fabricant de bonneterie, s'était suicidé en 1930 alors que son fils était âgé de huit ans.)

En 1938, exactement six mois après l'Anschluss du 13 mars, le jeune Gernreich alors âgé de seize ans et sa mère se joignirent au flot de réfugiés juifs qui fuyaient l'Autriche et s'installèrent en Californie. Son premier travail aux USA consista à travailler dans une morgue. Gernreich évoquait cet épisode en ces termes : « Je suis devenu adulte du jour au lendemain. Entouré par tous ces corps morts. Finalement, je me suis habitué aux cadavres. Mais je souris parfois quand les gens me disent que mes vêtements sont si ›intelligents‹ que je dois avoir étudié l'anatomie. Vous parlez si j'ai étudié l'anatomie ! »

En tant qu'étudiant en arts plastiques au Los Angeles City College, Gernreich était géographiquement proche d'Hollywood. Mais bien qu'il ait travaillé dans le service publicitaire des Studios RKO et ait un jour remplacé un ami qui assistait la dessinatrice de costumes Edith Head, il n'a pas fait carrière dans le stylisme de costumes de cinéma, tout en ayant passé sa vie à proximité de cet univers.

Après avoir assisté à un spectacle de ballets donné par la Modern Dance Company de Martha Graham, Gernreich abandonna l'art et les studios de cinéma en faveur de la danse et du théâtre. C'est en étudiant avec le chorégraphe Lester Horton, qu'il décrit comme « une sorte de Martha Graham de la côte Ouest », qu'il finit par moins s'intéresser aux aspects statiques des vêtements et davantage à leur allure en mouvement.

Au milieu des années quarante, Gernreich arrondissait ses fins de mois de danseur en dessinant des tissus pour la Hoffman California Fabrics. Comprenant qu'il ne deviendrait jamais un second Lester Horton, il quitta la troupe en 1949, gagna New York et trouva un travail chez un fabri-

cant de costumes et de manteaux du nom de George Carmel. Voici comment Gernreich décrit l'atmosphère de la mode à cette époque : « Tous ceux qui avaient un certain talent – stylistes, détaillants, journalistes – étaient mus par une grande admiration et une loyauté inconditionnelle pour Paris. Christian Dior, Jacques Fath, Cristobal Balenciaga étaient des dieux. Il n'était pas question de dévier de l'image féminine qu'ils imposaient. Une fois qu'ils avaient opté pour une ligne d'épaule basse, un styliste américain n'avait plus le droit de proposer une manche rapportée. Une fois qu'ils avaient décidé d'une longueur de robe vous ne pouviez vous en écarter d'un centimètre. La septième avenue vivait de leurs dessins. Je débordais d'idées originales, mais elles étaient toujours rejetées parce qu'elles ne cadraient pas avec les normes françaises. Après environ six mois, je me mis à vomir chaque fois que je pensais à l'autoritarisme de ce système. Je créais des versions horribles des modèles de Dior. On finit par me mettre à la porte. »

En 1951, grâce au célèbre dessinateur de costumes Jean Louis, « le seul styliste à m'avoir aidé en m'écrivant des lettres d'introduction », Gernreich obtint un rendez-vous avec la styliste new-yorkaise Hattie Carnegie, qui lui conseilla de rentrer en Californie, de faire quelques échantillons et de les lui envoyer. Il s'exécuta et elle répondit en lui envoyant des chèques « pas d'autre communication, juste des chèques … de temps en temps je reconnaissais un de mes cols ou une de mes poches sur ses modèles. »

Plus tard au cours de cette même année, Gernreich fut engagé chez Morris Nagel Versatogs « Une boîte ringarde avec un nom ringard ». Quand il se rendit à New York pour présenter sa collection à Marjorie Griswold de chez Lord and Taylor's, elle lui répondit que ses modèles n'étaient pas pour elle. Gernreich fut d'autant plus contrarié que c'était ce magasin qui avait lancé la mode américaine (l'idole de Gernreich, Claire McCardell, ainsi que Vera Maxwell et Clare Potter ont toutes été «découvertes» par Lord & Taylor's) et sa présidente, Dorothy Shaver, fut la première à briser la loi non écrite selon laquelle toute mode devait être française.

L'aspect réussi de ce voyage fut la première rencontre de Gernreich avec Diana Vreeland, alors responsable des pages mode de *Harper's Bazaar*. «Je suis allé la voir avec une simple valise d'échantillons. Je me rappelle m'être trompé d'étage ; une charmante petite hôtesse m'a raccompagné au bon étage et au bon bureau où la journaliste m'a demandé avec ce dédain particulièrement instinctif aux gens de la mode :‹Que voulez-vous ?›. Quand je lui dis que j'étais un styliste californien, elle me demanda de lui montrer ce que j'avais dans ma valise. Je lui répondis que j'avais besoin d'un mannequin. Elle me dit qu'elle connaissait les vêtements et qu'elle n'avait absolument pas besoin d'un mannequin. Je lui répondis que je ne lui montrerais rien sans mannequin. Nous étions dans une impasse et j'ai finalement ouvert ma valise et sorti une ou deux choses. Elle s'est éclipsée et à peine une seconde plus tard, m'a-t-il semblé, est revenue en me disant que Madame Vreeland aimerait me voir.

Ses premiers mots ont été : ‹Qui êtes-vous, jeune homme ? Vous êtes très doué›. Je lui ai parlé de moi, lui ai brièvement montré mes modèles et elle m'a demandé de l'appeler si jamais j'avais besoin d'un travail à New York. »

Quand Gernreich fut rentré en Californie, Morris Nagel décida que ses modèles de Gernreich étaient trop en avance et lui demanda de dessiner une ligne de vêtements faciles à porter et à vendre, comme ceux qui avait fait la réputation de la marque depuis toujours. Gernreich s'en alla.

En juillet 1950, alors qu'il assistait à une répétition au studio de danse de Horton, Gernreich rencontra Harry Hay, fondateur de la Mattachine Society, précurseur dans les années cinquante de l'actuel mouvement gay. De 1950 à 1952, Gernreich et Hay furent et Gernreich devint l'un des sept membres fondateurs de la Mattachine. Lui et les autres fondateurs démissionnèrent de la société en 1953 après un désaccord idéologique. Conformément au secret jurés par les membres de la Mattachine, Hay ne révéla jamais que Gernreich appartenait à cette société, jusqu'à la mort de ce dernier en 1985. Depuis, des photos montrant Gernreich, Hay et d'autres fondateurs sont

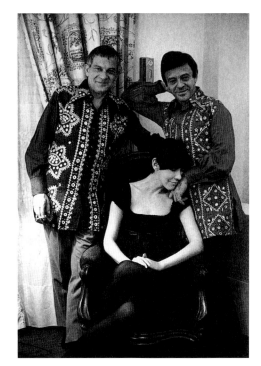

Avec Oreste Pucciani, Noël, New York, 1969

parues dans l'ouvrage de Stuart Timmon : *The trouble with Harry Hay, Founder of the Modern gay Movement*.

Que l'homme qui a bousculé tant de conventions avec ses vêtements révolutionnaires ne se soit jamais déclaré ouvertement homosexuel en dit long sur Gernreich et son époque. En ce temps, l'homosexualité était illégale et Gernreich lui-même s'était fait arrêter avant de rejoindre les Mattachines. Oreste Pucciani, le compagnon de Gernreich pendant trente et un ans se souvient : « Rudi m'a qu'il avait été stupéfait quand le verdict de culpabilité avait été prononcé. Il avait insisté pour plaider innocent et avait demandé à être jugé par un jury. Il me raconta qu'il avait regardé chacun des jurés en face ; une femme qui lui avait semblé compatir, un peu avant, et sur le soutien de laquelle Rudi croyait pouvoir compter se tourna vers le mur pour éviter son regard. »

Peggy Moffitt, le mannequin-muse de Gernreich explique qu'ils «parlaient beaucoup de sexualité. Ses vêtements parlaient de sexualité. Il me raconta avoir appartenu à la Mattachine Society, mais pas comme s'il me révélait un grand secret. Il me disait souvent qu'il avait l'impression que la sexualité de quelqu'un était perceptible et qu'il n'y avait aucun moyen de la cacher. J'ai connu beaucoup d'homosexuels qui ne pouvaient s'empêcher de souligner leur homosexualité, de s'emparer de la moindre occasion de la clamer. Ce n'était pas le genre de Rudi. Je pense qu'il n'a jamais éprouvé le besoin de se déclarer ouvertement parce qu'il avait l'impression que sa sexualité allait de soi. Il n'aurait pas convoqué une conférence de presse pour évoquer sa sexualité pas plus qu'il n'en aurait convoqué une pour parler de ses yeux bruns. »

Pucciani explique ainsi la répugnance de Gernreich à « sortir » de l'anonymat : «Révéler votre sexualité est une chose. Etre contraint de le faire en est une autre. Rudi ne s'est jamais déclaré officiellement, il n'en a jamais éprouvé le besoin. Jusqu'à ma retraite de l'Université de Californie (Los Angeles) en 1979, je me suis tenu au principe consistant à ne jamais le déclarer et à ne jamais le nier. Les gens intelligents le comprenaient à ma façon de vivre. Après ma retraite de l'UCLA, j'ai accepté d'être interviewé par le journal gay de l'université. Rudi a appris que j'avais donné cette interview et un matin au petit déjeuner, je lui ai demandé ce qu'il en pensait. Il me répondit qu'il trouvait que c'était une bonne interview, mais : ‹Pourquoi les as-tu laissés faire ça ?› Je lui ai dit qu'après tout j'étais à la retraite, alors pourquoi pas – Que pouvait-il arriver ? Alors il m'a demandé pourquoi j'avais attendu et je lui ai dit que c'était simple, que personne ne me l'avait jamais demandé. Quand j'ai demandé à Rudi pourquoi il ne s'était jamais déclaré ouvertement, il m'a dit avec ce ton de voix particulier qu'il adoptait toujours

quand il plaisantait : ‹C'est très simple, c'est mauvais pour les affaires.›

Après sa mort, j'ai estimé que je devais respecter son point de vue. La solution est venue d'elle-même quand l'Union américaine pour les libertés civiques a annoncé que la succession de Rudi Gernreich et Oreste Pucciani avait créé une fondation qui devait intervenir dans les actions en justice mettant en cause les homosexuels et promouvoir une meilleure éducation dans le domaine des droits des gays et des lesbiennes. Tel fut donc le ‹déballage› posthume de Rudi. »

Au début des années cinquante, la carrière de Gernreich ne se déroulait pas aussi bien qu'il l'avait escompté. Après un travail temporaire chez « Matthews », une boutique de Beverly Hills, il rencontra en 1952 Walter Bass, rencontre qui fut à l'origine d'une collaboration de huit ans.

« Il n'y avait aucune autre possibilité pour moi, à ce moment-là », disait Gernreich en évoquant cette période. « J'allais de déconvenue en déconvenue. Et puis Walter est arrivé et, je ne sais comment, bien que nous ne soyons jamais entendus et que j'aie su que notre association était vouée à l'échec, les choses ont vraiment démarré. » Ce fut en effet le début du succès. Grâce à Jimmy Mitchell, son premier mannequin d'essayage, Gernreich entendit parler de Jack Hanson et de sa petite boutique JAX. « Je me souviens avoir expliqué à Jimmy Mitchell que je devais avoir un grand magasin, un Saks ou un I. Magnin parmi mes clients pour pouvoir décoller notre collection, mais elle a insisté. Nous nous sommes rencontrés tous les trois, Jimmy et moi lui avons montré la collection, surtout des formes amples, des robes étroitement ceinturées à la taille dans des tissus vichy et des tweeds de coton, et sa réaction a été instantanée. J'ai livré personnellement la première commande et en une heure tout était parti. »

Encouragé par son succès, Gernreich emporta la collection à New York. « Walter ne voulait pas avancer l'argent du voyage alors j'ai dit que je me le paierais moi-même et ça a marché. » Sally Kirkland, responsable de la rubrique mode du magazine *Life* persuada Gernreich de tenter à nouveau sa chance avec Marjorie Griswold de chez Lord & Taylor's. « Cette fois elle fut enthousiaste et elle déclara qu'elle voulait la collection. A un moment elle m'a demandé si nous ne nous étions pas rencontrés auparavant. Je n'ai pas pu lui dire la vérité, alors j'ai dit non. Des années plus tard, je lui ai raconté l'histoire de notre première rencontre. Et ça nous a amusés tous les deux. »

Après un an de travail et vu les commandes rapides et répétées des boutiques, Bass demanda à Gernreich de signer un contrat de sept ans. « Quand je l'ai vu, je me suis presque évanoui. Notre association avait déjà porté ses fruits, mais le contrat était très désavantageux pour moi. J'étais terriblement contrarié par la façon dont l'avocat de Walter me traitait et je me suis vanté de devenir un jour beaucoup plus important que Mainbocher. J'étais extrêmement arrogant à l'époque et j'avais une inébranlable confiance en moi, mais elle a été momentanément prise en défaut. ‹Quand tu seras plus important que Mainbocher, nous renégocierons›, me lança Walter et j'ai signé. »

En mars 1952, Gernreich créa le prototype du premier maillot de bain sans armature en jersey de laine avec une emmanchure débardeur. Cette création lui valut sa première récompense de styliste, le prix du vêtement de sport américain, décerné en 1956 par *Sports Illustrated*. Gernreich devait passer l'essentiel des années cinquante à libérer le corps féminin des vêtements qui l'enserraient. Sa robe tubulaire en tricot de 1953, qui lui valut sa première publication dans un magazine (*Glamour*, février 1953), préfigurait les minirobes stretch de la fin des années quatre-vingt et quatre-vingt-dix. La tenue qui lui a valu sa première publication dans *Life*, en avril 1953, peut être considérée comme l'ancêtre des vêtements pop/op des années soixante. Elle se composait d'une tunique en feutre noir sanglée à la taille sur un pantalon à carreaux rouge, orange et jaune. Elle était portée par Lauren Bacall. Bien que Gernreich ait dessiné ses premiers maillots de bain pour Bass, ceux qui devaient le rendre célèbre furent réalisés pour la Westwood Knitting Mills, la société avec laquelle il a travaillé à partir de mars 1955. De 1955 à 1960, il y eut donc deux lignes Gernreich : une ligne de vêtements de sport pour Bass et une ligne de maillots de bain pour la Westwood.

Dans les années cinquante, un styliste pouvait être lancé par des magazines, comme *Harper's Bazaar*, *Vogue*, *Mademoiselle*, *Glamour*, *Charm*, *Life*, *Look* et *Sports Illustrated*. Le message était clair : obtenez l'éditorial d'abord et les boutiques et les clients suivront.

Gernreich a très tôt et très bien compris ce principe, si bien que Jack Hanson, qui lui avait passé sa première grosse commande pour JAX et qui plus tard annula toutes ses commandes à cause d'un litige sur l'exclusivité de la diffusion, surnomma Gernreich « un chien de publicité ».

Pour la Westwood, Gernreich a réalisé des maillots en maille stretch qui épousaient la ligne du corps au lieu de la comprimer. Quand la rédactrice en chef de *Harper's Bazaar*, Diana Vreeland, les vit, elle envoya ce télégramme à Gernreich : « Je ne puis vous dire à quel point ils sont joliment réalisés, joliment conçus et combien nous les adorons. Nous espérons, si nous parvenons à nous arranger, leur donner la meilleure place possible. »

Un des premiers maillots en jersey, un modèle à décolleté profond en V, garni de cinq boutons, fut décliné par Gernreich jusqu'en 1959. Les acheteuses le connurent d'abord sous le nom de *Style numéro 6001*, puis sous celui de *Style 601*. En 1969 ce maillot fut copié par un styliste qui devait obtenir un prix Coty. Commentaire de Gernreich : « Quand un industriel produit une version d'un modèle que j'ai conçu, c'est très bien. C'est toujours une confirmation. Quand un styliste connu me pique un de mes maillots les plus connus, c'est scandaleux. »

Le *Style 601* a réapparu à maintes reprises jusque dans les années quatre-vingt-dix chez différents stylistes, réitérant la preuve du talent de Gernreich et de la longévité de ses dessins.

Celui-ci a encore élargi son champ esthétique en dessinant les costumes de Sarah Churchill pour la pièce *No Time for Comedy*, et en juin 1956, quand il présenta ses premiers modèles masculins. Ces « vestes de serveurs chinois » avaient été dessinées à l'origine pour les employés du restaurant chinois préféré de Gernreich, qui se trouvait dans le quartier chinois de Los Angeles *General Lee's Man Jen Low*. Quand les convives ont commencé à essayer de convaincre les serveurs de leur céder leurs vestes, Gernreich décida de les décliner comme vestes de plage, autocoats et vestes-chemises d'intérieur. *Life* a dévoilé ces modèles dans son numéro du 6 août 1956.

En 1957 la gamme des créations de Gernreich se diversifie encore avec la collection de chaussures qu'il réalise pour la General Shoe Co. *Vogue* a montré son escarpin en veau noir à bride en T avec faveur en satin assortie dans son numéro du 1er février 1957.

En 1958 et 1959 – les deux dernières années de collaboration avec Bass – Gernreich créa de plus en plus d'accessoires et comprit que la mode ne se limitait pas aux vêtements. Voici un extrait d'une invitation de mai 1958 conviant ses acheteurs à venir voir sa collection automne-hiver :

« Ce qui arrive aujourd'hui est très curieux : pas de taille, tailles hautes, tailles basses, silhouettes minces, silhouettes généreuses, robes droites, robes-trapèzes, et toutes ces tendances sont bonnes. Le changement important ne réside pas dans la silhouette mais dans l'attitude. On a enregistré plus de transformations importantes dans l'expression d'un visage, dans la position de la jambe et du pied l'an dernier que dans la forme des robes. L'accent porte sur la tête et la jambe, ce qui fait de la robe un accessoire. C'est pourquoi, pour stimuler et renforcer la conscience de cette attitude, j'ai éprouvé la nécessité de compléter mon image en ajoutant des chapeaux ainsi que des chaussures à mes modèles. »

Parmi les premiers chapeaux figuraient des chapeaux de marin en tissus écossais, des chapeaux mous à bords flottants, des feutres mous et un chapeau cloche incrusté de strass assorti à une paire d'escarpins confectionnés dans le même tissu scintillant. Des bas vinrent s'ajouter à cet ensemble en 1959, les premiers bas en nylon à rayures et carreaux.

Durant cette période, le seul autre styliste de mode à ôter autant de détails superflus à éliminer autant de doublures, à alléger autant d'étoffes et à recourir à des couleurs aussi vives, fut l'italien Emilio Pucci.

En 1964, Gernreich mentionna Pucci comme l'une des raisons qui l'avait poussé à introduire le *topless swimsuit*.

La veille de la présentation de sa collection automne-hiver 1963, Pucci déclarait dans le *New York Herald Tribune* : « Dans dix ans, les femmes auront complètement supprimé le haut du maillot de bain. » Gernreich, qui avait quant à lui prédit un délai de cinq ans, décida de ne pas laisser Pucci le devancer dans la surenchère.

Bien que Gernreich ait connu son heure de gloire dans la mode durant les années soixante, il déclara dans une interview de 1972 qu'il ne pouvait nullement évoquer avec fierté cette période de sa carrière :

« Ce qui me consterne aujourd'hui c'est mon engagement total dans quelque chose d'aussi futile. Je trouve difficile à croire que j'aie pu élaborer des collections autour d'Ophélie, de George Sand, de clowns, de cowboys, de danseurs Kabuki, de bonnes sœurs, de gangsters, d'officiers de cavalerie autrichiens et d'opéras chinois. Tous ces thèmes de fantaisie me sont aujourd'hui insupportables.

Même chose pour les modèles de 1971, quand je croyais faire acte de réalisme en accessoirisant les vêtements avec des revolvers et des plaques d'identité. La journaliste Eleanor Lambert me rabroua en ces termes : ‹Ne confondez-vous pas mode et comédie en habillant vos modèles comme des soldats ?› En un sens, elle avait raison. »

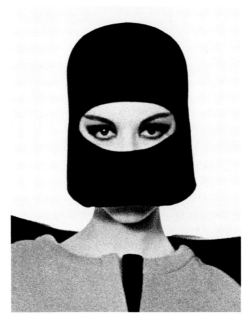

Chapeau « Yashmak », 1964

Moffitt considère les rétractations tardives de Gernreich comme totalement inutiles : « Sa tenue Ophelia était en fait une très jolie robe de mousseline. Sa tenue George Sand, un tailleur pantalon très seyant. Toutes ces idées étaient avant tout des idées de styliste. Vous pouviez très bien les porter en oubliant le thème de fantaisie. »

Gernreich commença les années soixante par une rupture de son association de huit ans avec Bass d'une part et les Westwood Knitting Mills d'autre part. En août 1960, deux mois seulement après avoir appris qu'il avait reçu le prix spécial Coty pour sa ligne de maillots de bain, Gernreich annonça que la collection qu'il réalisait jusque-là pour Bass serait désormais produite à Los Angeles sous sa propre marque, G. R. designs, Inc., et que la maille serait fabriquée à Marinette, dans le Wisconsin, par Harmon Knitwear, Inc., propriété de Harmon Juster qui avait appartenu à la Westwood.

En 1960 et 1961, Gernreich ouvrit la voie à la mode pop et op. Alors que Jackie Kennedy, encore *First Lady*, faisait de la toque une coiffure nationale et escortait ses visiteurs dans la Maison Blanche en escarpins et tenue minimaliste composée d'un chemisier à col montant et d'une jupe près du corps, Gernreich allégeait et dénudait toujours plus. Le numéro de *Vogue* du 1er janvier 1961 montrait la robe-maillot de bain de Gernreich échancrée sur les côtés, laquelle dérivait d'un maillot de bain de Gernreich qui était identique – sauf pour la jupe.

Il a aussi révolutionné les harmonies de couleurs par ses combinaisons choquantes de rose et d'orange, de bleu et de vert, de rouge et de violet. Il a renouvelé les

normes esthétiques en faisant cohabiter des carreaux avec des pois et des rayures avec des diagonales. Et il a bousculé les conventions textiles en imposant le vinyle sur la plage et les vêtements en tapisserie espagnole.

Bien que Gernreich lui-même ait décrit le phénomène de la mini comme un raccourcissement progressif, il a dénudé les genoux dès 1961. Voici ce qu'en disait le numéro du *New York Times* du 2 juin de cette année : « Rudi Gernreich, le produit le plus exporté de Californie après les oranges, se déchaîne. Il découvre les rotules (à dessein), les jupes tourbillonnent et ondulent, les vêtements tombent librement, ne touchant le corps qu'au niveau de la poitrine. »

En juin 1962, Gernreich se voit décerner un autre prix de stylisme, cette fois de Woolknit Associates pour ses « silhouettes innovatrices et son travail sur le tissu dans les robes en maille. » Le « look petit garçon » fut l'un de ses thèmes majeurs cette année-là avec les fourreaux réversibles, les chandails à emmanchure basse, les robes-chemises droites à manches longues, les tailleurs du soir en étoffe chatoyante et transparente comme de la cellophane et les robes frangées de plumes.

Le rôle de critique social de Gernreich commença à s'affirmer dès 1963. Il déclarait ainsi dans le *New York Times* du 22 mai de cette année :

« Il y a un mauvais goût typique de cette région de Californie du Sud qui est extrêmement agressif. Les pantalons de femme trop serrés. Les sacs en vannerie tressée décorés. Les lunettes serties de pierres précieuses. Les cardigans en cachemire à col de vison. Les mules en vinyle avec des dorures. Vous voyez, le côté bastringue. L'aspect positif c'est que les gens d'aujourd'hui portent beaucoup plus de couleurs qu'autrefois, grâce à la Californie et à l'Italie. Il y a seulement quelques années, une New-Yorkaise n'aurait pour rien au monde porté une robe orange. Les acheteurs de l'Est et du Middle West s'enfuyaient en voyant mes combinaisons de jaune et de rose criard. Aujourd'hui ils les réclament. »

L'année 1963 est celle où le mot « kooky » (dingue, cinglé) est entré dans le vocabulaire. C'est l'année des fourrures pop comme le cuir de cheval. L'année des smocks petite fille, du retour au style Garbo et des ensembles safari. C'est aussi l'année où Gernreich a remporté deux autres prix importants, celui de *Sports Illustrated* en mai et le prix Coty des critiques de mode en juin. Cette dernière distinction provoqua un des plus formidables grabuges qu'a connu la mode américaine.

En manière de protestation contre la victoire de Gernreich, Norman Norell renvoya son prix Coty, en expliquant au magazine *Women's Wear Daily* (27 juin 1963) « Il ne veut plus rien dire pour moi. Je ne peux plus supporter de le regarder. J'ai vu une photo d'un tailleur de Rudi, l'un des revers était un revers type-châle et l'autre était cranté. C'est tout dire ! »

Le lendemain, il renchérit en déclarant au *New York Herald Tribune* : « Les trop nombreux membres du jury venant de *Glamour* et de *Seventeen* – qui ne se déplacent pas pour voir les collections de haute couture – sont à l'origine de l'élection de Gernreich. »

Bonwitt Teller riposta en s'offrant une demi-page de pub qui portait en gros titre : « Rudi Gernreich, on devrait vous donner le prix Coty une nouvelle fois ! »

Lors de la présentation du prix Coty, où les stylistes primés montrent traditionnellement des vêtements de la collection qui leur a valu le prix ainsi que des résumés de leurs lignes actuelles, Gernreich causa encore un certain émoi avec un tailleur pantalon en satin blanc qu'il appela son costume Marlène Dietrich. Quand Moffitt le porta pendant la répétition, des membres du jury Coty lui déclarèrent qu'elle ressemblait à une lesbienne et demandèrent à Gernreich de ne pas le présenter. Il accéda à cette demande à contrecœur. L'année suivante, un costume similaire en satin blanc luisant fut présenté par le gagnant du prix Coty de cette année-là sans que personne ne trouve rien à y redire. Comme Moffitt le souligne : « La coiffure toute en hauteur et les hauts talons avaient rendu la tenue acceptable un an plus tard. »

L'apparition du *topless swimsuit*, en 1964, occasionna un chahut qui devait littéralement tourner à l'incident international. Le 12 septembre 1962, Gernreich avait prédit à Sylvia Shepard, une journaliste du *Women's Wear Daily*

que « les poitrines allaient s'exhiber d'ici à cinq ans ». Il répéta cette prédiction dans le numéro du 24 décembre 1962 de *Sports Illustrated*. Voici le récit par Gernreich des événements qui ont suivi : « En 1964, j'étais allé si loin avec les échancrures de maillots de bain que j'ai décidé que le corps lui-même, y compris les seins, pouvait devenir partie intégrante du dessin du maillot.

A cette époque, les poitrines devenaient plus volumineuses sinon physiquement du moins symboliquement et surtout sociologiquement. Elles étaient presque des objets de plaisanterie. Toutes les filles que je connaissais étaient scandalisées par l'attitude de vilain garnement qu'adoptaient les mâles américains envers les poitrines américaines. Pour moi, les poitrines vraiment belles appartenaient à des corps vraiment jeunes. Dénuder ces poitrines me paraissait logique dans une période de libération des attitudes et des esprits, d'émancipation des femmes.

J'étais conscient que pour la plupart des gens un tel acte paraîtrait choquant et immoral, mais je ne pouvais m'empêcher de refuser l'hypocrisie implicite qui faisait que ce qui était immoral dans une culture était parfaitement acceptable dans une autre. La poitrine était devenue un symbole sexuel, non pas à cause d'un vœu immuable de la nature mais parce que nous en avions fait un objet sexuel.

Après mes déclarations au *Women's Wear Daily* et les gros titres de *Sports Illustrated*, les gens ont commencé à me demander si je pensais vraiment ce que je disais. Plus ils me le demandaient, plus je sentais que mon idée était juste. Vers la fin de 1963, Susanne Kirtland, du magazine *Look*, m'a appelé pour me dire qu'elle allait écrire un papier sur les tendances futuristes et qu'elle voulait que je lui fasse un maillot sans haut. J'ai refusé en lui disant que ce n'était pas le moment. Elle m'a répondu : ‹ Oh, mais il le faut, j'ai déjà obtenu le feu vert de la direction ! ›

Au début, j'ai pensé que si je ne le faisais pas, elle demanderait à Emilio Pucci ou à quelqu'un d'autre parce qu'elle semblait très résolue à l'obtenir. J'ai pensé que ce serait terrible si quelqu'un d'autre faisait de ma prédiction une réalité. Je ne voulais pas me faire devancer.

Je savais que ce coup pouvait détruire ma carrière, me mettre définitivement hors jeu, mais ma conviction qu'il s'agissait d'un concept juste et ma peur d'être dépassé par quelqu'un d'autre m'ont poussé à accepter. Je trouvais que c'était un peu prématuré, mais comme ça allait arriver dans les deux ans à venir, j'avais déjà intégré et rationalisé cette échéance.

Le premier maillot que j'ai envoyé était un sarong balinais qui s'arrêtait juste sous les seins. Susanne m'a dit qu'elle ne le trouvait pas assez fort, qu'il fallait une proposition audacieuse, presque comme un point d'exclamation. Bien que, selon moi, ce maillot dût se réduire à un bas de bikini, cette idée n'aurait représenté qu'une déclinaison d'un concept antérieur, pas un nouveau concept. C'est pourquoi j'ai créé le maillot à bretelles qui est entré dans l'histoire plus tard et dont une photo de dos est parue dans *Look*, le 2 juin 1964. Ce maillot a été photographié aux Bahamas sur une prostituée.

Pour tâcher d'éviter tout sensationnalisme, le photographe William Claxton (le mari de Peggy), Peggy et moi avons décidé de prendre nos propres photos de Peggy dans ce maillot et de les présenter aux journalistes de mode et aux magazines d'actualité. Nous sommes tombés d'accord pour éviter *Playboy* et les magazines de filles nues.

A notre complète stupéfaction, toutes les personnalités du monde de la mode ont été paniquées par ce modèle. Ni Sally Kirkland de *Life*, ni Nancy White de *Harper's Bazaar*, ni personne ne voulait entendre parler de ce maillot ou des photos. Finalement Carol Bjorkman de *Women's Wear Daily* a fait passer la photo de face de Peggy dans le numéro du 3 juin et *Newsweek* a publié une photo de dos le 8 juin.

Je n'avais pas l'intention de faire fabriquer ce maillot pour le grand public, jusqu'au moment où j'en ai parlé à Diana Vreeland de *Vogue*. C'est la seule rédactrice en chef à qui j'ai personnellement montré le maillot. Peggy m'accompagnait et elle portait ce maillot sous un petit kimono japonais qu'elle avait acheté quelque part sur Hollywood Boulevard. Je crois qu'elle avait dû le payer huit dollars. Quand Madame Vreeland a demandé à voir le maillot, Peggy est apparue dans son kimono, l'a ôté et

a présenté le maillot. Il y a eu un silence de mort. Absolument aucune réaction. Je n'ai fait aucun commentaire. Comme Peggy posait la main sur la porte pour sortir, Diana Vreeland s'est exclamée de cette voix inoubliable « Mèèèèèèèrveilleux kimono ! » Quelques minutes plus tard elle m'a demandé de lui parler du maillot et m'a demandé pourquoi je l'avais fait.

Je lui ai répondu que j'avais l'impression que l'heure de la liberté avait sonné aussi bien dans le domaine de la mode que pour tous les aspects de la vie. Quand elle m'a demandé si j'allais le fabriquer pour le public, je lui ai dit que non, que c'était juste une proposition.

‹ C'est là que vous faites une erreur › m'a-t-elle dit. ‹ S'il paraît une photo du maillot, c'est un événement d'actualité. Vous devez le faire. ›

Quand je suis rentré à l'hôtel, j'avais déjà reçu des appels d'Harmon qui me disait que des magasins voulaient acheter le maillot. Nous nous sommes mis d'accord pour le faire fabriquer. Finalement, tous les plus grands magasins du pays l'ont vendu ou l'avaient commandé et n'ont

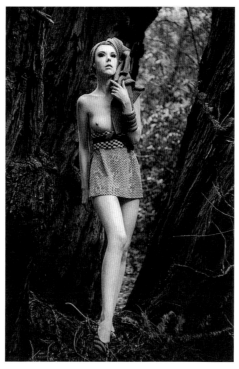

Première création topless, Big Sur, 1964

pu le vendre parce que les PDG des magasins situés dans les états les plus conservateurs ont protesté.

Melvin Dawley, de Lord & Taylor's est l'un de ceux qui ont bloqué la diffusion du maillot. Je me souviens d'une boutique, Splendifero*us*, qui a « hérité » de la livraison qui leur était destinée. Des gens ont manifesté devant Hess Brothers, à Allentown, en Pennsylvanie et on a menacé de poser une bombe chez Milgrim's, à Detroit. »

Le *topless swimsuit* est devenu un événement dont les répercussions sont restées sans égales dans l'histoire de la mode américaine.

Voici ce qu'en disait le *New York Times* du 22 juin 1964 : « Le journal gouvernemental soviétique *Izvestia* a rendu compte de l'apparition de ce nouveau maillot de bain et ajouté que la mode américaine spéculait sur d'éventuelles robes du soir *topless*. » Le mode de vie américain favorise tout ce qui permet de fouler aux pieds la morale et les intérêts de la société pour le plus grand bien de l'ego. La décadence de la société du porte-monnaie continue. »

Los Angeles Herald Examiner, 14 juillet 1964 : « Le maillot a été agréé par les autorités en Suède, en Allemagne et en Autriche. Il est interdit en Hollande, au Danemark et en Grèce. »

New York Times, 2 juillet 1964 : « Pendant un bref moment, les maires de la Côte d'Azur ont eu l'occasion de se dresser et de s'affirmer comme des hommes qui luttaient pour préserver un mode de vie normal et décent. Les femmes ont été averties que même si elles ôtaient le haut de leur bikini, il y aurait des répercussions

légales. C'est le maire de Saint-Tropez qui s'est signalé par l'attitude la plus indignée. Il aurait déclaré qu'en cas de troubles avérés à l'ordre public, il aurait recours aux hélicoptères pour patrouiller au-dessus des plages et repérer les contrevenants. »

Saturday Evening Post, 31 octobre 1964 : « Des ennemis aussi naturels que *Izvestia*, l'*Osservatore Romano* et la Mission baptiste de Dallas sont tombés d'accord au nom des Ecritures Saintes et de Karl Marx pour décréter que le *topless swimsuit* était immoral et antisocial. »

New York Herald Tribune, 16 novembre 1964 : « L'Italie n'a pas réagi après l'interdiction du *topless swimsuit* par le pape. »

Sur les trois mille femmes qui achetèrent le maillot, au moins deux le portèrent en public. Carol Doda, une entraîneuse de San Francisco (proportions : 99/66/91) a porté le sien au Condor Club, dans le cadre de son activité professionnelle. (Le magazine *Playboy* a mentionné son apparition dans son numéro d'avril 1965). Toni Lee Shelley, dix-neuf ans, a été emmenée au poste par un policier de Chicago pour avoir porté le *topless swimsuit* à la plage. Elle a été inculpée de « port de vêtement inapproprié pour la baignade ». Après la lecture de l'acte d'accusation elle a demandé que le jury soit composé exclusivement d'hommes.

Moffitt décrit la sensation qu'elle a éprouvée quand elle a posé en *topless swimsuit* : « Quand Rudi m'a expliqué qu'il avait accepté de créer le maillot pour *Look*, je lui ai demandé qui il allait choisir pour le présenter. Il m'a répondu : ‹ Toi › et j'ai répliqué : ‹ Ah, Ah, Ah ! › Plus tard, parce que je comprenais l'importance d'une dramatisation dans la lutte pour une totale liberté d'expression, j'ai accepté de poser pour les photos qu'a prises mon mari, mais j'ai expliqué à Rudi qu'il y aurait quelques règles. Bill, Rudi et moi nous sommes mis d'accord pour que je ne porte jamais le maillot en public, que cela ne ferait qu'accroître le caractère sensationnel de toute cette affaire. J'ai aussi refusé de poser pour tout autre photographe.

Bill a d'abord apporté ces photos de moi au magazine *Life*. Ils lui ont dit qu'ils ne pouvaient les publier parce que *Life* ‹ est un magazine familial et que les photos de seins nus ne sont autorisées que si la femme est une aborigène. ›

Vu qu'ils avaient mis les pieds dans le plat en présentant la nouvelle comme un événement d'actualité – et à cette époque c'en était un –, ils nous ont demandé à Rudi, Bill et moi si nous pouvions les aider à présenter cette histoire sous l'angle d'une analyse de la poitrine dans l'histoire de la mode. Si bien que nous avons repris la photo spécialement pour *Life* et j'ai placé mes bras devant mes seins sur leur demande expresse.

La photo de moi dans ce numéro – cachant mes seins avec mes bras – est scabreuse. Si vous portez un vêtement qui ne comporte pas de haut parce qu'il a été conçu comme ça et tenez vos mains devant vos seins, vous ne faites que renforcer l'ambiance prude et grivoise, comme une *bunny* de *Playboy*.

La photo du *Women's Wear Daily*, que je trouve belle, a vraiment frappé Madison Avenue. Si les seins cessent d'être considérés comme un symbole sexuel, ce qui arrive à partir du moment où vous les découvrez – comment continuer à en plaisanter dans la publicité ? Comment arriver à vendre de la pâte dentifrice ? »

Claxton a montré plus tard ces photos du *topless swimsuit* à *Paris-Match*. Il se souvient : « Ils ont dit à peu près la même chose que *Life* – *Paris-Match* était un magazine familial et ne pouvait montrer des seins nus en couverture. J'ai toujours trouvé étrange que la photo de couverture du numéro de la semaine ait montré une famille complètement mutilée dans un accident de voiture. »

La controverse sur le *topless swimsuit* a continué à faire rage jusqu'en 1985, après la mort de Gernreich, quand le Los Angeles Fashion Group a programmé sa rétrospective Gernreich « Regard rétrospectif sur un futuriste. » Moffitt a menacé de démissionner de son poste de directeur artistique de l'exposition si le *topless swimsuit* était présenté sur scène au Wiltern Theatre. Elle a déclaré au *Los Angeles Times* (2 août 1985) : « Pour Rudi, ce maillot traduisait une pensée sur la société. C'était une exagération qui parlait de la libération des femmes. Ça n'avait rien à voir avec une exhibition et à la minute où quelqu'un le

porte pour exhiber son corps, c'est le principe même de ce projet qui est né. Je l'ai porté en tant que mannequin pour une photographie qui a fini par faire le tour du monde parce que je croyais à cette proposition sociale; et aussi parce que nous trois – Rudi, Bill et moi – avions l'impression que cette photo traduisait exactement la pensée de Rudi. *Playboy* m'a offert 17 000 dollars en 1964 pour publier cette photo de moi en *topless swimsuit*. J'ai refusé, c'était impensable pour moi. Et je ne veux pas exploiter les femmes. L'idée originale n'a pas changé. Ce maillot parle toujours de liberté et pas d'exhibition. »

Sara Worman, alors vice-présidente de Robinson's et directrice régionale du Fashion Group, expliqua au *Los Angeles Times* : « Je ne peux pas le croire : on se retrouve à nouveau en 1964. Je suis d'accord pour dire que le maillot était une proposition sociale – la plus prophétique jamais formulée par un styliste dans le monde. Ce fut son concept le plus brillant et à partir de là sont sorties toutes sortes de choses que nous tenons à présent pour acquises. Pourquoi prendre la seule idée vraiment importante qu'il ait jamais eue – celle qui a changé la façon dont les femmes s'habillent dans l'ensemble du monde occidental – et refuser de la montrer sur un mannequin alors que nous montrons toutes ses autres créations sur des modèles vivants ? »

Moffitt l'a emporté, le maillot ne fut pas présenté sur mannequin. On en a seulement montré des photos.

Le *topless swimsuit* est aussi à l'origine d'une autre grande première de Gernreich: l'anti-soutien-gorge. Celui-ci a sans doute fait plus pour changer la façon dont nous nous habillons que tout autre vêtement, intime ou non. Comparé avec les soutien-gorge « à double obus » de l'époque (que Gernreich comparait à des coiffures de Nouvel An), l'anti-soutien-gorge fabriqué par Exquisite Form était incontestablement révolutionnaire: il donnait une allure naturelle et libérait les femmes des rembourrages, des baleines et des coutures apparentes qui caractérisaient les bonnets de cette époque. Il se composait de deux bonnets de nylon souple et transparent attachés à des bretelles et montés sur une fine bande de tissu élastique qui entourait la cage thoracique.

Dès le printemps 1965 l'anti-soutien-gorge se révéla un grand succès commercial et fut rapidement suivi par le soutien-gorge coupé bas sur les côtés pour des robes à emmanchures très basses, le soutien-gorge coupé bas sur le devant pour des robes très décolletées et le soutien-gorge sans dos (qui s'attachait au niveau de la taille) pour des robes très décolletées dans le dos.

L'anti-soutien-gorge est le catalyseur qui incita Peggy Moffitt à venir à New York, où, dans le studio de Richard Avedon, elle rencontra un autre moderniste de cette époque, le coiffeur et visagiste Vidal Sassoon. Des mois plus tard, quand il vint à Los Angeles, elle lui présenta Gernreich. Tous deux sont immédiatement devenus amis et ont collaboré à la création de nouvelles coupes de cheveux et de vêtements.

Tandis que les Mods et les Rockers luttaient pour imposer la suprématie de leur look à Londres et que les Beatles donnaient le coup d'envoi des nouvelles coiffures branchées, Gernreich honorait Ringo Starr en baptisant son costume de flanelle à fines rayures de l'automne 1965 du nom du chanteur pop. L'Angleterre lui retourna le compliment quand le *Sunday Times* attribua à Gernreich son prix international de la mode pour récompenser le rôle qu'il avait joué « sur la scène mondiale de la mode en imposant une allure déstructurée, et dans la mode féminine américaine à travers ses collections de vêtements de sport et de lingerie. » Moffitt et Claxton accompagnèrent Gernreich en Angleterre pour la cérémonie d'attribution du prix. Moffitt se rappelle: « Après la cérémonie, Rudi, Bill et moi sommes partis à Paris. J'ai rencontré Dorian Leigh et elle m'a incitée à intégrer son agence de mannequins. Rudi aussi m'a encouragée à rester, il m'a expliqué que ce serait bon pour ma carrière. Et c'est ce que j'ai fait, j'ai travaillé presque un an à Paris et à Londres. Des années plus tard, Rudi m'a expliqué que même s'il savait qu'il valait mieux que je reste en Europe, il craignait de ne pouvoir créer ses collections sans moi. C'est l'une des choses les plus touchantes qu'il m'ait jamais dites. »

En Août 1965, ce qui allait devenir une longue querelle avec *Women's Wear Daily* commença à poindre dans le

Au mont Baldy, 1965

livre de John Fairchild *The Fashionable Savages*. Dans le compte-rendu qu'elle fit du livre, Eugenia Sheppard, du *New York Herald Tribune* écrivit: « Je pense que Fairchild sous-estime Gernreich, un créateur authentique. Sa protestation contre les vêtements ‹mal construits› de Gernreich met le doigt sur l'essentiel: une rébellion contre une mode de type haute couture que John Fairchild ne saurait accepter. »

Les prix élevés des vêtements de haute couture troublaient le styliste encore plus que Sheppard ne le soupçonnait. Le 3 janvier 1966, Gernreich brisa la règle tacite de la mode américaine qui voulait que les stylistes ne diffusent pas leurs produits dans des chaînes de grands magasins en signant un contrat avec Montgomery Ward pour créer une collection exclusive de produits. Cet accord fut reconduit durant plusieurs saisons, prouvant à Gernreich comme à Montgomery Ward que des collections originales peuvent être populaires, à condition de pratiquer des prix grand public.

A cette époque, Montgomery Ward demanda à Gernreich d'apparaître en personne dans un de ses magasins de Chicago. Ce fut une leçon d'humilité. « C'était une présentation complètement conventionnelle d'un styliste dans un magasin, organisée pour que les gens puissent venir poser des questions, vous savez, innocentes. Ils ont punaisé une petite affiche sur un des piliers du rez-de-chaussée avec une photo de moi à l'arrière-plan. J'avais des piles de photos à dédicacer. Et l'endroit où je me trouvais avait été entouré de cordons de velours. On annonça ma présence entre midi et deux heures. A midi je vis des foules de gens arriver par les ascenseurs. J'ai cru que j'allais être submergé par la cohue. En fait, personne n'est venu me voir. Pas une seule personne. J'attendais dans mon coin et finalement deux dames se sont approchées de moi et je me suis dit: ah, ça y est, ça va commencer. Elles m'ont demandé de leur indiquer les toilettes pour dames. Et ce fut tout. »

Dans ses collections de cette période, Gernreich a introduit des maillots de bain en maille et des bas élastiques avec pièces de vinyle appliquées retenus par des jarretelles en vinyle. Il a créé la première robe-T-shirt en mousseline de soie. Il a créé des chapeaux-casques qui recouvraient le visage, des manteaux à cols montant au niveau du nez, des maillots de bain qui ressemblaient à des pulls à col cheminée. Il a aussi utilisé des jerseys mats à imprimés de plumes avec bas et chapeaux assortis. Il a reçu un second prix Coty en 1966.

A partir de septembre 1966, Gernreich a appliqué son sens graphique très aigu directement au corps, effectuant les premiers tatouages par apposition de triangles, de carrés, de cercles et de rectangles collés sur les bras, les jambes et les torses de ses modèles vêtus de bikinis. Les ornements adhésifs étaient emballés dans des sacs en plastique et vendus avec les maillots de bain par la maison Harmon. Moffitt se souvient de l'évolution de ces premiers éléments graphiques pour le corps: « Quand nous

élaborions la collection indienne de 1965, j'ai voulu dessiner le point rouge des indiennes sur mon front, mais je ne pouvais pas mettre de rouge à lèvres sur mon front parce que je devais porter un maillot de bain moderne occidental juste après, alors j'ai découpé un rond fuchsia dans une pochette d'allumettes et l'ai appliqué avec de la colle à faux-cils. Les décalcomanies qu'on devait voir apparaître plus tard sont venues de ce petit rond collé. Pour la collection suivante, j'ai fabriqué de petites larmes géométriques en papier alu. Plus tard, quand je suis revenue d'Europe, Rudi poussa cette idée à ses dernières limites en me donnant un bas de bikini rouge à porter et en me collant des triangles de vinyle noir sur le reste du corps. »

Plus tard, en 1966, les vêtements de Gernreich ont été montrés dans ce qui est devenu le premier film vidéo sur la mode, *Basic Black* (Noir Basique). Claxton raconte l'histoire: « Après que Peggy et moi fûmes arrivés en Europe, j'ai été contacté par un producteur de spots publicitaires pour la télé qui voulait faire un film pour montrer des exemples de mon travail, une sorte de livre d'échantillons pour ainsi dire. J'ai décidé de mêler les choses que je connaissais le mieux, les vêtements de Rudi et mes photos. Peggy et moi avons écrit une esquisse de script pour ce que nous considérions comme un film de mode abstrait. Le week-end suivant, nous avons loué un studio à New York et avec Peggy, Léon Bing et Ellen Harth nous avons achevé le projet en deux jours. Rudi a souvent montré le film dans les présentations de collections qu'il faisait en Amérique du Sud et en Orient, et Vidal Sassoon l'utilise encore. Je considère ce film comme le premier où les vêtements parlent pour eux-mêmes, sans commentaires ».

La reconnaissance de Gernreich par ses pairs, au début très réticents, était si générale désormais que même Norman Norell finit par reconnaître qu'il avait eu tort. « Il [Gernreich] a fait des progrès », confia Norell à un reporter du *Washington Star*, le 30 septembre 1966. « Aujourd'hui, je serais d'accord pour qu'ils lui donnent le premier prix Coty. »

Gernreich, le metteur en scène-né, surprit son public lors de la présentation de sa collection d'octobre en montrant un mannequin vêtu d'une robe-chemisier ceinturée qui lui couvrait les genoux. Comme si ce n'était pas assez choquant, elle portait un soutien-gorge rembourré, des bas de nylon et des escarpins à talons aiguilles avec un sac et des gants assortis. Alors que les reporters et les acheteurs sidérés commençaient à pousser des cris d'étonnement, Moffitt fit son entrée dans une minijupe au ras des fesses dans le même imprimé que la robe-chemisier et chaussée d'escarpins. L'idée, expliqua Gernreich, c'est qu'il n'y avait pas de principes justes et faux, que l'esprit du moment était dans la façon de combiner les vêtements.

Pour s'assurer que personne n'ait mal interprété son message de 1967, Gernreich ouvrit sa collection printemps-été par cette phrase: « Pour la première fois dans l'histoire du monde – au moins depuis la Croisade des enfants – ce sont les jeunes qui donnent le ton. Les jeunes ont maintenant leur élite dirigeante. Ils découvrent la puissance de la mode comme leur pouvoir social et politique.

Ils apportent une fusion naturelle de la personne et du vêtement. Et ce qui est amusant, c'est que les personnes plus âgées commencent à se révolter. Cette attitude en soi pourrait avoir des conséquences intéressantes pour la mode dans quelques années, quand les jeunes vieilliront. Depuis plus de trois cents ans la femme française a dicté la mode au monde. Maintenant, enfin, la femme américaine arrive à maturité et conquiert sa liberté en matière de mode.

Et rien n'est bien sûr plus limité que la liberté. C'est le fil du rasoir, l'épaisseur d'un cheveu, le millimètre qui fait la différence. C'est la beauté, mais la beauté est toujours affreuse au début. C'est le sex-appeal, mais le sex-appeal est toujours austère. C'est l'art, mais mineur, pas majeur. »

Le 30 juin 1967, l'art de styliste de Gernreich devint majeur dans le sens où il fut admis dans la Fashion Hall of Fame par les critiques de mode du prix Coty, le prix le plus prestigieux de l'époque, et il reçut cette distinction cette même année au Metropolitan Museum of Art.

Le *New York Times* lui avait également tressé ces lauriers : « Presque tout ce qui est nouveau dans la mode américaine semble avoir été inventé par ce styliste de 44 ans, né à Vienne et basé en Californie. Plus connu pour son *topless swimsuit*, – le seul objet d'engouement qui ne s'est pas vendu –, Gernreich a toujours su anticiper les tendances. Il est célèbre pour sa façon d'ôter le superflu du vêtement. Ayant commencé par un maillot de bain sans doublure il y a quinze ans, il continue depuis quelques saisons par des robes transparentes ou découpées. »

Le travail sur le corps de Gernreich en 1967 proposait des tuniques et des robes avec des décolletés plongeants à des niveaux inégalés, dix centimètres sous une large ceinture de cuir. Il baptisa cette collection « Sous le nombril ». En octobre, le bas de l'ourlet se plaçait douze centimètres au-dessus du genou, et Pierrot, Edith Sitwell et Diaghilev étaient devenus des éléments du style « Rudimentaire ».

Les culottes bouffantes occupaient aussi une place importante dans cette collection, tout comme les jupes bouffantes. Une des robes de Gernreich en mousseline de soie blanche avec jupe bouffante et collants assortis eut les honneurs de la Maison Blanche lors du mariage de Lynda Bird Johnson au capitaine Charles S. Robb. Sa propriétaire, Carol Channing, devint le sujet d'une controverse sur la mode et la décence. Elle expliqua à *Newsweek* (le 25 décembre 1967) : « Je pensais que c'est ce qu'on porte à un mariage en 1967. »

Le plus grand hommage journalistique rendu à Gernreich eut lieu le 1er décembre 1967, quand lui et ses mannequins, Peggy Moffitt et Léon Bing, eurent les honneurs de la couverture de *Time*, où il était décrit comme « le styliste le plus excentrique et avant-gardiste des USA. »

Bien qu'il ait continué à élargir son champ d'intervention stylistique en 1968, d'abord avec les bas pour la boutique McCallum, plus tard avec des foulards signés pour Glentex et des dessins d'imprimés pour McCall's, Gernreich montra une attitude de plus en plus désenchantée devant la direction que prenait la mode. En janvier 1968, il expliqua aux journalistes de mode qui assistaient à son défilé que « l'influence du film *Bonnie and Clyde* sur la mode avait fini par devenir écœurante. Ce film est génial, c'est un beau film tragique, mais il n'a rien à voir avec la mode en tant que telle. Les périodes historiques antérieures reviennent toujours dans la mode, mais elles doivent toujours être réinterprétées. Sinon il y a fuite devant la réalité dans une nostalgie costumée. L'histoire doit être utilisée, pas seulement revisitée. »

Les propositions de Gernreich cette année-là comportaient des robes de harem siamois qui s'attachaient entre les jambes, des bandes de vinyle transparentes appliquées sur des robes et des maillots de bain en maille, des tenues de cosaques, des bottes garnies de plumes blanches, des collants et des foulards signés non pas du nom de Gernreich (les foulards signés par les stylistes étaient à l'apogée de leur popularité) mais par un alphabet de lettres emmêlées qui ne voulaient rien dire. Comme Gernreich l'a baptisé, le « foulard non signé ».

Il apporta encore la démonstration de sa clairvoyance en mai de la même année avec une idée que les autres stylistes ne devaient pas tarder à adopter. « L'ère de la dictature de la mode est finie, et avec elle, l'approche autoritaire des vêtements, annonça-t-il dans le dossier de présentation de sa collection d'automne. Il y a une confusion mondiale sur tout et cela englobe aussi les vêtements. Toutes les institutions établies se cassent la figure. Cette confusion fait sentir ses effets partout et le styliste doit travailler avec et contre elle. C'est un phénomène intéressant mais nous vivons dans une pagaille noire. Nous avons découvert que la nudité n'est pas nécessairement immorale, qu'elle peut avoir une signification logique et décente. Le corps est une dimension légitime de l'être humain et peut être utilisé pour beaucoup d'autres choses que la sexualité. Peu à peu la libération du corps guérira notre société de ses obsessions sexuelles. Aujourd'hui, nos notions du masculin et du féminin sont remises en question comme jamais auparavant. L'attraction élémentaire que les sexes éprouvent l'un pour l'autre réside dans leur personnalité et non dans leurs vêtements. Quand un vêtement devient suffisamment basique il peut être porté par les deux sexes. »

Il terminait cette déclaration en expliquant que les jupes était périmées, que les pantalons et les tuniques les avaient remplacées. *Women's Wear Daily* récusa ces propos. C'était Gernreich, et non la jupe, qui était une espèce en voie de disparition. L'article parut le 12 juin 1968 : « Rudi Gernreich s'est enfermé dans une impasse. Pendant des années il a été le styliste américain le plus avant-gardiste et il a été célébré en tant que tel. Mais cette saison, Rudi manque son coup avec ses trouvailles, ses costumes et ses blagues des saisons passées. Ses mini-tuniques sur des jambes lacées de haut en bas, ses superpositions qui alourdissent la silhouette et ses culottes bouffantes qui gonflent de plus en plus n'appartiennent ni au présent ni au futur. Rudi explique que nous avons besoin de nous amuser et de jouer en ce moment, mais sa collection ressemble surtout à une comédie des erreurs. »

L'amusement et le jeu s'arrêtèrent le 16 octobre 1968, quand Gernreich annonça qu'il prenait une année sabbatique. Dans une brève déclaration à la presse, il confia : « Ce n'est pas bien grave. Je pense seulement qu'il est temps pour moi de prendre un peu de champ. Je veux seulement me reposer. »

Le costume à miroirs, 1969

L'explication de cette décision est plus complexe : « Ça faisait des années que je trouvais que la haute couture était périmée, que les vêtements chers n'avaient aucun sens. Mes propres dessins Rudi Gernreich étaient devenus prohibitifs. S'acheter une tenue complète avec chaussures, bas et chapeau assorti était non seulement cher, mais compliqué du point de vue du consommateur : les grands magasins n'étaient pas conçus pour vendre des bas et des sous-vêtements dans le même rayon qu'une robe ou une jupe, si bien que personne ne se composait le ‹look total› auquel je croyais. Je savais qu'il fallait que je me développe pour faire baisser les prix ou que je reste petit et que j'accepte que les prix augmentent. L'idée de me développer et de devenir une affaire beaucoup plus grosse m'effrayait. Je ne voulais pas me transformer en un gros fabricant avec tous les problèmes de gestion que cela allait entraîner. Ce n'était pas ma vocation, mon intérêt premier. Je croyais que je devais rester expérimental à tout prix et cela signifiait être toujours sur le fil du rasoir du succès ou du fiasco.

En même temps, j'avais des problèmes avec mon équipe, des difficultés qui signifiaient qu'il allait falloir que j'accepte de profonds changements. J'étais au bord de la dépression nerveuse, surmené, sous une pression constante, saturé. Ma dernière collection avait été d'un extrémisme total, une démonstration par l'absurde. Tout le monde l'avait critiquée. Et je m'étais tellement engagé dans la gestion de mon affaire que je n'avais plus assez de temps pour dessiner.

Les tricots pour Harmon représentaient ma profession de foi : pratiques, faciles à porter, au juste prix, mais je voulais aussi en finir avec ce contrat. Pourtant avec Harmon, à la différence des autres fabricants avec qui j'ai travaillé, il n'y a jamais eu le moindre problème.

Quand je lui ai parlé de ma décision, il a été merveilleux, très, très compréhensif. Il m'a dit de prendre trois mois de repos, que nous en reparlerions et il m'a assuré que nous continuerions la ligne de tricots Harmon de la manière la plus facile pour moi. Il m'a dit que ce serait stupide d'interrompre notre collaboration et comme j'avais déjà presque fini ma collection, je l'ai achevée

avant de partir au Maroc. Ce fut l'une des collections les plus rentables que j'ai dessinées pour lui.

Une fois ma décision prise, la dépression nerveuse a disparu d'un seul coup. Je me sentais libre, soulagé. Et j'ai loué un endroit de rêve, un château à Tanger, qui appartenait à Yves Vidal, le président de Knoll International. J'ai voyagé au Maroc et aussi en Europe et mon périple a duré près d'un an. J'ai préparé les collections pour Harmon facilement, joyeusement et je n'ai pas manqué une seule collection de maille. Quand je suis revenu, une toute nouvelle vie professionnelle a commencé pour moi. »

C'était à l'automne 1969, peu après qu'il soit revenu de son année sabbatique avec la décision de simplifier sa vie de styliste. C'est l'année où ses homologues européens avaient décidé de lancer les jupes longues pour inaugurer la nouvelle décennie, l'année où l'on a marché sur la lune, l'année des moratoires, des défis lancés aux pouvoirs établis.

Pour Gernreich c'est aussi l'année de la mort de la mode. Presque symboliquement, le magazine *Life* lui a demandé de se projeter dans le futur. Helen Blagden a demandé à Gernreich d'imaginer ce que les hommes et les femmes porteraient en 1980.

Encore une fois, comme dans le cas de *Look* et du *topless swimsuit*, Gernreich a dit non, qu'il était impossible de prédire une réalité visuelle sans tomber dans une caricature de bande dessinée de science-fiction. Impressionné par le fait que le numéro spécial de fin d'année de *Life* « Vers les années soixante-dix » devait comporter des spéculations sur les conséquences du voyage dans la lune par Norman Mailer et un sondage de l'institut Louis Harris sur les coalitions sociales qui allaient façonner le futur, Gernreich accepta de faire ce qu'il considérait comme une projection assez réaliste des vêtements de demain.

« Si vous vous écartez trop de quelque chose de plausible, vous perdez précisément cela, la vraisemblance de la chose. Je crois vraiment que vous ne pouvez voir les choses que dans votre propre moment, que vous êtes prisonnier de votre époque. Mes idées pour *Life* étaient prisonnières de leur époque, mais j'ai essayé de reculer les limites de l'époque qu'elles traduisaient en les repoussant jusqu'à l'an 2000. »

Ces idées, les corps rasés et tout un chacun réduit à son expression la plus strictement essentielle, ont été condensées en ces termes par le numéro de *Life* de janvier 1970 : « Selon lui (Gernreich), le côté ‹cirque› et ‹nostalgique› des vêtements d'aujourd'hui est le symptôme sinistre de notre aveuglement devant les problèmes de la vie contemporaine. Les vêtements de l'avenir devront être fonctionnels. Gernreich prévoit un futur proche où ‹les gens cesseront de projeter leur vie sentimentalement sur leurs vêtements›. La femme de demain renoncera à ses bijoux, à ses cosmétiques et s'habillera exactement comme l'homme de demain. La mode se passera de la mode. Le ‹principe d'utilité› nous incitera, explique Gern-

1968

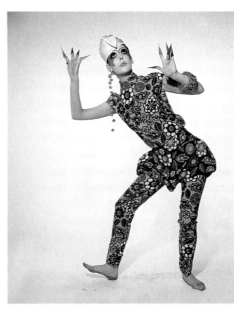

reich, à nous désintéresser de notre apparence et à nous concentrer sur les problèmes vraiment importants. L'allure vestimentaire ne sera plus soumise à l'alternative masculin/féminin, si bien que les femmes porteront des pantalons et les hommes des jupes et vice-versa. Et comme la nudité ne sera plus un objet de réprobation morale, les vêtements transparents le seront avant tout pour des raisons de confort. Quand le climat le permettra, les deux sexes se promèneront torse nu, les femmes continuant à s'enduire de crèmes protectrices. L'esthétique de la mode va intégrer le corps lui-même. Nous exercerons notre corps pour devenir plus beaux, plutôt que de le couvrir pour produire une impression de beauté ».

Pour les plus âgés, Gernreich prévoyait des sortes de capes ou de caftans. « Le culte actuel de l'éternelle beauté n'est pas honnête et n'a rien de très attirant. A une époque où le corps va devenir la convention de la mode, les plus âgés adopteront un uniforme à eux. Si un corps ne peut plus être souligné, il doit être stylisé. Les jeunes ne porteront plus d'imprimés mais les personnes âgées si, parce que leurs propres passions et les soucis liés au vieillissement disparaîtront. »

Quand l'article parut, accompagné de croquis, Eugenia Butler, un marchand d'art lié à Gernreich, organisa un

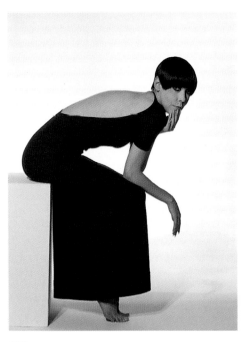

1971

rendez-vous avec Maurice Tuchman, conservateur en chef au département d'art moderne du Los Angeles County Museum of Art, qui dirigeait la section « art et technologie ». Il préparait une exposition sur ce thème pour Expo 70, une exposition internationale qui devait avoir lieu à Osaka, au Japon. Tuchman demanda à Gernreich de créer un événement spécial pour Expo 70, qui mêlerait l'art et la mode dans des propositions destinées aux artistes et aux journalistes de l'exposition.

Expliquant sa décision de donner vie aux dessins qu'il avait publiés dans *Life*, Gernreich raconta : « J'étais terriblement contrarié par ce qui se passait. Je voulais que les gens soient perturbés. Je sentais qu'il fallait envoyer un signal violent, répulsif, et qu'un dessin restait vague et irréel. Je pensais que si je traduisais ces dessins par des vêtements, ce serait réel, ça aurait de l'impact. La plupart des gens ont considéré l'article de *Life* comme une violente prise de position contre la sexualité. Quelques-uns ont trouvé cette vision unisexe lyrique, comme une manière sereine d'être ensemble. J'étais curieux de savoir comment ils réagiraient devant la réalisation de cette idée. »

Il demanda à Moffitt d'être son mannequin. Elle refusa : « Pour moi, il était parfaitement légitime de se projeter dans le futur, trente à cinquante ans avant, mais le fait de présenter des mannequins nus me paraissait contestable. Si vous prédites le futur et le présentez la semaine suivante, ce n'est plus une vision futuriste. J'ai essayé de lui dire qu'il serait attaqué personnellement parce qu'il allait

montrer des gens sans cheveux alors que lui-même cachait sa calvitie avec un postiche, mais je n'y suis pas arrivée. Il a justifié sa résolution d'aller au bout en donnant vie à ses dessins mais je ne pouvais m'associer à ce projet. »

Après que Léon Bing se fut aussi excusée, Gernreich se mit en quête d'un jeune homme et d'une jeune femme qui accepteraient de se raser la tête et le corps et de l'accompagner à l'Expo 70. La femme fut Renée Holt, un jeune mannequin de vingt-deux ans et l'homme Tom Broome, le gérant de Chequer West, une boutique de Los Angeles. Le magazine *Time* a raconté le moment du rasage dans son numéro du 26 janvier 1970 :

« La première étape de l'affaire consistait à raser la tête et le corps de ses deux mannequins ‹Les cheveux cachent beaucoup›, a expliqué Gernreich ‹et les poils sont trop connotés sexuellement. Je ne veux pas créer de confusion entre l'idée de liberté et celle de nudité sexuelle. L'ouverture et l'honnêteté exigent de supprimer toute dissimulation quelle qu'elle soit.›

Pour Thomas Broome, le mannequin masculin de Rudi, la perspective d'apparaître totalement glabre n'avait rien d'horrifiant : ‹Ça faisait longtemps que j'avais envie de me débarrasser de mes cheveux. J'avais cette théorie que le jour où j'y arriverais, je me débarrasserais aussi d'autres choses, mes inhibitions peut-être›. Mais Renée Holt vit arriver l'heure de son rendez-vous chez le coiffeur avec anxiété. Caressant affectueusement ses longues tresses dorées, elle déclara bravement : ‹En un sens, une longue chevelure est un handicap pour une femme. Une fois qu'on a les cheveux courts on peut développer d'autres qualités comme l'intelligence. Mais je me demande ce que mon père va dire.›

Une heure plus tard, Tom et Renée ôtaient leurs blouses et entraient dans des salles de bains séparées pour raser tout vestige de poil.

‹Vous êtes magnifiques, tout simplement magnifiques !›, s'exclama Rudi quand ils revinrent. Une maquilleuse appliqua une fine couche de fond de teint coloré sur leurs corps nus et le moment vint pour eux d'enfiler leurs tenues, tels quels. Les deux mannequins étaient vêtus de *topless swimsuits* noirs et blancs identiques, sur lesquels ils enfilèrent des pantalons à pattes d'éléphant et des débardeurs qui s'arrêtaient sous les côtes. Pendant que les photographes les mitraillaient et que Gernreich leur donnait des directives, les mannequins enchaînèrent une série de gestes qu'ils devaient répéter plus tard, le 20 janvier, chez Eugenia Butler et lors d'une autre soirée, à sa galerie. Ils retirèrent leurs débardeurs, leurs pantalons tombèrent à terre. Les *topless swimsuits* glissèrent lentement vers le sol. Après avoir fait un pas de côté, Tom et Renée restèrent immobiles comme des statues ou des détenus d'un camp de concentration. »

La curiosité de Gernreich concernant les réactions des gens à l'apparition de Tom et Renée se mua en traumatisme lors du happening chez Eugenia Butler. Alors qu'il guidait les mannequins dans la cohue des invités, un homme apparut soudain, exhibant ses organes génitaux, brandissant un coussin jaune et parodiant de façon burlesque Renée et Tom. Quand Gernreich apprit que l'exhibitionniste se nommait Paul Cotton, l'un des artistes de Mme Butler, et qu'elle avait mis en scène tout le spectacle, il lui demanda si c'était vrai et elle le nia. Plus tard, quand elle fut arrêtée en compagnie de Cotton, qui s'exhibait à nouveau devant le pavillon américain au Japon, Gernreich comprit qu'il avait été dupé. Et quand Cotton répéta sa performance en apparaissant totalement nu, excepté la fine couche de peinture argentée dont il était recouvert lors d'une présentation chez les Tuchman, à Kyoto, Gernreich comprit qu'il s'était encore fait piéger.

Bien que les créations de Gernreich aient eu, dans les années soixante, des répercussions médiatiques dans le monde entier, sa proposition futuriste de 1970 ne souleva qu'un intérêt limité. *Women's Wear Daily* rendit compte du happening dans sa rubrique Arts et Loisirs. La plupart des journalistes étaient plus intéressés par les longueur des jupes qui rallongeaient que par la disparition des poils.

Le numéro du 22 janvier 1970 du *Los Angeles Times* l'évoquait de la manière suivante : « La *Projection 1970* de Rudi Gernreich relève plus de la philosophie que d'une vision arrêtée du futur de la mode. Elle est, en fait, anti-

mode. Par-delà le choc de ces corps complètement glabres et de leur nudité, la projection de Gernreich constitue une exploration sincère de sa vision du futur et de la façon dont celui-ci affectera notre apparence. »

Le *Los Angeles Herald Examiner* du 21 janvier 1970 : « Tout cela s'est déroulé dans une atmosphère inexplicablement morose. Quand tout a été fini, il manquait beaucoup plus que des vêtements et des poils ou des cheveux. Disparus aussi l'imagination, les soi-disant ‹inhibitions› et la pudeur, les attitudes traditionnellement masculines et féminines, sans parler des profits futurs du monde de la mode, des professionnels du textile et des teinturiers. »

Fashion Week, 22 janvier 1970 : « 2001 sera-t-il moins impressionnant parce que Kubrick ne sera pas de la fête ? Non. Nous sommes engagés dans le futur. Et c'est peut-être notre salut que quelqu'un s'en soucie sérieusement. »

Women's Wear Daily, 22 janvier 1970 : « Le styliste Gernreich a pris un congé sabbatique de plusieurs mois pour recharger ses batteries créatives. Dommage qu'il se soit remis à la planche à dessin trop tôt. »

Gernreich résuma les compte-rendus en disant qu'il était devenu plus difficile de choquer les gens. « Ils sont habitués aux concepts insolites. Certains restent aisés à déconcerter, mais moins qu'avant. J'ai bien reçu quelques lettres de haine, mais la majorité silencieuse est restée plus silencieuse qu'autrefois. »

Parmi tous ceux qui s'insurgèrent contre les mannequins rasés de Gernreich, seul un, Le Ponce College of Beauty de Palo Alto, Californie, prit des mesures concrètes. Cette école fit paraître une publicité d'une demi-page dans le *Palo Alto Times* titrée : « Contribuez à éliminer Rudi Gernreich ». Le voyage au Japon, bien que n'appartenant pas au programme officiel de l'Expo, fut financé par Max Factor. A cause de ce parrainage, Gernreich étoffa sa « projection » originale parue dans *Life* et y intégra une réflexion sur le maquillage conçu comme une sorte de protection corporelle pour protéger l'homme des rayons du soleil et du froid. Les vêtements unisexes faisaient partie de cette présentation, pantalons, jupes, bikinis, combinaisons-pantalons – tous ces modèles appartenaient à des collections antérieures de Gernreich. Les bottes avaient été réalisées pour lui par Capezio en 1965. Si les vêtements paraissaient nouveaux et bizarres, Gernreich expliqua que c'était seulement parce qu'ils avaient été portés par deux êtres glabres. « C'est vrai de tous les vêtements : celui qui les porte en fait ce qu'ils sont. »

Quand Gernreich présenta ses modèles de 1971 sur des mannequins armés de revolvers, chaussés de bottes de combat et munis de plaques d'identification, un nou-

1971

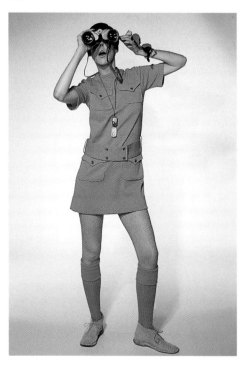

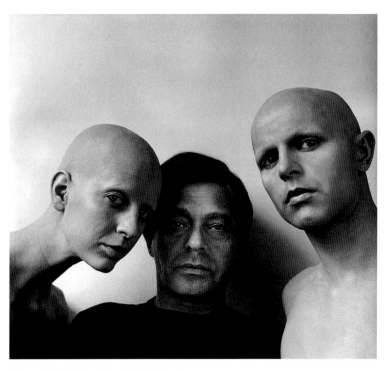

Unisexe, 1970 (photographie de Patricia Faure)

veau coup de canon ébranla le monde de la monde. Les modèles eux-mêmes, déjà montrés en octobre 1970 peu après les émeutes étudiantes meurtrières de Kent State, étaient des vêtements basiques, en maille, faciles à porter; mais les armes qu'arboraient les mannequins semblaient porter un coup mortel à la mode elle-même.

« Les femmes sont sur le sentier de la guerre », expliqua Gernreich à la presse et aux clients qui assistaient à son défilé. « Elle sont fatiguées d'être des objets sexuels. » Puis, dans une allusion perfide aux stylistes qui montraient des vêtements de paysannes russes et d'autres héroïnes de livres d'histoire, Gernreich continua: « Vous ne pouvez tout simplement pas dessiner des vêtements pour des héroïnes de Tchekhov en 1970! La mode doit concerner les femmes d'aujourd'hui. Il n'y a pas de modèles ‹d'évasion› dans cette collection parce qu'il n'y a pas d'évasion. Désirer le passé, c'est nier à la fois le présent et le futur. »

Par fidélité au thème réaliste de la collection, tous les vêtements furent vendus à des prix inférieurs à six cents francs. Et à une époque où la plupart des stylistes les plus importants faisaient des jupes mi-longues, la longueur d'ourlet de Gernreich resta très au-dessus du genou.

A l'automne 1971, Gernreich intensifia ses attaques contre ce qu'il appelait « le culte de la nostalgie. » Voici quels sont pour moi les paramètres aujourd'hui : l'anonymat, l'universalité, l'unisexualité, la nudité comme fait et non comme excitation et par-dessus tout, la réalité. Par réalité, j'entends l'utilisation de choses réelles : blue jeans, chemises polo, T-shirts, blouses. La mode-standing appartient au passé. Que reste-t-il? Quelque chose que je suis obligé d'appeler authenticité. Le dénominateur commun, c'est le confort. L'élégance découle plus de la personne que de ses vêtements. Ceux-ci sont simplement le mode d'expression du message corporel propre à l'individu. Les prix doivent rester modestes. C'en est fini de la consommation ostentatoire. Aujourd'hui, « cher » connote ce que « bon marché » connotait autrefois : c'est l'emblème d'une incurable vulgarité. Et nous avons acquis une conscience de l'âge, du vrai âge, ce qui est le signe d'un véritable progrès spirituel. Une femme de plus de vingt-cinq ans n'éprouve plus l'obligation morale de ressembler à une adolescente. On commence à voir apparaître des séparations marquées entre les âges. Ce simple phénomène, ouvre d'infinies possibilités. »

Le plus grand choc que causa Gernreich dans les années soixante-dix fut sans doute d'avouer qu'il n'avait plus rien à dire sur le futur. Le meneur des futuristes de la mode était devenu le champion de « l'instant présent ». Et il fut, étonnamment, aussi seul dans le présent des années soixante-dix qu'il l'avait été quand il prédisait

le futur des années soixante.

Alors que la fièvre de la nostalgie gagnait la plupart des stylistes de mode, Gernreich s'etait immunisé, lui et ses adeptes, contre cette tendance par l'injection de doses massives de ce qu'il appelait des uniformes, hauts et bas en maille simples et fonctionnels qui reflétaient la personnalité des hommes et des femmes qui les portaient. « Voyez-vous une quelconque signature de Rudi Gernreich sur ces vêtements », demandait-il à ses clients. S'ils lui répondaient oui, son visage s'assombrissait. Il voulait par-dessus tout que ses vêtements de cette époque restent anonymes.

Moffitt se rappelle un incident révélateur de cette époque : « C'était en 1972. Bill et moi venions de nous réinstaller à Los Angeles. Le monde de la mode new-yorkaise me déprimait et je voulais travailler davantage avec Rudi. Nous déjeunions, lui et moi, en face du Los Angeles County Museum of Art et parlions de l'impression déplorable que nous éprouvions à voir *Women's Wear Daily* s'extasier devant les cardigans de Halston qui se nouaient sur l'épaule. Je lui ai lancé : ‹S'ils pensent que c'est si bien, pourquoi n'intègrent-ils pas carrément un pull-over dans la robe?› Rudi eut l'air absolument sidéré et répondit : ‹Comment étais-tu au courant? C'est exactement ce que je suis en train de faire.› Il devint alors très sérieux et ajouta : ‹Je ne veux pas travailler avec toi en ce moment. Tu m'inspires et je ne veux pas être inspiré.› Dépitée, je suis rentrée chez moi et j'ai décidé de fonder une famille. Deux mois plus tard, un Rudi en pleine effervescence a fait irruption dans mon salon et m'a demandé de présenter une armure futuriste qu'il allait faire pour une promotion Max Factor en juillet. Quand je lui ai rappelé que je serais enceinte de huit mois à ce moment-là, il a décidé que je pourrais quand même la présenter. Rudi était comme ça. Tout avait changé et maintenant il était d'accord pour être inspiré. Je n'ai finalement pas travaillé pour lui à cette occasion mais notre collaboration s'est poursuivie après la naissance de mon fils Christophe jusqu'à sa dernière collection en 1981. »

Convaincu de «la disparition de l'aspect créatif de la mode», Gernreich pensait que le futur renouveau du vêtement serait technologique. « Quand les machines à coudre auront été remplacées ou qu'elles auront gagné en sophistication et que les stylistes pourront pulvériser de la teinture sur les vêtements ou transférer des tissus sur le corps humain, de nouveaux phénomènes se produiront », écrivait-il en 1971.

Le styliste deviendra moins artiste et plus technicien. Il sera une sorte d'architecte ou d'ingénieur avec une solide formation de chimiste. Couturières et coupeurs ne seront plus nécessaires. D'autres machines se chargeront de ce travail. C'est pourquoi une connaissance technique comme celle des ordinateurs sera alors essentielle.

Quand notre technologie a permis d'envoyer des hommes sur la lune, tout s'est accéléré si rapidement que les gens n'ont tout simplement pas pu faire face et ils se sont réfugiés dans le passé. Le passé nous réconforte et nous permet d'exorciser le présent. Aujourd'hui, personne ne parle du présent. Pour la plupart des gens il n'existe pas. Par contre ces mêmes gens essaient de s'adapter au futur. Nous avions l'habitude de penser uniquement par référence au présent. Mais le présent d'aujourd'hui est le passé, et le futur n'est qu'un moment fugace dans le temps. »

Dans l'optique de Gernreich, l'aspect futuriste et lunaire des années soixante a brutalement cessé dans les années soixante-dix et les stylistes ont commencé à revenir au passé parce que la lune était encore une idée abstraite au début des années soixante et que cela avait du sens de l'utiliser comme thème de stylisme.

« Une fois que c'est devenu une réalité, une fois que nous avons vu la possibilité d'entretenir un rapport direct avec elle, elle est devenue effrayante. Pour la plupart d'entre nous, la lune paraît toujours éloignée et déconnectée des problèmes quotidiens. D'une certaine manière, la vacuité de la lune ennuie beaucoup de gens. Elle en rebute même certains – comme moi. Envoyer un homme sur la lune a constitué un exploit phénoménal, je ne le nie pas. Mais les sommes d'argent dépensées pour accomplir cet exploit auraient très bien pu être employées à résoudre des problèmes terrestres. J'ai toujours le sentiment que notre souci légitime doit porter sur l'instant présent, pas sur le futur, ni le passé. Peut-être, quand la première station spatiale sera du domaine du réel, la lune nous paraîtra-t-elle plus fortement ancrée dans la réalité et aura-t-elle une influence réaliste. Pour le moment la lune ne peut jouer aucun rôle véritable dans notre vie. »

S'ancrer dans la réalité dans les années soixante-dix, cela a consisté pour Gernreich à produire des vêtements pour ces années tout en appliquant ses talents de styliste à d'autres domaines. A l'automne 1971, Gernreich dessina une collection de meubles pour Fortress, mêlant verre, cuir et aluminium poli, dans laquelle figuraient notamment une petite table basse contrefaisant une porte à laquelle ne manquait même pas son bouton, des tables basses semblables à des cageots d'oranges et des tables qui ressemblaient à des civières. En 1971, il a créé des quilts pour Knoll International, qui intégraient tous les motifs qu'il avait utilisés pour ses vêtements en maille; ces quilts ont été exposés au Louvre, à Paris. En 1974, pour le dixième anniversaire du *topless swimsuit*, Gernreich a lancé un parfum, *Rudi Gernreich,* dont le flacon était un vase à bec de chimiste, produit sous les auspices d'American Essence. Après un bref succès soutenu par ses apparitions personnelles, la société a fait faillite et le parfum de Gernreich comme celui d'Anne Klein, sorti à peu près à la même époque, disparurent du marché.

Cette même année 1974, Gernreich a créé un autre vêtement inspiré de la devise *Less is More* (« moins, c'est plus »), baptisé le *thong*. Ce slip constitué d'une mince bande de tissu dévoilait les fesses. Il y en eut des versions masculines et féminines. Gernreich a dit qu'il avait créé le *thong* pour servir le « confort indéniable et le plaisir que les êtres humains prennent à la nudité. » Il considérait le *thong* comme un compromis entre la liberté et la loi, parce qu'il offrait la liberté du nudisme sans violer la loi sur les plages publiques. Il était loin d'imaginer que seize ans après la première apparition de sa création sur les plages, celle-ci serait considérée comme indécente et illégale. En juin 1990, les sept membres du gouvernement de l'Etat de Floride édictèrent un décret qui prohibait des plages publiques de Floride ce type de maillot de bain se réduisant à un string. Cette réglementation prit effet le 22 juin et déclencha une polémique nationale sur ce que les législateurs de Floride intitulèrent « le pli fessier ». Même le journaliste Phil Donahue y prit part en interviewant deux jeunes qui avaient été arrêtés pour violation de la loi alors qu'ils portaient des *thongs* à Sarasota. Ils présentèrent leurs maillots sur une chaîne de télé nationale.

Cette même année 1974, Gernreich collabora à nouveau avec Bella Lewitzky avec qui il avait dansé dans *Salomé* presque trente ans auparavant, quand tous deux appartenaient à la troupe de Lester Horton. Ses remarquables costumes pour la présentation d'*Inscape*, le spectacle de Lewitzki, constituèrent des éléments essentiels du décor et de l'action. Ainsi, les crânes de ses « combattants siamois » étaient attachés par des cagoules élastiques qui unissaient ces danseurs à la fois littéralement et figurativement. Gernreich continua à collaborer avec Bella Lewitzky et conçut les décors et les costumes de *Pas de Bach* en 1977, de *Rituals*, en 1979, de *Changes and Choices* en 1981 et de *Confines* en 1982.

Cette idée de Gernreich de relier les costumes pour *Inscape* est ensuite devenue un des thèmes de son travail : en 1975, Gernreich a créé une robe tubulaire noire en jer-

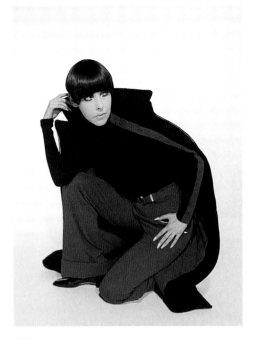

1972

sey de nylon attachée à une sculpture-bijou en aluminium de Christopher Den Blaker. Il inventa aussi des colliers aux formes libres, retenant des robes dos-nu ou de larges bracelets en forme de menottes. Cette même année, Gernreich dessina les premiers slips Jockey et des boxer-shorts pour Lily of France, anticipant de sept ans les modèles similaires de Calvin Klein. Les cosmétiques Rudi Gernreich pour les laboratoires Redken sont apparus en 1976, les collants de danseur Rudi Gernreich pour la marque Ballet Makers Inc., en 1977, les accessoires de cuisine, serviettes et sets de table Rudi Gernreich pour Barth et Dreyfuss en 1977, les tapis Rudi Gernreich pour Regal Rugs en 1978 et le mobilier de salle de bain en céramique Rudi Gernreich pour Wicker Wear Inc., également en 1978.

La dernière collection de maille Rudi Gernreich est sortie en 1981. Sa dernière aventure en dehors du monde de la mode, « Gourmet Soups » a débuté en 1982 pour s'achever peu de temps avant sa mort. Son dernier concept de styliste fut le pubikini « libérant totalement le corps humain ». Le photographe Helmut Newton, témoin de cette expérience, en relate le déroulement : « Rudi m'a parlé du projet et m'a demandé si je voulais le photographier. Il n'était absolument pas question de » création ultime «. J'ai dis oui, bien sûr. Il m'a demandé de venir chez lui, il m'attendrait avec un mannequin. C'était en mars, un début d'après-midi. »

Le mannequin, Sue Jackson, avait été préparé à l'avance, ses poils pubiens mis en forme, rasés et teints en vert acide par le coiffeur de Los Angeles Rodney Washington qui avait suivi la ligne dessinée par Gernreich au crayon gras sur le corps de Jackson. La maquilleuse Angelika Shubert créa un maquillage corporel et colora les lèvres et les ongles du mannequin en rouge brillant. S. Jackson, dont les cheveux étaient aussi traversés d'une zébrure de vert brillant portait une minuscule bandelette de tissu qui s'étendait des hanches à l'entrejambe, dessinant un large V qui laissait apparaître le triangle pubien teint en vert.

« Je l'ai fait poser sur le canapé et Rudi s'est assis à côté d'elle. Je me rappelle Rudi appliquant de la peinture ou de la teinture verte sur elle, et je me souviens de son extrême excitation à propos de ce concept. Depuis, j'ai toujours pensé que ce pubikini avec le vert sur les poils pubiens était une expression beaucoup plus nouvelle de la nudité que le fait de laisser dépasser un sein, comme Yves Saint-Laurent l'avait fait pour certains mannequins en 1989. J'ai trouvé touchant et merveilleux qu'il puisse être encore si passionné à ce moment de sa vie. »

Gernreich mourut un mois plus tard, le 21 avril 1985, d'un cancer du poumon.

EPILOGUE

J'ai rencontré Rudi Gernreich alors que j'effectuais un reportage à Los Angeles pour le *Chicago Tribune*. A partir de ce moment jusqu'à mon emménagement à Los Angeles en 1969, je l'ai toujours appelé M. « Gern-raïk ». Il n'a jamais corrigé cette erreur de prononciation. Et j'ai finalement compris ma méprise après plusieurs appels téléphoniques à ses bureaux du boulevard Santa Monica en entendant Fumi, sa secrétaire, répondre : « Rudi Gern-rick ».

J'ai toujours pensé que celui qui était assez gentil pour ne pas m'avoir corrigée toutes ces années était quelqu'un de très spécial. Et Rudi était sans aucun doute très spécial. Il n'était pas le seul styliste au monde à avoir une vision. Mais il a été le premier styliste à regarder par-delà les salons, par-delà la caste des privilégiés et le « gratin » comme on disait à cette époque, et à s'inspirer de la rue, à penser à la foule des ouvriers et des petits employés.

C'était un artiste, un sociologue, un économiste, un humoriste, un devin, du signe du Lion, et probablement le seul révolutionnaire à posséder deux voitures et à porter des mocassins Gucci. Même à l'apogée de sa rébellion anti-standing, il se rendait au travail dans une grosse Bentley blanche de 64 et entretenait une relation d'amour-haine avec sa Nash-Healy de 53 toujours sur le point de tomber en panne.

Christian Dior a dit qu'il connaissait ses meilleurs moments d'inspiration dans son bain ou au lit et il comparait ce qu'il appelait sa période d'incubation – les deux semaines qu'il passait à la campagne avant de commencer chaque collection – à la migration des anguilles dans la mer des Sargasses.

L'« incubateur créatif » de Gernreich était son esprit. Il était aussi cérébral que visuel, aussi intelligent que chaleureux. Ses vêtements étaient à son image. Ils parlaient, tourmentaient, taquinaient et chatouillaient l'imagination. Parfois, ils effrayaient même les gens.

Gernreich était très spirituel. Il adorait les calembours et aimait faire des blagues. En 1972, par exemple, je me souviens de lui pouffant et éclatant de rire devant son canular sur les twin-sets de Halston – qui tournait en dérision l'affectation alors en vogue consistant à porter un pull attaché sur les épaules au-dessus d'un autre pull semblable. Les pulls-pastiches de Gernreich avaient quatre manches, deux pour les bras et deux qui se nouaient autour des épaules.

Rudi avait une présence, une personnalité qui s'imposait fortement, ce que sa taille modeste (1,67 mètre) ne laissait pas augurer. Quand il captivait l'attention générale, il ronronnait. Quand il n'était pas au centre de l'attention, soit il devenait le centre de l'attention – en général grâce à une histoire amusante – soit il partait. Et bien que son corps fut fort et compact, il se mouvait avec une grâce de danseur, même s'il avait pris des rondeurs avec l'âge. Gernreich, le brillant coloriste, était toujours vêtu de noir afin de pouvoir « s'entendre penser ».

Il parlait avec un accent américain théâtral et s'exprimait avec aise, éloquence, souvent avec un esprit d'autodénigrement. Il adorait raconter des histoires. Une de mes préférées concerne cette femme de chambre de l'hôtel Algonquin (New York) où Gernreich est descendu pendant des années. « Pauvre Monsieur Gernreich », l'at-il entendu dire à un des clients qu'elle avait vu de nombreuses fois dans la suite où il présentait ses échantillons, « Il vient ici au moins quatre fois par an. Il travaille comme un forcené pour vendre ses vêtements, il ne cesse de les montrer et pourtant personne ne lui achète la moindre chose. Il doit toujours tous les remballer et les remporter en Californie avec lui. »

Le siège social de Rudi Gernreich au 8460 Santa Monica Boulevard était une maison de forme rectangulaire, couverte de stucs kaki ; c'était un édifice moderne, presque mystérieux. J'ai toujours été frappée par le symbolisme de ce bâtiment qui se dressait, solitaire, sur une artère trépidante de circulation, exactement à l'image de Rudi, isolé dans le monde de la mode.

La seule décoration de cet édifice était constituée par les portes à caisson de 3,40 mètres de haut sur lesquels le nom du styliste était gravé en majuscules chromées. La décoration alliait le style Bauhaus, une tendance futuriste, une tendance pré-écologique et une tendance

« post-standing » comme en témoignait le T-shirt avec la photo de Gernreich punaisé au mur, là où avait naguère trôné une reproduction de la couverture de *Time* dédiée au styliste.

Dans le show-room, tout était soit blanc (trois murs et le sol couvert de carreaux hexagonaux blancs type salle de bains), soit noir (le cuir des chaises chromées et du sofa Marcel Breuer) ou kaki (un mur de grosse toile). Les seules notes de couleur étaient apportées par la jungle de plantes vertes et de palmiers qui atteignait le plafond et par les lithographies rouges et vertes de Carmi.

Il n'y avait pas de photos de famille, pas d'albums, pas de souvenirs de voyages, pas de bar dissimulé et programmé pour s'ouvrir à 17h30, même pas une reproduction en or de son millionième anti-soutien-gorge.

Le bureau privé de Gernreich était un univers de bruns – des bruns chauds et personnels qui contrastaient avec l'atmosphère plus impersonnelle du show-room noir et blanc. Un fauteuil Charles Eames en peau de porc, un téléphone en nacre, un coffre champignon … Avec tous ces tons sépia, la pièce ressemblait à un vieil atelier de rotogravure redessiné par un designer moderne. La seule concession de cette pièce au passé était un coffre mexicain orné d'incrustations d'os. Il était brun, également, et à l'intérieur, derrière ses portes fermées, s'empilaient les nombreux prix de Gernreich.

Derrière le mur marocain qui entourait la maison qu'il partageait avec Oreste Pucciani dans Laurel Canyon, à Hollywood, Rudi se montrait à la fois ouvert et réservé sur ses relations avec son amant : il conviait volontiers des invités hétérosexuels à des dîners où il recevait avec Oreste, mais répugnait à évoquer son homosexualité – en tout cas avec moi. Je savais qu'il était gay et je pense qu'il savait que je savais, mais aucun de nous n'a jamais abordé le sujet.

Rudi commençait chaque nouvelle saison en reprenant les croquis sur le vif qu'il jetait sur le papier où et quand l'idée lui venait, croquis dont il tirait des dessins détaillés complets, avec échantillons de tissus et gammes de couleurs. Ces esquisses rapides et brutes pouvaient avoir été suscitées par un incident de la vie quotidienne comme celui que relatait Gernreich : en 1970, une idée de maillot de bain lui était venue après un moment passé « à regarder des jeunes gens plonger tout habillés dans une piscine et en ressortir les vêtements collés au corps par l'eau avec un sex-appeal qui faisait paraître les bikinis presque ennuyeux. »

Rudi disait que les idées lui venaient juste avant de se réveiller ou de s'endormir. Il affirmait que cette expérience un peu mystique était une sorte d'état de transe qu'il éprouvait toujours avant l'échéance d'une collection.

Les critiques les plus ordinaires de Rudi étaient ses trois mannequins attitrés, Jimmy Mitchell, Peggy Moffitt

Costumes pour Max Factor, 1973

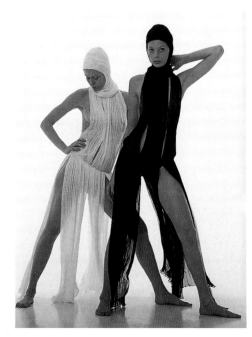

et Léon Bing. « Ce que les mannequins pensent m'importe beaucoup », expliquait Rudi dans une interview concernant leur influence sur son travail. « Je travaille seulement avec des mannequins que j'aime et que je respecte, et leurs réactions sont extrêmement importantes pour moi. Je suis stimulé par une réaction honnête et immédiate. Si le mannequin est froid, si elle me dit que quelque chose cloche dans le vêtement, ou si elle se sent tout juste bien dedans, je ne me sens pas vraiment à la hauteur. Je ne me sens pas très concerné si elle n'aime pas un dessin spécifique, mais je suis très affecté, si elle ne se sent pas à l'aise dans le modèle. »

Quelle sera la place définitive de Rudi Gernreich dans l'histoire ? Fut-il plus grand que Chanel ? Dior ? Balenciaga ? Givenchy ? Pucci ? Cardin ? Courrèges ? Saint-Laurent ? Comme il n'a jamais présenté ses collections à Paris, avec toute la publicité et le rayonnement qui en découlent, il est difficile de le situer parmi ses pairs. Mais son influence persistante sur la mode internationale est restée évidente, au moins jusqu'en 1991 où l'on a vu réapparaître des motifs, des couleurs, des tatouages, des formes et des attitudes à la Gernreich. Les vêtements de l'ère spatiale qu'il avait lancés avant de les descendre en flammes connaissaient une nouvelle heure de gloire dans les défilés de mode, de Milan à New York. Tous les thèmes « gernreichiens » des années soixante, le moulant, le mini, le néo, le géo, le pop et le op, appartiennent à nouveau au vocabulaire de la mode internationale. Les formes simples et sobres que l'on considérait comme futuristes en 1961 sont devenues « modernes » trente ans plus tard. L'esprit que Gernreich avait insufflé dans la mode était à nouveau à la mode ces dernières années. L'unisexe est entré dans les mœurs. Et ces costumes historiques qui semblaient si datés à Rudi dans les années soixante commençaient à paraître déphasés à beaucoup de gens vingt ans plus tard.

L'éloge de Rudi que je préfère est dû à la journaliste de mode Bernardine Morris, du *New York Times* : « La contribution essentielle de Rudi Gernreich ne consiste pas en la coupe d'une manche, ni en une couleur particulière ou des détails de confection si chers au cœur des gens de la mode qui adorent en revenir au bon vieux temps qu'ils comprenaient si bien. Il a apporté un concept d'une audace et d'une nouveauté insignes : les vêtements doivent être confortables. Et un rien amusants à porter. »

Rudi fut mon premier héros de la mode. Je pense que c'était un génie.

Page 10 :
Rudi au travail, Los Angeles, 1966.

Page 12 :
Début des années cinquante, jupe-sarong en laine. (Photographie © Christa)
1953, tunique noire et pantalons à carreaux multicolores. (Photographie © Christa)
Début des années cinquante, manteau en laine. (Photographie © Christa)

Page 13 :
A droite, Rudi en jeune danseur au début des années quarante. (Photographie © William Ricco, collection Lilly Fenichel)

Page 14 :
1956, vestes chinoises de serveurs en coutil de coton. (Photographies © Christa, courtesy *Life Magazine*)

Page 15 :
1952, premier maillot de bain sans armature. (Photographie © Tommy Mitchell Estate)

Page 16 :
1953, première robe tubulaire. (Photographie © Alex dePaola)
Milieu des années cinquante, tailleur en poil de chameau. (Photographie © Alex dePaola)
1954, à droite, robe blanche en plastique. (Photographie © Tommy Mitchell Esate)

Page 18 :
Fin des années cinquante, à gauche, maillot à fenêtres. (Photographie © Tommy Mitchell Esate)

1956, au centre, robe d'hôtesse avec pantalons de plage en trompe-l'œil. (Photographie © Christa)
1957, en bas à gauche et à droite, maillots de bain, dont une version à échelle dans le dos. (Photographies © William Claxton)

Page 20 :
1964, tailleur et bas marron et noir en maille (collection de l'auteur).

Page 22 :
1965, ci-dessus, larmes géométriques. (Photographie © William Claxton)
1966, ci-dessus à droite, modèles en vinyle pour Montgomery Ward (collection de l'auteur).
1966, ci-dessous à droite, décalcomanies en vinyle et bikini (photographe inconnu).
1966, à Londres, vêtue du costume « Ringo » (avec Dennis Deagan et Sir Mark Palmer). (Photographie © William Claxton)

Page 24 :
1966, à gauche, tenue de petite fille en lainage violet avec pois en vinyle jaune appliqués.
1965, à droite, costume « Ringo » en laine beige et noir.

Page 25 :
Eté 1967, Madame Vieux-Jeu et Mademoiselle Dans-le-Vent

Page 26 :
1971, quilt pour Knoll International.
1971, à droite, mini-robe en lainage avec un motif en trompe-l'œil.

Page 28 :
1970, unisexe. (Photographie © Patricia Faure)

Page 29 :
1973, au verso, armure en plastique créée pour une promotion Max Factor.

Page 32 :
1974, ci-dessus, « Rudi Gernreich », le parfum créé pour American Essence.
1983, à droite, Rudi en chef invité au Cadillac Café de Los Angeles.

Page 35 :
1974, ci-dessus, le *thong*.
En haut à gauche, publicité humoristique sur le *topless swimsuit*, 1970 (avec la permission de l'agence de publicité J. Walter Thompson).
Au centre, couverture de *Time Magazine*, 1er décembre 1967. (Copyright © 1967 Time Warner Inc. Réimpression autorisée.)
1976, en bas à gauche, Rizzoli a demandé à plusieurs stylistes réputés de créer des vêtements de fantaisie pour une exposition. Rudi a habillé ce couple avec des pièces détachées de bicyclette. (Photographie © W. Claxton)

Page 36 :
LE CERCLE DANS LE CARRÉ
Un jour, à Vienne, un petit garçon se rend au jardin d'enfants et sa maîtresse demande à la classe de dessiner un carré sur une feuille de papier et de dessiner un cercle à l'intérieur de ce carré. Le petit garçon prend son crayon et dessine une énorme cercle qui touche les quatre côtés de la feuille. Quand il a fini, il court fièrement vers sa maîtresse. Elle regarde son travail et lui dit : « Mais Rudi, tu t'es trompé. Tu n'as pas suivi mes directives. » Et il répond : « Oui, mais c'est beau, non ? »

Des années plus tard, de l'autre côté du monde, une petite fille de quatre ans aux cheveux bruns enfile les chaussures trop grandes de sa sœur ainée, une longue robe rose et une cape bleu foncé. Puis elle sort de la maison clopin-clopant et se promène dans le quartier en criant à tous ceux qui veulent bien l'entendre : « Je suis Blanche-Neige ! »

L'essentiel de ce livre est un tendre souvenir illustré de ce qui s'est produit quand ces deux êtres se sont rencontrés.

1955, ci-dessous, le maillot à cinq boutons « style 6002 », probablement le maillot le plus copié de l'histoire. (Photographie © William Claxton) ; à droite le maillot à cinq boutons sur le mannequin Jimmy Mitchell. (Photographie © Tommy Mitchell Estate)

Page 37 :
JIMMY
J'ai entrevu Jimmy Mitchell pour la première fois quand j'étais adolescente et que je travaillais après l'école chez JAX à Beverly Hills. Un samedi j'ai vu entrer le couple le plus extraordinaire qui soit dans la boutique. Lui ressemblait à une sorte de petit Peter Lorre élégant et elle à un guépard à forme humaine. C'était Rudi et Jimmy Mitchell. Jimmy l'a aidé à lancer sa carrière et elle est restée son amie jusqu'à sa mort.

Elle ressemble toujours à un guépard.

Page 38 :
Milieu des années cinquante, maillots sans armature, d'après des vêtements masculins. (Photographie © Tommy Mitchell Estate)

Page 40 :
JAX
Quand j'étais adolescente, j'ai découvert une boutique extraordinaire à Beverly Hills, qui se nommait JAX. J'ai jeté un coup d'œil dans la vitrine et le ciel s'est fendu en deux, un coup de foudre géant m'a clouée sur place. Ce coup d'œil a changé ma vie pour toujours.

J'avais vu une robe qu'on appellerait aujourd'hui un caftan. C'était une robe courte en crêpe noir, barré de deux bandes verticales qui allaient de l'épaule gauche à l'ourlet. L'une des bandes était ocre et l'autre orange. La robe n'avait ni pince de poitrine ni ceinture. Elle était aussi droite qu'un kimono et pendait sur un cintre métallique. Je ne voyais qu'une chose, le corps qui n'était pas dans la robe. Ce que cette robe pouvait faire pour un corps, onduler, changer, envelopper, révéler un corps. Ce caftan avait été dessiné par quelqu'un qui aimait le corps. Cette personne devait être un danseur. Et quel choc par rapport aux autres vêtements de cette époque ! Tout, de la haute couture au catalogue Sears, était basé sur le « New Look » de Dior. Tous les vêtements de femmes dans le monde regorgeaient de milliers de pinces, de coutures, de tailles de guêpes, de jupons, de bustiers, de gaines. Même les anorexiques portaient des corsets pour se donner une taille de guêpe. Et voilà que je découvrais une réfutation suprêmement élégante de ce style, cette robe simple, sexy, parfaite, complètement logique, qui dessinait une nouvelle femme séduisante. Ce caftan suspendu sur son cintre me parlait de bras, de jambes, de pieds, de cous, de mouvement et pourtant elle pendait, immobile, attendant un corps qu'elle pourrait rehausser au lieu de le soumettre et de le tourmenter.

En regardant cette robe, j'ai pensé : « Je ne sais pas qui a dessiné ça, mais un jour je me marierai avec lui ou je travaillerai avec lui ou… »

1958, en haut à gauche, plaid de style « sud-ouest » (photographie © Patricia Faure) ; page 41 : en haut à droite, chapeau cloche en feutre coupé comme un carré court. Au centre, chapeau cloche en plumes (photographies © Tommy Mitchell Estate) ; en bas à droite, chapeau-cloche constellé de strass. (Photographie © William Claxton)

1960, à gauche, présentation d'un maillot typique de Rudi dans la vitrine de JAX.

Page 42 :
1963, en haut à gauche, pull-over d'homme en laine, type patchwork.
1962, ci-dessous, maillots de bain dans des coloris caractéristiques de Rudi, photo publicitaire pour la Ferus Gallery, Los Angeles, avec le marchand d'art Irving Blum. A droite, P. Moffitt posant au bord de la piscine d'un ami, vêtue d'un modèle masculin de maillot débardeur en jersey.

Page 44 :
Vacances 1962, en haut à gauche, maillot en jersey échancré et maillot à « hublot » ; en haut à droite, ensem-

bles en lin irlandais, vestes trapèze; au centre à gauche, robe en soie et flanelle à une seule manche; au centre à droite, robe en soie op-art noire et blanche; en bas à gauche, maillots «de plongeurs» en jersey; en bas à droite, tailleur bleu et blanc à motif de nappe damassée avec chemisier vichy. (Photos © Tommy Mitchell Estate)

Page 46:
LA PETITE ROBE NOIRE
En 1963, Rudi et moi présentons sa collection dans sa suite de l'hôtel Gotham à New York. Un jour un client nous dit, au cours de la présentation: j'ai exploré tout le marché à la recherche d'une jolie robe de cocktail noire et je ne parviens à la trouver nulle part. « Nous avions une robe en soie matelassée noire qui s'attachait avec une large ceinture à nœud à la taille. Je l'ai enfilée et lui ai montrée. Il l'a trouvée jolie. Quand je suis repartie me changer, et que Rudi me pressait («Allons, allons, Peggy!»), j'ai retiré la ceinture et je l'ai nouée autour de mon corsage, à la manière d'un obi, je suis ressortie et je l'ai montrée à l'homme comme si c'était un vêtement entièrement nouveau. Rudi contenait à peine un fou rire quand nous sommes retournés dans le vestiaire. Puis j'ai remis la même robe devant derrière, j'ai défait la fermeture-éclair jusqu'en bas, j'ai attaché la ceinture en la serrant étroitement autour de ma taille et j'ai présenté la robe pour la troisième fois. A ce moment, le client, sidéré, déclara: «Dire que j'ai sillonné toute la ville pour la parfaite petite robe noire et vous m'en montrez trois! Je ne sais pas laquelle acheter!» Rudi et moi avons éclaté de rire et expliqué à ce client que ces trois robes n'en étaient qu'une. C'est le seul styliste que je connaisse dont les robes pouvaient être enfilées le haut en bas et le devant derrière en restant magnifiques.

1963, nous devenons amis. Je porte une robe en patchwork.

Page 48:
1963, en haut à gauche, maillot de bain avec un haut en vinyle marron et un slip en jersey noir. Au centre, bikini en patchwork; en bas à gauche, maillot de bain jaune et orange en jersey à ceinture en vinyle; en bas à droite, maillot de bain à bretelles une pièce noir et rouge; à droite, maillot de bain en vinyle jaune.
1963, verso, maillots de bain en vinyle noir.

Page 53:
Automne 1963, à gauche: Rudi a remporté le prix Coty pour cette collection. Le tailleur en tissu écossais qui avait rendu Norman Norell tellement furieux parce qu'il associait un col châle et un col cranté est présenté ici avec un manteau en cuir de cheval. Les chapeaux sont des créations de Léon Bennett.
Automne 1963, «Chicago», ensemble composé d'une tunique très épaulée et d'une jupe en flanelle anthracite.

Page 55:
Automne 1963, robes en maille «Kabuki». (En haut à gauche et à droite, photographies © William Claxton; à dessous, photographie © Peter James Samerjan)
Automne 1963, à gauche, Don Bachardy dessine l'une des robes «Kabuki» dans notre appartement-atelier de Hollywood.

Page 56:
Automne 1963, à droite, tailleur-pantalon «Actor's Studio» très épaulé, en vigogne tabac.
Automne 1963, ci-dessous à gauche, robe en maille noire et brune avec casquette de jockey; ci-dessous à droite, modèle «High Noon» en flanelle grise. Ce modèle était amusant parce que la veste s'enfilait sur une autre veste si bien que même quand on avait enlevé la première, on en portait encore une. La chemise et les doublures étaient faites en gabardine de coton «blouse de coiffeur».

Page 59:
Eté 1963, ensemble en crêpe de soie associant deux imprimés noir et blanc.

Page 60:
Eté 1964, à gauche, robe en soie imprimée rose, turquoise, vert et noir de la collection «Van Dongen»; à droite, le tailleur «Dietrich» qui avait tellement consterné le comité du prix Coty – j'avais soi-disant l'air d'une lesbienne – qu'ils l'ont exclu du défilé.

Page 61:
MA JOURNÉE
Quand j'ai commencé à travailler avec Rudi en 1962, je vivais à Los Angeles. Je lui servais à la fois de mannequin d'essayage et de mannequin de défilé. Ce qui impliquait que j'accompagne Rudi à New York plusieurs fois par an. Nous séjournions à l'hôtel Gotham où Rudi louait une suite pour montrer sa collection.

Je me levais tous les jours vers six heures du matin, je prenais un bain, je me lavais les cheveux, je prenais mon café tout en composant un maquillage élaboré, je m'habillais et je grimpais deux étages pour rejoindre la suite de Rudi. Là, je m'asseyais et je bavardais avec Rudi pendant qu'il buvait son café et mangeait un œuf coque. Les rendez-vous commençaient vers huit heures trente ou neuf heures et s'étalaient sur toute la journée. Nous montrions la collection à des clients et à des rédacteurs en chef, en les recevant un par un, et j'étais en général le seul mannequin. Ce qui signifie

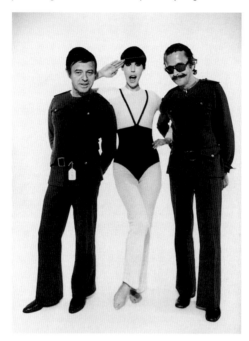

En compagnie de Jacques Faure, 1972

que j'étais tout le temps sur la brèche. Trois choses m'ont empêchée de devenir complètement folle dans ce train-train fatigant et fastidieux: c'était fascinant de partager l'intimité amicale et artistique de Rudi, l'ami et le créateur. Ses vêtements étaient si brillants que c'était toujours un plaisir de les porter. Et je me divertissais moi-même (et le public) en considérant la collection comme un jeu dont chaque nouveau modèle constituait un nouvel acte ou un nouveau personnage. Cela signifiait que la collection avait un commencement, un milieu et une fin émotionnelles avec une tension dramatique, des plaisanteries et un côté burlesque. En fait, je ne présentais pas seulement les modèles, je les «jouais».

A la fin de notre journée de travail, nous sortions ensemble. Nous passions souvent des soirées avec des gens du milieu de la mode. Une fois, nous avons assisté à une représentation du cirque de Moscou. Nous allions parfois au cinéma ou au théâtre, mais en général nous sortions seulement pour dîner. Parfois, nous dînions dans de grands restaurants comme le *Lutèce*, mais la plupart du temps nous choisissions des endroits calmes et sans prétention. L'un de nos préférés était un restaurant grec proche de la 42e rue qui s'appelait le *Panthéon*. Après dîner, nous rentrions à l'hôtel à pied par des rues pleines de prostituées et de maquereaux et nous chantions des chansons. La préférée de Rudi était: *Falling in Love Again*. Et il la chantait toujours au moins une fois en rentrant chez lui.

Page 63:
Eté 1964, robe en soie «Van Dongen» avec foulards cache-col et manches plissées.

Page 65:
Eté 1964, à droite, il y aura toujours des clowns, celui-ci est Art deco, en robe de coton à fronces avec des pois noirs flous. Sur la page de gauche, cliché en pied du tailleur Dietrich en satin de soie blanc avec un chemisier en soie blanche. En haut à gauche, robe en soie à imprimé blanc et rouge. En bas à gauche, tunique en crêpe de soie grège sur une jupe en crêpe de soie noir.
1964, verso, un moment de rigolade dans le photomaton de la jetée de Santa Monica, avec Rudi et Bill.

Page 70:
LES CLICHÉS QUI ONT FAIT LE TOUR DU MONDE
Pensez à un événement de votre vie qui aurait pris un soixantième de seconde: mais que vous deviez passer le reste de votre vie à en parler. Voici le *topless swimsuit*, probablement la photo de mode la plus célèbre de tous les temps et ma bête noire.

Je pense toujours que c'est une belle photographie. Mais comme je suis fatiguée d'en parler!
1964, ci-dessus, le premier modèle de *topless swimsuit*. Page de droite, le seconde modèle de *topless swimsuit*, qui est devenu célèbre.

Page 72:
Automne 1964, j'avais vu la première rétrospective des photographies de Jacques-Henri Lartigue au Musée d'Art Moderne et elle m'a tellement captivée que j'y suis retournée avec Rudi. Rudi était très impressionné et a dit, au moment de partir, «J'allais faire une collection indienne, mais je ne peux plus maintenant, même si j'ai commandé les tissus.» Le résultat fut cette collection, la préférée de Rudi. Les photographies de Lartigue sont le brillant reportage d'un enfant sur la Belle Epoque. Grâce à elles, on peut voir comment Rudi a perçu les vêtements du début de ce siècle et en a tiré des modèles modernes et excitants. Rudi a toujours regretté que le tumulte provoqué par le *topless swimsuit* ait éclipsé cette collection, qu'il trouvait plus innovatrice que toutes les autres.
Automne 1964, à gauche, manteau en poil de chameau réversible beige et noir, avec chapeau de feutre noir «Yashmak». Tous les chapeaux de cette collection ont été réalisés par Léon Bennett; page de droite, robe en poil de chameau assortie au manteau, complètement réversible.

Page 75:
LA PENDERIE
Quand j'ai commencé à montrer les vêtements de Rudi à New York, Rudi et une habilleuse m'aidaient à me changer et je portais toujours un soutien-gorge, par pudeur (je ne portais jamais de soutien-gorge dans la vie quotidienne quand je portais ses vêtements.) Après avoir travaillé quelques saisons, je lui ai dit ceci: «Je ne rends pas service à tes vêtements en portant un soutien-gorge. Ils ont tellement meilleure allure sans. Désormais, je me changerai dans la penderie et vous n'aurez qu'à remonter la fermeture éclair quand je sortirai.» J'ai donc passé des heures chaque jour à entrer et sortir de la penderie, ce qui était éreintant, vu que les vêtements étaient de plus en plus difficiles à enfiler. Finalement, à l'époque où la première photo du *topless swimsuit* est parue, il s'avéra impossible pour moi d'enfiler rapidement les modèles de la collection que nous montrions toute seule. A chaque changement il fallait enfiler des collants, des cuissardes, des bottes à fermeture éclair, une tunique, une robe, un chapeau qui couvrait le visage, un manteau réversible … vous imaginez la scène! C'est pourquoi j'ai annoncé officiellement à Rudi et à l'habilleuse qu'à dater de ce jour, j'allais me changer devant eux parce que j'avais besoin de leur aide et tant pis pour la pudeur. Tous les autres mannequins sont venus à l'essayage et se sont instantanément mises en petite culotte sans se poser de question. Il y avait des soutien-gorge partout. Ils pendaient au lustre du salon d'essayage. Rudi a adoré ce moment. Et c'est comme ça que je suis sortie de la penderie.

Automne 1964, page de gauche, combinaison pantalon d'aviateur, avec manteau réversible en poil de chameau;

page de droite, premier ensemble en maille avec collants assortis marine et blanc nacré avec des escarpins vert acide.

Page 77 :
Automne 1964, page de gauche, une Marie-Antoinette moderne porte une longue robe en soie noire semée de boutons de rose roses (la jupe a été repliée sous la ceinture pour révéler des pantalons moulants assortis.); à sa droite, le chemisier en soie rouge rebrodé d'or tranche sur une culotte bouffante en soie noire également rebrodée d'or; page de droite, un « soldat japonais » en lainage écossais gris et lavande porte des guêtres assorties; à sa droite, la jeune fille au chat est vêtue d'un ensemble tunique-pantalon « Mozart » en tweed brun, beige et noir.

Page 78 :
Automne 1964, à gauche, des tons vert acide et chocolat pour cette robe du soir en jersey mat; à droite, un ensemble pantalon en toile de ciré sur un chemisier transparent en soie laquée noire.

Page 80 :
Automne 1964, les premières photos de mode de Barbra Streisand parues en couverture du magazine *Show*; ci-dessus, manteau en tweed noir et blanc à chevrons, doublé d'une fourrure en synthétique; ci-dessous, Rudi et Barbra, vêtue d'un ensemble en poil de chameau réversible; page de droite, coiffée de plumes de coq noir.

Page 82 :
Automne 1964, ci-dessus, grand manteau de tweed sur une robe en tweed plus ajustée et coiffe en plumes de coq. (Photographie © David Bailey, collection de l'auteur); à la manière d'une photographie de Lartigue, à gauche, ensemble pantalon en poil de chameau, et, page de droite, robe de cocktail en mousseline de soie noire imprimée avec voilette assortie. (Photographies © Jerry Schatzberg, collection de l'auteur)

Page 84 :
Eté 1965, ci-dessus, Peggy Moffitt avec Lydia Fields et Léon Bing, toutes trois coiffées de visières pare-soleil créées par Layne Nielson; à droite, maillot de bain débardeur en maille, cuissardes et visière pare-soleil. Les bottes sont de Capezio, comme toutes les bottes et les chaussures que Rudi utilisait pour ses modèles.

Page 86 :
Eté 1965, page de gauche, maillot en jersey noir et ceinture en cuir verni noir, cuissardes en vinyle noir et visière pare-soleil violette; page de droite, bikini en jersey ocre avec cuissardes vert acide en vinyle, ceinture en vinyle orange et visière pare-soleil jaune.

Page 88 :
Eté 1965, en haut à gauche, robes de cocktail en mousseline de soie « Klimt » photographiées dans la demeure de Brooke Hayward et Dennis Hopper, avec le producteur de télévision Bert Bertman, le marchand d'art Irving Blum et le peintre Billy Al Bengston. Assis sur le sol, le fils de Brooke et Dennis Hopper; en haut à droite, l'ensemble en soie « petit garçon » photographié avec Steve Mac Queen; au centre, Peggy Moffitt qui porte un ensemble tunique-pantalon de safari en lin est photographiée avec les Byrds; page de droite, en robes de soie à imprimés « Kandinsky » dans le restaurant *La Scala*, à Los Angeles, avec le propriétaire Jean Leon.

Page 90 :
LE « LOOK TOTAL »
Au début des années soixante, je rencontrais sans cesse Rudi à des fêtes et dans des soirées. Je l'admirais et un soir je le lui ai dit. Mais j'avais tout de même une réserve : je pensais que ses vêtements qui étaient si spirituels, si amusants, étaient présentés sans beaucoup d'humour. Il régnait alors une image de la « femme américaine idéale » qui avait beaucoup d'argent et passait sa vie dans une ambiance factice où les clubs de loisirs jouaient un grand rôle. Je voyais l'influence de l'humour européen et de la pureté orientale dans le travail de Rudi.

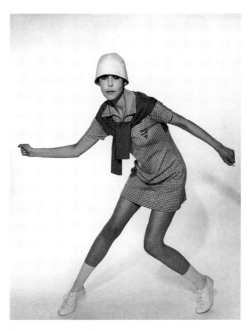

Robe en trompe-l'œil, 1973

Un jour, Rudi m'a appelée pour me dire qu'il allait créer une ligne de vêtements junior et qu'il voulait que je la présente pour lui. (Il pensait que j'étais trop jeune pour sa ligne normale.) J'ai commencé à faire des essayages et comme les lignes de vêtements junior ressemblaient à sa ligne normale, nous avons commencé à travailler ensemble sur tous les modèles.

Nous nous sommes immédiatement bien entendus. Nous avions les mêmes idées et échangions nos points de vue sur toutes sortes de sujets. Ce qui m'inquiétait le plus dans son travail, au début de notre collaboration, était une certaine ambiance « bohème » dans ses présentations. Il ne se souciait nullement qu'un beau tailleur novateur en tweed soit porté par un mannequin pieds nus ou que l'ourlet d'une robe en soie parfaite ne soit pas droit … Moi si, et je lui ai dit qu'une paire de chaussures pouvait faire toute la différence. Rudi prit ce conseil à cœur et il inventa peu de temps après le *Total Look* dans lequel la robe était assortie au caleçon, aux collants, au chapeau. N'importe qui d'autre se serait contenté de me donner des accessoires convenables.

Eté 1965, ensemble pantalon « Gauguin » vert-jaune, turquoise, rose, jaune et abricot en mousseline de soie. Le pantalon est coupé comme un jean.

Page 93 :
Eté 1965, Rudi a finalement réalisé sa collection indienne; page de gauche, une tunique en lin orange avec des pantalons en lin rose (photographie © William Claxton); à droite une veste Nehru en soie safran; ci-dessus, des pendants d'oreilles miroir par Layne Nielson. (Photographies © Peter James Samerjan)

Page 95 :
Eté 1965, combinaison moulante « seconde peau », avec des manches et des jambes extra-longues en jersey mat aux couleurs vives. A droite, des hauts en crêpe de soie noir et blanc se superposent à ces combinaisons « seconde peau ».

Page 96 :
Eté 1965, ci-dessus, costumes indiens photographiés à Watt Towers à Los Angeles. Le costume rose se compose d'une jupe et d'un pantalon, la première se portant sur le second. Au centre, l'acteur James Coburn et en bas à gauche Layne Nielson. (Layne a réalisé les accessoires de Rudi durant de nombreuses années, à partir de 1965); page de droite, avec Lydia Fields et Léon Bing, nous portons le point rouge, marque de caste que j'avais découpée dans des échantillons de vinyle et qui ont inspiré Rudi pour les décalcomanies qu'il a réalisées plus tard.
1965, verso, la publicité pour l'anti-soutien-gorge. (Photographies © Richard Avedon, avec la permission d'Exquisite Form)

Page 100 :
Automne 1965, ci-dessus, robe en maille à smocks bleue et noire avec collants assortis; page de droite, robe en maille noire et blanche avec bandes vert acide et collants rayés noirs et verts.

Page 103 :
Automne 1965, en haut et en bas à gauche, les « nuits arabes » de Rudi : veste réversible et jupe avec manteau réversible en lainage anthracite/orange; page de gauche, à droite, robe en laine jacquard anthracite et grise avec chaussettes montantes assorties; page de droite, cape réversible en lainage pied-de-poule dans des tons beiges et bruns.

Page 104 :
BOUTONS ET FAVEURS
La plupart des stylistes de mode sont en fait ce que j'appelle des « faiseurs de robes ». Les bons savent faire de belles robes sophistiquées qui ont une petite courbe ici, une grosse faveur là, un camélia en soie sur le cou: leur travail s'apparente beaucoup à la réalisation d'abat-jour chers. Les robes qu'ils font sont exactes et adaptées à leur époque, à l'âge et à la richesse de celle qui les porte ainsi qu'aux tissus et matériaux disponibles. Ces couturiers produisent ce qu'on appelle la mode. Ce qu'ils fabriquent ne peut pas être transposé dans d'autre étoffes et conserver son intégrité sans sacrifier la qualité intrinsèque du vêtement. Pensez à une robe de bal en taffetas imprimé de roses cent-feuilles. Maintenant, imaginez-là en tweed Harris. Ça ne fonctionne tout simplement pas.

Le design, en revanche, doit être envisagé d'un tout autre point de vue. S'il est rigoureux, pur et fonctionnel, il peut être interprété dans différents matériaux et être indéfiniment réutilisé. La mode finit par se périmer, le bon design, non. La mode crée des problèmes, le design les résout.

La robe à trois volants de la page de droite reprend le même dessin que celle de la page 45, en mousseline de soie beige, marron et noire. C'était comme de porter un nuage. Ici, elle est coupée dans un lainage à plusieurs motifs. Elle a une allure complètement différente et la sensation quand on la porte est tout autre. Elle reflète le style excentrique et le rythme des années soixante. Comme elle traduit un design pur, elle pourrait être réalisée dans des dizaines d'étoffes et des longueurs différentes en restant toujours juste et contemporaine. Là réside l'élément essentiel du talent de Rudi. Ses dessins pouvaient être réinterprétés à l'infini.

Page 105 :
Automne 1965, page de gauche, tunique noir et blanc en maille avec pantalons et mi-bas noir et blanc; page de droite, robe à trois volants en maille avec collants assortis blanc cassé, gris et noir.

Page 106 :
« NANAS »
Il me semble que toutes les vraies grandes formes classiques dans la mode féminine proviennent des vêtements masculins. Des toges aux sarongs, aux kilts et aux robes de moines, aux robes-chemises et aux trench-coats, tout a commencé avec les hommes, sauf la robe Empire qui est magnifique et très féminine. Rudi en a réalisé des centaines et nous les avons appelées robes « Nana ».

1965, ci-dessus, sur le *Queen Elizabeth*, deux marins et une robe « Nana ».
1965, page de droite, maillot de bain, haut en jersey lavande avec de gros pois en vinyle rouge, bikini lavande avec des jarretelles amovibles en vinyle rouge et collants maille « filet » blanc cassé.
1965, Londres, pages 107 – 110, les maillots de bain présentés à l'occasion de la remise du prix de la mode du *London Sunday Times*. (Rudi m'obligea à les prendre, parce qu'il avait peur d'être arrêté par les douaniers et jeté en prison si on les trouvait dans ses valises.)

Page 108 :
1965, en haut et en bas à gauche, tourisme à Londres. (Nous formions un trio merveilleusement improbable dans les rues de la ville : Bill mesure un mètre quatre-vingt-

douze, Rudi, un mètre soixante-sept et je me situe entre les deux, avec mes paupières ombrées de rouge.
1965, ci-dessus, maillot de bain avec jarretelles détachables en vinyle rouge, collants maille filet rouges et applications de vinyle rouge; à droite, haut en maille synthétique vichy bleu et blanc avec un bikini rose et blanc et ceinture assortie.

Page 111:
1965, Paris, ci-dessus, Bill me rend une visite surprise dans la salle de bains plus que modeste de notre hôtel; à droite, je suis interviewée dans le meublé un peu plus cossu de Rudi, au Crillon; au verso, une séance de pose avec Jean-Loup Sieff.
1965, à gauche, maillot de bain noir en jersey, collants en maille filet et longues bretelles-rayures en vinyle rouge.

Page 114:
1966, Londres, pages 114–119, Bill et moi avons pris une série de clichés pour le magazine *Queen* sur la collection d'été de Rudi, en utilisant des tissus de satin Tzaim Luksus's destinés à la lingerie. Vidal Sassoon a conçu les coiffures; ci-dessous et à droite, longue robe droite du soir imprimée dont le col foulard peut se nouer sur la tête ou se porter en col boule.
1966, à gauche et ci-dessous, robe du soir Empire dans des tons argent et blanc à imprimés de triangles; au centre, longue robe-chemise orange et blanche à motif «positif-négatif» de flèches.

Page 118:
1966, à gauche, robe Empire courte orange et blanche à imprimés de triangles; ci-dessous, pantalon blanc et noir à motif «positif-négatif» de flèches avec une tunique en satin blanc ornée d'une broche en mosaïque de miroir; page de droite, le costume «petit garçon» avec un débardeur qui a fait la couverture de *Queen*.

Page 120:
1966, tirée de l'affiche de notre film *Basic Black*, la «Goya lady» velours noir rasé sur mousseline de soie.

Page 121:
1966, pages 121–123, (Peggy Moffitt, Léon Bing et Ellen Harth) photos prises sur le tournage du court-métrage *Basic Black* dans lequel Rudi exposait le «Look total». Les «animaux» ôtaient leur manteaux ou vestes en vachette peints au pochoir pour révéler des robes, puis des collants, des culottes et des soutiens-gorge assortis. Les modèles du film ont valu à Rudi son second prix Coty et le film lui-même a remporté de nombreux prix.

Page 125:
Eté 1967, robe «cerf-volant» rouge, blanc et marine avec décalcomanies en vinyle rouge.

Page 126:
Eté 1967, à gauche, chemisier rose avec minijupe verte en maille, caleçon et mi-bas assortis; page de droite, caftan «sumo» en soie violet, orange et blanc.

Page 128:
ELLEN
Belle Ellen Harth, la divine allemande. Je n'oublierai jamais le jour où elle est arrivée dans le show-room avec son regard si résolu. Elle a traversé la pièce où nous nous trouvions sans dire bonjour. Après un instant de silence sa puissante voix teutone a retenti: «Whoodie, where is my wed dwess!» («Whoodie, où est ma feste rouches!»)

Eté 1967, à gauche, Ellen Harth: soutien-gorge rouge en maille avec pantalon de marin taille basse en jersey retenu par une ceinture blanche.
Automne 1967, page de droite en haut, robe en maille avec motifs colorés imprimés en relief; en bas, minirobe en maille décolletée «sous le nombril» avec caleçons assortis. Cette collection a valu à Rudi le prix Coty «Hall of Fame».

Page 130:
Automne 1967, «l'écolière japonaise», robe en maille à petits carreaux noir et blanc avec nœud papillon rouge;

page de droite, «l'écolier japonais», tunique en maille noire avec nœud papillon rouge et shorts noirs.

Page 132:
Automne 1967, robes-tabliers «opéra chinois» et ensemble pantalon avec tunique en soie associant différents imprimés; page de droite, minirobe en crêpe avec longs pendants d'oreilles en chapelets de fleurs d'organza.

Page 135:
Automne 1967, manteau en tweed «Pierrot», noir, blanc et gris avec pendants d'oreilles en plumes de faisan.

Page 136:
Automne 1967, en haut à gauche, tenue «Officier de cavalerie autrichien» avec frise rebrodée en vinyle; en bas, ensemble pantalon «George Sand» en velours côtelé porté sur un chemisier en satin. La veste est garnie de petits boutons en laiton à têtes de lion.
Automne 1967, page de droite, minirobe transparente en mousseline de soie laquée et crêpe de laine.

Page 138:
Automne 1967, à gauche, tailleur-pantalon gris et noir à fines rayures «George Raft»; page de droite, à gauche, robe droite «Ophélia» en mousseline de soie verte et noire; à droite, Léon Bing en «bonne sœur» dans une robe droite en maille blanche sous une chasuble noire en maille.

Page 139:
LÉON
Rudi s'attaquait à tous les tabous. Ici, Léon Bing en sœur de l'Immaculé Mascara (qui n'est pas un ordre silencieux!). Léon est réputée pour ses plaisanteries divines et sa façon très joyeuse de prendre le voile. Cette tenue, si choquante qu'elle paraisse d'abord, consiste en deux charmantes robes toutes simples portées l'une sur l'autre.

Page 141:
Automne 1967, page de gauche, robe de «Pierrot» en coton argent, rebrodée et constellée de sequins Mylar. Chapeau recouvert de petits miroirs carrés; page de droite, «tenue de motard»: combinaison pantalon avec casque à visière et veste en laine à carreaux noire et beige.

Page 142:
LE MAQUILLAGE N'EST PAS UNE SINÉCURE
Les vêtements de Rudi m'inspiraient tellement que j'ai conçu mon maquillage en fonction d'eux. Ça n'a pas toujours été facile. La collection de l'été 1965 ne comportait pas seulement des vêtements inspirés par la civilisation de l'Inde de l'Est mais aussi des maillots de bain de l'ère spatiale, de petites robes en mousseline de soie, des robes en lin et des ensembles-pantalons. J'ai résolu ce problème en utilisant une marque de caste rouge amovible pour les tenues indiennes.

Pour la collection de l'automne 1967, j'ai voulu créer un maquillage basé sur le personnage de la Mort dans le *Septième Sceau*, le film d'Ingmar Bergman. Il y avait quelques modèles d'allure assez sinistre dans la collection de Rudi et j'ai pensé qu'un maquillage style «tête de mort» serait approprié. Le seul problème, c'est que cette collection montrait aussi des tenues d'écoliers japonais, une «Ophélia» et des robes d'opéras chinois. J'ai donc blanchi mes sourcils et j'ai dessiné d'énormes yeux noirs (de tête de mort) et quand j'apparaissais sous les traits d'un enfant, je rabattais ma frange sur mon front.

Le plus étonnant exemple de ma connivence avec Rudi s'est produit en 1968, lors de la présentation de la collection d'été. A cette époque, je vivais à New York et je n'avais pas la moindre idée de ce à quoi devait ressembler la collection de Rudi. Juste avant qu'il arrive, quelque chose m'a poussée à me composer un visage siamois très exotique. Quand j'ai vu les vêtements et que Rudi a vu le maquillage, ni l'un ni l'autre n'en avons cru nos yeux. On avait l'impression qu'une seule et même personne avait conçu les deux. Je m'étais dessiné des lignes rouges qui entouraient les yeux et formaient une pointe sur le nez comme un tatouage. Mais il n'y avait que quelques modèles siamois dans cette collection, les autres n'étaient pas orientaux du tout. Ce qui signifiait que je

devais me peindre ce masque sur le visage en plein milieu du défilé. Je suis allée dans un Prisunic et j'ai acheté un masque noir de Halloween, je l'ai coupé et je m'en suis servi comme pochoir. Il ne restait plus qu'un problème. Rudi insistait absolument pour que le dernier modèle du défilé soit une petite robe noire bouffante en mousseline de soie avec des pendants d'oreille en plumes noires (et elle n'était pas siamoise). Que faire? J'ai enfilé le masque dont je m'étais servi comme pochoir et je suis devenue la plus élégante cambrioleuse du monde.

Le dernier défilé de Rudi en 1981, posa un problème encore plus délicat. Il devait se dérouler dans une boîte de nuit nommée la Cage aux Folles et les producteurs du défilé voulaient que Rudi se serve des travestis du cabaret comme mannequins. Lui ne voulait pas en entendre parler et détestait l'idée d'avoir à montrer ses modèles dans ce cabaret. Il me demanda de le conseiller. J'ai suggéré que je pourrais porter une moustache. Il a adoré l'idée. La toute dernière robe que j'ai portée pour Rudi était donc une longue robe sexy – avec moustache. Le public a applaudi à tout rompre et les travestis qui étaient dans le public sont ceux qui ont le plus aimé cette idée. Je suis contente que notre dernière apparition professionnelle ensemble se soit achevée par un clin d'œil.

Automne 1967, à gauche, tunique et jupe en velours noir à grosses côtes et larges manchettes en satin blanc; page de droite, la «Sorcière», vaste robe de coton noir rebrodée et semée de sequins noirs.

Page 144:
Eté 1968, à droite, long pantalon et chemisier assorti en soie de la série «siamoise»;
Eté 1968, ci-dessous, le pan de cette robe en shantung de soie qui passe entre les jambes se fermait avec des boutons-pression dans le dos. Quand on l'ôtait, il restait une robe toute simple sans rien de siamois. Rudi savait parfaitement réduire un dessin à l'essentiel.

Page 146:
Eté 1968, à gauche, longue robe noire en jersey mat. Quand on tirait le pan de l'entrejambe vers le haut et qu'on le rejetait sur une épaule, la robe se transformait en pantalon court; page de droite, chemisier et pantalon en coton imprimé jaune, bleu et blanc, short en coton imprimé marine, rouge et blanc. Les chapeaux sont en soie.

Page 148:
UNE VILLE MARRANTE
A la fin des années soixante, New York a traversé une période très troublée et devenait un endroit où les gens avaient peur de séjourner. La Chambre de Commerce a décidé de lancer une campagne publicitaire montrant

Esquisse de Rudi pour le pubikini, 1985

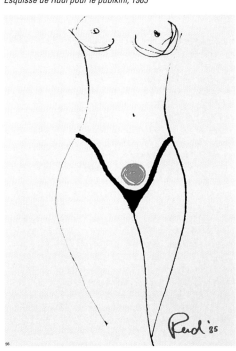

quelle ville délicieuse c'était et ils ont inventé le slogan de « ville marrante ». On voyait des affiches avec ce slogan partout, dans les magazines, sur les bus et sur les panneaux d'affichage. Partout où on posait les yeux, on voyait « Une ville marrante ».

A peu près à cette époque, Bill et moi sommes rentrés d'Europe. Nous avons décidé de nous installer à New York et trouvé un appartement sur la cinquante-septième rue. Au lieu de rentrer à l'hôtel Algonquin après le travail, avec Rudi, je devais traverser seule Time Square et l'effrayante quarante-deuxième rue. Evidemment, si j'arrivais à attraper un taxi, je m'engouffrais dedans, mais je n'en trouvais presque jamais. Un certain soir mémorable, j'étais debout à l'angle de la quarante-deuxième et de la septième avenue, attendant que le feu passe au rouge, quand j'ai remarqué un groupe de gens de l'autre côté de la rue qu'il allait falloir que je traverse. Il y avait des prostitués, hommes et femmes, des travestis, des dealers, des gens couverts de tatouages, d'autres avec des os qui leur traversait le nez et au centre un nain cul-de-jatte, sur une petite planche à roulettes. Détournant le regard, j'ai commencé à traverser la rue et à ce moment, le nain a commencé à me pointer du doigt et à hurler aux autres : « Regardez-là, regardez-là, ce qu'elle est moche ! »

Ce n'était qu'une délicieuse journée de plus dans la vie d'un mannequin de mode dans la « ville marrante ».

Page 149 :
Eté 1968, Léon Bing porte des robes !!! kimono en soie imprimée à brocart métallique « obis » et avec de larges ceintures en vinyle.

Page 150 :
Eté 1968, les « zouaves » : ci-dessous à gauche, tunique en lin beige avec jupe bouffante en piqué de coton blanc ; ci-dessous à droite, ensemble en lin beige avec ceinture en taupe ; page de droite, tunique et culotte bouffante en lainage écossais à grands carreaux beige et blanc cassé sur un chemisier en coton blanc.

Page 152 :
SEPTIÈME AVENUE
Deux clients habillés de façon ringarde qui venaient d'une petite ville de province entrèrent dans le showroom à New York, la semaine où Rudi faisait la couverture du *Time*. Ils s'avancèrent vers lui – il était là, par hasard – et lui demandèrent : « Montrez-nous ce que vous avez comme pulls ornés de bijoux. » Ah, la gloire !
Eté 1968, ci-dessus et page de droite, une robe en maille avec incrustations en vinyle transparent. Ces deux robes ont paru avec Rudi sur la couverture de *Time*.

Page 154 :
HAUTE COUTURE OU GRAND CONFORT ?
Certains critiques ont prétendu que les modèles de Rudi étaient d'une confection médiocre. Ce n'est pas vrai. La qualité de la fabrication était irréprochable. Mais ils n'étaient pas conçus comme des vêtements de haute couture. Rudi ne recouvrait pas un bouton-pression d'organza s'il n'avait pas besoin d'être recouvert. J'ai compris la différence entre ces deux écoles quand j'ai été photographiée à Paris lors d'un défilé et que j'ai présenté un caftan d'une grande maison parisienne de couture. Il était très beau sur cintre mais quand je l'ai enfilé, j'ai découvert qu'à l'intérieur, cette forme flottante se doublait d'une robe fourreau corsetée avec des poids en plomb lestant les pans du vêtement. Ces poids me battaient les chevilles quand je marchais et la robe intérieure était si serrée que je ne pouvais marcher que tout doucement, à petits pas.

Pour moi, l'intérêt d'un caftan, c'est la liberté de mouvement. Les nomades ont traversé les déserts pendant des siècles dans ces merveilleux vêtements confortables. Il y a de la beauté et de la sensualité dans ce confort ; toute la séduction du caftan est là. Les avocats des méthodes de confection de la haute couture (presque toujours des hommes) m'ont répété pendant des années que telle ou telle robe est magnifique parce qu'elle est si raide et structurée qu'elle peut tenir debout toute seule. Ma réponse a toujours été : « Ainsi soit-il. Elle n'a pas besoin de moi pour la faire tenir debout et je n'ai pas besoin de la torture qu'elle va m'infliger. »
Voici l'un des caftans de Rudi. Il est en soie et il est

doublé soie de Chine. C'est tout. Il glissait et ondulait sur mon corps nu et j'avais l'impression que mille mains de bébé me caressaient.

Eté 1968, bikini en jersey noir à bretelles en vinyle transparent.

Page 155 :
Eté 1968, caftan en soie noir et blanc, à damiers et pois jaunes.

Page 156 :
Eté 1968, à gauche, robe de cocktail noire en mousseline de soie bouffante et pendants d'oreilles en plumes ; page de droite, maillot de bain en jersey et genouillères inspirées des tenues de surf.

Page 158 :
SUR LA PLAGE
Lors d'un voyage à Mexico, Rudi n'a pu s'empêcher d'aller sur la plage de nudistes locale. Et là, une belle fille nue s'est approchée de lui et lui a lancé : « Oh, Monsieur Gernreich, j'adore vos maillots de bains ! »
Eté 1968, ci-dessus, maillot de bain en jersey garni de

Rudi chez lui, 1975

bandes « sport » en vinyle transparent ; à droite, robe de plage noire en jersey avec col en vinyle transparent et bikini avec incrustations en vinyle.

Page 159 :
Eté 1968, maillot de bain en jersey noir à décolleté « sous le nombril » avec ceinture en cuir verni.

Page 160 :
LAYNE
Quand je suis revenue d'Europe en 1966, j'ai été époustouflée par l'évolution du travail de Layne Nielson, l'assistant de Rudi. Les accessoires qu'il faisait étaient incroyables, qu'il s'agisse des chapeaux garnis de plumes portés sur une tenue noire basique ou des pendants d'oreille en fleurs d'organza amidonnées et pressées de la longueur d'une robe. Pour la série siamoise il a créé des protège-doigts en papier laqué et des bijoux inventifs assortis. Il y avait un chapeau que nous n'avons jamais photographié et dont je me souviendrai toujours. C'était une petite calotte noire avec une plume noire souple qui jaillissait du sommet du chapeau. La plume mesurait six mètres de long. Quand le mannequin qui portait ce chapeau quittait la pièce, il fallait à la plume encore une minute et demi pour disparaître. Ci-contre, un des chapeaux à plumes de Layne. Il a passé des heures à coller les plumes sur les bottes assorties (voir page 162). Layne a créé le délicieux glaçage du gâteau de Rudi. Cette collection contenait certaines de ses créations les plus spectaculaires.

Automne 1968, coiffe et boa en plumes de coq.

Page 162 :
Automne 1968, avec Rudi. Tunique de laine noire à man-

ches gigot, chapeau, boa (page précédente) et bottes de plumes ; page de droit : veste, combinaison bouffante et chapeau lainage écossais en camaïeu de gris.

Page 164 :
Automne 1968, gamme « Beardsley ». En haut : l'ensemble en lainage écossais dont la veste ouverte laisse entrevoir le haut en mousseline de laine de la combinaison bouffante ; page de droite : la combinaison sans la veste ; à gauche, au centre et en bas : culotte bouffante en tweed, chemisier mousseline et tweed.

Page 166 :
Automne 1968, à gauche : tailleur pantalon à veste réversible « Duc de Windsor », en tweed beige et vert. Page de droite : combinaison jodhpur courte en flanelle grise « Genghis Khan » et spencer vinyle et velours, sous une veste vinyle et toile.

Page 168 :
Automne 1968, la « Reine des Neiges » : imitation vison blanc et mousseline, veste en velours blanc brodée. Page de droite : veste en mouton blanc brodée, débardeur et pantalons bouffants en satin noir.

Page 171 :
Automne 1968, à gauche : robe et collants « Typographie » noir et blanc, écharpe soie « signature » ; à droite, tunique Renaissance en maille à motifs anthracite et vert-de-gris, incrustée de maille écrue et collants maille assortis.

Page 172 :
Automne 1968, à gauche, robe « Nana » à volants de mousseline noire ; page de droite, trench-coat de satin noir sur collants de crêpe noir.

Page 174 :
A la maison à New-York, 1970. A gauche, Bill et moi portons des caftans dessinés par Rudi ; en bas, en combinaison de maille noir et blanc. Page de droite : Rudi au travail, à Los Angeles, 1966.

Page 176 :
Automne 1968, en haut, tunique en maille à rubans, collants assortis. Au centre, tutu de tweed, chemise en mousseline et en tweed, collants à rubans élastiques. En bas à gauche, minirobe Renaissance avec entre-deux blanc cassé et collants assortis. En bas à droite, tunique maille et collants assortis. Page de droite, pull et pantalon en maille côtelée, col-fraise et poignets à volants.

Page 179 :
Automne 1970, collection maille. Page de gauche, le mannequin Diana Newman en longue robe topless de jersey noir mat et décalcomanies. Ci-dessus, en haut : combinaison dont le haut est en maille noire, pantalon et jupe à bretelle unique, amovibles. A gauche : robe longue à dos nu en maille noire, ceintures rouge et blanche. Au centre et à droite : combinaison et jupe maille à carreaux gris et blancs. (Photographies © Patricia Faure)

Page 180 :
1969, combinaison en mousseline translucide pavée de miroirs, casque et bottillons à miroirs. Ce modèle fut dessiné et photographié pour le numéro de Noël de *McCALL's*.

Page 182 :
1970, l'unisexe, vision du futur. Rudi a prédit que le vêtement perdrait son identité masculine ou féminine : « Les hommes comme les femmes porteront des jupes … l'esthétique de la mode aura trait au corps proprement

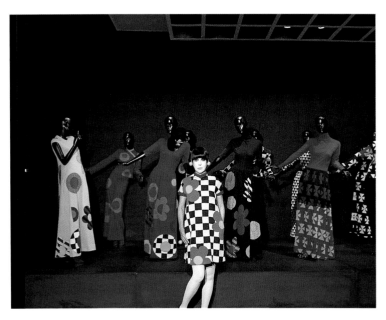

Présentation posthume de tenues de 1973, Otis Parsons Art Sustitute, 1985

dit. » Les mannequins pages 182 à 187 sont Renée Holt et Tom Broome. (Photographies © Patricia Faure)

Page 184 :
1970, unisexe. En haut, maillots et pantalons unisexes (photographies © Patricia Faure) ; en bas à gauche et à droite : maillots de bains et caftans unisexes. (Photographies © Hideki Fujii)

Page 185 :
1970, jupes homme et femme, décalcomanies pour les seins de la femme (photographies © Patricia Faure).

Pages 186 et 187 :
1970, combinaisons unisexes en jersey, portées avec perruques, montres et bottes page 187. (Photographies © Patricia Faure)

Page 188 :
Eté 1971, à gauche : maillot de bain une pièce « Rouault » en jersey ; page de droite, le look militaire en maille. En fait, Rudi a créé et présenté cette collection en 1970, au moment des émeutes étudiantes de Kent State. Léon Bing l'a appelée la collection « rentrée des classes » de Rudi.

Page 192 :
Automne 1971, pages précédentes : robes longues en trompe-l'œil, en jersey noir et blanc, gris et blanc.

Page 193 :
Automne 1971, page de gauche : à gauche, veste et pantalon à bretelles vert-mousse, gansées de cuir, haut en jersey mat vert-mousse ; à droite : combinaison trompe-l'œil, maille taupe et noir. Page de droite : à gauche, ensemble pantalon trois pièces en maille à trois damiers noir et blanc ; à droite : short maille noir et blanc, sous-pull et débardeur court. Tous les ensembles sont ceinturés de laisses de chien.

Page 196 :
Printemps-été 1972, à gauche : combinaison jersey mat blanc à bandeau rouge sur la manche et maillot de bain noir topless « rapporté ». (Je l'ai appelé « le brassard rouge du courage ») ; à droite : maillot de bain une pièce, jersey rouge et noir en trompe-l'oeil. Page de droite, à gauche : maillot de bain en jersey noir qui annonce le pubikini (la coupe du soutien-gorge et du slip empêche le boutonnage) ; à droite : T-shirt « message abstrait » jersey mat blanc, noir et vert-acide, short jersey mat noir ; en bas : T-shirt long en jersey mat noir avec incrustations de virgules blanches simulant des plis.

Page 199 :
Printemps-été 1972, page de gauche : T-shirt long en jersey mat vert acide, avec une manche verte et une manche multicolore ; en haut à droite : jeans en jersey mat noir

et T-shirt court rouge avec incrustations de rose fuchsia ; au centre : T-shirt long en jersey mat rose fuchsia avec incrustations d'orange ; en bas : maillot de bain trompe-l'œil en jersey rouge, violet et noir. **Printemps-été 1972**, à droite : T-shirt long en jersey mat orange avec incrustations de rose fuchsia sur une manche ; en haut, maillot de bain en trompe-l'œil en jersey mat noir et blanc, avec incrustations en maille.

Page 200 :
Automne 1972, en haut : blouson de motard en maille matelassée noire doublée de rouge ; à droite, manteau mi-long en maille noire matelassée et pantalon en maille prune.

Page 201 :
Automne 1972, robe longue en maille noire à dos et manches mousseline.

Page 202 :
Automne 1972, chaque collection comportait des modèles à la fois beaux et faciles à porter, qui en général n'étaient pas photographiés parce qu'ils n'étaient pas nouveaux. Ils n'étaient jamais démodés ni ennuyeux et pouvaient être portés par des femmes qui ne ressemblaient pas à des mannequins. Ici, trois de ces robes, de la collection automne 1972.

Pages 204–208 :
Printemps-été 1973, collection maille. Page 204, ci-contre, une parodie de Halston : faux cardigan cousu sur un chemisier.

Page 209 :
Automne 1973, une semaine avant la naissance de mon fils. Rudi avait dans sa collection plusieurs robes amples que j'ai portées comme robes de grossesse. La robe à damiers et fleurs a été copiée un nombre incalculable de fois. La robe « cœur croisé » rose et verte avait été créée en 1960 et a connu une telle vogue qu'elle a été souvent rééditée dans des collections suivantes.

Page 211 :
1979, le *thong*. Frénésie médiatique devant la maison de Vidal Sassoon lors de la présentation de sa coupe *thong*. Le *thong* de Rudi est devenu depuis le nom générique d'une coupe de maillot de bain. (Pourtant, en 1991, certaines autorités locales américaines interdisaient encore le port du maillot *thong* sur les plages) ; double page suivante, le maillot *thong* dans son habitat naturel.

Page 214 :
Printemps 1975, robe et ensemble pantalon en jersey mat noir, reliés à des bijoux d'aluminium de Christopher Den Blaker. Chapeau de mousseline noire à armature d'aluminium.

Page 216 :
1976, Rudi a créé les costumes pour plusieurs ballets de Bella Lewitsky. Ici, les costumes de *Inscape*. (Photographies © Dan Esgio)

Page 218 :
1976, collection « simple appareil » créée pour Lily of France ; en haut à gauche, combinaison et cape de boxeur en satin noir et blanc ; en haut à droite, combinaison de boxeur et serviette de satin blanc ; en bas, short jockey femme ; page de droite, boxer-short et chemise d'homme.

Page 220 :
1981, Rudi et sa dernière collection. (Photo © Tony Costa)

Page 221 :
LE COUP DE TÉLÉPHONE.
Au début de 1985, mon fils Christopher et moi étions en train de boire une tasse de thé, en riant comme des fous à propos de je ne sais quelle blague, quand le téléphone a sonné. Christopher a décroché et m'a passé l'appareil en disant : « C'est Rudi ». J'étais encore en train de rire quand j'ai répondu : « Salut Rudi », et il faut croire que c'était contagieux, car Rudi s'est mis à rire aussi en disant: « Tu ne devineras jamais où je suis … à l'hôpital. C'est peut-être grave ». Dès cet instant, j'ai su qu'il était mourant.

Le lendemain matin, je suis allée à l'hôpital avec Bill. Nous lui avons apporté un livre et une grande orchidée « cymbidium » que j'avais cueillie dans notre jardin. Impossible de trouver un vase assez grand à l'hôpital. Rudi a planté l'orchidée dans un urinal en disant : « C'est ce qui s'appelle pisser avec élégance ».

1985, le pubikini photographié chez Rudi, un mois avant sa mort. (Photographie © Helmut Newton)

Page 222 :
LE RÊVE
Peu avant de mourir, Rudi m'a téléphoné : « J'ai rêvé cette nuit que j'étais dans un cimetière et que je voyais ma pierre tombale. Je me suis approchée. Il y était inscrit : Il a toujours eu dix ans d'avance sur son époque ». J'ai trouvé cela terrible mais j'ai ri. Rudi m'a dit : « Si je t'ai raconté ça, c'est parce que je savais que tu serais la seule à trouver ça drôle ». Il se trompait, évidemment. C'est trente ans d'avance qu'il avait.

PAS DE DEUX
Sans Rudi, j'aurais été un mannequin doué et innovateur. Sans moi, il aurait été un styliste d'avant-garde de génie. Nous nous sommes améliorés mutuellement. Chacun a été le catalyseur de l'autre. Nous ne nous sommes pas inventés réciproquement – nous avons joué une partie de ping-pong esthétique. Quand l'un des deux disait, remarquait ou faisait quelque chose, l'autre lui renvoyait la balle. C'était amusant, stimulant, c'était une vraie collaboration. Oui, c'était de l'amour.

1968, Rudi et la Reine des Neiges.

Page 256 :
L'alphabet décoratif utilisé dans ce livre est une création de Peggy Moffitt en hommage à Rudi Gernreich, sous le nom de « Rudi Bold ». Il a été dessiné par Joe Goebel.

1965

Acknowledgments

We would like to thank the following people for
their support and contributions to the book:

Pauline Annon
Léon Bing
Joan Brookbank
Bureau of Advertising
Kathy and Alan Buster
Otis Chandler
Christopher Claxton
Tony Costa
Jan Curry
Charles Davey
Alex dePaola
Dan Esgro
Exquisite Form Industries, Inc.
David Fahey
Patricia Faure
Lilly Fenichel
The staff of the Fashion Institute of Design
 and Merchandising
Jane Fluegel
Claudia Frey
Hideki Fujii
Joe Goebel
Ellen Harth
Arthur Imparato
Michael Konze
Bella Lewitsky
Pedro Lisboa
Joel Lobenthal
Marylou Luther
Donn Matus
Darrell Mayabb
Steven Meisel
Carole Mitchell
John Morgan
Bernadine Morris
Helmut Newton
June Newton
Layne Nielson
Bernie Owett
Photo Impact Hollywood
Oreste Pucciani
Peter James Samerjan
Carla Sozzani
Ivy Fischer Stone
Angelika and Benedikt Taschen
Stuart Timmons
Priscilla Tucker
Jack Voorzanger
John Weitz
Elizabeth White
Christa Zinner

Note · Hinweis · Note

Rudi Gernreich dated his designs the year and
season that they would become available in sto-
res. This book follows his system. However,
many of the designs were actually made and
photographed in the year prior to the date given
– dates that follow either "Resort" or "Spring/
Summer" were actually designed the year befo-
re. Since Rudi Gernreich's designs were often
sociological and always dealt with the time and
culture in which he lived, this discrepancy
should be noted.

Wie in der Modeindustrie üblich datierte Rudi
Gernreich seine Kollektionen auf die Saison und
das Jahr, in dem sie zum Verkauf angeboten
wurden. Viele seiner Entwürfe wurden jedoch
tatsächlich in dem Jahr gefertigt und fotogra-
fiert, das dem angegebenen Datum vorausgeht.
Wenn in diesem Buch nach "Resort" oder "Früh-
jahr/Sommer" eine Jahreszahl angegeben ist,
stammen die entsprechenden Entwürfe also
tatsächlich aus dem vorangegangenen Jahr. Da
Rudi Gernreichs Entwürfe oft gesellschaftskriti-
scher Natur waren und sich immer auf die Zeit
und Kultur ihrer Entstehung bezogen, sollte
diese Diskrepanz beachtet werden.

Rudi Gernreich datait ses créations de la péri-
ode à laquelle elles seraient disponibles en
magasin. Ce livre suit le même système de
datation. Toutefois, de nombreuses créations
ont été en fait réalisées et photographiées
l'année précédant la date donnée : les modèles
« Eté » ou « Printemps-été » ont souvent été
créés un an avant la date indiquée. Ce décalage
mérite d'être souligné, sachant que Rudi conce-
vait ses modèles dans une optique sociologique
étroitement liée à l'époque et à la culture qui
l'entouraient.

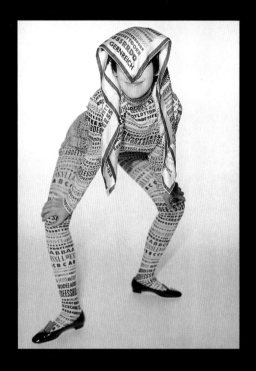

A B C
D E F G H
I J K L M
N O P Q R
S T U V W
X Y Z

The decorative alphabet used in this book was
designed by Peggy Moffitt as a tribute to
Rudi Gernreich and is called Rudi Bold.
The artist is Joe Goebel.